ISLAMIC ART

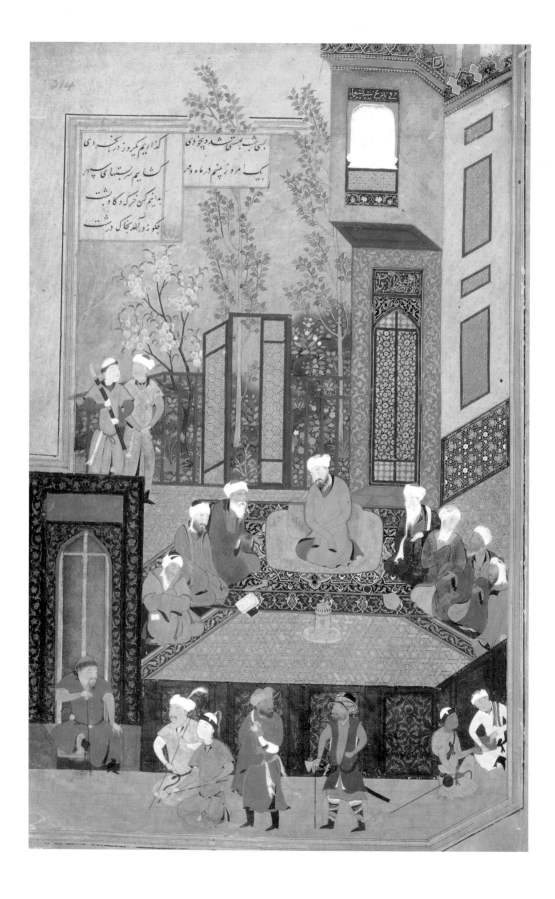

ISLAMIC ART

Barbara Brend

HARVARD UNIVERSITY PRESS
CAMBRIDGE, MASSACHUSETTS
1991

To those with whom I have travelled

Copyright © 1991 British Museum Press
All rights reserved
Printed in Singapore
10 9 8 7 6 5 4 3 2 1

Library of Congress Cataloging-in-Publication Data
Brend, Barbara, 1940–
 Islamic art / Barbara Brend.
 p. cm.
 Includes bibliographical references and index.
 ISBN 0-674-46865-1 (cloth)
 1. Art, Islamic—History. I. Title.
N6250B76 1991
709'.17'671—dc20 90-25589
 CIP

FRONT COVER AND FRONTISPIECE 'Iskandar and the
Seven Sages', from a *Khamseh* of Nizami, Herat,
900/1494–5 (the date is inscribed above the
window). Very probably the work of the painter
Bihzad. London, British Library.

BACK COVER Minaret of the *khanqah* of Faraj
b. Barquq, Cairo, 813/1410–11.

Contents

THE MUSLIM ERA

The Muslim era is dated from the departure of the Prophet from Mecca to Medina on 16 July, AD 622: this departure, known as the *hijrah* (adjective *hijri*), occurred on 1 *muharram*, AH 1. The Muslim year is lunar and has 354 days, the months having 29 or 30 days. Thus *hijri* years do not remain in phase with the longer solar years of the Christian calendar, but gradually gain upon them. As a result, equivalent years cannot be reckoned precisely, unless the month (and sometimes the day) is known; and without this it is usually impossible to tell in which of two years of the other system an event took place. When the month is not known, authorities vary in the way they indicate equivalent dates: some offer both the alternative years; some quote only the earlier, and some quote only the more probable. It is therefore all too easy for a certain slippage to occur.

A consequence of the Islamic system is that months have no seasonal significance. To indicate a seasonal month the historians of the Islamic world sometimes referred to the position of the sun in the zodiac.

TRANSLITERATION

Transliteration is always a matter of compromise. Arabic was, and largely is, the script of the Islamic world. Here, for the sake of simplicity it is rendered without diacritical signs, but with the use of the consonant 'ayn and *hamzah* between vowels. The terminal *h* (*ta marbutah*), which is omitted in some systems, is used: *madrasah*, instead of *madrasa* (exception made for some words with a very well-known English form, such as Agra, veranda). For convenience false English plurals with 's' have been used; 'b.' in names represents *bin/ibn-i* (son of).

The three principal historical languages of the central lands of Islam come from different linguistic families: Arabic is Semitic, Persian is Indo-European and Turkish is Altaic, thus a strict Arabic rendering does not always do justice to the other languages. Therefore, words which are of Persian origin (and Arabic words when they are only needed in a Persian context) are here rendered with a bias towards Persian: *nameh*, instead of *nama*; *khamseh*, instead of *khamsa*.

The case of Turkish is rather different, since modern Turkish acquired its own transliteration when it adopted Roman script in the 1920s. To the English-speaking reader the most unexpected points of modern Turkish orthography are that 'c' is pronounced as 'j' and 'ç' as 'ch'. Here modern Turkish is used for words which are exclusively Turkish and for the current names of buildings in Turkey. But personal names are given in a conventional historical form: Bayezid, instead of Beyazit. And the compromise Seljuk is used instead of either Saljuq or Selçük.

A few words here are from Hindustani or Urdu, the mixed language developed by the Muslims in India. These may already have suffered a transliteration from the Hindu script into Persian, and may thus be known in several forms; conventional renderings are used.

ACKNOWLEDGEMENTS

Firstly, I should like to thank Professor J. M. Rogers of the School of Oriental and African studies (formerly of the British Museum) for reading a draft of the manuscript and making valuable corrections. Other members of the British Museum whose help I have been grateful to receive are Venetia Porter and Rachel Ward, Jessica Rawson, Elizabeth Adey and Jane Portal, Geoffrey House, John Reeve and Patsy Vanags. I acknowledge my debt of long-standing to Norah Titley (formerly of the British Library), and recent help from Rekha Mukherjee. I am grateful to my former tutor Professor G. Fehérvári, and to others of SOAS, of other institutions or of none, who have answered my questions: Professor A. Bryer, Josephine Bayliss, Professor T. Gandjei, Professor R. Hillenbrand, Teresa Fitzherbert, Dr R. Irwin, David James, Dr N. D. Khalili, Ralph Pinder-Wilson, Basil Robinson, Dr N. Shehaby, Robert Skelton, Frank Stabler, Dr O. Watson and Professor O. Wright. Most particularly, I acknowledge the information and the encouragement which I have received from Dr Patricia Baker.

I should also like to acknowledge a beautiful calligraphy by Hassan Massoudy; fine photographs taken by Dr P. Baker, Professor E. Grube, Dr G. King, Dr B. O'Kane, Vivienne Sharp, Roger Wood and John Youngman; and a lucid map by Graham Reed. I am also very grateful for the generosity, advice and administrative time of all those who assisted my quest for pictures, especially: Sheikha Hussa al-Sabah of the Kuwait Museum, with Katie Marsh and Marcia Drury; Leslie Tate Boles of the Textile Museum, Washington DC; Professor J. Carswell and Nabil Saidi of Sotheby's; Dr Y. Crowe; Alistair Duncan of the World of Islam Trust; Dr K. von Folsach of the David Collection; Godfrey Goodwin of the Royal Asiatic Society; Derek Hill; Wilfred Lockwood of the Chester Beatty Library; Jeremiah Losty of the India Office Library; Dr A. Menteş, Dr T. Tezcan and Dr F. Çağman of Topkapı Sarayı Museum; Doris Nicholson of the Bodleian Library; Penny Oakley of Bernheimer's; Dr N. Ölçer and Dr Ş. Aksoy of the Museum of Turkish and Islamic Arts; Yanni Petsopoulos of the Alexandria Press; Jennifer Scarce of the Royal Scottish Museum; Dr E. Sims; Anna Terni of the Biblioteca Berenson; Dr A. Topsfield of the Ashmolean; Edmund de Unger; Dr D. Walker and Beatrice Epstein of the Metropolitan Museum of Art; Jennifer Wearden, Isobel Sinden and Charles Newton of the Victoria and Albert Museum.

For technical assistance I thank the Rev. C. Challenger, Paul Fox, Sarah Norman, Cynthia and Alastair McCrae. Finally, I should like to say that it has been a pleasure to work with my editor, Teresa Francis.

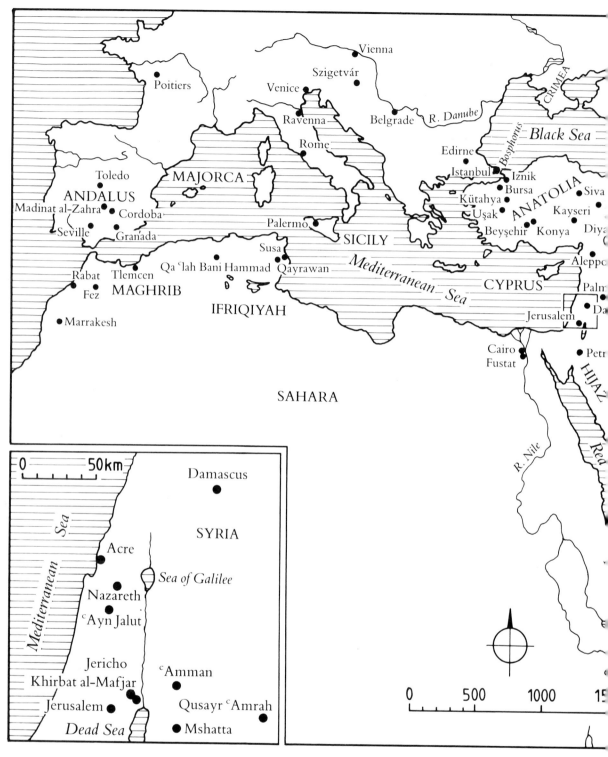

General map of the Islamic world.

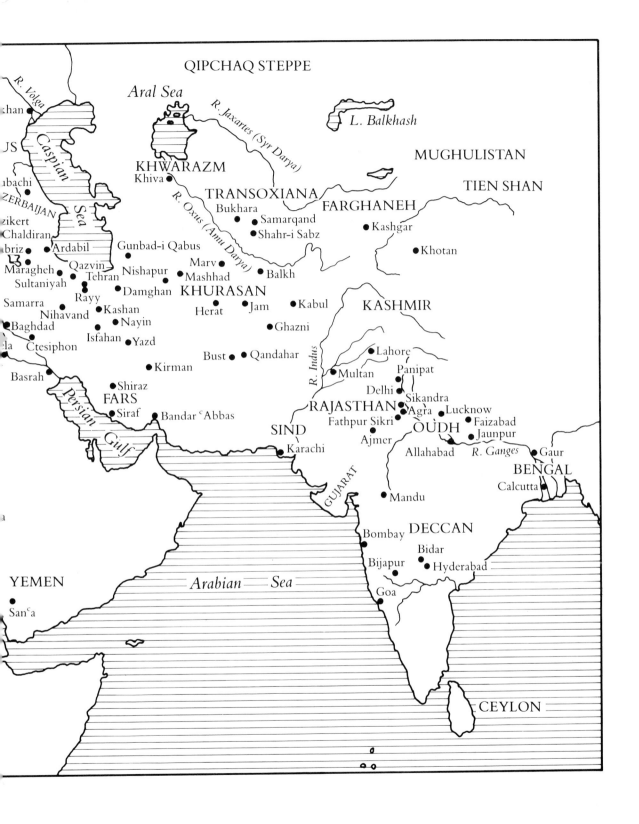

QIPCHAQ STEPPE

Aral Sea

R. Volga

Caspian Sea

R. Jaxartes (Syr Darya)

L. Balkhash

MUGHULISTAN

TIEN SHAN

KHWARAZM

Khiva •

TRANSOXIANA

R. Oxus (Amu Darya)

Bukhara •

• Samarqand
• Shahr-i Sabz

FARGHANEH

• Kashgar

• Khotan

JS

ZERBAIJAN

ubachi •

zikert

Chaldiran

briz •

• Ardabil

Gunbad-i Qabus

• Qazvin

Mragheh •

• Nishapur

Marv •
• Mashhad

• Balkh

Tehran

Sultaniyah

• Damghan

KHURASAN

Samarra

Rayy •

Nihavand •

• Kashan

Herat

• Jam

• Kabul

KASHMIR

• Ghazni

• Nayin

Baghdad •

Isfahan •

• Yazd

la •

Ctesiphon

Bust •
• Qandahar

R. Indus

• Lahore

Basrah •

Persian Gulf

• Kirman

• Multan

Panipat •

• Shiraz

FARS

Delhi •

Sikandra

• Siraf

• Bandar ᶜAbbas

RAJASTHAN

• Agra
• Lucknow

SIND

Fathpur Sikri •
• Karachi

OUDH

• Faizabad
Jaunpur

Ajmer •

Allahabad •

R. Ganges

• Gaur

BENGAL

GUJARAT

Calcutta •

• Mandu

DECCAN

Bombay •

• Bidar

Bijapur •
• Hyderabad

YEMEN

Arabian — Sea

Goa •

• Sanᶜa

CEYLON

INTRODUCTION

I slam arose in the west of the Arabian peninsula in the seventh century AD when, as Muslims believe, the Prophet Muhammad received a series of revelations from God transmitted by the Angel Jibra'il (Gabriel). By the early eighth century the Arab armies had carried Islam westwards as far as Spain, and eastwards to Samarqand and the Indus valley. Under later rulers there was further expansion into present-day Turkey and deeper into the Indian subcontinent. As a world religion Islam is no longer confined to these lands: it is also found in North-West China and South-East Asia, and it is represented in Europe and the New World, but these regions are beyond the scope of this book.

Islamic art can mean different things to different people. To a Muslim it may be an expression of religion, of faith read in the assured and stately progress of writing across a page or in the calm austerity of the cloister of a mosque. To a non-Muslim it tends to evoke rich and mysterious decoration applied to objects which often have obviously practical purposes. To a tourist it may first present itself in the form of distinctive shapes, the noble swell of a dome hovering over a city skyline or the assertive silhouette of a minaret against a sunset. For the curators, collectors, specialists and students who have been gripped by the subject, Islamic art is a world of irresistible fascination in which they strive for a better understanding of the objects and of the people who made them. A definition of Islamic art needs to be wide enough to include all the artefacts which might interest any of these approaches, and the definition used here will be: the art produced for rulers or populations of Islamic culture. The works discussed did not always have a specifically religious purpose, sometimes far from it, and the patrons and artists were not invariably good Muslims, and occasionally not Muslims at all. It is for this reason that it is appropriate to speak of this art as Islamic, which admits of some latitude in definition, rather than as Muslim, which does not. However, the culture in which the works were produced was permeated with Muslim thought, and this, together with factors of geography and history, conditioned what was made. The latter two factors will be considered first.

The particular contribution of geography to Islamic culture is a dangerous

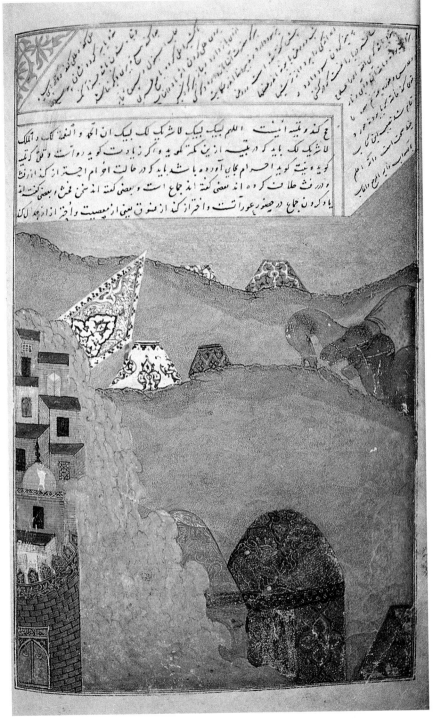

The Arabic/Persian text within the illustration:

عج کذ و لبیه ا ینت اللهم لبیک لبیک لا لشریک لک ان الحم و النعمه ٔ
لک و الملک لا شریک لک باید که در قیه ٔ از ین کمه ٔ کو ید و کر زیاد ت کو ید روا ست و نقل کرده ا
کو ید و نبت کو ید احرام جا بن آورده و باشد باید که در حالت احرام اجتنا ز کند از ر
و درفث طلافت کرد ه ا ند بعضی کفت اند بجاع است و بعضی کفت اند سنن کفث و بعضی کفتا ا
باد کرون بجاع در حیضه ٔ عورا ت ست و احتراز کند از سنن لین بین از معصیت وا حتراز کنه از لکلا

1 'Desert outside Mecca', from a *Miscellany* for Iskandar Sultan, Shiraz or Isfahan, 814/1411: the right half of a double-page illustration to a treatise on religious observance.

subject. Something, however, must result from the fact that the central Islamic lands contain some of the driest regions of the world. The deserts, semi-desert, steppe and mountains of dry rock, are interspersed with cities and areas of cultivation where water is available; the climate is often fiercely hot, but sometimes bitterly cold. Much of this landscape presents a difficult

11

environment where survival depends upon the concentrated application of certain techniques and where superfluous activities tend to be pared away. Islam has sometimes been described as a desert religion, the vast open landscape being conducive to the formulation of an absolute monotheism. In its simplest form this view is clearly mistaken, since monotheism is by no means the invariable creed of desert dwellers; however, it may be that, when for complex reasons monotheistic ideas become current, desert land fosters them. At a more prosaic level, in lands where the scope for agriculture is limited many must survive by herding or by trade. The herdsmen of camels, sheep and goats must move as they exhaust pasture, and thus their culture is nomadic; nomadism requires a portable material culture of tents, small objects and baggage, but it is also a stimulus to certain non-material ways, to clan loyalty, hospitality and oral literature. Moreover, the Middle East, set between producers of silk in China and spices in India and the insatiable demands of the Mediterranean, was from time immemorial crossed by the routes of the caravan trade. This was another life of mobility and one which tended to encourage a mixing of fashions in forms and ideas from distant origins; furthermore, the need for transport animals on the one hand and depots on the other meant that the caravan trade linked the nomads to the town dwellers.

Where the land is watered by great rivers, as in Egypt and Mesopotamia, it is often extremely fertile, and it supported ancient civilisations whose creations were to contribute to the world of Islam. Even in the minor oasis towns the possibility of cultivation made for a different way of life from that of the surrounding land. In this setting it is not surprising that the design of Islamic gardens and garden courts is governed by the square grid of water channels which derives from the practical needs of irrigation. Nor is it strange that the vision of Paradise which Islam offers to the believer is that of a garden with running waters, and that every garden created in the Islamic world tends to be seen as a metaphor for Paradise. In Islamic ornament, too, the concentrated development of the vegetal scroll – which came to be known in Europe as the arabesque – suggests the same meaning, and the love of decorative patterns of great richness and complexity is in part a tribute to the oasis-paradise.

The nature of the characteristics which Islamic art acquired from its historical context will be explored in the following chapters; for the present, it will be enough to outline the circumstances in which Islamic history began. The world into which Islam was to expand was dominated by two great powers, the Byzantine empire surrounding the Mediterranean, and the Persian empire, which extended as far as Central Asia and had acquired a bridgehead in south-western Arabia in the Yemen. The Byzantine empire was heir to Graeco-Roman civilisation, had been Christian since the fourth century, and its capital city Constantinople was to continue to entice the Muslims until it fell to the Ottoman Turks in 1453. The Persian empire, under the Sasanian dynasty, was Zoroastrian by religion, though with communities of Jews, Buddhists and Nestorian Christians; its rulers were god-kings, and its court ceremonial was elaborate. Like their forerunners the Achaemenians, whom Alexander the Great had defeated in 331 BC, the

Sasanians originated in western Iran, in Fars – the province whence was derived the name Persia, which until this century did service for the whole country. In AD 226 the Sasanians gained control of Ctesiphon on the Tigris and thus came into opposition with the then Roman empire. Over the centuries the two empires faced each other across an indeterminate frontier in the region of eastern Anatolia and the upper Euphrates; in the sixth century both were allied to an Arab buffer state, for the Byzantines the Ghassanids in North Syria and for the Sasanians the Lakhmids of Hirah on the lower Euphrates.

In the early seventh century the empires set in train a sequence of events which seriously weakened both and facilitated the Arab conquest. Khusrau II Parviz (591–628) had secured the Persian throne with the help of the Byzantine emperor Maurice; thus, when Maurice was assassinated in 602, Khusrau took the revenging of his benefactor as a pretext and launched a war in the course of which he destroyed the Lakhmids, possibly because they had turned to Christianity, and in 614 captured Jerusalem. On the Byzantine side the slayer of Maurice had been overthrown by Heraclius, who in 626 was threatened in Constantinople by the Persians. Heraclius counter-attacked, regained Jerusalem, and in 628 sacked Ctesiphon. Khusrau was killed in a palace revolt. Persia was then ruled by some ten weak kings until Yazdgard III, who reigned from 632 to 651. Heraclius died in 641, having struggled in vain to retrieve his empire's strength by internal reforms. Thus by the mid-seventh century neither empire was what it had been in the sixth.

The Arabs of the pre-Islamic period were divided into two groups, those living in the north of the peninsula and beyond it in Syria, and those living in the Yemen. The latter group had in ancient times included the Sabeans (whence the Queen of Sheba). In the mid-sixth century the south was under governors from Abyssinia, and in 572 it was annexed by the Persians. In this fertile area, agriculture was practised and the resin of the frankincense tree was harvested; through it passed the sea-borne trade in spices from India. A caravan route rose from Yemen along coastal Hijaz through the cities of Mecca and Yathrib (later Medina), carrying perfume and spices by way of Gaza to Egypt and Rome, or through Nabatu (Petra) and Tadmur (Palmyra) to Mesopotamia.

In the cities of Syria the Arabs were exposed to the influences of the great empires. Thus, the rock architecture of Petra, which flourished in the first century AD, is strongly Hellenised; and Palmyra, whose Queen Zenobia was defeated by the Romans in 272, is largely Roman in architecture, with traces of Persian style in its figure sculpture. Within the Arabian peninsula the influences of the empires were much less powerful. The town-dwellers, heavily dependent on the caravan trade, lived in simple houses of stone or unbaked brick, which may have had some decoration in whitewash in the manner still to be seen in the Yemen; and the Bedouin of the deserts, who occasionally harried the caravans, lived in tents. The dominant cultural thread which united the town-dwellers and the Bedouin was the Arabic language. Its power and intricacy were exploited in poetry ranging from dramatic and tragic odes reflecting the life of desert warriors to proverbs, satires and popular songs. Long held in oral memory, pre-Islamic poetry was

2 'Pilgrims at the Kaʿbah', the left half of the illustration shown in Fig. 1. A pilgrim touches the black stone; he wears the ritual costume of two pieces of white cloth. Later representations show the Kaʿbah draped in a black cloth, the *kiswah*.

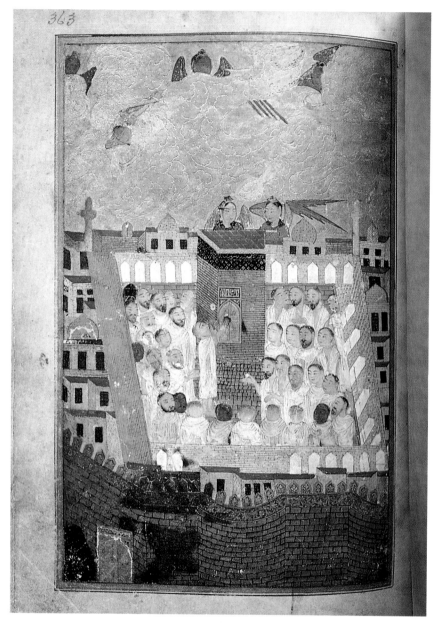

collected and written down in the ninth century. Together with sporting contests such as camel or horse races, poetry was a feature of the trade fairs which formed a meeting point for town-dwellers and Bedouin. The fairs were often held on the occasion of pilgrimages to holy places, the most important of which was Mecca (Makkah).

In the early sixth century Mecca was a rising mercantile and religious centre under the control of the Quraysh tribe. Religious rites there were focused upon a sacred precinct (*haram*) containing a shrine called the Kaʿbah, a small rectangular structure with a black stone set in its side. The principal deities revered were Allah and three goddesses seen as his daughters, al-Lat, al-ʿUzza and Manat (who presided over birth, fertility, and death respectively). The *haram* contained idols of these and other divinities in forms which may have

resembled the rather schematic sculptures which survive from South Arabia, or which may have been touched by the more naturalistic styles of Syria. Muslim tradition sees this state of idolatry as a corruption of a primal monotheism which had been known to Adam and to Ibrahim (Abraham), the forefather of the Arabs through his son Isma'il. Yearnings towards monotheism might also be stirred by Judaism. Yathrib, north of Mecca, had a large Jewish community, and Judaism had been dominant in Yemen for a period in the sixth century. Christians of both the Monophysite and the Nestorian sects were also present. It was, indeed, a slight to a church in San'a which precipitated an attack on Mecca by the Christian Abyssinian governor of Yemen in the year 570. The governor advanced with elephants, but his army is said to have been routed by divine intervention.

The traditional date for the birth of Muhammad is 570, the year of the Elephant; he was born at Mecca, a member of the Quraysh. His father 'Abdallah having died before his birth, Muhammad was brought up by his uncle. He worked with the trading caravans, and as a young man married a rich widow, Khadijah. At about the age of forty Muhammad began to experience revelations which he communicated to his family and the people of Mecca. The words which he received were learned by his followers, and probably also written down; they form the Qur'an (a name which implies either recitation or reading), the holy book of Islam. The Qur'an was codified under the caliph 'Uthman (644–56). Each chapter (*surah*) begins with a formula known as the *bismillah*, the initial words of the pronouncement 'In the name of Allah, the Merciful, the Compassionate', and the *surahs* are arranged, for the most part, in descending order of length. The shorter chapters at the end, however, are considered to have been revealed at Mecca in the earlier phase of Muhammad's prophethood. The Meccan *surahs* are visionary in tone, speaking of the beneficence of the one God, of the Judgement which awaits mankind, and of a man's duties to his fellow men.

The message which Muhammad proclaimed had a divisive effect amongst the tensions in Mecca between those growing in prosperity and those who had been left behind. Many prominent citizens and guardians of the Ka'bah, whose interests were served by a polytheism which accepted all comers, were bitterly hostile. The less powerful members of society, moved perhaps especially by the social teaching which appealed to the old tribal code of care for members of the group, were more willing to accept the teaching. The animosity of the former group grew so intense that in 622 Muhammad and his followers left Mecca in the hope of finding a more sympathetic reception in Yathrib. This departure, known as the *hijrah*, is the date from which the Muslim era commences.

Yathrib, which came to be called Madinat al-Nabi, the City of the Prophet (Medina), was to be the home of Muhammad until his death in 632, and the legal character of the Medinan *surahs* revealed there reflects the need to structure the new and uprooted Muslim community. At first Muhammad hoped to win support among the Jewish population, and when at prayer he turned northward in the direction of Jerusalem, but in 624, when praying in a *musalla* (open-air place of prayer) outside Medina, he received a revelation instructing him that Mecca was to be his *qiblah*, the point towards which he

should turn his face, and he turned southwards to face Mecca. The rule of orientation to the *qiblah* was observed in Muhammad's house, which was the centre of the Muslim community. The house consisted of a mud-brick wall which enclosed a courtyard some 50 metres square. At the south end, colonnades of palm trunks supported a flat roof of palm fronds to protect the community from the sun when they were gathered there; at the north end of the courtyard a smaller roofed area sheltered those who were homeless. The private area of the house was formed by the living quarters of the wives whom Muhammad had married after the now deceased Khadijah. These consisted of four apartments with subdivisions and five huts which communicated with the courtyard through the east wall. The east, north and west walls of the courtyard each contained a gate. The basic scheme of Muhammad's house, a rectangular enclosure with a hall on columns on the *qiblah* side, was to become the pattern for the early Islamic mosque.

Muhammad would sometimes discourse standing in the shaded area of the courtyard and leaning against a palm-trunk; from the year 7/628–9 he made use of a high seat with three steps. After Muhammad's death this feature, known as a *minbar*, was at first seen as the perquisite of the leader of the community, but it soon came into general use in congregational mosques. The *minbar* came to be the position from which was delivered the *khutbah*, an oration in the course of Friday prayer which named the sovereign acknowledged by the community. The use of the *minbar* thus typifies the close relation of religion and politics in Islam. In the time of Muhammad the minaret was not yet in use, and the call to prayer (*adhan*) was given – by a black Abyssinian muezzin named Bilal – from a roof. Nor was the most characteristic feature of a mosque, the *mihrab*, instituted until after the death of Muhammad. Now a concave niche, the *mihrab* is set in the *qiblah* wall of a mosque and so indicates the orientation of the building. It is probable, however, that the first *mihrab* was a flat slab in the shape of a niche placed in the house of Muhammad after his death to commemorate the position from which he used to lead the faithful in prayer. Before its Islamic use, the word *mihrab* was applied to the apse in a palace which honoured the place of a king.

During the period in Medina the political standing of the Muslim community was enhanced by a network of alliances with other Arab groups, and, in the desert tradition, Muhammad authorised his followers to attack the Meccan caravans. Clashes ensued with Mecca, but in 9/630 Muhammad captured the city, meeting little resistance, and was at last able to cleanse the Ka'bah of idols. The followers of the Prophet were now the most powerful group in Arabia.

On the death of Muhammad in 11/632, Abu Bakr, one of his trusted companions, was chosen to be his successor or *khalifah* (caliph). He held this position for two years, continuing Muhammad's policy of penetration into Iraq and Syria. On his death, 'Umar was chosen to succeed him, during whose caliphate a major expansion took place. The bounds of Muslim territory, the Dar al-Islam (Abode of Peace) were carried ever further into alien territory, the Dar al-Harb (Abode of War), by the process of *jihad* (holy war). The Byzantine empire lost the eastern Mediterranean, and the Sasanian empire succumbed entirely. Damascus was taken from the Byzantines in

14/635, Jerusalem in 17/638 and Egypt in 19–20/640–41. The Persians were defeated at the battle of Qadisiyah on the Euphrates in 15/636, thus losing Ctesiphon, and again at Nihavand near Hamadan in 21/642, after which Yazdgard III spent ten years as a fugitive until his assassination by an unknown hand in 31/651–2. ᶜUmar himself was murdered by a Persian slave in 23/644. Six members of the Quraysh, whom ᶜUmar had appointed as he lay dying, debated the succession of ᶜUthman, a father-in-law of Muhammad (of the Umayyad branch of the Quraysh), or ᶜAli, Muhammad's cousin and son-in-law, and chose the former. The new state now experienced the difficulties of a less rapid expansion, discontent grew, and in 35/656 a mob broke into ᶜUthman's house in Medina and killed him. ᶜAli was now chosen as caliph, but his succession was opposed, first by ᶜA'ishah, a widow of Muhammad, and then by Muᶜawiyah, the governor of Syria. As a member of the Umayyad family, Muᶜawiyah demanded vengeance upon the murderers of his cousin ᶜUthman. Negotiations began, but in 41/661, before any outcome was reached, ᶜAli was assassinated in the mosque at Kufah, his power-base on the lower Euphrates. Muᶜawiyah succeeded to the caliphate and founded a dynasty which ruled until 750. Of yet more fundamental effect was the beginning of a rift in Islam between two religious and political factions: the partisans of Muᶜawiyah who claimed to follow the *sunnah*, or way of the Prophet (Sunnis), and the *shiᶜat ᶜAli*, or party of ᶜAli, whose adherents are devoted to the lineal descendants of the Prophet through ᶜAli (Shiᶜis) – two persuasions which were often to find themselves in opposition down the ages.

The essential features of Islamic architecture have been mentioned above in the historical context in which they came into being, but it is self-evident that Islam, considered timelessly, conditions the nature of Islamic art. The language of the Qur'an and of formal prayer is Arabic, and thus, paradoxically, the language, which existed before the time of the Prophet, came to be most intimately associated with the faith which he declared. Arabic words are usually derived from roots of three letters which, with certain letters prefixed, suffixed and interpolated, give rise to a range of meanings. The root *s-l-m*, which encompasses meanings of safety and peace, gives *Islam*, meaning submitting oneself to the will of Allah (God) and *Muslim*, one who has made that submission. The linguistic structure of Arabic, in which words are related to each other by a pattern of units, probably has an influential role in Islamic design. Similarly, the implication which the language carries that large webs of topics are related to each other has probably fostered the use of analogy, even between topics which are not linguistically related. Thus, in Muslim jurisprudence a fundamental procedure is *qiyas* (analogy), which, under certain conditions, derives a ruling on one matter from that on a comparable case. The predisposition to analogy probably contributes to such features of Islamic architecture as the widespread use of the niche form for *mihrab*, tombstone, door, window or decorative feature, or to the nexus of associations which unite foliage, garden and Paradise. These suggestions must be qualified by the fact that many of the craftsmen who created Islamic art were not native Arabic speakers; however, in general they worked within a culture imbued with Arabic modes of thought.

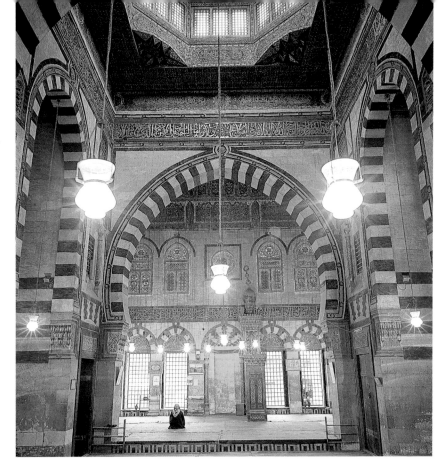

3 The mosque in the mausoleum complex of Qa'it Bay, Cairo, 879/1474–5. In the centre is the *mihrab* niche with the *minbar* to the right. Since prayer is performed on the floor, the windows extend down to this level. The foreground area under the lantern dome is known as a *qaʿah* (see p. 103).

The essential duties of a Muslim are summed up in five principles, known as the Five Pillars. These are the profession of faith, the performance of prayer, payment of alms, fasting and pilgrimage. The profession of faith is the *shahadah*, 'There is no God but God, Muhammad is the Messenger of God', the first clause of which is often called the *kalimah*. The teaching implicit in the second part of this fundamental statement is that Muhammad is (only) the Messenger: the concept of divine incarnation – as it is found in Hinduism or in Christianity – has no place in Islam. The Message is more important than the Messenger and thus, in contexts where the Byzantine world would have used a figural icon, the Muslim world uses an aniconic icon, the *kalimah* in written form – which is, for example, often given pride of place on a *mihrab* or on a coin. The primacy accorded to writing is an important feature of Islamic art, but the displacement of the figural is not absolute, and it will be further discussed below. *Salat* is the prayer which Muslims are required to make at fixed intervals during the day, for the majority Sunni community five times. The physical requirements of prayer are a state of cleanliness achieved by ritual washing (or, in case of need, scouring with sand), a space sufficient to bow down the head to the ground, and the correct orientation towards Mecca. A building is not required; instead an individual's space can be marked out by an object placed in front of him (*sutrah*). Groups pray together in rows parallel to the *qiblah*, following the lead of any adult male, who stands before the rows in the role of *imam*. The word mosque is a Europeanisation of *masjid*, a word of pre-Islamic origin meaning a place for bowing down. The consequences of the Muslim form of prayer in

terms of mosque architecture are that a sufficient free and clean floor-space is required, with a *mihrab* for orientation. In some mosques washing facilities may also be provided, though this is not a necessity since ablutions may be performed at home. A subsidiary effect of floor-based prayer has been the development of the prayer carpet (*sajjadah*). The obligation to give alms (*zakat*) can be related to the impulse to create charitable foundations, such as hospitals, places of learning or simple public fountains, though these would often have been provided by gifts beyond the statutory limits of the *zakat*. The fast (*sawm*) observed in the month of *ramadan* has a more limited relevance to Islamic art, though particularly fine vessels might be produced for the feasts which follow the day's fasting. The *hajj*, the pilgrimage to Mecca which a Muslim is required to make at least once in a lifetime, if means and obligations permit, also gave rise to special items such as the new drapery (*kiswah*) which the caliph sent annually to the Ka^cbah, or ornamental certificates of pilgrimage. More generally, it must have assisted the continuing interchange and mixing of elements from all regions of the Muslim world.

A question which causes particular difficulties in the discussion of Islamic art is that of the lawfulness or otherwise of the representation of living beings. The matter is complex. It is not precisely the case, as is sometimes stated, that the Qur'an forbids representation. In the key passage in *surah* v, 92 – 'O ye who believe, wine and games of chance and idols and divining arrows are an abomination of Satan's handiwork; so avoid it and prosper' – it is clearly the worship of idols which is condemned. An antipathy to representation, related to the Jewish prohibition of graven images, seems to have been latent in early Islamic thought and to have hardened in the course of the first century. It is typified by the fact that the caliph ^cUmar is reported to have used a censer with figures on it to perfume the mosque at Medina, but in 783 the governor of Medina had the figures removed. The *hadiths*, traditions reporting the words and actions of the Prophet, collected after his death and sometimes at a considerable interval, tend to show him as disapproving of images. The message, however, is not absolute: it is reported that when Muhammad cleansed the Ka^cbah of idols he put his hands over the pictures of Jesus and Mary to save them. Nevertheless, the doctrine eventually evolved that the painter or sculptor was guilty of trying to usurp the creative activity of God. The representation of animate beings was absent in mosques from the first, and was usually omitted on buildings of secondary religious character such as colleges and tombs. The Qur'an is not illustrated, and, indeed, since much of it is hortatory and prophetic rather than narrative, it relates to a class of scripture which would usually be unillustrated under a different religion. Depictions of the Prophet are, however, found in accounts of his life, but these are of lesser standing than the Qur'an. In the secular sphere, practice was much more variable, and it is often not clear, when living beings are represented, whether this was seen by the first patrons as permissible or as a fault worth indulging. Palaces were sometimes rife with figurative work in statuary and wall-paintings. Books were illustrated chiefly for princes and the well-to-do, but, whether frankly rendered or half concealed as ornament, representation extended through textiles, metalwork and pottery to the possessions of other levels of society.

I

THE LEGACY OF EMPIRES
Syria, Iraq and Iran under the caliphs

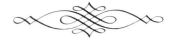

T he Umayyad caliphs ruled from 661 to 750. They were followed by the ʿAbbasids, whose rule extended in name until 1258 but whose political dominance lasted only until the mid-tenth century. The Umayyad century was a time of change as the leaders of the new state absorbed the culture of the eastern Mediterranean. By the early ʿAbbasid period, the Islamic world had developed a classical culture of its own, though it remained willing to accept what was useful from the older empires.

The character of the Umayyad polity was different from that of the Patriarchal Caliphs because of where they were and who they were. The Umayyad state was centred on Damascus; thus political power was removed from the Hijaz never to return, but Syria with its Mediterranean and Byzantine inheritance provided a background well suited to Umayyad inclinations. A more luxurious and ceremonial way of life developed, though new and formal ways were sometimes cut across by old tribal familiarities. The Umayyads belonged to one of the old ruling families of Mecca, and thus they had a confidence which depended not only on adherence to the Muslim community, but also on their own status and traditions. In Muʿawiyah (661–80), ʿAbd al-Malik (685–705) and al-Hisham (724–43) this confidence is shown in brisk and efficient administration which could rescue the state in times of crisis. Some measures taken were controversial in the extreme, such as Muʿawiyah's imposition of a hereditary instead of an elective succession, a decision fraught with danger. Other Umayyad rulers showed a remarkable insouciance with regard to the strictures of Islam. This sometimes took the form of a hedonistic enthusiasm for wine, women and song, for which architectural settings of exuberant luxury were devised. The great patrons of architecture, either religious or secular, were ʿAbd al-Malik, his son al-Walid (705–15) and probably also his grandson al-Walid II (743–4). The fall of the Umayyads was brought about by events known as the ʿAbbasid revolution, a movement which arose in Iran, fuelled mainly by the discontent of Persian converts who felt that they were not accepted as Muslims equal to the Arab establishment; it was supported by those scandalised by the Umayyads, and also, although the ʿAbbasids were Sunni, by Shiʿi supporters of the house of ʿAli.

4 The Dome of the Rock, Jerusalem, 72/691–2. The upper part of the walls was originally covered in mosaic and extended above the roof in an open arcade, which is now blocked and tiled. The tilework, originally Ottoman but recently restored, is in blue, white, yellow and black.

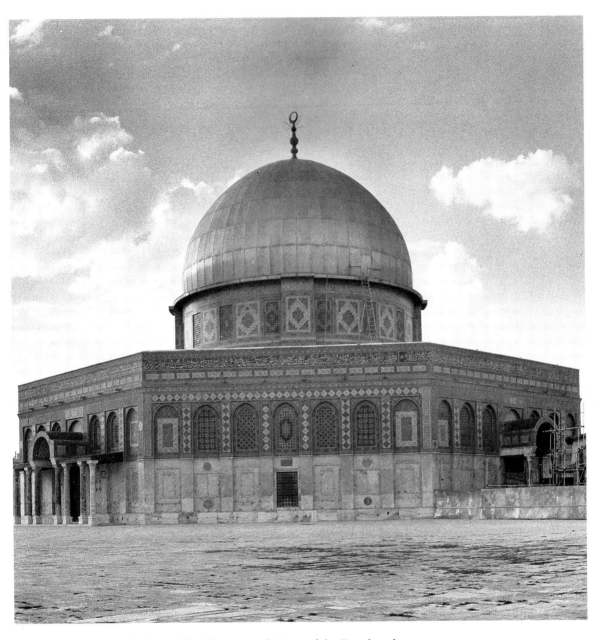

Like the Umayyads, the ᶜAbbasids were relations of the Prophet, but at a nearer degree and hence having a greater moral authority. The first ᶜAbbasid caliph was known as al-Saffah – an ambiguous epithet which may imply the outpouring of bounty or of blood. The establishment of the state, however, was the work of his brother al-Mansur (754–5), who founded a new capital west of the Tigris at a village named Baghdad (Gift of God). As the Umayyad move out of Arabia was of fundamental importance, so was this break from the Mediterranean and move towards Persia and the Orient.

The caliphs' theocratic rule was somewhat analogous to that of the

5 The Great Mosque, Damascus, completed in 96/714–15. The present dome was constructed following a fire in 1893 which destroyed an earlier wooden one. The small structure on columns is a treasury (*bayt al-mal*). The mosaic on this and on the gable end of the mosque has been recently restored. It is probable that the arcade of the sanctuary façade was originally supported by an alternation of one pier and two columns.

medieval papacy, though with major differences, one of which was the fact that the caliphate was confined to the house of ʿAbbas. Baghdad in the days of Harun al-Rashid (786–809) is the setting of the tales of the *Thousand and One Nights*, which, however, were not given written form until much later. Ninth-century Baghdad, especially during the rule of Harun's son al-Ma'mun (813–33), was a great centre of learning; fields of endeavour included the study of theology and the traditions of the Prophet, the collection of pre-Islamic verse, and translation from Greek works of science. In the mid-ninth century, however, problems arose. One was the friction between the local populace and the regiments of palace guards, which were no longer found from Arabs but from Turkish slaves from Central Asia. The desire to avoid clashes between these groups was a factor in the decision of al-Muʿtasim (833–42) to found on the Tigris north of Baghdad another capital, Samarra, which continued to flourish under al-Mutawakkil (847–61). Yet more threatening was the growing tendency of provinces to make themselves independent in all but name, or even to the point where the name of the caliph was omitted from the Friday *khutbah*. The leaders of provincial factions grew ever more daring, until in 334/945 the Shiʿi Buyids established themselves as virtual rulers, with the caliph reduced in terms of temporal power to a puppet.

Architecture and its decoration

It is generally held that the architectural tradition available to the Muslims in Arabia was severely utilitarian. This may not have been entirely the case, for a *hadith* which reports the Prophet as saying 'The most unprofitable thing which eats up the wealth of a believer is building' suggests that some temptation to luxury existed. However that may be, when the Arab armies entered Iraq and Syria they encountered a new range of architectural methods and styles. Both areas had an ancient tradition of stonework. The Persian empire could look back to the fifth century BC and the Achaemenian palace of Persepolis, with its hypostyle *apadana* halls and the brilliant low-relief carving flanking its stairways. In later periods the grand effect was often made more economically with rubble masonry covered by stucco, and a shortage of timber was a stimulus to the development of vaults and domes in brick. Byzantine Syria had inherited from Greece and Rome an architectural tradition which used columns both as supports for horizontal beams and for arcades. Fine stone was available locally, and also wood from Lebanon, which made for light roofing. A tradition of naturalistic ornament from the classical world had to some extent penetrated through Syria and into the Persian empire, and more formal oriental motifs had travelled in the other direction. In addition, each area had its own religious and royal iconography.

Arab armies on the march would have required only an open space to pray in, the sole constraint being the *qiblah* direction. Thus, when they first established themselves in South Iraq at Basrah and Kufah, we hear of mosques in the form of a simple square delimited by a stockade of reeds or a ditch. In Syria the need for a mosque could often be supplied by the requisition of a church. For liturgical reasons a church would be long and orientated to the east, but Muslims could use it by turning to face the

6 Mosaics in the west *riwaq* of the Great Mosque of Damascus, about 714 (with some recent restoration). Seen between the columns of the *bayt al-mal* is part of a composition sometimes named the 'Barada' panel, after the river of Damascus. Unlike the little houses, the jewel-hung palaces do not cast shadows, but the shading of their columns – like that of the tree-trunks – implies volume. The formal ornaments in the soffit recall mosaic decoration in the Dome of the Rock.

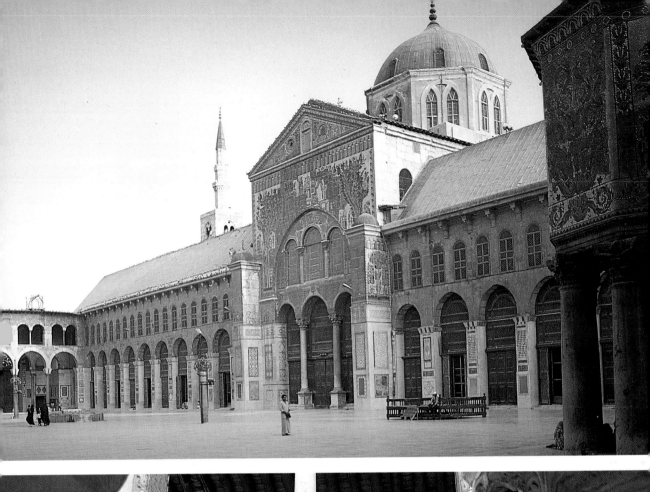

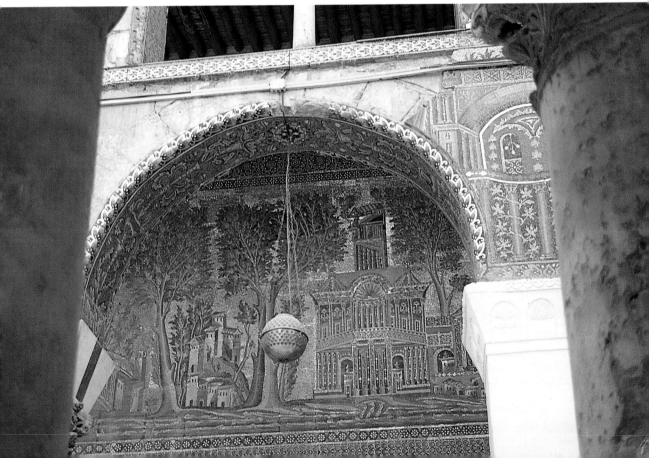

south wall, which – in Syria – would produce the correct *qiblah* direction.

The earliest Islamic building to survive in its original form is the Dome of the Rock (Qubbat al-Sakhrah) in Jerusalem, completed for ᶜAbd al-Malik in 72/691–2. Though it has often been restored down the ages, much of the seventh-century work is still visible. An octagonal building with a central dome, it is unlike the mosques which preceded it, in both form and purpose; it was evidently intended as a powerful symbol, and it has continued to be so. The building was raised within an enclosure known as the Haram al-Sharif (Noble Sanctuary) on the platform where the Jewish temple had stood until its destruction in AD 70; it is on Mount Moriah where Muslims believe Ibrahim had prepared to sacrifice his son Ismaᶜil; it has the centralised plan of a Christian shrine and, like Jerusalem's Church of the Holy Sepulchre, it focuses upon a rock; and it was built at a time when Mecca was in the hands of a rival caliph. The splendid new building could thus send a religio-political message to members of each of the three faiths. One reason for building need not cancel another, but it was probably the message to the Christians which most concerned ᶜAbd al-Malik since a long qur'anic inscription within the building proclaims the Oneness of God as against the Trinity. A further layer of meaning was added to the Dome of the Rock as it came to be seen as the point from which the Prophet made an ascent into the heavens, the *Miᶜraj*.

The plan of the Dome of the Rock proceeds directly from the centralised type used in the Christian world in general for baptisteries and in Palestine in particular for churches memorialising Christian events. In this case a circle is enclosed within an octagon, within another octagon – a simple geometrical scheme which can be derived from placing a square upon another and turning it through 45 degrees, a motif which is found in Byzantine ornament. The dome, the usual roof for such a building, is a restoration of ancient date; a double shell of wood plated with metal, it reaches 35 metres above the ground, giving the building a stately height. The lower half of the walls of the outer octagon is clad with marble; the upper half was coated with tilework in the mid-sixteenth century on the order of the Ottoman overlord Süleyman the Magnificent, but originally it had been covered with mosaic in stone and glass. The building is entered by columned porches which face the cardinal directions. Within, the intermediate octagon is supported by eight piers at its angles with two columns between each; these supports are linked by mighty tie-beams, which are covered with metal with rich repoussé ornament in the style of classical entablatures. The inner circle round the rock has four piers with three columns between each, linked by lighter tie-beams. Below the central rock is a cave, in part at least man-made, and in it an early flat *mihrab* set with a black stone.

The great glory of the interior is the mosaic decoration carried out at the level of the arcades and inside the drum below the dome, in shades of green and blue, in mother-of-pearl, and in gold foil sandwiched in glass. The motifs include thickly curling acanthus scrolls and grapevines, palm-trees, garlands and vases, with repeating abstract motifs in the soffits of the arches. In some places the acanthus grows into more formalised composite shapes, related to the classical thyrsus or trophy, and depicted as though bearing jewels. It has been suggested that the forms of Byzantine and, more especially, of Sasanian

crowns can be read here, as though they were offered in submission at the Muslim holy place. The qur'anic inscription runs above the arcades in a mosaic of gold on deep blue.

A richness comparable with that of the Dome of the Rock was created at the Great Mosque at Damascus, built by al-Walid between 87/706 and 96/714–15, but this has suffered more damage over the years. The Muslim building again occupies an older holy site, for it was constructed within the enclosure of the Roman temple to Jupiter Damascenus, which in Byzantine times had been converted to the Church of St John the Baptist – whose shrine remains within the mosque. The area, in an enclosure of massive Roman masonry, is a large rectangle which presents a long side to the south. The covered part of the mosque adopted the classical basilica form which was used both for churches and palaces. Three aisles with shed roofs run parallel to the *qiblah*; they are supported within by two arcades on large columns, with smaller arches above them. In the centre, on the axis of the *mihrab*, another basilical form cuts across the three aisles and presents an imposing gable end to the courtyard: the effect has been compared with that of Theodoric's palace, as shown in mosaics of the sixth century in Ravenna. The courtyard (*sahn*) is surrounded with cloisters (*riwaqs*) with two levels of arcading. The arches of the lower storey have a slight return at the bottom, the beginnings of a horseshoe form.

As at the Dome of the Rock, the lower part of the walls was faced with marble. Above that, the greater part of the courtyard shows bare stone, but the arches of the west *riwaq* and the wall behind them have retained much of their lovely mosaic. The decoration of the smaller areas is similar to that at the Dome of the Rock, but on larger surfaces, where the older scheme was conceptual, this is scenic. Appearing above the marble panelling, the mosaics seem to dematerialise the structure behind them and suggest a landscape seen over and beyond a wall. Tall trees are used as dividers between groups of buildings against a ground of gold. The buildings are of two classes: some are small, grouped in clusters, seen from the exterior and represented with illusionistic shadows; others are larger, grander, flatter, and more fantastical with domes, columns, ornaments. The complexity of the second type suggests that they derive from a pattern book. In the largest panel both sorts of dwelling are shown fronting a river. Human figures are totally absent, and it has been suggested that, in formal terms, the large trees occupy their role in the compositions. The various dwellings have been interpreted as representing the cities conquered by the Muslims, but it is far more probable that the mosaics portray the Paradise which awaits the believer – a Paradise of great beauty, in which it would seem distinctions of rank or of status continue to be observed.

Architecturally, the Great Mosque at Damascus was of great importance as a model: close imitations of it were built at Aleppo and at Diyarbakır (Amida). It has also been suggested that the early minarets of Western Islam, which have the form of square towers, may have been derived from the towers of the temple enclosure. Another important innovation which seems to be attributable to the patronage of Walid I is the introduction of the curved-backed *mihrab*. This form, whose apse-like shape would have had

7 OPPOSITE Stucco ornamented portal from Qasr al-Hayr al-Gharbi, 109/727. The form of the portal, with half-round buttresses, semicircular tympanum and stepped merlons, is typical of Ummayad style, as are the decorative features – stylised acanthus, geometric shapes, rosettes, and shell-headed niches which alternate with pointed ones. The niches may once have framed figures, and small female busts can still be made out in some of the spandrels. The tympanum probably framed a statue of the patron. Damascus, National Museum.

honorific connotations, was used instead of a flat *mihrab*, which may have had funerary connections, when Walid restored the Mosque of the Prophet at Medina from 88/707 to 90/708–9.

The secular building of the Umayyads is represented by their so-called desert palaces. Widely scattered in the Syrian areas, these are the heirs to the Roman and Byzantine fortresses which guarded the eastern frontier. Outwardly they often appear as forts, usually square, of well-cut stone, with corner and intermediate buttresses and an impressive gateway. Defence, however, was no longer a prime consideration, and the palaces seem often to have presided over agricultural estates in carefully irrigated land. Another function was probably to house a prince and his retinue as he moved about the country, and some were retreats for hunting and other princely pleasures. Internally, a central courtyard, perhaps colonnaded, would be surrounded by structures of two storeys, which in the larger examples might be subdivided into *bayts* ('houses', self-contained suites of rooms). Large rooms of state were often set in an axial position, and mosques can be distinguished by the curve of their *mihrab*. There might be amenities such as baths of classical type (*hammam*), or underground rooms for use in hot weather (*sardab*). There are some extensive remains of decorative schemes which draw principally on classical motifs, but with some Persian introductions.

Two examples which show the varied character of the desert palaces are Qasr al-Hayr al-Gharbi of 109/726–7 and Qasr al-Hayr al-Sharqi of 110/727–8, the Castles of the West and of the East Game-Parks, built in the reign of Hisham. These are situated one either side of Palmyra, and it may be that in addition to being hunting lodges they were intended as stages on a route from Damascus to Rusafah. The Eastern site comprises two enclosures. The smaller has been identified as a caravansaray, and the larger as a settlement for the production of olive oil. The large enclosure is entered by a portal with a machicoulis over the door, which suggests a serious possibility of defence. It had a central courtyard round which were grouped six *bayts* with subsidiary courtyards, together with a mosque and olive presses. The agricultural aspect of the settlement did not preclude luxury, and the Qasr had baths beyond the walls and stained-glass windows within. In contrast, Qasr al-Hayr al-Gharbi has more the air of a kingly retreat: its gateway was ornamented over all in stucco. It forms, indeed, an important document for the transformation of classical ornament into Islamic, for in it stylisation and pattern are becoming more pronounced. Stucco statues from the palace are dressed in classical drapery and in the Persian trousers and tunics seen at Palmyra, and two floor-paintings show a similar double heritage, the one having a bust of Gaea and tritons, and the other musicians and a mounted archer hunting in the Sasanian manner.

Experiments in iconography are again a feature of the decoration of Qusayr ᶜAmrah in the Wadi Butum east of ᶜAmman. The main structure resembles a small Syrian church with three barrel vaults; its interior is completely covered with wall-paintings, now unfortunately much damaged. The place of honour, the flat central end wall, is taken by an enthroned figure, in the style of a Christ in Majesty, flanked by two attendants. The west wall displays some of the major interests of this prince. Above, a herd of wild asses is

8 BELOW Symbols of the constellations painted on the ceiling of a dome in the bath annexe at Qusayr ⁽Amrah, first half of the 8th century. The constellations have been transposed from right to left, suggesting that the painter looked down at a cartoon. The greater and lesser bear are distinct in the centre, and Sagittarius, lower right, on the circle of the zodiac.

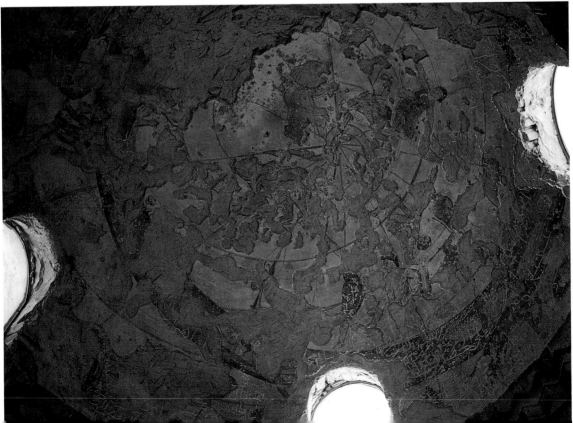

driven in a hunt; below, in a classical setting, acrobats tumble and a statuesque semi-nude female emerges from a bathing pool; while at the south end, a group of standing figures can dimly be descried. These last have been identified as Kings of the Earth, including those of Byzantium, Persia and Abyssinia. Also present is Roderic, the Visigothic ruler of Spain who reigned only in 711 and whose presence thus forms a *terminus post quem*. The kings have been interpreted as submitting to the Islamic lord, or as representing the status which he claims. The east wall gives access to a suite of baths. On the dome of the very small hot room are depicted figures of the constellations. 8 Other subjects include Cupid and Psyche, workmen, and a bear playing a stringed instrument. The identity of the patron of this building is not certain. The discrepancy between the small scale and the embracing vision supports the view that he may have been the gifted and pleasure-loving Walid b. Yazid, in the years before 743 when he attained the caliphate as Walid II.

Walid II may also have been the patron of the astonishing Khirbat al-Mafjar 9 at Jericho; the bold and opulent taste at both palaces, and a similar vegetal symbol in the floor mosaics suggest it. Much ruined, Khirbat al-Mafjar consisted of four main connected units: a palace round a courtyard, a mosque, a large octagonal foundation, and a great hall with baths adjoining. The hall was the most remarkable: with sixteen piers to support a roof which must have had a central dome, eleven apses in the walls, a floor of geometric mosaic, a swimming pool the length of one wall, a suite of hot baths on the

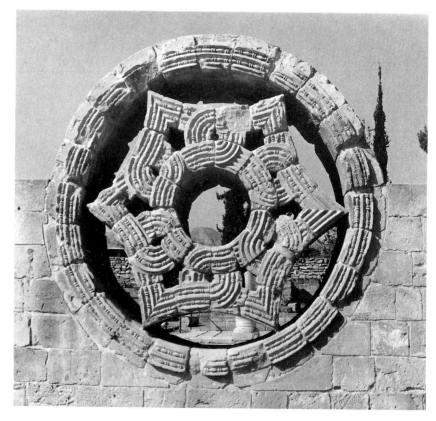

9 Stone knot, Khirbat al-Mafjar, probably 740s. Now displayed in the middle of a court, the roundel may once have been the central feature of a gable end, where its effect would have been striking. Though apparently unique, it is related in concept to contemporary geometric window grilles executed in marble. More generally, it derives from a tradition of geometric and knotted forms in classical decoration, and the bands of bead-and-reel ornament upon it are derived from classical types.

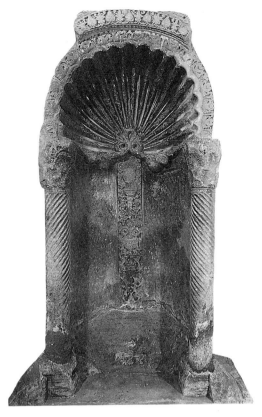

other side, and a private room, this could justifiably be called a stately pleasure dome. The hall was entered by a porch on which was set a statue in stucco, considered to be the patron, and within the porch chubby stucco figures assumed the role of caryatids. The entrance to the palace also was graced with stucco figures; they are of maidens, lightly dressed but heavily built. Other stuccoes showed animals, winged horses and dog-headed *senmurvs*, quails, and an armoured warrior.

The location of Khirbat al-Mafjar would have made it suitable for a winter palace, and this is the meaning of Mshatta, the name of a palace near ᶜAmman. This was probably being built in the last years of Umayyad rule, the late 740s, and it marks a transition to a new formality. The plan of the interior was conceived in three strips. The entrance block was central in the south side; directly opposite it the audience hall was entered by a triple arch, and a triconch surrounded the throne area. Vaults were of brick, but the walls were of stone. An ornamental border of dense carving on the outer wall, still naturalistic in outline though its relief is flattened, forms a farewell to this tradition of Syrian stonework.

The new formality was typified by the city which Mansur founded at Baghdad in 145/762–3; known as Madinat al-Salam, the City of Peace, it was the centre of the ᶜAbbasid world. Nothing, unfortunately, remains of the original structure, but historians have left us descriptions. The city was planned with great care, and work was commenced at an astrologically propitious moment. It was round, about a mile and a half in diameter; a residential ring enclosed a central area with administrative and palace buildings, at whose heart stood the great mosque and caliphal palace. The outer

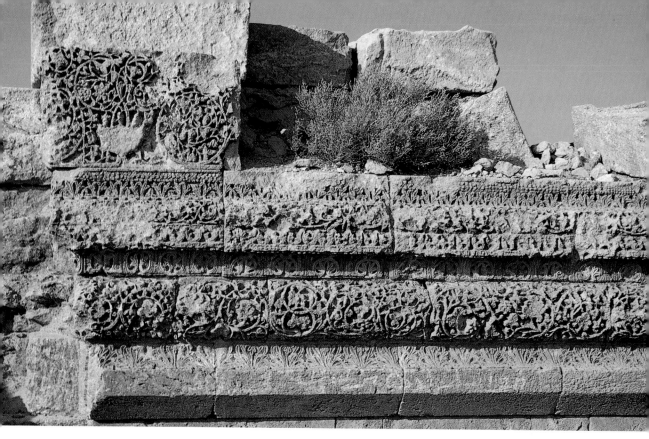

11 Detail of stone façade wall, Mshatta, probably 740s. The mouldings are classical in character, and the acanthus and vine-scroll are still very distinct, though with a flattened front plane. A large portion of the façade, now in the Islamisches Museum, Berlin, shows an upper register with triangular compartments and rosettes. Much of the scrollwork is inhabited by birds and real or imaginary beasts, but it has been established that where the wall fronted the mosque animals were omitted.

defence was formed by two circular walls of mud-brick with a space between. Four gates opened in the direction of the important regions, Khurasan, Basrah, Kufah and Sham (Syria), their plan being of the 'bent entrance' type where outer and inner gateways are set at an angle to each other so that they are difficult to take by storm. Above the inner gateways were reception halls with golden domes. The residential area of the ring had radial streets, but these did not connect to the central palace area, access to which was gained only by vaulted ways from the four gates. The caliph's palace was to the *qiblah* side of the mosque; known as the Golden Gate, it was crowned by a green dome, the Qubbat al-Khadra. It is reported that figures which turned in the wind were set on the domes of the gates, and another in the shape of a horseman on the palace roof; these would have been emblems of ready defence, rather than guides to the weather. Within his citadel the caliph was defended from attack, distanced from the people, and symbolically centre and ruler of the regions of the world. The circular plan which permitted this had an ancient history in the East, but the nearest example was Ctesiphon as built by the Parthians.

A debt to Sasanian architecture is often apparent in buildings of the early ᶜAbbasid period. Many Persian mosques are on ancient foundations but the mosque at Damghan (north-east of Tehran), which is probably datable to the mid-eighth century, has retained much of its ancient structure. Though some vaults have been reconstructed with a pointed arch, the main body of the vaulting preserves a parabolic profile of Sasanian character. Furthermore, the vaults are supported upon short thick brick piers, without any intervening capital. Parabolic arches and squat piers are also found at Ukhaydir, a lonely palace set in the desert south of Baghdad. Ukhaydir may well have been built

to house ʿIsa b. Musa, a nephew of al-Saffah who had been steered away from the caliphate in favour of Harun al-Rashid; its date would then be between 765 and 778. The palace bears a general resemblance to those of Syria, though larger in scale and more sombre in appearance; it was built of rubble and rough masonry in mortar with vaults of brick, and was designed to be covered with stucco. The surfaces of its imposing enclosure wall are adorned with half-round buttresses and blind niches which recall those of the Taq-i Kisra, a great brick vault which survives from a sixth-century palace at Ctesiphon. From the central court the entry to the domed throne-room is marked by an *ivan*, a large vault, open at the front, whose classic type is again the Taq-i Kisra. The front of the *ivan* at Ukhaydir was probably emphasised with the high rectangular frame of a *pishtaq*, literally a 'fore-arch'. The combination of *ivan* and domed chamber was to be of the greatest importance not only in palace architecture, but also in that of mosques. Other areas of the palace were separated off by corridors. Four *bayts*, each with its own courtyard, flanked the central courtyard but did not communicate directly with it, nor with each other. These may have been the residences of four wives.

Samarra (construed to mean 'Happy he who sees it') was built from 836 at a Sasanian site on the Tigris, and grew to be twenty-five miles in length; its ruins have been the subject of important studies, but much is still unexcavated. It is possible to make out the plans of vast palaces which are remarkable for their complexity and symmetry, the greatest being the Jausaq al-Khaqani (*c.* 837) and the Bulkawara (*c.* 849–59). Flights of steps rose from the waterfront to impressive gateways opening on to courtyards, audience halls, intricate living units, baths, pools, and gardens laid out in squares between water channels. The Jausaq al-Khaqani overlooked a polo ground, and there was also a race track which was arranged, for the convenience of spectators, in a quatrefoil plan. The appointments of the palaces were

13

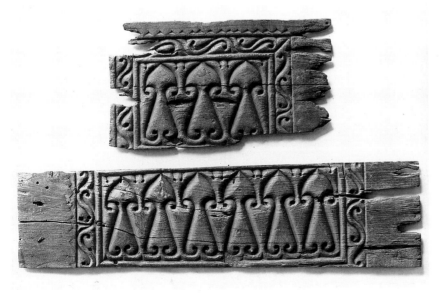

12 Teak panel, Iraq (or Egypt), 9th century. The smooth contours of the ornament are typical of the bevelled style. Though there may be a distant reference to natural leaf forms in the motifs, the design is almost entirely formal. London, British Museum.

31

13 Faces on fragments of wall-painting from the baths of the harem of the Jausaq al-Khaqani, Samarra, 9th century. Drawn with great economy, the faces are in the Sasanian tradition. They are long but fleshy, with large eyes, curved noses, full lips and heavy chins. London, British Museum.

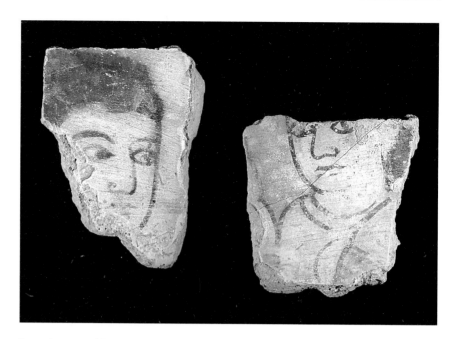

luxurious, and luxury with speed in building was permitted by the extensive use of decorative work in stucco. Three styles may be distinguished in the stucco of Samarra. The first has vine scrolls of a naturalism comparable with that produced in Syrian stone; the second has more stylised and densely packed shapes; the third is known as the bevelled style. The bevelled style, which is severely simplified and deals in long and curving shapes – which to the modern eye rather resemble violin bodies – may owe something to the artistic traditions of the Asian steppes which would have been brought to Iraq by the caliphs' Turkish guards. 12

Two fine mosques were built at Samarra in the days of al-Mutawakkil (847–61). The Great Mosque, measuring 156 by 240 metres, with buttressed walls similar to those of Ukhaydir, is an empty shell. But the outer enclosure (*ziyadah*) which surrounds it contains a huge conical minaret mounted by a spiral ramp. The somewhat smaller Mosque of Abu Dulaf was similar, but a particular feature of its interior was that the two arcades nearest to the *qiblah* ran parallel with it, and the axis of the *mihrab* was marked by a wide aisle, thus forming a configuration known as a ⊤-plan. This plan, which may go back to al-Walid's mosque at Medina, suggests a formal differentiation in rank among the worshippers.

Another important building was the Qubbat al-Sulaybiyah, whose plan, an octagon within an octagon, must refer to the Dome of the Rock, thus implying a monument of special holiness. It may be the tomb of the caliph al-Muntasir, who died in 862. Since Islamic law requires that the grave of a believer should be open to the sky, it had not been the practice to build tombs; however, the Byzantine mother of al-Muntasir obtained permission to raise a mausoleum, which probably gained acceptance by having no doors. The Qubbat al-Sulaybiyah would thus be the first Muslim mausoleum, and a vital link between the Dome of the Rock and the Taj Mahall.

Arts of the book

Calligraphy is regarded as the supreme art in the Islamic world: writing has a sacramental character since it can convey the Qur'an, the word of God. The practice of writing has continually been analysed and its exponents revered. Arabic script existed in a rudimentary form before Islam. It is a Semitic type, thought to have developed from Aramaic by way of Nabatean, early examples being preserved in a scattering of inscriptions in stone. The writing proceeds from right to left, symbols, sometimes no more than simple 'teeth', usually being linked by a base-line. The codification of the Qur'an under ʿUthman (644–56) would have given an impetus to the development of script in books. The Qur'an itself has a chapter entitled 'The Pen' (al-Qalam, LXVIII) and it also speaks of Allah teaching the use of the pen (XCVI, 4–5); it is, then, probable that portions of it were written down in the time of the Prophet upon such materials as were to hand – the blade-bones of camels, potsherds, and possibly papyrus. Under ʿUthman it was probably produced in the book form used by the Copts of Egypt, as leaves of parchment bound in covers of wood and leather. No Qur'ans of this antiquity are known to exist; indeed, the earliest survivals are probably of the eighth century.

Early scripts of the Muslim era are represented on the monuments of the Umayyads. A celebrated example is the qur'anic inscription of the Dome of the Rock, which is very plain and strong with uprights joining the base-line at a right angle. This is a class of script which is now known generically as kufic. In the early years Mecca, Medina, Kufah and Basrah were all renowned as centres of calligraphy, and thus kufic would have been only one of four branches; but, in the absence of sufficient manuscripts to distinguish these, it has proved convenient to group the angular styles of this and later ages together as kufic, in contradistinction to more curvilinear styles which are usually named individually. In the early period the choice of kufic or curvilinear was often determined by the materials to be used. Kufic was particularly suited to stone and mosaic, and curvilinear to the reed pen or brush – graffiti on the desert palaces are curvilinear. However, the monumental qualities of which kufic is capable were felt to be particularly apt for copies of the Qur'an. A Qur'an in the British Library which is judged to be of the eighth century and from the Hijaz is in a kufic type of script but employs a particular feature, ma'il (inclining), with most uprights having a backhand slant. This work is on vellum, and has pages of upright format; other surviving Qur'ans up to the tenth century are more usually in a horizontal format, and their kufic often employs an elongation of the horizontal strokes, known as mashq.

Several reforms to assist the accurate reading of the Qur'an were developed in the first hundred years. Since Arabic characters do not render short vowels, a scheme to indicate these by red or yellow dots was devised by Abu'l-Aswad Du'ali (d. 688). His pupils Nasr b. ʿAsim and Yahya b. Yaʿmur worked on the differentiation of letters of identical outline by black dots above or below the line. Further reforms to the consonantal signs, and a system of vowel signs which did not require colour were introduced in the later eighth century by Khalil b. Ahmad al-Farahidi. The adoption of these systems was, however, far from uniform.

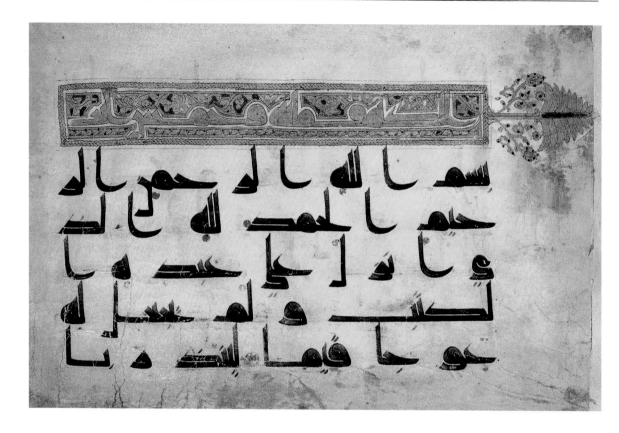

14 Folio from a Qur'an on vellum, Near East, 9th or early 10th century. The chapter heading is that of *surah* XVIII, *al-Kahf* (The Cave). This refers to the Seven Sleepers of Ephesus, who are accounted righteous men of the days before the Prophet. The kufic script has vowels in red and exhibits *mashq*. The palm-tree finial no doubt lost its tip at some time when the fore-edge was trimmed. Dublin, Chester Beatty Library and Oriental Art Gallery.

Curvilinear scripts for secular purposes were developed in the chanceries of the Umayyads and the ᶜAbbasids. By the ninth century they had proliferated, but the most enduring was to be the plain scribal hand, *naskhi*, which is now usually used in printing. In the early tenth century the vizier Ibn Muqlah (put to death in 940) evolved a system for the evaluation of the proportions of scripts; it was based upon a dot the square of the pen width, the simple vertical of *alif*, the first letter, and a circle of the diameter of *alif*.

The majestic calligraphy of Qur'ans of the early period is often accompanied by decorative illumination which is predominantly in gold, with elements of red, blue or green. In ornamental frontispieces and headings to the individual *surahs*, this work combines script with vegetal and geometric motifs. Leaves have recently been published from a Qur'an in the Library of the Great Mosque at Sanᶜa, datable to the Umayyad period, which show, quite exceptionally, a representation of a many-arched mosque. No secular illustrations have survived from this period.

Metalwork

Metal was worked in the Middle East from ancient times: bronze (copper alloyed predominantly with tin) had been known in Mesopotamia since the fourth millennium BC, and the celebrated bronzes of Luristan range from the second to the first. Bronze continued to be the most widely used metal, but in the centuries preceding the Arab conquest silver and gold were used in the

great empires for objects of religious significance or of luxury. The Byzantine pieces show Christian scenes or figures from classical mythology; the Sasanian often portray the kingly hunt. It seems that the Arabs immediately found these goods worthy of acquisition, and the historian Ibn Rustah even relates that the caliph ʿUmar used a figured censer from Syria in the mosque at Medina. It is probable that under the new regime craftsmen continued to work with little disruption, and this, together with the facts that survivals – especially in the noble metals – are scarce, and that metal objects are often undated and without provenance, means that it is not always clear which objects are pre-Islamic and which Islamic.

A number of pieces of silverwork, therefore, once thought to be Sasanian are now described as post-Sasanian or Islamic. Dishes are the most frequent shape, but bowls and ewers are also found. In some cases the body has been fashioned in repoussé in a radial decoration suggestive of petals; in other examples the repoussé decoration is figurative, with chased details. Sometimes an even higher relief is achieved by applied repoussé elements. There may also be parcel gilding. This highly worked decoration suggests that

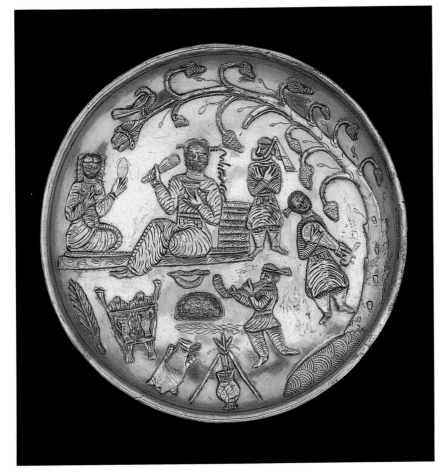

15 Silver dish with repoussé figures and parcel gilding. Iran, probably 8th century. The piece is said to have been obtained in Mazandaran, and is thought to date from the Islamic period in spite of having a Pahlavi inscription on it. A prince taking his ease in the open air is attended by a lady, musicians and a servant wearing a mask, who may be a cook. Wine jars wait in a cooler. London, British Museum.

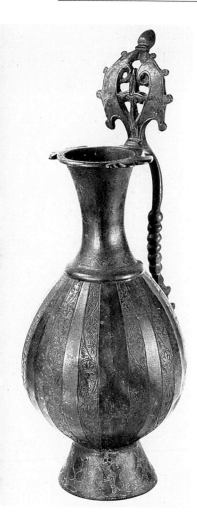

16 Brass ewer, probably made in Iraq, late 7th or 8th century. The large 'thumb-piece' takes the form of a palmette, and the flat lip is flanked by split palmettes. The elegant body is decorated with vertical panels on which vine-scrolls are chased, suggesting a use for wine. The five-lobed vine-leaves have the stylised quality of palmettes. The handle is marked 'work of ʿAuf' in kufic. Keir Collection.

some at least of the pieces were for contemplation rather than use. The question of date of a given item is sometimes not easily resolved, especially where birds and beasts are concerned. But in more complex scenes which include humans it is felt that those which depart from the awesome serious-ness of purpose of royal Sasanian art and instead embrace the pleasures of life are from the early Islamic period.

There is some disagreement among experts as to the extent of the use of bronze in the early Islamic period, as opposed to brass (copper alloyed predominantly with zinc). Until recently studies have tended to identify alloys by their appearance, but now the use of technical analysis has become more general, and it has shown that some objects, their brownish appearance notwithstanding, should be classed as brass since they contain more zinc than tin. Indeed, alloys are often found to be composed of several metals, and this is acknowledged in descriptions such as a 'high tin bronze' or a 'leaded brass'. These materials were used for objects of moderate luxury, such as ewers, lamps, lampstands, incense-burners, bottles, perfume-sprinklers, mor-tars. Astrolabes were also made, the earliest dated surviving specimen being of 314/927–8; instruments of Greek origin, they were used, among other things, to take astronomical observations.

Objects might be cast in piece moulds or by *cire perdue*, hammered out or spun on a lathe, and in the early period they are characterised by beauty of form rather than by richness of decoration, though they might also be ornamented with chasing, stamping, piercing or small amounts of inlay. Ewers, whether to service drinking or washing before prayer, were always of importance in the Islamic world, and a small group of elegant ewers with oval bodies and high necks is dated approximately by an example in the Hermit-age, Leningrad, which was made in Basrah in 69/688–9 (or 67/686–7). Various other types of ewer are known, including one found at the site south of Cairo where Marwan II was killed in 750, and now in Cairo's Museum of Islamic Art. This has a round body and a cylindrical neck with openwork at the top, and its spout is the open beak of a naturalistic cock. The theme bird-as-container is also found in a beautifully modelled incense-burner in the form of a raptor, in the Museum für Islamische Kunst, Berlin. This balances a plump body on two small feet; in its chased ornament arabesques outdo feathers, and the articulation of the wing has a whorl in the Sasanian manner. Other incense-burners are cylindrical containers on tripod feet, with pierced covers and horizontal handles. Heavy items such as mortars sometimes have protruding ornaments in the form of drops, a motif used in both empires.

Alas, one class of metalwork which has not survived is that of mechanical devices for the delight of princes, such as a tree of gold and silver, made for the caliph al-Muqtadir (908–32), which had fruit in the form of precious stones and birds which twittered in the breeze.

Coins

Coinage is one of the most evident forms in which a state mirrors itself, and early Islamic coinage shows an interesting search for a proper form of expression. At first the Muslim community used the local currency, and adopted its nomenclature: the Byzantine gold *denarius aureus* became the

dinar, the copper *follis* the *fals*, and the Sasanian silver *drachm* the *dirham*. From as early as the time of ʿUthman the local Arab governors were empowered to mint their own coinage, and they began to issue coins which imitated those of the old empires. Early coins retained either the portrait bust of Byzantine emperors, or emperors and consorts, accompanied by the Christian cross, or Sasanian emperor busts with the Zoroastrian fire-altar on the reverse. At first Greek or Pahlavi script continued to be used in the legends, together with Arabic in kufic. In a period of transition the alien religious symbols and scripts were removed. Some coins which are, or which appear to be, from the early years of ʿAbd al-Malik show a new Arab figure, a standing caliph who holds a straight sword. An attempt at a more abstract Islamic icon shows a *mihrab* niche which contains a short spear (*ʿanazah*), thought to represent that on which the Prophet was wont to lean or which was carried in front of him by Bilal. ʿAbd al-Malik evidently found these unsatisfactory, and from 77/696 he introduced an aniconic coinage with the profession of faith written horizontally in the centre and a circular dating inscription. The older forms continued to be made under later Umayyads, but eventually the aniconic type prevailed.

Rock crystal and glass

A magnificent Sasanian dish, now in the Bibliothèque Nationale, Paris, is formed of roundels of rock crystal and coloured glass set in a gold frame; it may date from the reign of Khusrau I (531–79). The crystal base is carved in relief to show the crowned ruler seated on a throne supported by winged horses, while smaller roundels bear rosettes. From such sources the Muslim world inherited an enthusiasm for rock crystal, which continued to be a prized material down the ages. A transparent and colourless quartz which takes a brilliant polish, rock crystal is obtained from sources as diverse as Morocco, East Africa, Armenia, Badakhshan in Northern Afghanistan, and Kashmir. It is hard, and the cutting which exploits its reflective property is achieved with a grindstone mounted on an axle which rotates with the to-and-fro movement of a bow looped round it. A very few objects can be attributed to the early and ʿAbbasid periods by the motifs used upon them.

Glass is an artificial material made from silica (sand, quartz) and lime fused together at a temperature of approximately 1100° C with the help of a flux, which in the ancient world was alkaline in character, being potash or natron. Colours can be obtained by staining with metallic oxides. In the fourth millennium BC this material was used as a glaze on small stone objects; later, small vessels were made by pouring it molten into moulds. A liberating advance occurred about the first century AD when Syrians evolved the technique of blowing glass, thus producing a more delicate body. In the pre-Islamic period developed glass industries existed in Syria, Egypt and Iran.

Dating items of glass is difficult. A fairly precise date may be available for glass used in an architectural context, such as the mosaic of coloured paste and clear cubes which sandwich gold foil at the Dome of the Rock. Similarly, the palaces of Qasr al-Hayr al-Sharqi and Khirbat al-Mafjar had coloured window-glass which had been spun out from a central point (as in 'bottle glass'), and this process, together with window-glass set in trays, was also

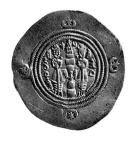

17 Silver *dirham* minted in Mah al-Basrah (Nihavand) in 27/658. The coin exemplifies the imitation of Sasanian types in the early period. The obverse shows Khusrau II Parviz wearing his particular version of the Sasanian winged crown. The modelling is crude compared with that of his own coinage, but the formula *bismillah* has been added (lower right) to indicate the triumph of Islam. The reverse shows a fire-altar with two attendants. London, British Museum.

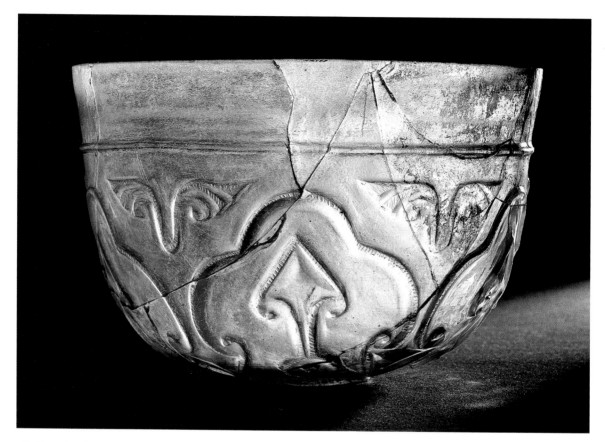

18 Blue glass bowl, made in Iran, 9th or 10th century. The decoration is similar to that on the rock crystal goblet shown in Fig. 21, though more stylised. The separate split palmettes used to fill the spaces between the trilobed framing elements recall examples in terracotta on the 10th-century Samanid mausoleum in Bukhara. London, British Museum.

found at Samarra. In respect of objects, it is reported that Umm Hakim, a wife of the caliph Hisham (724–43), possessed a wine cup of phenomenal size in green glass with a golden handle, and that this passed to the ᶜAbbasid treasury. For the most part, however, the use of various techniques can be seen as particularly favoured for a century or two and further precision is hard to obtain. Naturally, at any period there would be a quantity of simple blown glass for practical purposes. As it happens, free-blown glass is shown in a small wall-painting from the Jausaq al-Khaqani at Samarra (*c.* 837), in which two serving girls dance holding round-bodied long-necked wine jars, similar to yards of ale. Free-blown glass would have been used to make small containers, lamps for polycandela, and some technical equipment such as cupping glasses and alembics.

Various decorative procedures could be applied to blown glass while it was still hot. Simple pinches raised with tongs were used by the Sasanians and continued into the early Islamic centuries. From Roman Syria there was applied ornament standing proud of the surface in the form of small discs, handle loops, or trailed threads which wound round a vessel or stood away from its side in small undulations. Decoration of this sort would be used on small jars and cups. A decorative surface could also be produced by blowing glass into an ornamental mould, with sometimes a subsequent blowing into a second mould for further refinement. The surface pattern thus created might

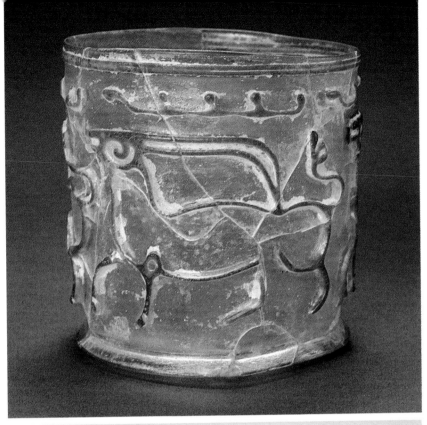

19 Glass beaker in cameo technique, Iran, 9th or 10th century. Depictions of the ibex are found in the art of Iran from prehistoric times onwards. The examples on the beaker are conveyed with a stylised line which subtly suggests naturalistic form and movement. Jerusalem, L.A. Mayer Memorial for Islamic Art.

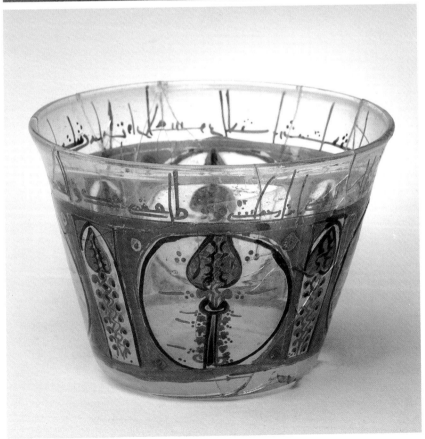

20 Glass beaker with polychrome lustre decoration, Near East (possibly Damascus), 9th century. The decoration shows a close affinity with the arts of the book, and the kufic has a rapid and lively quality. The palmette-headed trees, displayed against circles or cartouches in reserve, recall the ancient Mesopotamian 'tree of life' motif, but also resemble contemporary *surah* headings with finials. New York, Metropolitan Museum of Art.

39

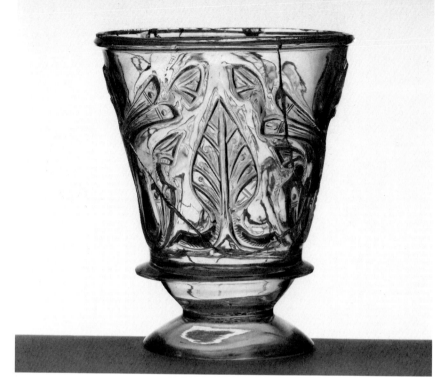

21 Rock crystal goblet from Iran (reportedly found at Qazvin), probably 9th century. Though its rim has been cut down, the goblet is finely proportioned. The wheel-cut ornament alternates whole and split palmettes standing upright. The segments of leaf with a dot bored at the tip have been compared with painted wall decoration at Nishapur. London, British Museum.

be fluted or have indentations in a honeycomb effect, or in some cases might reflect the bevelled style of Samarra. Small objects which were not hollow, such as tokens or weights, would be stamped with a design or a word. 'Millefiori' was made from clusters of coloured rods fused together, cut in transverse slices and fused again into larger designs; tiles of this material were used at Samarra.

Another group of techniques was practised on heavier moulded glass when it was cold. Simple whitish lines could be engraved with a diamond, but more satisfactory decoration was achieved in a number of ways by grinding on a wheel. Cuboid scent flasks are often notched on each side of the base so that they stand on four small legs – whence they are sometimes described as 'molar'. In the simpler decorative schemes the surface was covered with round or hexagonal facets which caught the light. More complex designs, which might include stylised animals, palmettes and geometric elements, were engraved with the aid of fine wheels and show an obvious kinship with the working of rock crystal. In a development of wheel-cutting, large areas of the surface were taken back to leave the design in relief; and if this was practised on a vessel with an extra outer layer of coloured glass, the result was a cameo effect.

Other procedures involved gold and metals. Gildings could be applied after firing, or ornamental gold foil could be incorporated into the body. The exterior could also be painted in lustre, an impalpably thin metal film deposited when a metallic oxide, suspended in vinegar, is heated in a smoky reducing atmosphere which removes its oxygen content. Lustre decoration on glass appears to have been developed in Egypt shortly before the conquest. The earliest datable Islamic example is the bowl of a goblet in the Islamic Museum, Cairo, which is secured to 155/772 by the name of a governor of Egypt. Lustre decoration spread to Islamic pottery, where it was to have a major importance.

Pottery

The Islamic world is famed for its decorated pottery in fine but practical wares. In the earliest days of Islam, pottery appears to have been simple and utilitarian, but gradually the suggestions of earlier traditions were adopted and formed a starting point for new inventions. A class of ware which extends from earlier centuries into the first century of Islam illustrates the mixed inheritance of the Near East. Made in Syria or Mesopotamia, these heavy vessels often refer – albeit clumsily – to amphorae of the Graeco-Roman tradition. They are covered in a blue-green glaze whose use of an alkaline flux was probably borrowed from ancient Eypt, but which was also favoured in Iran by the Parthians (249 BC–AD 226) and by the Sasanians. This ware, however, stands to one side of the Islamic tradition, as the use of an alkaline flux does not become general until some four centuries later.

The classical *terra sigillata*, or stamped earthenware, seems to have been the basis for dishes made and decorated by being pressed into or over moulds. The Islamic ware is sometimes unglazed; it is buff in colour (without the red surface of *terra sigillata*), and its ornament may include small and neat vine scrolls. An unglazed example important for its inscription is a thin-walled cup in the National Museum, Damascus, made at Hirah by Ibrahim the Christian for Sulayman, the son of a caliph – presumed to be al-Mansur (d. 755). Some small dishes attributable to the ninth century are glazed. The flux used in these glazes is lead, which had been used on earthenware in Egypt and the Eastern Mediterranean immediately before the Islamic conquest. Lead glazes may be stained bottle-green, amber, brown or purple; they are by nature runny, but the raised lines of the moulded decoration could be used to separate colours in the firing. At the time of the residence of the caliphs at Samarra, the moulded pattern was sometimes used to imitate the linear decoration of metalwork, and a yellow, rather lustrous, glaze may have been intended to imitate gold.

The period also saw a great development in pottery stimulated in part by imports from China, a source which continually inspired Islamic potters. The fluid quality of lead glazes was exploited in vessels which imitate eighth-century T'ang polychrome stoneware. The objects were first given a thin coating of white slip (semi-fluid clay); they then received a covering of colourless glaze, and were splashed with coloured glazes which spread and mingled. Chinese porcelains were also imitated. Made from white kaolin and fired at high temperatures, these gave rise to a centuries-long endeavour on the part of the potters of the Middle East to reproduce their whiteness, and if possible also their hardness. To compensate for the buff colour of their clays the potters of Iraq applied a lead glaze made white and opaque with an admixture of tin-oxide (perhaps with borax). Some tin-glazed vessels imitate Chinese shapes and, with no further ornament, were doubtless meant to pass for such. In others, however, the local taste for decoration prevailed and motifs were added in cobalt blue – the first Islamic use of the blue-and-white combination which was to prove of such importance down the ages. The appearance of the cobalt decoration on early tin glaze is similar to that of ink upon blotting paper. The motifs are usually relatively simple, such as a rosette or a geometric knot, but a rather damaged dish in the British Museum

22 Earthenware bowl with polychrome lustre, Iraq, 9th century. Twirling half-palmettes, reminiscent of the wings on the crown of Khusrau Parviz (Fig. 17), also suggest the turning of the potter's wheel which created the vessel. Kuwait, National Museum.

shows a structure with a palmette plume rising from it, a motif which has been interpreted as a Zoroastrian fire-altar. Splashes of green glaze were sometimes added to the cobalt decoration.

Tin glaze was also used as a background to lustre decoration; the technique, borrowed from glasswork, required a second glaze firing at a lower temperature than the first. In its earliest phase lustre decoration was polychrome in tones of red, brown, green, gold and purple, and patterns were confused, suggesting a period of experiment. However, at the Jausaq al-Khaqani palace highly controlled drawing appears on tiles which show cocks and eagles surrounded by wreaths against speckled grounds suggestive of marble. Dishes follow, on which a mass of dots and hatchings, principally in brown and yellow lustre and with very faint limiting outlines, give a curiously soft effect, perhaps in imitation of textiles or manuscript illumination. By the 860s colour is reduced to brown and yellow, and patterns tend to be clearly defined with small geometrical compartments containing stiff palmettes; tiles of this variety were sent from Baghdad to the Great Mosque of Qayrawan in Tunisia in 862 to be set around the *mihrab*. Though these have retained a glint of lustre, it must be admitted that the intended effect is often missing from pots and dishes decorated in a similar mode. Lastly, from the late ninth century and into the tenth come vessels decorated in monochrome lustre of a greenish yellow. These present highly stylised animals and humans, the figures surrounded by a white contour line against a ground of dots, and sometimes having the enigmatic accompaniment of illegible words. The animals are curvilinear and suggest the large facets of Samarra's bevelled style; they carry fronds of palmette in mouth or beak. The humans have large staring eyes and small limbs, and they are sometimes musicians: hints of both Christian and Buddhist types have been descried in them.

Textiles and carpets

Some of the supreme achievements of Islamic art are knotted carpets, in which rows of tufts of wool are tied on to warps between passes of the weft. In use carpets receive hard wear, and remains from the early centuries of Islam are extremely scanty. However, a venerable pre-Islamic tradition of knotted carpets existed, from which a few important pieces survive. The earliest surviving carpet, now in the Hermitage, was found among frozen grave goods at Pazyryk in Siberia, and is dated approximately to the fifth century BC. It has a field of squared rosettes, and borders with elk and led horses. Whether the Pazyryk carpet was made in Central or Western Asia is a matter of debate, but Armenia in particular has been mentioned as a possible place of origin. As it happens, Armenia is also quoted as the source of rugs among which the Umayyad Walid b. Yazid sat to receive guests, though the technique used to make these particular floor-coverings is not certain. Some doubt as to technique must also attend the account of another famous carpet, the 'Spring of Khusrau'. This was found by the Arabs in the royal palace at Ctesiphon in 21/642. It is said to have portrayed a garden in spring with flowers and watercourses, a type of design which was to be used again in the seventeenth century. However, it is reported that, in addition to silk, and gold and silver (which might be thread), jewels and pearls were incorporated into it. It is thus probable that it was more in the nature of a tapestry wall-hanging than a floor-covering.

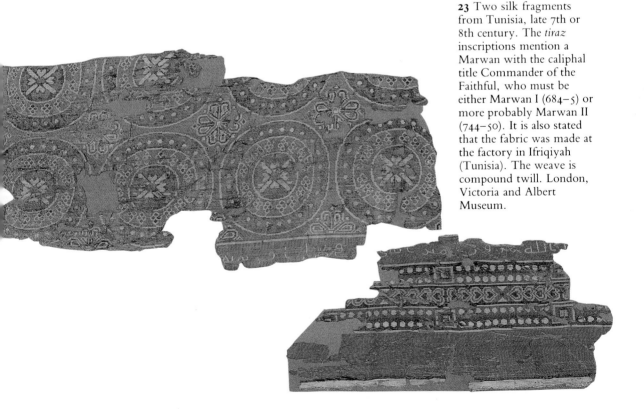

23 Two silk fragments from Tunisia, late 7th or 8th century. The *tiraz* inscriptions mention a Marwan with the caliphal title Commander of the Faithful, who must be either Marwan I (684–5) or more probably Marwan II (744–50). It is also stated that the fabric was made at the factory in Ifriqiyah (Tunisia). The weave is compound twill. London, Victoria and Albert Museum.

43

Carpets were not used in the very earliest mosques, where some nuisance was caused by worshippers clapping their hands to clear them of dust, but some type of floor-covering would probably have been introduced under the Umayyads. An interesting scrap of evidence for the use of a textile floor-covering in the desert palaces is found in the private room off the great hall at Khirbat al-Mafjar where, in a small apse, a floor-mosaic of a tree with animals below has a border which portrays tassels. Among early fragments preserved in the Museum of Islamic Art in Cairo, one in the knotted technique is datable to the ninth century; others are in the looped-pile towel technique of Egyptian tradition, and use linen, a material characteristic of Lower Egypt.

It seems that figured textiles were available in Arabia at the time of the Prophet. A *hadith* reports that Muhammad reproved ʿA'ishah for having a curtain with figures on it, but was satisfied when she cut it up for cushions. In the main, however, it is probable that fabrics were plain, or patterned simply with woven stripes; by the tenth century the Yemen was renowned as a source for striped cottons, made by dyeing warps in a technique which is now usually known by the Indonesian term *ikat*. The Umayyad princes adopted Persian dress with tunics over wide trousers in a light material, which could be cotton, silk, or *mulham* (a Persian combination of the two). The garments were ornamented with decorative bands. Turbans do not appear in the pictorial record, but literature mentions turbans in silk, and a turban cloth in linen with a wool tapestry band survives from 707. Princes sometimes wore a rich robe in the form of a coat, and the racy Walid II is said to have cast magnificent robes aside as gifts as he plunged into his swimming pool; in more formal circumstances, as robes of honour (*khilʿah*), coats were given as a mark of esteem or a reward. The designs on *khilʿahs* would have been derived from the richly patterned fabrics of the Byzantine and Sasanian courts, or from work by the Copts of Egypt, which has survived in considerable quantities.

Ornament could be applied to plain fabrics by embroidery, painting or printing, but in the grander fabrics it was incorporated into the weave. The technique for woven decoration was often tapestry, in which coloured wefts are threaded into the warps and return upon themselves without reaching the selvedge. This had been known in Egypt since the mid-second millennium BC, and was also practised by the Persians. It could be executed in wool or silk. Highly decorated fabrics were produced in factories known as *dar al-tiraz* (from the Persian *tarazidan*, to embroider). A particular aspect of this work was the introduction of bands of inscription, *tiraz* bands, into the borders of plain fabrics or as an element in the composition of patterned ones. The bands are sometimes rich in information, giving, after the *bismillah*, the name of the caliph, the vizier, the status of the factory (*khassah*, 'private', for the use of the caliph, or *ʿammah*, 'public', for anyone who could afford its wares), the city, and the date.

Finer and richer effects were produced by compound weaving. The principle of this is that the fabric has two layers of structure, each with a warp and a weft, and that coloured threads are brought forward from the back structure when required, and return to it when they have played their role on the front. Supplementary wefts may be added in to form a brocade. Until the

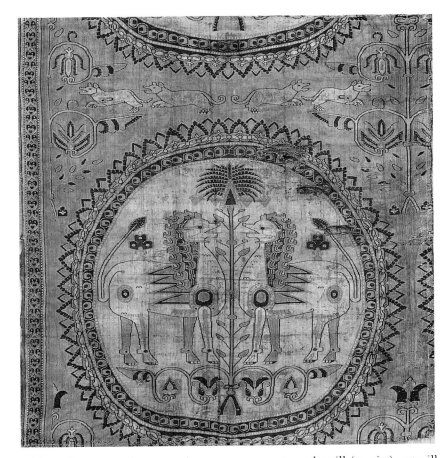

24 Silk fragment with confronted lions. Transoxiana, 8th or 9th century. The piece is associated with relics of St Amon and is thus possibly datable before 820 when these were placed in Toul Cathedral, France. It is a compound twill, with beige warp; the wefts, now faded, probably ranged from dark blue and apple green to orange, rose pink and white. This is the finest, and probably the earliest, of a group of silks which have been linked to Zandaneh near Bukhara by a note in Soghdian on one of them. Nancy, Musée Historique Lorrain.

mid-tenth century the weave in use was a compound twill (samite), a twill being a structure in which either the warp or weft threads pass over two or more of the other, the points where they pass under the other thread being offset row by row to appear as diagonal lines. Two celebrated fragments of an early compound twill with a pattern of large roundels have a *tiraz* inscription which mentions Marwan, the Commander of the Faithful, thought to be Marwan II (744–50), and the factory of Ifriqiyah (Tunisia). Some textiles from Samarra were also patterned with circular motifs, though smaller and with ornament somewhat like 'millefiori'. Other silks show animals and birds, which are usually organised within a scheme of circles.

These splendid fabrics sometimes reached the West, where they were so much esteemed that they were used to wrap relics in church treasuries, a fact which is sometimes a useful guarantee of authenticity and, to an extent, of age. Two early examples are a fragment with confronted lions which was preserved in the cathedral of Toul and two fragments with confronted elephants and a border of Bactrian camels from Saint-Josse-sur-Mer. Both are from the eastern lands of the caliphate. The former, whose origin near Bukhara is demonstrated by a note in the local Soghdian on a related piece, is probably of the seventh or eighth century. The latter, the 'shroud of Saint Josse', now in the Louvre, Paris, bears an inscription in the name of a commander of Khurasan, Abu Mansur Bakh-takin, who was executed in 961; he was a Turk, and the splendour of the silk is symptomatic of the rise of Turkish powers at this period.

2

LANDS OF THE WEST
Egypt, North Africa and Spain

T he Western lands of Islam, extending from Egypt at the eastern limit, through North Africa, to the Maghrib (the West), and al-Andalus (southern Spain), have an intricate interconnected history. They were formerly under Roman and then Byzantine rule, so that influences from the culture of the classical cities are to be found, but volatile semi-nomadic Berber tribes were to prove a powerful force of a different kind. The region was also somewhat removed from the mainstream of events in Eastern Islam. As might be expected, Egypt was the most closely affected by the culture of the ᶜAbbasids, while Spain, by a quirk of history aided by its geographical position, continued to reflect that of the Umayyads.

The conquest of Egypt from the Byzantines was completed in 21/642 under ᶜAmr b. al-ᶜAs. A new city was established near the site where Cairo would later be founded: it was called al-Fustat (the Camp). The Arab armies fought their way along the Barbary coast against resistance from Byzantine forces and Berber tribes, and crossed into Spain in 92/711 under Tariq, after whom Gibraltar, Jabal (Mount) Tariq, is named. Toledo, the capital of the Christian Visigothic kingdom, fell to them in 712, and it was not until twenty years later, in 114/732, that Charles Martel halted their advance near Poitiers.

25 An entrance to the Mosque of Ibn Tulun, Fustat (Cairo), 265/879. One of the seven entrances on the east side of the mosque is here seen from the *ziyadah*, the flaked stucco revealing the brick construction. Below the merlon frieze, arched embrasures containing stucco window grilles alternate with shell-head niches. The springing of a horseshoe arch is visible within. Modern mosque lamps have been strung over the door.

Spain was ruled on behalf of the caliphs by governors until in 756 it accepted as overlord ᶜAbd al-Rahman I, an Umayyad from Syria, who had escaped massacre at the hands of the ᶜAbbasids and led a wandering life for five years. ᶜAbd al-Rahman founded a dynasty which was to rule for two and a half centuries, resisting pressure from Christian powers in the north, finally to succumb to attack from North Africa. The Umayyads of Spain, based on Cordoba (Qurtubah) tended to follow the pleasure-loving ways of their predecessors in Syria, and indeed a poem by ᶜAbd al-Rahman addresses a solitary palm-tree in his garden which, like himself, is an exile from the East. Considerable tolerance was extended to Jews and Christians who participated in the culture of the state. In the tenth century, and especially under ᶜAbd al-Rahman III (912–61) – himself the son of a Christian princess – a period of great prosperity and brilliance was achieved. In 317/929 ᶜAbd al-Rahman was moved to declare himself caliph, in opposition to the ᶜAbbasid al-Muqtadir. ᶜAbd al-Rahman was succeeded by al-Hakam II

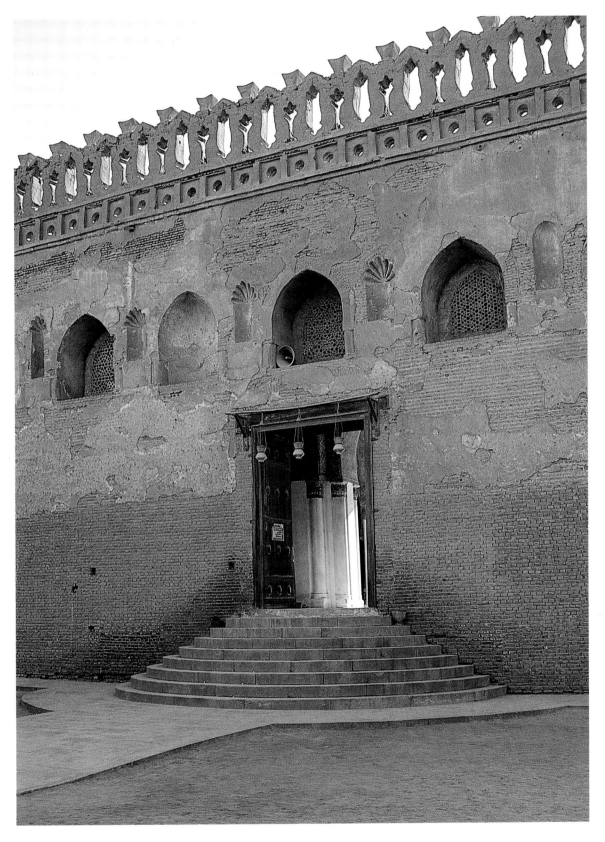

47

26 The Great Mosque, Qayrawan, rebuilt in 862 (with later work). The Qubbat Bab al-Bahu (Dome of the Gate of the Pavilion), constructed by Ibrahim II, draws attention to the axis of the *mihrab*. It is flanged, in contrast to the *mihrab* dome behind it, which is ribbed.

(961–76), a great patron of the arts. But in the time of Hakam's son effective power was grasped by a minister, al-Mansur, and in 1031 Umayyad rule was extinguished by an uprising in Cordoba. Muslim Spain was then divided among petty kings, the 'Reyes de Taifas'. Most prominent among these were the ᶜAbbadids of Seville (Isbiliyah) who, however, appealed to the Almoravids from North Africa to assist them against Christian adversaries, and in 1090 found themselves engulfed by their protectors.

In the ninth and tenth centuries North Africa and Egypt were largely ruled by three dynasties descended from governors installed by the ᶜAbbasids, who had acquired virtual independence: the Aghlabids, the Tulunids and the Ikhshidids. The founder of the Aghlabid fortunes was Ibrahim b. Aghlab, whom Harun al-Rashid had appointed in 184/800 to Ifriqiyah. An important achievement of the Aghlabids was the conquest of Sicily, which was finally accomplished in 859. Seen from the Muslim point of view as a stepping stone to Byzantine Italy, and from the Byzantine as a way back to Africa, Sicily in fact proved to be neither, though it did form a channel of cultural exchange. Aghlabid Ifriqiyah fell to the Fatimids in 296/909. The Tulunid dynasty was founded in 254/868 by Ahmad b. Tulun, a governor of Egypt, whose father had been a Turkish slave sent by the Samanid ruler of Bukhara to the caliph al-Ma'mun. In 264/878 Ahmad was able to fulfil a desire felt by many rulers of Egypt, by extending his control over Syria also. The dynasty was deposed by ᶜAbbasid forces in 292/905, but, though short-lived, it was important in art-historical terms. The third dynasty of governors, the Ikhshidids, again of Turkish extraction from Central Asia, ruled Egypt, Syria and the Hijaz in the mid-tenth century; they also were displaced by the Fatimids.

Like the Umayyads, the ᶜAbbasid governors were Sunni Muslims, but Shiᶜi missionaries were active among the Berbers in North Africa, fostered in part by the Idrisids who ruled in the Maghrib until 985. There was therefore a fervid constituency of support for the Shiᶜi ᶜUbayd Allah, known as al-Mahdi (the Rightly Guided), who, claiming descent from the Prophet's daughter Fatimah, established himself in Ifriqiyah in 909, and (before ᶜAbd al-Rahman in Spain) announced a rival caliphate. By this date Shiᶜism had divided into two main streams, one of which acknowledged a succession of twelve spiritual leaders (*imams*) and the other one of seven. The Fatimids were of the latter more militant group, known as Ismaᶜilis. Their eventual aim being to defeat the ᶜAbbasids, the Fatimids set their sights on movement eastwards, and in 358/969 they conquered Egypt and established near Fustat their city al-Qahirah (the Conquering), Cairo. For two hundred years this was the seat of a dynasty which combined with its religious intensity an enlightened patronage of art. Though much of what was made has been lost, we can glimpse the riches of the palace treasure-houses in an account – relayed by the Mamluk historian Maqrizi – of what was discovered when the palaces were sacked in the 1060s. In the eastern Mediterranean the Fatimids were rivals for dominance with the Byzantine empire, with which they were sometimes on relatively friendly terms. But though they were able to take control of Syria in the late tenth century, they were never in a position to displace the ᶜAbbasids. Furthermore, they suffered losses in the west, where Sicily was captured by the Normans by 1091. The realisation that the

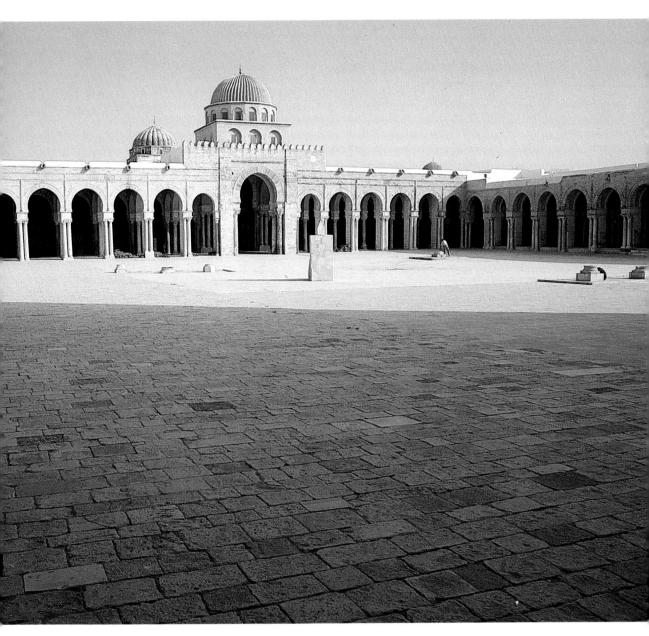

Fatimids were not invincible led to a falling away of popular support for them, and they were defeated by Salah al-Din (Saladin) in 567/1171.

From the mid-eleventh to the mid-thirteenth century the Maghrib and southern Spain were dominated by two Berber dynasties, first the Almoravids and then the Almohads. The Almoravids came to power in 1056. Their name is derived from *al-Murabit*, one who mans a *ribat* or fortified religious frontier-post (whence also *marabout* in the terminology of the French Foreign Legion). In 1069 their leader Yusuf b. Tashfin founded Marrakesh (or Marrakush, whence Morocco). Called to Spain to assist the ⁽Abbadids

against Alfonso VI of Leon and Castile, they won the battle of Zallaqa in 1086 (Alfonso was at the time estranged from his champion, known from the Arabic *sayyid*, lord, as the Cid). From 1090 the Almoravids ruled Andalusia as a province from Africa. In 541/1146–7 Marrakesh was conquered by a second Berber confederation, the Almohads (*al-Muwahhids*, named for their severely anti-anthropomorphic view of the nature of Allah). Using the title caliph, they ruled a territory from the confines of Egypt to the Atlantic and Spain. Defeated by Alfonso VIII at Las Navas de Tolosa in 1212, they lost control of Andalusia, and in 677/1269 they lost Marrakesh to the Berber Marinids.

Cordoba had been lost to the Christian advance in 1236. In 635/1237–8 Muhammad b. Ahmar, an Arab Nasrid, took Granada (Gharnatah) and founded the last Muslim state in Spain. He found it advisable to accept the suzerainty of Ferdinand of Castile, and, after assisting his lord at the capture of Seville in 1248, he was able to call himself *al-Ghalib*, the Victor. Later Nasrids were fain to turn to the Marinids for help against the Spaniards. The most flourishing period for the Nasrid dynasty was the mid-fourteenth century under Yusuf I (1333–54) and his son Muhammad V (1354–9 and 1362–91). A hundred years later, with his surrounding territory lost, Abu ʿAbdallah Muhammad XI (known to Europe as Boabdil) was obliged to surrender Granada in 897/1492 to Ferdinand of Aragon and Isabella of Castile, and to leave for exile in Morocco.

Architecture

A mosque stands today where ʿAmr b. al-ʿAs founded the first mosque of Fustat in 20/641, before the conquest of Egypt was complete. The main lines of the present building, however, were determined in 212/827, and it has undergone recent renovations; it is hypostyle in form, with re-used columns and classical capitals. Also of the ninth century, but in more pristine condition, is a structure unique to Egypt, the Nilometer (*miqyas*), a monumental device to measure the height of the Nile's flood. It was constructed in 247/861–2 under the ʿAbbasid al-Mutawakkil, an earlier version having been swept away. Set in the downstream point of Raudah Island, the Nilometer is a well of fine ashlar masonry with a stone column standing as a gauge in the centre. The Nile waters enter it through tunnels. The well is not uniform but is composed of three chambers diminishing in size from ground level, two cubic and one cylindrical; a stairway runs down it. Though directed downwards and round a void, the structure has a relationship to the spiral minaret of al-Mutawakkil's mosque at Samarra.

The governors who rose to power in the ninth century were glad to express their new dignity by the patronage of buildings. In Egypt Ibn Tulun even went so far as to introduce the building techniques of ʿAbbasid Iraq in the mosque which he built in 265/879 to the east of Fustat: instead of the stone of Egypt he used brick and stucco. The mosque is almost square in plan, and the site is made entirely so by the addition of a *ziyadah*, which is like those used at Samarra, though it does not run behind the *qiblah* wall. The walls of the *ziyadah* and of the mosque proper are topped with a frieze of openwork merlons which, without transgressing the bounds of the non-figural, hint at a derivation from rows of figures at prayer. The mosque was entered by seven

25

doorways in the east wall, approached by semicircular sweeps of steps. Within there is an atmosphere of noble serenity. The weightiness of substantial piers, with engaged colonnettes at their corners, is balanced by the controlled richness of a continuous band of vegetal ornament in stucco, which runs above them and rims the arches between them. The stucco capitals of the colonnettes are vase-shaped and correspond to the second style of Samarra. The arch form is pointed, drawn from two centres, but with the merest suggestion of a horseshoe return at the base. Important but harmonious restorations were carried out under the Mamluk Lajin in 696/1296. This work gave its present form to the dome before the *mihrab*, to the fountain, and to the minaret.

The present form of the Great Mosque at Qayrawan in Tunisia is largely the work of the Aghlabid dynasty – Ziyadat Allah I in 221/836, Abu Ibrahim Ahmad in 248/862–3, and Ibrahim II after 875; a mosque had, however, been on the site since the seventh century. The extended building period results in a less unified appearance than that of Ibn Tulun. The mosque forms a large irregular parallelogram, the outside walls supported by square-sectioned buttresses which respond to need rather than to a predetermined plan. The supporting system is here in the local classical tradition with re-used columns and capitals. A wide central aisle on the axis of the *mihrab* and a wide aisle before the *qiblah* wall create a T-plan, and this is emphasised by a dome on grouped columns at the base of the T on the courtyard façade, and another at the intersection of the aisles before the *mihrab*. The aisle before the *qiblah* is partially enclosed by a wooden screen, known as a *maqsurah* (a word related to *qasr*, castle), an area reserved for the ruler and his attendants; it was constructed for al-Muʿizz, a governor for the Fatimids, in the second quarter of the eleventh century. The mosque is dominated by a tall minaret of square section which rises from the north *riwaq*. Whether some portion of the minaret is datable to the eighth century is a matter of debate.

In spite of its attachments to the past the Great Mosque of Qayrawan shows an awareness of contemporary developments. The acquisition of lustre tiles from Iraq in 248/862–3 has already been mentioned. The tiles were used to frame the *mihrab* arch and the spandrels beside it. They are square and were probably designed to be used in a horizontal and vertical grid, but they are here set radially round the arch, so that the design is a little awkward; however, their gleaming surfaces compensate for this. The *mihrab* in finely carved marble may also have been imported from Iraq.

The dome in front of the *mihrab* and its supporting system display features which were to be of the greatest importance in North Africa and in Spain. The technical problem of setting a dome over a cubic space requires a zone of transition. Western architecture had addressed the problem by the use of pendentives (curved triangular forms lowered into the corners of the cube), a method which had been used at Khirbat al-Mafjar. The usual Persian solution, however, was the squinch, an arch raised over the corner of the cube, and that is used at Qayrawan. The interior of the Qayrawan squinches, however, is grooved so that it relates to the shell-head niche of classical origin, which the Muslims had used in decorative contexts since the Umayyad period. The dome, also, grooved internally and ribbed externally,

is a logical extrapolation from the shell-head niche. The dome and zone of transition thus demonstrate a brilliant synthesis of Eastern technique and Western design. The synthesis was not necessarily devised in Qayrawan, but it certainly spread from thence.

Ziyadat Allah was also the patron of a *ribat*, built at Susa in 821. The title *ribat* sometimes means no more than a caravansaray for travellers, but, especially in unsettled areas on the borders of Islamic territory, it implies the base of a garrison whose business it was to extend the Dar al-Islam. The *ribats* of North Africa have the latter character, and the structure at Susa is a well-preserved small square fort with a mosque chamber on an upper floor.

Meanwhile the Umayyads in Spain were actively creating a substitute for the splendours lost to them in Syria. The Great Mosque at Cordoba, their most brilliant and influential building, was begun as early as 786 by ᶜAbd al-Rahman I, but by 987 it had been enlarged three times, reaching a size such that after the Christian conquest of the city a small cathedral could be implanted in its centre. The mosque is a hypostyle hall with aisles running perpendicular to the *qiblah*, but its unique feature is the use of double-tiered arches: impost blocks on the top of the columns support not only arches, but also short piers from which spring a second level of arches. These supported a flat wooden ceiling within and ridge roofs without. The arches of the lower

27 The Great Mosque, Cordoba: extension of al-Mansur, begun in 377/987. In the time of Hisham II, the minister al-Mansur extended the mosque eastwards by eight aisles. In the Muslim period light was admitted by many doors, now blocked, instead of at ceiling level. The contrast of stone and brick in the voussoirs has been heightened with paint.

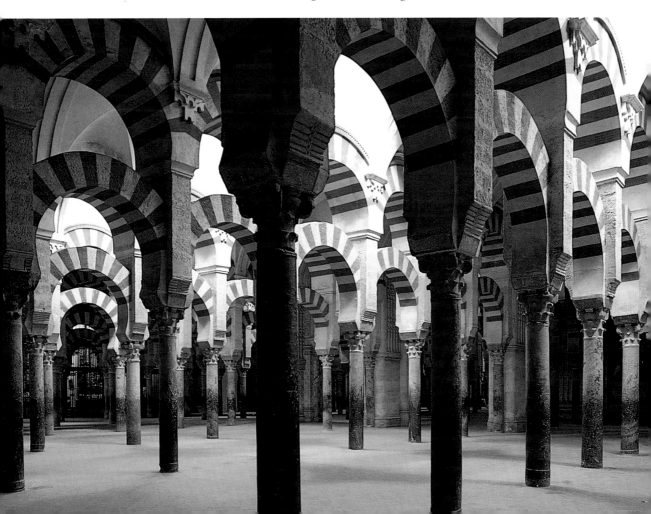

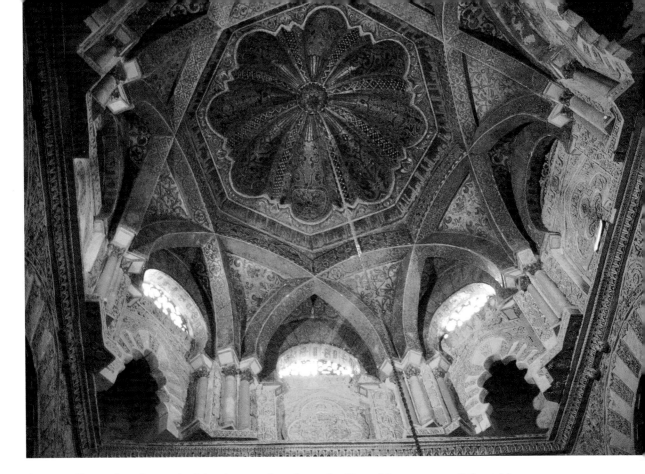

tier are of horseshoe form, the Islamic precedent from the Great Mosque at Damascus doubtless reinforced by the Visigothic usage in Spain. Similarly, the conception of the double-tiered arcade, though it recalls the superposed arcades at Damascus, seems to have resulted from the contemplation of the Roman aqueducts of Spain. Within the mosque the red and white voussoirs of the arches, which alternate brick and stone in a late classical manner, call the maximum of attention to this triumph of Islamic engineering.

The most important additions to the mosque were made for al-Hakam II in the ten years following his accession in 350/961. The *qiblah* wall was moved south, and doubled so that it was able to contain a deep *mihrab* and also flanking cells of unknown purpose. A version of the т-plan of Qayrawan was introduced in the form of an elaborate vault over a three-bay section of the aisle on the *mihrab* axis and three vaults parallel to the *qiblah* and centered on the *mihrab*. The vaults feature systems of crossing ribs which have been compared with those in Armenian churches, and domelets whose undersides are ribbed or flanged. The supports below the vaults, which delimit the *maqsurah*, exemplify a tendency in Islamic design to the reduplication of forms. Columns again uphold two tiers of arches, but those of the lower tier are now polylobed and rise to intersect each other and the upper tier. The alternation of voussoirs, plain or covered with floral ornament, is used to express the lines of this interlaced arch system.

By contrast with the arches of the *maqsurah*, the *mihrab* arch is a simple low horseshoe. This gives a weighty and solemn effect to a new and mysterious

28 Great Mosque, Cordoba: dome before the *mihrab*, 354/965. Squinch arches with a polylobed finish span the corners of the space in front of the *mihrab*, and above them eight intersecting ribs carry the dome. The ribs and the interior of the dome are sheathed in mosaic. In the topmost cupola rounded flutes alternate with angular flanges, and the latter are made to appear double by re-entrant points in the ceramic border which rims the base of the cupola.

53

type of *mihrab*. The recess beyond the arch is here not simply a niche, but a small chamber with six interior facets which invites comparison with a shrine. The ceiling of the chamber is formed by a naturalistic shell-head, which is only visible from within; but for any of the interior of the *mihrab* to be seen, it would have had to be illuminated with a lamp. The reasons for this development of the *mihrab* are not clear, but they may parallel the development of a procession of the Qur'an which appears to have been borrowed from Byzantine ceremonial. The relations of Cordoba with Byzantium were reasonably cordial, and it is said that al-Hakam sent for Byzantine workers in mosaic to adorn his mosque. Above dado level the *mihrab* is framed in mosaic which includes a fine kufic inscription. Mosaics with light-hearted floral forms on a ground of gold fill a row of blind niches over the *mihrab* arch, and above the zone of transition golden mosaic clothes the vault and the interior of the ribbed dome. 28

The exterior façades of the Cordoba mosque are carefully composed, with buttresses interspersed with doorways which reflect the framed arch of the *mihrab*. The upper line of the wall is given a dramatic and eastern finish with a row of stepped merlons. Horseshoe arches in square frames were also a feature of the now ruined palace city of Madinat al-Zahra (the Flowering City) which ᶜAbd al-Rahman III had built near Cordoba from 936.

In 969, as al-Hakam's renovation of the Cordoba mosque reached completion, the Fatimids were founding their city of Cairo, some of which survives, though much altered, embedded in the modern city. The first mosque, which came to be called al-Azhar (the Splendid), was founded in 970, and built with columns, like the Mosque of ᶜAmr; from 990 to 1013 the Mosque of al-Hakim was built with piers, like that of Ibn Tulun. To assist their religious programme the Fatimids built their mosques with a new emphasis upon a composed external façade with a monumental entrance. This formed a setting for the new ceremonial of processional visits on certain holy days, a practice which is again thought to have been influenced by the precedent of Byzantium, where the emperor's visits to the churches of Constantinople followed an elaborate ritual pattern. Unprotected by the religious status which preserved mosques and tombs, the Eastern and the Western palaces of the Fatimids have been swept away, but an impression of the urban glories of Fatimid Cairo can be gained from the writing of a Shiᶜi Persian traveller, Nasir-i Khusrau, who visited it in 1047 and who tells of six-storeyed buildings and roof gardens. In the 1080s a new wall was built for the expanding city and al-Hakim's mosque, previously outside its compass, was brought within. Much of the wall survives, with magnificent buttressed 29
gateways at intervals.

A legacy of great importance from the Fatimid period is the introduction into North Africa of a quintessentially Islamic form, the *muqarnas*. Sometimes known in Europe as honeycomb or stalactite vaulting, this is easily recognisable, but puzzling in every other way. *Muqarnas* is often found in the zone of transition of a domed building, and may derive from the subdivision and reduplication of the squinch; it often achieves an immense complexity which resembles a crystalline structure. Whether a given example is useful structurally or simply decorative is not always easily determined. Nor is it yet

clear where the feature first developed, though it may have been in Iran or Central Asia. In Egypt it is found from the eleventh century, and from thence it spread to North Africa and Spain.

Architecture of the period of Almoravids and Almohads drew on both Egypt and Spain, and relayed a synthesised style back to Spain. Columns could not always be found for re-use, so mosques were sometimes built with

32 piers. The arch form might be a round horseshoe, smooth or polylobed, or a broken horseshoe, like a more curled version of that at Ibn Tulun, and this too might be polylobed. There might be deep *mihrabs* and complex vaults, like those of Cordoba, but mosaic was not available, and would probably not have been approved if it had been. Square minarets were built, like that of Qayrawan, but these now had pattern in relief. The use of *muqarnas* spread, a strange rectangular variant of it being found in the eleventh-century Qaʿlah (palace-fortress) of the Bani Hammad in Algeria. Schemes of tilework employ bold geometric patterns; surviving examples are usually of the fourteenth century or later.

The Alhambra in Granada, the palace-fortress of the Nasrids, occupies a magnificent site on a low spur of the Sierra Nevada; though not complete, it is – with Topkapı Sarayı and Fathpur Sikri – one of the best-preserved palaces of the Islamic world. The name al-Hamra (the Red) derives from the tinge of the walls and their square towers. The two most important complexes of the

31 palace, the Courts of the Myrtles and of the Lions, were established within the older enceinte in the fourteenth century under Yusuf I and Muhammad V. Rectangular spaces, colonnades, pools and fountains, and rich decoration in stucco and tilework combined to create a setting of luxurious calm. Doorways are given very little emphasis so that the courts form a complete and inward-looking world, an image of Paradise. Use is made of the broken arch and of frothing *muqarnas* ornament, but the dominant architectural forms – columns and round arches – and the ornaments – colonnettes, networks of niche forms and shell-headed niches – are of Umayyad origin, though here developed to an extreme degree of refinement. The style of the Alhambra was echoed in later Moroccan architecture.

Carving in stone, wood and ivory

Characteristic of this period is a great delight in the use of carved ornament, both in architecture and for the decoration of objects. In Egypt this burgeoning can be traced in the epigraphic inscriptions on buildings, and also in the tombstones which have survived in considerable numbers. Letters first develop serifs and then flourishes, which are described as foliation, or, when very exuberant, floriation. In the Fatimid period, inscriptions in floriated kufic – with characteristically swan-necked ascenders – might run in a horizontal line across the smooth side of a building in a manner analogous to that of a *tiraz* strip on a costume. Within a building, it was probably more

30 usual to use stucco for ornament. In mosques the zone of transition and the spandrels of the arches which sustained it might be filled with stucco-work. These relatively large spaces allowed for very powerful and elaborate designs combining bold kufic inscriptions with stylised vegetal forms which were surely intended to evoke the gardens of Paradise.

29 ABOVE The walls of Cairo, 480/1087. Cairo was rewalled by the Armenian general Badr al-Jamali al-Juyushi, who is said to have employed three Christian architects from Urfa (now southern Turkey). On the left is the rectangular Bab al-Nasr (Gate of Victory) and on the extreme right, with rounded bastions, the Bab al-Futuh (Gate of Conquests). Between the gates rises the minaret of the Mosque of al-Hakim.

30 RIGHT Stucco *mihrab* in the Mosque of Ibn Tulun, Fustat, 487/1094 (replica; original in Islamic Museum, Cairo). The *mihrab* was installed by al-Afdal, the son of Badr al-Jamali. The kufic inscription begins in the bottom left-hand corner with the *bismillah*, followed by a reference to al-Afdal's father. At the top a blessing is invoked upon the Fatimid caliph al-Mustansir and his descendants.

56

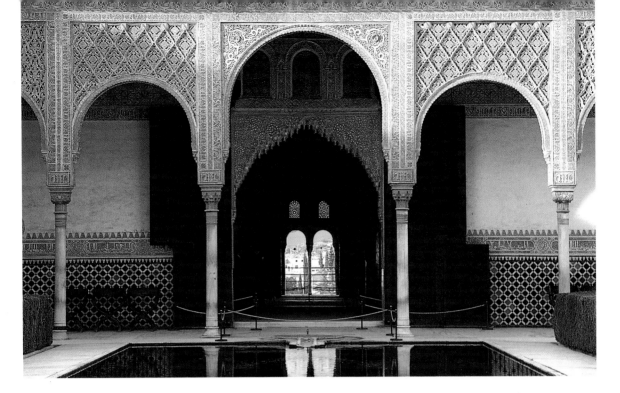

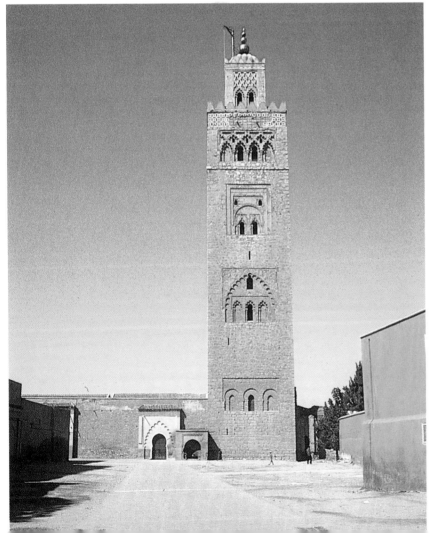

31 ABOVE The Alhambra, Granada: north end of the Court of the Myrtles, 14th century. Seen through a lobby (Sala de la Barca), is the audience hall (Hall of the Ambassadors). The decoration, and possibly the structure, are of the time of Muhammad V, whose conquest of Algeciras in 1369 is extolled in a stucco inscription.

32 LEFT The Kutubiyah minaret, Marrakesh, second half of the 12th century. The minaret was probably begun about 1160 when the mosque was extended, and its lantern top dates from the reign of the Almohad Yaᶜqub al-Mansur (1184–99). The minaret is climbed by an internal ramp. Window arches are horseshoe, polylobed, and polylobed and interlaced. The stone structure was once plastered, and has a band of tilework at the top.

33 RIGHT Ivory casket probably from Madinat al-Zahra, 353/964. The casket was made for the mother of a son of al-Hakam II, Subh (Dawn), a Basque captive said to have caught the attention of the caliph by dressing as a man. The design combines a sense of freedom with strong vertical axes. The casket has a silver hinge and catch. Madrid, National Archaeological Museum.

34 BELOW Ivory plaques from Egypt (or Sicily), early 12th century. Presumably intended to decorate furniture, the openwork plaques with traces of red paint give lively expression to courtly pleasures. Fine detail in the hunting plaque reveals the decoration of a jar and the problems of mounting a horse with a hawk on one's fist. Berlin, Museum für Islamische Kunst.

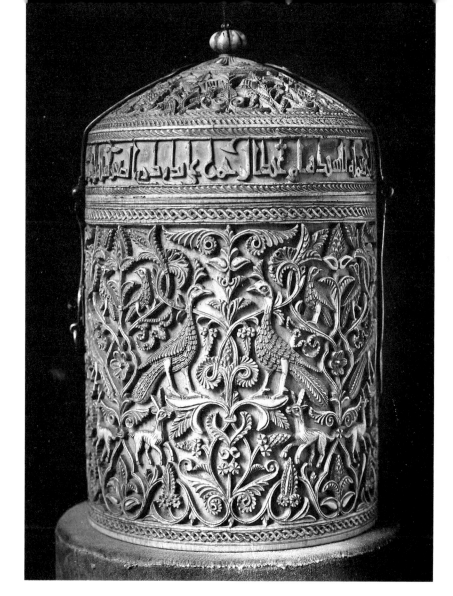

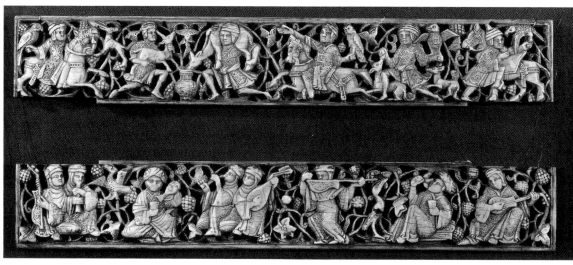

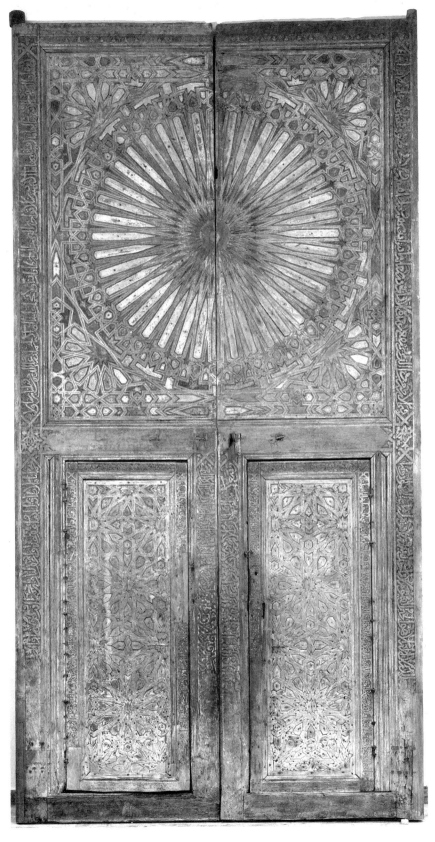

35 Pair of wooden doors
from Fez, 14th century.
The lower panels can be
opened as an alternative to
the full door. Segments of
wood are mortised and
rabbeted; the arresting
circular geometric figure is
typical of North African
design. Carved inscriptions
at the sides are from the
Qur'an. *Surah* II, 255,
speaks of the greatness of
Allah and 285–6 of the
Messenger and of the
justice of Allah to the
individual. Kuwait,
National Museum.

Marble was used more sparingly, often to draw attention to a particular feature. In marble panels an interesting tension is often felt between naturalism in the drawing of leaves and a strong impulse towards vertical symmetry. A magnificent example of carving in marble is the *mihrab* at Qayrawan, which shows in its decoration a further working-out of Umayyad themes. The *mihrab* is semicircular in plan and lined with marble panels. A central vertical row has shell-head niches, while side panels, which are partly in openwork, have vine-scrolls and geometric schemes with circular elements. Marble was also favoured for capitals and column bases, and for the basins of fountains – one such at Madinat al-Zahra being decorated with palmettes of elegant simplicity – or for stands for water-jars.

Wood was used with great skill and inventiveness. Ornamental carved panels and shutters from the Tulunid period refer to the bevelled style of Samarra, but they venture to include birds among its abstract motifs. At Qayrawan the delicately carved teak *minbar* and the *maqsurah* pay homage to the decoration of the *mihrab*. Later, however, the woodwork of *minbars* would tend to more geometric patterns, while that of *maqsurahs* would be composed of criss-crossing rods and spindles of turned wood. The latter technique came to be used in secular buildings for window-screens, and is known as *mashrabiyah*, meaning a place where drinks are left to cool. Wood was also used for long bands of inscription or of decorative work. From the Fatimid palaces there survive beams which, amid scrolls, show cartouches with figures occupied in the pleasures of courtly life, dance, music and conversation. Traces of paint remain upon the beams and the figures have graceful rounded forms and an air of cheerfulness.

Ivory was also a favoured material. In the 960s ivory caskets were made at 33 Madinat al-Zahra, usually for the women of the family of ʿAbd al-Rahman III and al-Hakam II; some bear the name of a workshop, Khalaf. Some boxes are rectangular and others spherical. They are often inscribed in foliated kufic, and covered with a luscious but controlled scrolling in which the vine-leaf seems to be on the point of becoming acanthus. The decorative work is sometimes inhabited by confronted birds or animals, or it may yield to lobed cartouches which contain enthroned monarchs, minstrels and riders. The plump-faced figures tend to have dour expressions and to be bare-headed, which may indicate a Western or Byzantine connection. In Egypt ivory was used for plaques which were probably intended for furniture. These are 34 carved with vibrantly lively figures which reflect in a small scale those of the palace beams. Ivory was also used as an inlay for wood. Different in character, but again from Egypt, are a number of small figures made in bone; they resemble 'clothes-peg' dolls marked with tattoos, and may have been playthings or have had more arcane purposes.

By the eleventh century scrolling ornament in the Islamic world generally had evolved away from its naturalistic beginnings into a stylised form which is known as arabesque.

Rock crystal and glass

Some of the most exciting objects made for the Fatimids are in rock crystal. The surviving items are usually small, and because of the beauty of the

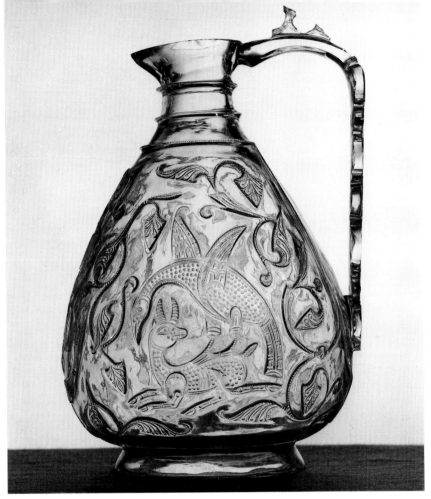

36 Rock crystal ewer, Egypt, early 11th century. This ewer is more elegant in shape and fluent in decoration than others of the small class to which it belongs, and it lacks the rim which they have at the base of the body. It was probably made later, in the latter days of al-Hakim (966–1021) or the reign of al-Zahir (1021–36). London, Victoria and Albert Museum.

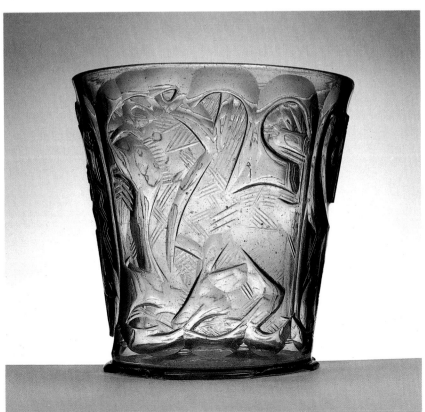

37 Glass 'Hedwig' beaker made in Egypt (or Syria) in the 11th or 12th century. A griffin prowls left; on the other side of the beaker a lion comes to meet it, while a hawk (seen only as a wing on the left) stands between. The play of light on wheel-cut facets gives an ambiguity to the design in which the animals emerge from the background and vanish into it. London, British Museum.

material and its ornamentation several were later incorporated into Western ecclesiastical vessels. Small pieces were used for sceptre-heads, talismans, chessmen and small standing bottles of the 'molar' type. The latter would have been used to contain scent or possibly kohl; however, it is difficult to understand the function of other small objects, in the shape of lions or fish, which are bored horizontally and which would thus be unsuitable as receptacles for liquid: could they perhaps have contained a talisman or charm?

The makers well understood the radiant effect of light on rock crystal. A crescent, unadorned save for the name of the caliph al-Zahir (1021–36) and now mounted in a reliquary, is thought to have been part of a horse trapping and would have made a striking effect flashing in sunlight. Conversely, if a scoop-shaped vessel with scrolling decoration, now in the Hermitage, is correctly identified as a lamp, it would have been exquisite in use at night. The largest surviving pieces are a small group of ewers with pear-shaped 36 bodies and handles which curve out and then drop straight at the back, a shape also found in Persian glass. The earliest dating among these is furnished by an example for al-ᶜAziz (975–96) which has cheetahs on the body, while an ibex as the thumbpiece on top of the handle suggests a Persian connection. The latest ewers are considered to be datable to the first quarter of the eleventh century.

A lovely but rare type of glass beaker rejoices in the name 'Hedwig' because 37 of an unsubstantiated claim that such a vessel played a role in the story of St Hedwig (1174–1245), a Silesian princess. The date and place of origin of this type are both in debate, but the tenth or eleventh century in Fatimid Egypt, or in Syria under Fatimid influence, seems probable. The beakers, large and thick-walled, are of very clear glass which is slightly tinted. The wheel-cut decoration includes abstract motifs which recall Tulunid style, and bold lions and hawks of heraldic appearance.

Arts of the book

Like those of the Near East, the North African Qur'ans of the ninth and tenth centuries are on vellum in a horizontal format, and they are written in kufic, though some diacritics follow local conventions. Chapter headings are contained in a rectangular cartouche, in which the motifs of closely packed gold ornament often resemble contemporary stucco or woodwork. Palmettes which project from the cartouche into the outer margin are thought to reflect the handle of the ancient writing-board. A number of ancient Qur'ans are preserved in the Museum of the Great Mosque, Qayrawan, and among them are some leather bindings – rare survivals, since early bindings are often lost. In early manuscripts the covers were usually of wood, covered with elaborately tooled leather. Designs are often composed of a central field with surrounding borders, and geometric patterns and knots predominate. A cover at Qayrawan, which has been dated between the ninth and eleventh centuries, shows a rare technique in which a foliate pattern is moulded by cords beneath the leather.

A celebrated large Qur'an on vellum, now dispersed, which was probably copied at Qayrawan under the Aghlabids in the early ninth century, is written in unoutlined gold on a blue ground; royal Byzantine manuscripts had

sometimes been written on purple vellum, but a more direct influence is probably the mosaic inscription in gold on blue at the Dome of the Rock. The ends of verses were marked with silver rosettes which have unfortunately oxidised to grey. The manuscript is unique and must have been prepared for a special occasion, perhaps a restoration of the mosque.

The curvilinear script of North Africa and Spain is very different in character from those of the East. Its most characteristic feature is the use of deep, almost hemispherical, loops for the letters which descend below the line; in addition, the tops of the verticals incline to the left. The loading of the rather thin brownish ink is very variable and this, together with the very soft attack of the strokes and the flick of the descenders, gives an appearance of brushwork rather than penwork; however, it is more probable that a rather soft and fibrous reed was used. Coloured vowel signs continued to be used in these areas when they had become obsolete elsewhere.

Figurative painting in the period is partly represented by a number of isolated scraps which have been retrieved from the debris of old Fustat. These are often simple and crudely drawn doodles rather than pictures, and are of course difficult to date with any precision. But even so they show certain stylistic features. The most striking of these are the large dark and haunting eyes of many figures, which distantly recall those of encaustic funerary portraits of the classical and early Christian periods. Another feature which points to past prototypes is the use, even in some very simple drawings, of a hint of fold lines to indicate volume. There are also some links with Samarran painting, such as black locks which curl against the cheek, but the spirit is gayer. Most remarkable of the drawings considered Fatimid is a study in the Israel Museum, Jerusalem, of an extremely corpulent, tattooed, nude woman, which may have been a cartoon for a wall-painting.

The great palace libraries – that of al-Hakam II at Cordoba contained 400,000 manuscripts – were destroyed. As a result our knowledge of painting for patrons of a high level in the twelfth to early thirteenth centuries is mainly derived from two sources. One of these is firmly located in time and place, but tantalising for other reasons, and the other is of uncertain origin. The first is work done in the 1140s in Sicily at Palermo and Cefalù for Roger II. The walls and dome of Palermo's Cappella Palatina were adorned with Christian subjects by Byzantine mosaicists, but its ceiling of wooden *muqarnas* was decorated by painters who were evidently working in a Fatimid tradition. The individual facets of the *muqarnas* show kufic script, the real and mythological fauna of the Islamic decorative world, lions, griffins, hawks, pea-cocks, and men and women sitting singly with drinking cups or musical instruments. A few panels amount to scenes, depicting chess-players in a tent or water being drawn from a well. The painting style is highly developed and seems to derive from book illustration rather than mural decoration.

The only illustrated narrative available for comparison with this ceiling is the *Story of Bayad and Riyad*. This is a romance set in Iraq, in which Bayad, a young merchant, falls in love with Riyad, the attendant of a noble lady. The illustrations convey the vicissitudes of the emotional drama with great clarity. Facial types resemble those in the Cappella Palatina, though they are a little heavier. The picture plane is shallow, but volume is indicated by fold

38

39

38 Man playing a pipe, from the ceiling of the Cappella Palatina, Palermo, 1140s. The musician's haunting face has the large eyes of the Egyptian painting tradition; he wears a high-set turban in the Fatimid style and has ornamental *tiraz* bands in his sleeves. The flask beside him was surely meant for wine and indicates the princely context from which he is derived.

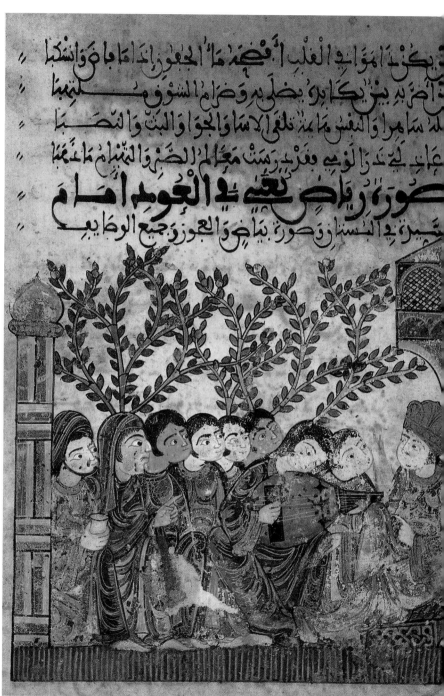

39 'Riyad plays and sings to the lady on the '*ud*', from *Bayad and Riyad*, Spain, 13th century. Bayad and an old woman are among the listeners in the lady's garden; Riyad's song tells of the torments of love. The lady, in a golden headdress, sits below a tower whose window is screened with *mashrabiyah* work. Vatican, Biblioteca Apostolica.

lines in the garments. Architectural elements suggest an origin in Spain, and the script is of a Western Islamic type. The manuscript probably dates from the thirteenth century.

Pottery

Throughout this period the Western Islamic region produced pottery decorated with coloured glazes, predominantly yellow, green, brown and purple, which were applied under a clear glaze or over an opaque white. Bowls and plump jars are decorated with splashes, geometric elements, kufic inscriptions which often take the form of the word *barakah* (blessing), and sometimes with simply drawn birds, animals and human figures. In the tenth century Umayyad Spain introduced an important new technique which came to be known in Europe as *cuerda seca* (dry cord): motifs are outlined with a pigment which burns off in the firing, leaving a matt black line which is an effective barrier to running glazes. Vessels found at Madinat al-Zahra use *cuerda seca* with white and light green glazes.

However, by far the most important form of pottery decoration was lustre. The history of lustre in the region is still a matter of debate, but it is probable that the technique and styles from the ᶜAbbasid centres were introduced at two points: at Qayrawan, where local products in polychrome lustre followed the small motif patterns of tiles sent for the Great Mosque; and at Fustat, where monochrome pieces would echo the Tulunid version of the bevelled style. But it was under the Fatimids that a great flowering of lustre painting took place, with a new assurance in every sort of design. In abstract and floral work there is a great increase in clarity as sectors of pattern or motifs which have grounds of lustre are contrasted with and balanced by areas with grounds in reserve. Vine-scrolls twist with a new abstraction but also a new richness. A fresh element in non-figurative schemes is the use of inscriptions in a confident, often foliated or floriated, kufic.

In figurative designs the rather boneless animals of ᶜAbbasid lustreware brace up and take on the swagger which would characterise the beasts of European heraldry. The largely ungulate ᶜAbbasid fauna is joined by the cheetah, the hare and, above all, by the winged and four-legged griffin. In the human sphere, the earlier rudimentary musicians with staring eyes may take on a more decorous life as Coptic priests – an indication of one particular area of patronage. Other treatments of the human figure on some of the loveliest Fatimid dishes are thought to be datable to the eleventh and twelfth centuries. One style produces a very striking two-dimensional pattern. The ground is usually in reserve, and against it the courtly figure, who may be sitting drinking or playing a lute, is treated in areas of lustre ground and reserve. Drawing harks back to Samarra, with heavy features, languishing eyes and thick kiss-curls, while in costume there is an emphasis on ornament, including *tiraz* bands, crowns or head-bands, and jewellery. The figures are here in curved postures which partly conform to the shape of the dish. By contrast, the other mode uses a ground of lustre, often with scrolls upon it, and maintains most of its figures in reserve. Detail is drawn upon them with a fine lustre line which aims to indicate folds and volume rather than surface pattern. The subject-matter of these scenes is sometimes courtly but often of a

40 ABOVE LEFT Earthenware dish with lustre decoration on a white glaze. Egypt, 11th century. Vine-scrolls are still recognisable in the design, though semi-abstract palmette forms dominate. There is a superb balance between areas in lustre and areas in reserve, which creates an illusion of decoration in three layers. Keir Collection.

41 ABOVE RIGHT Fragment of an earthenware dish with figures in reserve on a lustre ground over a white glaze. Egypt, 11th century. The subject is courtly and the drawing suggests a manuscript influence in the treatment of the garments and the foreshortened leg of the figure on the left. The name Muslim appears on the rim and on the base: this is probably Muslim b. Dahhan al-Hakimi, whose appellation shows that he worked for al-Hakim (966–1021). Athens, Benaki Museum.

more 'low-life' character, with workmen, wrestlers and cock-fighters, who wear plainer clothes. The figures are presented on a horizontal axis across the dish, suggesting a source in a lost school of manuscript painting, though an influence from classical or Byzantine pictorial metalwork may also be suspected in some cases. Lustre pieces sometimes bear a name, which may be the signature of a maker or decorator, or the identification of a workshop; this is certainly an indication of the regard in which the ware was held.

Spain appears to have received the lustre technique from North Africa, but there was also contact with Egypt and the Eastern Islamic lands. Celebrated among Spanish products are the small group of 'Alhambra' vases attributable to the fourteenth century. These are large and of amphora shape, with handles in the form of flat wings. Their ornate decoration includes bands of inscription in kufic or *naskhi* and sectors of ornament from the repertoire of architectural decoration. After the reconquest lustreware continued to be made by the *mudéjar* population (Muslims under Spanish rule); it is described as Hispano-Moresque. Though lustre of the thirteenth century is believed to have been golden in colour, by the fifteenth century it is usually russet; it is sometimes set off by details in cobalt blue. Patterns are frequently of multiple vine-scrolls, but European blazons are introduced, and some pieces for church use have Latin inscriptions. Centres of production were Malaga and Valencia; items traded from the latter via Majorca gave rise to the term 'maiolica'.

Metalwork

The principal producers of fine metalwork were Egypt, where there was a strong tradition among the Copts, and Spain; but it is sometimes difficult to tell in which land a piece had its origin. Works in base metal alloys, often with engraved decoration, include small lamps in various forms, lampstands, hanging lamps, incense-burners, dippers, mortars and ewers. A group of

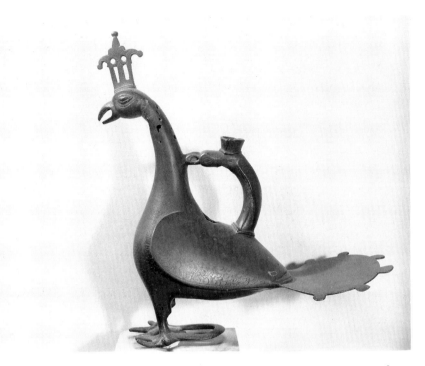

42 Aquamanile in base
metal alloy in the form of a
peacock, Spain (or Sicily),
11th or 12th century. The
breast of the bird is
engraved with inscriptions
in both Arabic and Latin;
they read *ʿamala ʿabd al-
malik al-nasrani* (ʿAbd al-
Malik the Christian made
it) and *Opus Salomonis erat*
(work of Solomon). While
the precise significance of
these is puzzling, they
demonstrate an interesting
mixture of cultures. The
peacock's crest has acquired
something of the character
of a palmette, like a
thumb-piece on a ewer.
Paris, Musée du Louvre.

ewers with handles bent like a question mark are thought to come from Egypt. Two brass astrolabes from Toledo are dated 460/1067 and 461/1068.

Many objects are in the shape of animals. From Egypt there are hares, goats, camels, parrots and eagles. They are small and often rather naturalistic, though they may be decorated with scrolls, human figures and even Egyptian hieroglyphs. Their purpose seems to have been ornamental, and they may perhaps have been fittings on furniture. Creatures in more stylised form were used for aquamaniles (ewers of zoomorphic shape). Related to these are fountain spouts, like the graceful deer from Madinat al-Zahra in the Archaeological Museum, Cordoba, or the lions which support the basin in the Alhambra's Court of the Lions, but which may date from pre-Nasrid days. The largest animal piece and the most striking is a griffin, which is now in Pisa. It stands four-square and its head and wing tips may have been intended to support some object.

Towards the end of the period a more extensive use of inlay seems to occur in Egyptian metalwork. In the National Archaeological Museum, Madrid, is a fine hanging lamp, dated 705/1305 and made for the Nasrid ruler Muhammad III. This takes the form of a bell-shaped cage with four small globes in line above it, the whole in finely pierced work; glass lamps placed within it would have cast intricate shadows.

Nothing remains of the Fatimid treasures of silver and gold, but some pieces of jewellery in filigree are attributed to the period. In Spain, in about 970, a casket was made for Hakam II as a gift for his son Hisham; now in Gerona Cathedral, it follows the rectangular ivory type, but in silver with ornate repoussé work and gilding. Fine weapons were also made. A sword now in the Army Museum of Madrid and once the possession of Abu

ʿAbdallah Muhammad XI, the last Nasrid of Granada, has a hilt thickly decorated with gold filigree and enamel in a pattern related to Alhambra stucco-work.

Textiles and carpets

In Fatimid Egypt the display of grand costume was an important element in public rituals, and *tiraz* inscriptions conveyed a Shiʿi message with references to the pure descent of the caliphs. Quite a number of linen pieces survive with *tiraz* inscriptions in silk. The most celebrated example, known as the 'veil of St Anne', of 489/1096 or 490/1097 and in the name of al-Mustaʿli, is preserved in the Church of St Anne, Apt. Though it is known that sumptuous silks were made, far fewer remain. The traveller Nasir-i Khusrau speaks of seeing

Byzantine silks in Cairo. This may indicate an import, or it may be that he means a certain type of design, such as the use of the circular motif.

That textile designs could carry a religious and political meaning was well understood in Norman Sicily. The coronation mantle of Roger II, in the Kunsthistorisches Museum, Vienna, considered to have been made in Palermo in 528/1133–4 by artists of Fatimid training, is of red silk with gold embroidery. Hemispherical in shape, it resembles a circular motif cut in half: it is rimmed with a kufic inscription, and has a palm-tree as a central axis, on either side of which a proud lion is ravaging a camel, an evident symbol of post-Muslim rule.

The Arabs brought the production of silk to Spain, where work became centred upon the towns of Almeria, Malaga, Seville and Granada. Coptic workmen were brought from Egypt in the tenth century, and thus it is not surprising that designs reflect those of the more eastern lands. A splendid *tiraz* fragment in the Academia de la Historia, Madrid, refers to Hisham (Hisham II), and is thus datable between 976 and 1013. In silk tapestry incorporating silk thread wrapped in gold, this has a central row of octagons containing seated human figures, animals and birds in white, purple, blue and green. The bordering inscriptions are on a reddish ground, the ascenders of the foliated kufic pointing inwards to the central strip. Human figures treated in a relatively naturalistic way are found on another silk tapestry fragment, of the twelfth or thirteenth century, which shows circles with ladies drinking.

43 More complex and fantastical forms appear on silks in compound weaves, the design often being composed of a grid of circles which contain pairs of confronted creatures. Celebrated in this category is a silk lampas (a compound weave which incorporates satin), datable about 1100 by its use in the tomb of San Pedro de Osma, and now in the Museum of Fine Arts, Boston. This shows opposed harpies mounted on the backs of lions, while around them men hold pairs of prancing griffins apart. The spurious claim of the inscriptions that the fabric was made in Baghdad is an interesting indication of the prestige of the products of the ᶜAbbasid world. A piece in Quintana-ortuña, near Burgos, with a similar design, but featuring opposed lions, bears the name of the Almoravid ᶜAli b. Yusuf b. Tashfin (1107–43).

From about the thirteenth century there comes into vogue a different type of pattern which uses grids of geometric motifs between horizontal borders. It is probable that some at least of these are intended for hangings, rather than costume, and indeed those of the fourteenth and fifteenth centuries are closely related to the tile and stucco dados of the Alhambra, with rows which include cartouches of cursive script or strips of stepped merlons borrowed from architecture.

Carpets with knotted pile are known to have been made in Spain from the thirteenth century. Their technique, which may again have been introduced with Coptic workers, is characterised by the fact that the pile knots are tied on single warp threads, and not on to pairs as is more usual. Designs include kufic borders, and grounds with grids of hexagons. In later centuries commissions for European patrons might include their blazons.

43 Silk lampas fragment with addorsed lions, Spain, probably second half of the 10th century. The ground is cream with script and creatures in crimson; the upper band is black against gold. The animals are powerful and bear-like; alternating with them are less emphatic peacocks. The upper inscription band, which repeats *al-rahman* in normal and mirror script, suggests the period of ᶜAbd al-Rahman III (912–61), and the simple dotted frames of the compartments support an early date. London, Victoria and Albert Museum.

3

RENEWAL FROM THE EAST
The Seljuks enter Iran and Anatolia

From the tenth to the thirteenth century the power of the caliphate in the secular sphere was challenged by Persian and Turkish dynasties. The rule of the Seljuk Turks does not embrace the whole period, but is its most important feature.

The first dynasties to assert themselves were Persian. They arose where the Arab impact had been least felt, in the north-east of the Islamic territory or the secluded areas south of the Caspian; and though Muslim, they felt themselves heirs of the old Persian culture. The world of the pre-Islamic Persian kings, indeed, had for them a resonance and a glamour comparable with that of Troy and Rome for the medieval West. The Shiʿi Buyids have already been mentioned; their domination of Western Iran and Iraq lasted until they were displaced by the Seljuks in 447/1055. As early as the ninth century, the Samanids, descendants of a Persian noble from Balkh, had established themselves in the East as virtual rulers in Ma waraʾl-nahr ('That which is across the river', Transoxiana), with a capital at Bukhara. Their state was extended under Ismaʿil b. Ahmad (892–907) to include Khurasan, the great north-eastern province of Iran.

For all that they prided themselves on their Persian culture, the Samanids were – like the caliphs – obliged to support themselves with the help of recently converted Turks from Central Asia. The Turks, who are considered to belong to the family of peoples which embraces both the Mongols and the Finns, appear to have originated in the steppe lands of southern Siberia, where many Turkic peoples live today. Such peoples were often nomadic, and belonged to tribal confederations in which authority was to an extent shared among members of a ruling family. For centuries they had tended to move south or west towards more settled and fertile lands, and they appear in the histories of other nations as the Hiung-Nu, Saka, Scythians or Huns, invading China, India, Iran or Europe. The name Turk was known to the Byzantines by the sixth century, and it is found on inscribed stones of the seventh and eighth centuries by the Orkhon river, south of Lake Baikal. Also mentioned there are Uighurs, another Turkic people, who established a state with a high level of culture in the mid-seventh century. Before their contacts with Islam, the Turks had adhered to various religions, a primitive shaman-

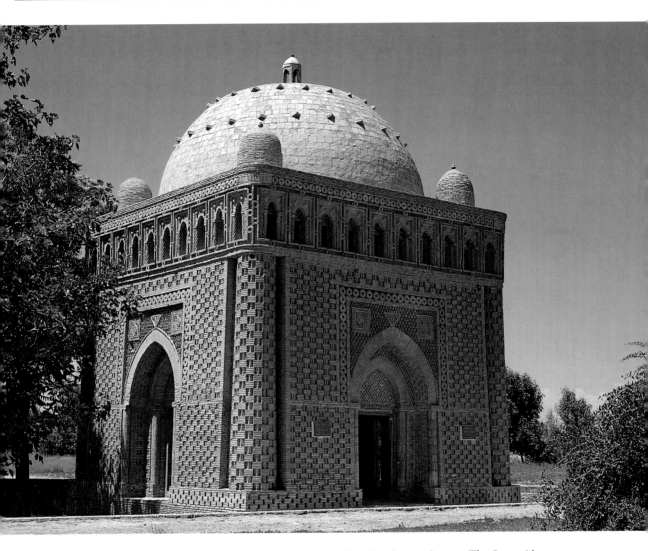

ism, Buddhism, Manichaeism and Nestorian Christianity, but by the tenth century the westerly groups were being penetrated by Sunni missionaries. Samanid rule was weakened in the 960s when their Turkish governor of Khurasan, Alptegin, set himself up in virtual independence in Ghazni; and the Samanids were extinguished by a clash in 389/999 with the Turkish state on their eastern marches, that of the Qara Khanids (the 'black', or great, lords).

Greatest of the Ghaznavids was Mahmud b. Sebuktegin, who ruled from 988 to 1030 and whose Muslim first name and Turkish patronymic reflect the changing times. From Ghazni, in south-eastern Afghanistan, he was able to conduct a series of campaigns in a new direction, into India, taking control of the Punjab and ranging as far as Gujarat. As a devout Sunni he challenged the Shi'i Buyids, and in 1029 he destroyed their library at Rayy. Enriched by the spoils of North India, Ghazni became a centre of attraction, and among others the poet Firdausi sought the patronage of Mahmud. It appears that the attempt was unsuccessful; however, Firdausi's great epic, the *Shahnameh*,

44 The Samanid mausoleum, Bukhara, early 10th century. Burials were required to be underground, but tombs were provided with cenotaphs at ground level. The inventiveness of the decoration is seen in details as small as the alternation of spirals and zigzags on the colonnettes of the niches of the gallery and the ornament in their hoods. Borders of small rings, sometimes known as beads, reflect Sasanian style.

probably completed in 400/1009–10 and telling of the kings of Iran from the beginning of civilisation until the Islamic conquest, came to be accounted the greatest monument of Persian literature. Shortly after the death of Mahmud, the Ghaznavids suffered their first major reverse, defeated in 1040 at the battle of Dandanqan by the Seljuks, who had earlier been in the service of the Qara Khanids. In the twelfth century the Ghaznavids came into dispute with the Ghurids, a dynasty from central Afghanistan; Ghazni was destroyed in 1161 and the Ghaznavids were forced south-east to Lahore, which also they were obliged to yield to the Ghurids in 1187.

The Ghurids inherited the Ghaznavid interest in India, and in 1192 they defeated Prithvi Raj, a Rajput prince, and captured Delhi. They were defeated in 612/1215 by the Khwarazm-Shah, the representative of a dynasty descended from a Turkish slave of the Ghaznavids, who ruled in Khwarazm (around Khiva in Soviet Uzbekistan) and who in 1210 had defeated the Qara Khanids of Samarqand. The empire of the Khwarazm-Shahs was brief, the last, Jalal al-Din Mingirini, being murdered in the course of an epic pursuit by the Mongols in 1231.

The Seljuks (also written Saljuqs) were members of a tribal federation called the Oghuz. They moved west from Central Asia, and in the late tenth century, under Saljuq b. Duqaq, they served the Qara Khanids against the Samanids. The Seljuks then developed ambitions of their own: they swept into Khurasan, taking Nishapur in 1038, and in 1055 Tughril, the grandson of Saljuq, defeated the Buyids and made himself the protector of the caliph in Baghdad. He had already adopted the ruler's title of sultan. The branch of the family which based itself in Western Iran is known as the Great Seljuks; it reached its zenith under Malik Shah (1072–92), and lasted until 1157. Other branches survived longer in Iraq, Syria and Kirman.

In addition to the Seljuks, bands of nomadic Turks – distinguished from the more islamicised Seljuks by the description Turkman (Türkmen) – operated in semi-independence. In 1071 they captured Jerusalem from the Fatimids, in reaction to which the Christian powers launched the first Crusade. The Turkman had already raided into Anatolia, the portion of present-day Turkey which is in Asia and which at its eastern extremity was, in the eleventh century, an ill-defended frontier land. In the fateful year 1071 the Great Seljuk Alp Arslan defeated the Byzantine emperor Romanus Digenis at Manzikert (Malazgirt) north of Lake Van. The ethnic and religious division between the two forces was anything but clear-cut, with renegades on both sides; in particular, some Armenians fought with the Turks, since Byzantium had recently disaffected this Christian buffer state.

The Turks who entered Anatolia penetrated rapidly as far west as Nicea (later Iznik), but were forced to withdraw by the first Crusade. A capital was established at Konya (classical Iconium) in the midst of Anatolia and the Seljuk branch ruling there became known as the Seljuks of Rum, which is to say of 'Rome', or of the erstwhile Byzantine lands. The Seljuks of Rum were in competition with a number of Turkman states, and it was not until the second half of the twelfth century, spanned by the reign of Qılıç Arslan II, that they were able to assert themselves as the dominant power in the area. The heyday of the Seljuks of Rum was the thirteenth century, during which

the rulers' sense of royal dignity is marked by their use of Persian names from the *Shahnameh*. The greatest rulers of the dynasty were Kay Ka'us I (1210–19), who acquired the ports of Antalya in the south and Sinope in the north, thus facilitating trade, and Kay Qubad I (1219–37). In 1243 the Seljuks of Rum were defeated by the Mongols, and became subservient to them. The country did not suffer greatly, but in the later thirteenth century power lay in the hands of the great officers of state rather than in those of the sultans. The dynasty continued until 1307.

Throughout the region the pre-Mongol period tended to see an increase in prosperity. Secular literature and Islamic learning flourished, as did the refined mysticism of brotherhoods of Sufis.

Architecture in Iran and the Eastern lands

The principal building material in Iran and Central Asia was brick. Stone might be used in foundations, wood occasionally for supports and for roofing, and of course for doors, but brick predominated, usually baked for formal structures and unbaked for informal. The small size of bricks as individual units makes it possible to generate rounded forms progressively, and hence to make domes and vaults. Domes could, if small enough, be made without centering, working from the outside, ring upon ring towards the centre. The brick unit also offers the opportunity to create surface pattern by ornamental lays – bricks set at an angle or recessed – a type of decoration which is particularly suited to areas of strong sunshine.

Both features of brickwork are illustrated by the earliest building of the area to survive in its original form, the Samanid mausoleum at Bukhara. In design the mausoleum appears to derive from the canopy structure which protected the sacred fire in the Sasanian fire-temples: on a square plan, four corner piers support arches in the walls of a cube, and carry a dome on squinches. This structure is known as a *chahar-taq* (four-arch). Though following this simple scheme, the Samanid mausoleum has many sophisticated refinements. The proportions of each section are beautifully related to one another so that the viewer is almost tempted to think of it as a finely wrought casket, rather than a building. The outer face of the walls slants inwards with a slight batter, and the outer corners are expressed as engaged round buttresses. Above the walls the structure is surrounded by the arches of a small gallery, which masks the zone of transition, and above this the semicircular dome is ringed by four domelets, which refer to the corner buttresses, though they are not directly above them. On the inside, the transition to the dome is performed by four squinch arches, with rib-like half-arches which brace them to the corners of the structure below. Between the squinches light from the gallery filters in through brick lattices. Over the greater part of the surface there is a play of bricks laid horizontally or vertically, flush or recessed. Some bricks are formed into rows of circles – a favourite Sasanian motif – and the colonnettes of the gallery arcade are worked with zigzags. The decorative brickwork, probably the work of specialists, was evidently applied when the structure was complete, since photographs of the building prior to recent restoration show a relatively smooth surface behind areas of damage. The mausoleum is given an approxi-

44

mate dating by a wooden inscription in foliated kufic in the name of Nasr b. Ahmad (914–43).

Other mausolea take various forms. That of ᶜArab Ata, at Tim near Samarqand, of 367/977–8 is again a dome-on-square but exterior interest is all concentrated on one façade, which was given up to a *pishtaq*. In the interior, the zone of transition employs the first known example of the tri-lobed squinch: it is as though the Samanid squinch had parted down the back bracing rib and the resulting segments were united by another arch bridging their tips. In its turn, the trilobed squinch may be the unit from which *muqarnas* was generated. A modest trilobe is found at the back of the entrance to the Gunbad-i Qabus, a remarkable tomb tower built for himself in 397/1006–7 by Qabus b. Vashmgir, a minor ruler of Persian origin in Gurgan. Set upon an artificial mound, the tomb is a cylindrical shaft with ten angled flanges running up the exterior to meet a conical roof. Legend has it that the glass coffin of Qabus was suspended inside where a ray of sunlight from a small east window in the roof would penetrate in the morning. Other tomb towers were more compact than the Gunbad-i Qabus; they might be cylindrical – smooth or ribbed – square or faceted. The most magnificent of the Seljuk tombs is a great dome-on-square at Marv, built for Sultan Sanjar who died in 1157. A gallery recalls the Samanid tomb, but the dome, no longer the single hemisphere of the earlier building, was a double shell. This development, which lightened the upper area of the dome, also tended to make it more stable – though it must be admitted that in many instances the outer shells are now broken; it also permitted differentiation of the inner and outer shells for aesthetic effect.

The forms taken by mosques in the tenth and eleventh centuries were also various. In some places, as shown by excavations at Siraf, the hypostyle hall enclosing a court continued. A type using brick piers as supports survives from about 960 at Nayin, and this has fine stucco decoration in the tradition of Samarra. Also ornamented with stucco but very different in structure was a mosque at Balkh, which had nine domes, arranged three by three. It has also been argued that some mosques were not complete structures, but delimited open areas – in the manner of a *musalla* – with a *chahar-taq* or an *ivan* to house a *mihrab* at the *qiblah* direction, but this is doubtful.

Many of the *masjid-i jamiᶜs* – the Persian term for congregational mosques as opposed to smaller private ones – or *masjid-i jumᶜehs*, Friday mosques (from the same root), are on sites which have been in constant use from ᶜAbbasid times to the present day, and so they represent a series of building periods. Nevertheless, it is possible to distinguish those which acquired their principal lines in the Seljuk period, and foremost of these is the Masjid-i Jumᶜeh of 45 Isfahan, which had become the capital under Alp Arslan. It is probable that until the eleventh century the mosque was hypostyle. Between 1072 and 1075 a new domed unit before the *mihrab* was built on the order of Nizam al-Mulk, the vizier of Malik Shah. The new dome is on trilobed squinches, and within it lines of flush brickwork form a radiating pattern; it is stern and strong in appearance. In 1088 another domed chamber was built to the north of the mosque; this was on the order of Taj al-Mulk, the vizier of Malik Shah's wife (Terken Khatun, a Qara Khanid princess) and an enemy of Nizam al-Mulk.

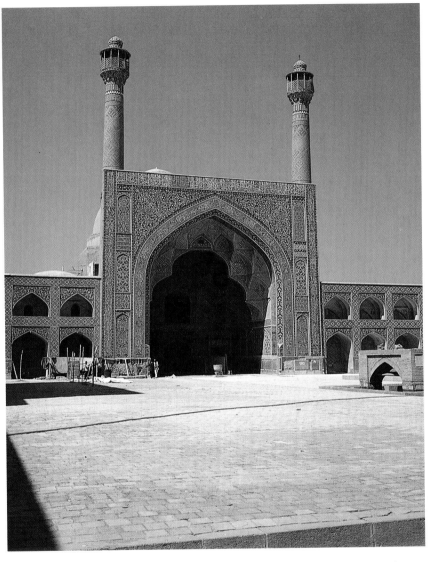

45 The Masjid-i Jum'eh, Isfahan, rebuilt after 515/1121–2 (with later work). The *qiblah-ivan* is the harmonious result of work at different periods: the structure of the *ivan* dates from the 12th century, the *muqarnas* probably from the 14th, and the minarets and tilework from the 17th. The 11th-century south dome is seen behind.

The mosque has since grown to encompass the north dome chamber, but it would originally have been free-standing; its intended function is unclear, but it may have been a royal oratory or anteroom. The north dome chamber is considered the supreme masterpiece of the architecture of the Great Seljuks. Framing arches round the trilobed squinches contribute to a soaring effect which is both strong and graceful. The foundation inscription in brick circles the inside of the base of the dome, and the interior of the dome itself is criss-crossed with a geometric star pattern and dotted with stucco plugs between the bricks which suggest minor stars.

The Masjid-i Jum'eh of Isfahan was a centre of Sunnism, and the main body of the mosque had to be rebuilt after being burned in 514/1120–21 by Isma'ili (Seven-er) Shi'is. The new structure had lofty brick piers supporting majestic vaults and star domes, and an *ivan* in the centre of each courtyard

46 Minaret of Mas⁽c⁾ud III, Ghazni, early 12th century The photograph, taken in 1880, shows the minaret with a cylindrical upper shaft, partly fluted, above a lower shaft of eight-pointed star section. By 1916 or 1917 the upper portion had fallen. Mas⁽c⁾ud (1099–1115) is named in the tall kufic inscription at the top of the lower shaft.

façade. The origins of this four-*ivan* plan are a matter of debate; it may be traceable to palace architecture of the pre-Islamic period. In the late eleventh century the plan was also used for a new type of teaching institution, the *madrasah*, which Nizam al-Mulk was fostering to counteract Shi⁽c⁾ism. The renovated Masjid-i Jum⁽c⁾eh may not have been the first four-*ivan* mosque, but it is the classic example of the form, which was to become general in Iran. The four-*ivan* format firmly establishes the courtyard façade of such mosques as more important than their exterior façades. This is in keeping with the developing mysticism in Islam at the time, which was continually seeking for the true meaning within the appearance. This way of thought was well served by the architectural ambiguities of façades which look inwards upon space, with *ivans* which are both enclosed and open forms, like doorways between the material world and the spiritual.

Though the oldest minarets in Iran may have been square in section, like those of the West, from the eleventh century onwards there survive examples of a tall and slender cylindrical Persian type. These are often faced with brick in ornamental lays which generate wonderfully effective geometric patterns. On the slim shafts of the minarets of Iran proper, the pattern may be continuous over the full length, but on the more thick-set and distinctly tapered minarets of Central Asia it is in discontinuous bands to allow for adjustments to the diminishing field. Some minarets are thought to have functioned not only as the place from which to give the call to prayer, but as monuments to victory, particularly the victory of Islam. Two minarets at Ghazni, built by Mas⁽c⁾ud III (1099–1115) and Bahramshah (1118–52), seem to be of that type, though as they have long been bereft of surrounding buildings it is difficult to be sure how they functioned. If recent events have spared them, these survive as shafts whose section is an eight-pointed star – a form which recalls the flanges of the Gunbad-i Qabus. Formerly these lower parts were surmounted by cylindrical sections. The lower shafts are decorated with brick-framed panels of carved terracotta. 46

The Ghazni minarets would have inspired the wonderful minaret of Jam, which was erected by the Ghurids at Firuzkuh in central Afghanistan in 590/1194, two years after the defeat of Prithvi Raj. The tall cylindrical shaft is interrupted by the bracket supports of two lost balconies, and is surmounted by a small aedicule. Much of the decoration is formed by a band of geometric interlace which contains the whole of Qur'an *surah* XIX, *Maryam* (Mary); there is also a shorter inscription in blue-glazed terracotta. In the higher reaches some of the ornament in the form of hanging buds and swags is clearly derived from the stonework of Indian temples.

The remains of secular architecture are few. Between Bukhara and Samarqand, the eleventh-century Ribat-i Malik displays a single massive wall, ribbed with half-round buttresses. From the twelfth century, the Ribat-i Sharaf, between Nishapur and Marv, has two courtyards entered by imposing *pishtaqs*, and fine stucco-work. It may have been a caravansaray in origin, but it appears that it was refurbished in 1154–5 by Sultan Sanjar and inhabited by him and his Qara Khanid queen in a state of palace-arrest.

Architecture in Anatolia

Penetration into Anatolia brought the Seljuks to a region where the grander buildings were of stone, and this became their usual material, though brick was used for some vaults and wood for some columns. The buildings of the Seljuks of Rum combine a bold eclecticism with dignity of form and fineness of detail. These traits had already been apparent in the Great Mosque (Ulu Cami) of Diyarbakır. This was begun by Malik Shah, whose name appears in handsome inscriptions dated 484/1091–2. The Great Seljuk sultan had recently renovated the Umayyad mosque at Damascus, and the mosque of Diyarbakır was based upon it. A quarter-century later the two-storeyed arcade of the western courtyard façade was built under Malik Shah's son, with a piquant mixture of re-used classical elements and translations into stone of Islamic brick or stucco ornament.

Eclecticism is also evident in the citadel mosque at Konya, which was built in the mid-eleventh century but restored in 616/1219 by Kay Qubad I, by whose honorific title (*laqab*), ʿAla al-Din, it is known. Seen from the exterior, it has a fine stone wall, a (blocked) doorway with a design in white marble and grey stone in a Syrian manner, and a conical dome suggesting either a Persian tomb or the crossing of an Armenian church; the mosque within consists of two halls with re-used Byzantine columns. The finest section, however, shows the Seljuks' own treatment of the dome before the *mihrab*: the transition is made not by squinches but by clusters of triangular pendentives, and the whole was once decorated in tilework in black and turquoise.

Already by the beginning of the thirteenth century a more regular Seljuk style had begun to evolve. For many Anatolian buildings two related factors were of prime importance, the severity of the winter climate and the local building tradition which had evolved to meet it. Walls are built thick and courtyards become small, in some cases reduced to the size of a single bay with an oculus above: it is as though the building wraps itself around the visitor. As a result, interiors tend to be rather dark, and this may have contributed to the fact that the most ornamental feature of many buildings is the outer portal. The stone portals of Anatolia are akin to the *pishtaqs* of Iran, but they have their own characteristic design. In its usual form, the doorway arch is a shallow segment of a circle; this is capped by a hood of *muqarnas*, around which is inscribed a pointed arch, and the whole is enclosed in multiple frames of stonework.

In addition to mosques and tomb towers (*türbes*), the Seljuks built fine hospitals, caravansarays and *madrasahs* (in Turkish *medreses*). The hospital built by Kay Kaʾus in Sivas in 614/1217–18 has three *ivans* round a central court. The great *ivan* opposite the entrance has the broad pointed arch favoured by the Seljuks, and the founder's tomb, in brick, is behind a lesser *ivan* on the south – *qiblah* – side. The Seljuks were not the only patrons of architecture in Anatolia, and in 626/1228–9 a mosque and hospital were built at Divriği by the Mengücek ruler Ahmad Shah and his wife Turan Malik. The mosque has a range of eccentric vaulting, and the hospital has three *ivans* round a central pool under an oculus. The portals of both buildings have extravagantly carved stone ornament which seems to owe something to both Persian stucco and Armenian manuscript illumination.

47 A corner of the Karatay
Medrese, Konya,
649/1251–2. Light comes
from the central oculus.
Triangular pendentives
supporting the dome are
covered with seal kufic in
the name of Muhammad
and the Patriarchal Caliphs.
The qur'anic inscription
which borders the great
ivan is *surah* III, *Al 'Imran*
(The Family of 'Imran),
which denounces the errors
of the Christians.

48 OPPOSITE The Gök
Medrese, Sivas, 670/1271.
A symbol of Seljuk pride
during the period of
Mongol overlordship, the
medrese was built by a great
patron of architecture, the
vizier Fakhr al-Din 'Ali. Its
marble portal is carved
with features which refer to
buildings of the period of
Seljuk rule. The use of
tiles, both on the façade,
where there were once
roundels below the
minarets, and in the
interior, has caused the
medrese to be called *gök*,
sky-blue.

49 Stucco figure, Iran, 12th century. Little is known about a small number of stucco statues which may, as here, range up to life-size, but it seems probable that they represented attendants in audience halls. While the face is of a standard type, the costume of this martial figure is rich and it may be that a particular officer was intended. The long tresses of hair characteristic of Seljuk style are here looped up. The figure would originally have been painted. New York, Metropolitan Museum of Art.

Caravansarays (*hans*) lined the trade routes at intervals of some fifteen to twenty miles. Travellers could sometimes take advantage of baths, libraries and the services of veterinary practitioners and craftsmen. The two most magnificent *hans* were built by Kay Qubad in 1229 and 1236; known as the Sultan Hans, they are near Aksaray and Kayseri respectively. Both have a square courtyard surrounded by stabling, and beyond it a slightly narrower accommodation block. The vaulted interiors of these halls are so stately that they are often compared to cathedrals. Both courtyard and hall are entered by carved portals, and the courtyards contain small prayer halls (*masjids*), raised to preserve them from the animal traffic below.

An important new form of *medrese* was developed in Konya in the mid-century. Pioneered in the Karatay (Qaratay) Medrese of 649/1251–2 and perfected in the Ince Minareli Medrese of about 1260, the scheme partly resembled that of the Divriği hospital in having a large *ivan* facing a central pool which is under an oculus, but there are chambers at the sides instead of lateral *ivans*. The plan is said to be a т-form, *ivan* and domed pool being the upright and the entrance block the cross-piece. The inward concentration of the form of these *medreses* and the fact that the heavens would have been mirrored in their pools evoke the mystical and scholarly concerns of the brotherhoods who would have used them. *Medreses* were also built in a more conventional shape surrounding courtyards. In the year 670/1271–2 no less than three splendid *medreses* of this type were built in Sivas.

Glazed tilework – usually turquoise – had been used in the more easterly countries to emphasise exterior inscriptions, and appeared as ornament upon some twelfth-century tombs, but it was in Anatolia that cut tilework was brought to full development for interior decoration. The *mihrab* area of the ᶜAla al-Din Mosque shows the stage reached by the 1220s. In the zone of transition geometric shapes are fitted together, and in the frames of the now vanished *mihrab* black inscriptions are set against turquoise scrolls in a bed of white plaster. To achieve this, tiles of the required colours would have been cut into shape, laid face-down on a cartoon, plastered, and raised as a slab. Evidently pieces for script and arabesque were much more difficult to cut than geometric shapes, but in the course of the century the craftsmen developed their skill to the point where curvilinear pieces could be closely interlocked, as in a jigsaw, with no white plaster showing, though in some examples it is clear that small details have been refined by scraping away the glaze. This technique is known as tile mosaic. Plain tilework and tile mosaic were used in a number of interiors, and a succession of beautiful *mihrabs* in tile mosaic reaches its apogee in the Mosque of the Eşrefoğlu of 696–9/1296–1300 at Beyşehir.

A few fine wooden mosque fittings survive, the most important being the *minbar* of 550/1155 from the ᶜAla al-Din Mosque. There are also cenotaphs to be placed over graves, and *rahlahs*, folding stands for the Qur'an, which are carved with qur'anic verses and arabesques.

Palace decoration in painting and sculpture

The structures of palaces have suffered badly, but enough survives to show that royal traditions continued. Excavations at Lashkari Bazar near Bust in

Afghanistan revealed a four-*ivan* palace, which may be datable to the time of Mahmud of Ghazni or his architect son, Mas‘ud (1030–41). The upper walls of the throne-room were decorated with terracotta arabesques, geometrics and inscriptions, and the lower part was painted with a row of figures which may represent the 4,000-strong bodyguard of Mahmud. They wear rich kaftans with *tiraz* bands and belts with hanging straps. The heads have been removed, but a surviving fragment shows a round face with long and narrow eyes. Figures of similar character, but sculpted in stucco in the round, survive from unknown sources; these also have the round Turkish 'moonface', which was the ideal of the day for both men and women. The conventions for rendering this face had developed beyond the eastern boundaries of Islam, and were associated with representations of the Buddha. Hence, poets would sometimes describe a beauty as a 'Buddha', without further explanation.

In Anatolia the sculptural tradition was partly translated into low-relief stonework, striking examples being the angels who guarded a gateway at Konya. Stucco decoration was also used in the palace of Qubadabad at Beyşehir, completed for Kay Qubad in 634/1236–7; it showed animals of great vitality against arabesque scrolls of a juicy quality with many small rounded buds upon them. The special glory of the Anatolian palaces, however, was the tilework of their dados. The tiles were painted under the glaze in deep blue, turquoise and black. They were usually in schemes in which cross-shaped units with arabesque ornament alternated with eight-pointed tiles with motifs of prince, sphinx, bird, bear, horse, harpy or double-headed eagle. They would surely have been a source of great entertainment for the inmates of the palaces.

Arts of the book

Though Qur'ans on vellum are found up to the tenth century, paper was in use early in Iran, possibly following the capture of a number of Chinese craftsmen in 751. The greater clarity offered by paper as a vehicle may well have had a bearing on the very refined Eastern kufic which is found in Qur'ans of the tenth to thirteenth centuries, and which extended from thence to architectural and ceramic uses. Eastern kufic is slim and aristocratic; it combines base-line letters which slant forward with tall ascenders which are usually vertical, thus causing a dramatic tension. A few ascenders such as *kaf* (k) are drawn back at 45 degrees, and the unit *lam-alif* (the ascenders of l-a) forms a graceful mandorla: the effect is as though an archer's bow were drawn and discharged. Eastern kufic may be used with diacritics in gold and orthographic signs in red and blue. By the end of the period it was confined to headings, where it continued to be used until the fifteenth century.

The cursive scripts continued to develop: six were particularly regarded, *naskhi*, *thuluth*, *muhaqqaq*, *rayhani*, *riqa‘*, and *tauqi‘*, the first three of which are the more important. All six were practised by the great calligrapher of the Buyid period ‘Ali b. Hilal, known as Ibn al-Bawwab (the son of the door-keeper), who began as a house-decorator but learned his calligraphy from pupils of Ibn Muqlah. *Naskhi*, which had been elevated from a general-purpose business script by the proportional approach of Ibn Muqlah, was further refined in the hand of Ibn al-Bawwab into a strong and supple

50 OVERLEAF Qur'an copied in Baghdad in 391/1000–1 by Ibn al-Bawwab. The headings are in *thuluth* and text in *naskhi*. The *‘unvan* to the opening chapter of the book, *Fatihah al-kitab*, announces seven verses, and a roundel in the right margin, referring to a drop shape in the text, indicates the beginning of the fifth verse. The second *‘unvan* is that of *al-Baqarah* (The Cow) – a reference to the Biblical golden calf – which denounces the errors of the Jews. Dublin, Chester Beatty Library and Oriental Art Gallery.

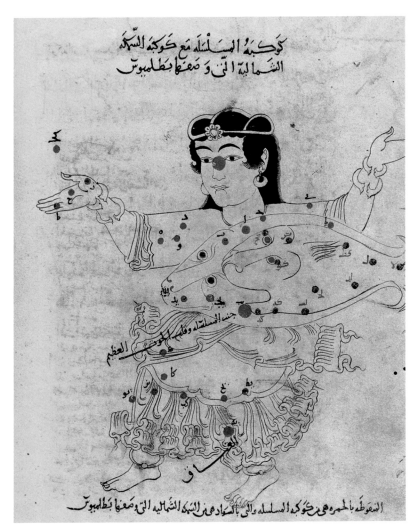

كوكبة السلسلة مع كوكبة السمكة الشمالية التي وصفها بطلميوس

السقوط وهي الحمرة هي مركوكبة السلسلة والتي بالصعاد هي السمكة الشمالية التي وصفها بطلميوس

51 LEFT Andromeda, from a *Book of Fixed Stars*, probably from Fars, copied in 400/1009–10 but the illustration probably mid-11th century. Andromeda, 'the Chained Woman' (*al-musalsalah*) wears the cap of a Chinese intellectual, and her bracelets and recessed fingernails are also oriental. Oxford, Bodleian Library.

52 BELOW 'Gulshah held captive by Ibn Rabi^c', from *Varqah u Gulshah*, probably copied in Konya about 1225. The heroine lies bound, while her captor (labelled *ghalib*, victor) prepares to violate her. Varqah, here hiding on the left, bursts into the tent and rescues her, thus requiting her for an earlier rescue. On the right is a guard, possibly first drawn as a waiting 'duty' horse. Cats in the tent fabric are interpreted as symbolising the cruelty of Ibn Rabi^c. Istanbul, Topkapı Sarayı Library.

medium of great clarity, worthy to copy the Qur'an. For its speed and convenience *naskhi* also continued to be used as the normal script of a growing educated class, and it would be found in the books of instruction or entertainment which they purchased. *Thuluth* was an ornamental script used for headings or tile inscriptions which required a striking effect over a limited length. It is curvaceous, sometimes employs unusual ligatures, and its rhythmic effects act upwards and downwards as well as forwards. *Muhaqqaq* is a qur'anic script. Its descenders are drawn up under the line, giving a forward momentum which is precisely balanced by the stability of its tall ascenders. It was later to be particularly associated with Qur'ans of the Mamluk period.

Illumination at this period becomes more delicate and complex. There is more use of arabesque scrolls and less of geometry, more use of blue and less of gold. In the early centuries writing and its headings (*unvans*) had appeared on the page as though suspended in a void, but from the eleventh century more precise conventions evolved which tended to treat the page as an entity. This is particularly true of the frontispiece (*sarlauh*), a rectangular composition which may reflect the writing-board upon which the scribe worked. The *unvan* may be placed in a cartouche, which may again be boxed in, and the text area may be delimited by rulings. Something of the earlier floating effect may be maintained by placing a cloud outline round the individual lines of text, but the interstices are filled with delicate scrolls, dots or hatching. Persian bindings survive from the twelfth century on. They are of finely pared leather over a cardboard of paper layers stuck together. The back cover is supplied with a flap with leather hinges which folds over the fore-edge of the pages and ends in a 'tongue', much like the cover of an envelope. Some bindings are finely worked with stamps, either in diaper patterns or with a central medallion and a border round the edge.

The origins of book illustration in the Islamic world are far from clear. It seems that there were some links to a Sasanian tradition, for the historian Mas'udi speaks of seeing a book in 915, at Istakhr in Western Iran, which contained the portraits of the Sasanian kings. Further, it is said that the Samanid Nasr b. Ahmad commissioned a copy of *Kalilah wa Dimnah*, a translated version of ancient Indian animal fables, and that he had it illustrated by Chinese artists. This story interestingly suggests that a desire for pictures existed which could not be satisfied by local talent; though whether the painters were indeed from China or from a nearer centre is open to question. Another account says that in 1092 the treasury library of Ghazni possessed the *Arzhang*, a book of pictures by Mani, the third-century founder of Manichaeism. This is of course unlikely, but Mani and his book were literary topoi and his name might well have become attached to a collection of Uighur pictures of the ninth century. On the whole it seems probable that the possession of paintings was seen as an adjunct of kingship, but that practitioners were rare. What little may have been produced would have been subject to the normal hazards suffered by books, and in addition would have been vulnerable down the ages to destruction at the hands of persons hostile to painting.

An illustrated manuscript which may have survived the latter threat on account of its scientific purpose is a *Book of Fixed Stars*, a work composed by 'Abd al-Rahman b. 'Umar al-Sufi, and copied by his son in 400/1009–10.

This draws on Ptolemy's *Almagest* to describe the constellations, and it illustrates them both as they would appear in the sky and, in mirror image of that, on a celestial globe. The illustrations, which were probably completed at the time of an early repair, are of striking beauty. Faces are not dissimilar to those on some Fatimid lustre, with firm chins, black curls on the cheek and, for the men, high-set turbans; the eyes, however, are narrower. The clothing of female figures suggests Buddhist prototypes, but its small bracketing folds are also known from Sasanian sculpture: styles such as these would have mingled in Central Asia and drifted west along the Silk Routes.

One illustrated verse romance remains from the thirteenth century, *Varqah u Gulshah* by the poet ʿAyyuqi, in the Library of Topkapı Sarayı, Istanbul; set in pre-Islamic Arabia, it tells of the adventures and trials of two lovers. The manuscript is copied in two columns of relaxed *naskhi*. There is no colophon to record the date and place of copying, but the painter has signed one picture as ʿAbd al-Muʾmin b. Muhammad al-Khoyi. Since the painter's appellation (*nisbah*) shows that he or his family was from Khoy in Azerbaijan, it might be that the manuscript originated there or in the Jazirah. However, since this name has been found in a document connected with the Karatay Medrese of Konya, an origin in Konya is more probable. The manuscript contains seventy-one illustrations in a horizontal format. The fluent drawing shows that a developed illustrative style existed at the time, but various awkward-nesses and inventive touches suggest that al-Khoyi was not working from a known programme. The figures are compact but graceful, and tend to lean forward eagerly. As in the palace sculpture, the face is round with slit eyes and a small mouth, and the hair of both men and women hangs in long black tresses. The heads are backed by a halo, a feature which is also seen in contemporary pottery; this is a borrowing from Buddhist painting, perhaps reinforced from Christian sources, and has no religious significance. A wide-skirted gown is worn, seemingly of a silky material, and below it are loose trousers or boots. Men wear crowns, turbans, or a cap resembling a fur-edged mitre. Scenes are suggested by a few properties in the form of tents and trees, but a ground of scrolls suggesting models in architectural decoration is also found.

Pottery

The period of eastern renewal was a great age of pottery. Between the tenth and twelfth centuries important centres were Samarqand and, even more so, Nishapur. Here the reddish local clay was masked with a white slip, which formed an excellent ground for ornamentation. On some large dishes the white slip was incised in a design of palmettes and then splashed with coloured glazes, creating an interesting tension between precise and semi-random pattern. A second ware makes a clear reference to the Sasanian past with pictures of horsemen and kings; quaintly drawn and with busy back-grounds, these are painted in slip in black, yellow, green and red. Most classically beautiful are dishes, often of a handsome size, decorated solely with inscriptions in Eastern kufic in black slip. The writing usually circles the inside wall of the dish, though it sometimes passes horizontally through a diameter: there is an evident relation to writing on paper. Space-filling *horror*

53 Earthenware bowl with incised slip and splashed glaze, probably from Nishapur, 10th century. The curved lines appear to have been drawn with compasses; the central motif is a split palmette. The contrasting splashed glaze decoration is particularly well controlled. London, British Museum.

54 OPPOSITE Fritware ewer with underglaze painting, Iran, early 13th century. The ewer has a double shell whose outer portion is pierced; this may have kept the contents cool, but was probably chiefly for aesthetic effect. The drawing is in black under a turquoise glaze, and there is some staining with cobalt. A few areas of the glaze have decayed. Kuwait, National Museum.

vacui, which is sometimes said to characterise Islamic design, is conspicuously absent. The inscriptions usually convey blessings upon unspecified owners. In later pieces touches of red, palmettes, and representations of ewers are included.

In other centres the incised technique (*sgraffiato* or *sgraffito*) was used under a clear glaze to imitate metalwork. In the Garrus area, more of the slip was carved away, in a champlevé manner, so that glaze pooled in the hollows. In a third type, associated with Aghkand near Tabriz, *sgraffiato* lines are used to separate different areas of coloured glaze. A substyle of slip painting, associated with Sari, south of the Caspian, has jaunty birds matched with flowers resembling lollipops.

A revolution in pottery is usually associated with the coming of the Seljuks, though its origins may pre-date their period and its finest development post-dates their rule in Iran: it is the use of fritware, a new body material which permitted a closer approach to the whiteness and fineness of Chinese *qingbai* porcelain. The new material may well have been developed at Kashan in Western Iran, and indeed an account of it is found in a treatise on pottery of 700/1301 by Abu'l Qasim of Kashan, scion of a family of potters. The body was composed of ten parts quartz, one part white clay and one part frit. The frit, itself a composite material, was made of quartz with a flux of soda; these were fused and the molten mass cooled sharply in water so that it shattered and could then be ground. The body of fritwares is whitish. It is hard, but not very malleable; thus it was often formed in moulds, but it could be made into thin-walled vessels if carefully pared with a blade. Since the frit glaze was

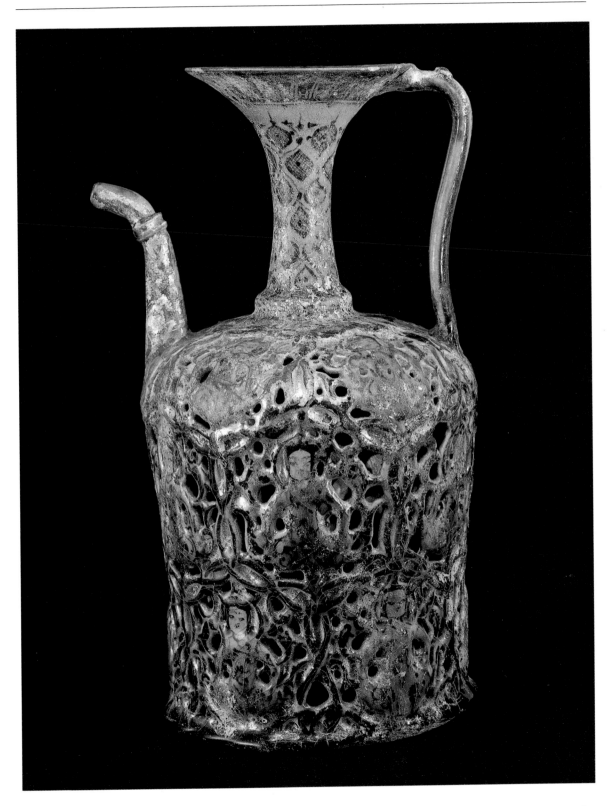

55 Earthenware bowl with slip-painted inscription, Samarqand or Nishapur, 11th century. The vitality of the Eastern kufic is more important than the content of the inscription, which reads 'He who speaks, his speech is silver, but silence is a ruby. With good health and prosperity.' The writing has been judged so that the ascenders point inwards at rhythmical intervals. The drawing of the letters was refined with a sharp instrument, and a central swirled dot gives a focus to the whole. London, British Museum.

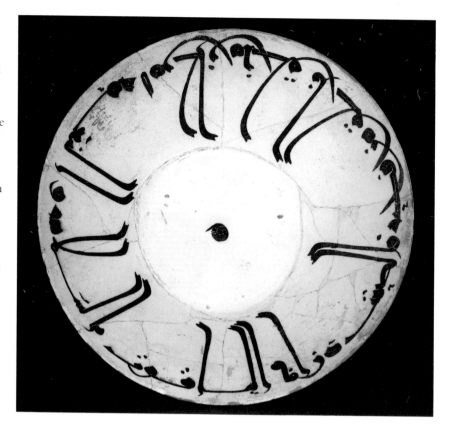

closely related to the body it adhered well, and, as its flux was alkaline, it gave rise to a new and cooler colour range, dominated by deep blue from cobalt and turquoise from copper.

The earliest wares appear to have been monochrome, with white perhaps the earliest amongst these. Small dishes, bowls, cups and jugs were made. Sometimes the use of wavy bracket rims, gadroons in the *cavetto*, or floral scrolls carved with a subtle slanting cut indicate a Chinese influence. In other pieces the effect of lightness is emphasised by pierced holes which fill with clear glaze; and beakers, clearly related to crystal or glass, have walls carved to translucency. The white body may also be set off by touches of cobalt blue. More numerous are the coloured monochrome wares in blue, turquoise, or the aubergine of manganese. Besides dishes and cups, there are aquamaniles in lion form, large jars, and even small tables.

A development which appears to link the slip painting of north-eastern Iran with the fritware body of the west is silhouette ware. Black slip is applied to the white ground and carved away to produce very sharply defined motifs which are then covered with a clear glaze, or – especially when a large coverage of slip is maintained – a glaze of transparent turquoise. The decoration sometimes includes script. It is thought that ever thinner applications of slip may have led by the later twelfth century to underglaze painting. In cobalt and black under clear glaze, or black under turquoise, this rejoices in a new delicacy and flexibility of line. In the early thirteenth century rippling motifs of willow or water-weed were much favoured. Remarkable ewers were made in this ware, their body enclosed in an outer shell of openwork.

54

Mina'i (enamel), known to Abu'l Qasim as *haft rang* ('seven' colour), was a luxurious ware of the late twelfth century. Its decoration required at least two firings, with painting both under and over the glaze, so that pigments maturing at two different temperatures could be suited. The glaze is colourless or light blue. The designs are often figurative, and some are close in style to the paintings in *Varqah u Gulshah*. The placing of figures may conform to the shape of the vessel, with, for example, horsemen trotting round a dish in a circle, or it may seem to adhere to an original page format and try to treat the dish as though it were flat. Two important pieces are in the Freer Gallery of Art, Washington: a beaker which gives, in strip form, the story of the lovers Bizhan and Manizheh from the *Shahnameh*; and a large commemorative dish which shows named warriors attacking a castle.

The later twelfth century also saw a new period of lustre decoration. It is probable that this resulted from the immigration of families of potters, or pot-decorators, skilled in this speciality, after the fall of the Fatimids in 1171. In Iran the industry was based upon Kashan; but Syria and Anatolia also had centres. The first dated piece is a vase of 575/1179 in the British Museum. Darkish brown lustre was applied to a great multiplicity of objects, including dishes, bowls, vases, cups, ewers, aquamaniles, jars, penstands and figurative statuettes. In early pieces bold scrolls and animals in heraldic stances recall Fatimid work. There also appears to be a connection with textile design, for this would help to explain an otherwise curious example in the Ashmolean Museum, Oxford, in which human figures in roundels decorate the body of a hawk. In time, the decoration becomes more complex and

56 Fritware bowl with lustre decoration, Kashan, 600/1203–4. A man (left) sits with five women. Though the subject is similar to that on Fig. 57, the rendering is very different since here the ceramic decorative tradition has asserted itself: the figures bend to fit the curvature, and their richly patterned garments tend to merge into a single ornamented surface. Oxford, Ashmolean Museum.

57 Fritware bowl with *mina'i* decoration, signed Abu Zayd. Kashan, 583/1187–8. The design radiates harmony. A young lord sits by a garden pool with his consort and with attendants, or perhaps children. The figures are ideal rather than individual, nevertheless the scene may intend a family group. The adjustment to the circular form is achieved by the shape of the pool and the canopy which echoes it. London, British Museum.

details finer. Scrolls take on an intricate shimmering quality. Bands of verse in a rapid cursive script encircle the object. Human figures adopt curvilinear postures which fit them to the vessels, and seem about to merge into their backgrounds, but for their moonfaces and haloes. By the thirteenth century figures often sit in a trance-like stillness. Some groupings appear to be pleasure parties, but others seem full of a meaning which now escapes us. These subjects, together with the dissolution of much of the distinction between figures and their surroundings, and even the varying effects of light upon the lustre, would have appealed to the mystical taste of the period.

Metalwork

The tenth century sees the beginning of the great age of Islamic metalwork, when utensils were made to transcend their ostensible functional roles by their fine forms and fascinating decoration in order to dignify and please their possessors. Early evidence of this development comes under the Buyids, when in the 960s some gold and silver coinage forsakes the strictly Islamic epigraphic format and revives some of the Sasanian iconography of royal power, with stamps of the portrait bust of the crowned ruler, or the lion or eagle which seizes upon its prey. Images of these animals of royal connotation, or others such as stag or ibex, are also found in repoussé on vessels of gold, silver or silver gilt. These may take the form of small jugs with rounded body and flaring neck, or bottles with spherical body and long cylindrical

neck – the former probably for wine and the latter for sprinkling perfume – which are thought to be datable prior to 1100. The relatively large scale of the decoration of these items refers to the Sasanian past, but the contemporary Islamic world contributes inscriptions in kufic, in which the dark and light contrast of ink on paper may be imitated by inlaying the letters with niello, a black metallic compound. Niello was not, of course, confined to epigraphic work, and it is also found as another colour element with gold and silver on jewellery or belt fittings.

At a less luxurious level, base metal alloys were used for such objects as bowls, bottles of bell shape, ewers of pear shape, mirrors, cylindrical mortars with knobs on their sides to facilitate the user's grip, candlesticks whose single candle-holder rises above a broad conical base, cylindrical ink-wells with domed lids, and incense-burners, either in the shape of birds or felines or the cylindrical type on trios of quaintly booted feet. These would usually be

58 Brass ewer with silver inlay, Khurasan (Herat), about 1200. The ewer is fitted with a strainer in its spout. Below the frieze of raptors on the shoulder, and again at the base, inscription bands have ascenders terminating in faces. Across the fluted body from right to left are zodiac cartouches: Mars on Aries; the musician equivalent to Venus on Taurus; Gemini with a scroll, since the equivalent to Mercury is a scribe; and Cancer with the Moon. London, British Museum.

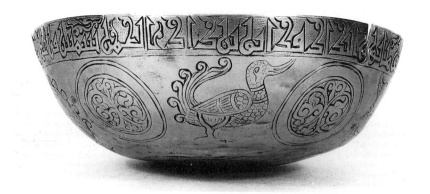

59 Gold cup made in Iran, early 11th century (reportedly found at Nihavand). The kufic inscription, from a poem by Ibn Tammar al-Wasiti, compares wine to a sun in a garment of red Chinese silk. London, British Museum.

cast, but sometimes hammered or spun, and would carry varying amounts of decoration – this in the case of the mortars suggesting that they were impressive pieces for the apothecary, rather than for kitchen use.

In the twelfth century, there seems to have occurred both a shortage of silver and an upsurge in demand for fine objects from merchant patrons as well as from princes. The apparent result was that silver ceased to be employed for the bodies of vessels and was instead used as an inlay on objects which were at first of brownish alloys, but from the thirteenth century often of distinctively yellow brass. Inlay had occasionally been used in the earlier period, but chiefly in the form of linear scrolls of silver wire; now it was used in larger patches which were hammered home into recesses made to accommodate them and often further ornamented by chasing with fine instruments. The inlayer's palette also included red copper, gold and, in place of niello, black compounds, which might include both organic and inorganic substances. Since fine pieces were now made of base metal there was no virtue in leaving expanses plain, and decoration became smaller in scale and more all-pervasive. Vessels were divided into zones according to their shape, with arabesque scrolls, script – now usually *naskhi* or *thuluth* – and figures, together with rows of small border elements such as drop or leaf shapes. The division of different categories of ornament was, however, less clear-cut than it appears at first sight: the inscription bands, which might seem inalienably aniconic, are sometimes represented as having faces at the end of their ascenders, and in a few pieces rows of lively human figures can be read as animated script. The scrolls also were not simply inhabited, in the sense used of classical ornament, but might develop animal heads on their terminations, a form which has come to be known as *waqwaq* after the *Shahnameh*'s account of a talking tree encountered by Iskandar (Alexander the Great). More often, however, human figures were to be read as belonging to one of two significant categories, astrological symbols or scenes of royal pleasures. In the former group the planets Sun, Moon, Mercury, Venus, Mars, Jupiter and Saturn, known by Arabic names and with attributes which do not entirely match those of classical mythology, were seen as domiciled in the twelve signs of the zodiac, the latter five having two houses each. The royal cycle shows enthroned rulers, mounted huntsmen, musicians and the like, in scenes whose composition is realistic rather than emblematic. Real and imaginary beasts – salukis, hawks, sphinxes, harpies – also appear, often in interstices or bands.

The function of pieces is usually evident from their form, and sometimes from inscriptions, but some raise interesting questions of use. The 'Vaso Vescovali' in the British Museum and the 'Wade' cup in the Museum of Art, Cleveland, both probably of the early thirteenth century, have rounded bowls set upon foot-rings. They resemble goodly sized chalices and were presumably intended for wine, but it would have been a prodigious quantity. The earliest dated piece of twelfth-century inlaid work is a penbox of 542/1148 in the Hermitage. Oblong in shape with squared ends, this would have lain on a scribe's table, as would similar boxes with rounded ends. A few examples, however, are flattened into a thin wedge shape, and these may have been intended to tuck into the belt of a scribe attending upon a prince. The most informative piece, however, gives an insight into a wealthy merchant milieu. The 'Bobrinsky' bucket, also in the Hermitage, of rounded shape with a handle held by lugs, is ornamented with bands of script and figures riding, making music, fighting with staves, and playing backgammon. It was made in 559/1163. Cast by one craftsman and with inlay by another, 'the decorator of Herat', it was ordered by one named individual for presentation to another, 'the pride of merchants', apparently in connection with the pilgrimage to Mecca. This type of bucket was used for visits to the *hammam*, and doubts have been expressed as to its practicality in a damp atmosphere, but its use as a container was only a part of its function: it was also intended to impress the observer, but perhaps most of all to entertain the mind of the owner. The more images which could be packed into an object, the more sustenance it could provide for the imagination.

The 'Bobrinsky' bucket points to Herat as a centre of metalwork, and Herat was probably also the centre of production of a number of candlesticks and ewers which were raised from sheet brass by hammering. These are characterised by bossed or ribbed bodies respectively and by lions or birds in repoussé at the shoulder.

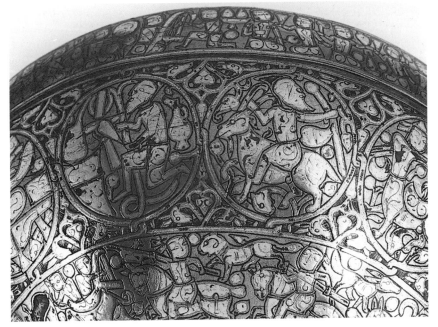

60 Detail from the cover of a goblet (the 'Vaso Vescovali') in high-tin bronze with silver inlay and chasing. Khurasan, about 1200. In the central roundels from right to left, Sagittarius is seen as a centaur, bearded Saturn rides the Capricorn goat and is shown again as Aquarius drawing water from a well; on the extreme left is the throne where Jupiter sits holding Pisces. In the lower sector is a hunt with a camel-borne harpist. London, British Museum.

62

61 Turkish carpet, probably 13th century. The field is dark blue with red stars in an interlace of light blue which is suggestive of knotted kufic script; the borders, in two reds with light blue, brown and yellow, recall designs in wood and stonework. Istanbul, Museum of Turkish and Islamic Arts.

62 OPPOSITE Silk fabric from Turkey, period of Kay Qubad I (1219–37). The silk is a compound twill with a warp of tan silk and weft of rose with gold-wrapped thread; it has been much cut about and an inscription with the sultan's name is presented upside-down. The lions are grand without stiffness, their tails terminating in dragon-heads and split palmettes. Lyon, Musée Historique des Tissus.

Textiles and carpets

Among the fragmentary silk textiles which seem to be attributable to the eleventh to thirteenth centuries, some are said to have been retrieved from a burial site near Rayy. It is, unfortunately, a matter of controversy how much of this material is authentic. With this *caveat*, the picture they present is one of highly sophisticated fabrics in compound twill or lampas. Some pieces are specifically designed in a long format as palls to drape a coffin or cenotaph, and have qur'anic inscriptions and prayers. Other pieces continue the design schemes of roundels, or geometric shapes filled with confronted or addorsed beasts and twirling arabesques, and were presumably intended for wear, before reaching a secondary funerary use. Silks attributable to the Seljuks of Rum are more rare, but they have the advantage of issuing from cathedral treasuries. A silk in the name of Kay Qubad I with paired lions is somewhat simpler in design than some of the Persian pieces, but very assured; a fragment with a double-headed eagle in similar style, once in St Servatius in Siegburg, is now in the Kunstgewerbemuseum, Berlin.

Early carpets, some almost complete, some fragmentary, have been gathered from the ᶜAla al-Din Mosque in Konya and the Eşrefoğlu Mosque in Beyşehir; they may be of the thirteenth, or possibly fourteenth, century. The knot used is the 'Turkish' type, in which the end of wool is wrapped symmetrically round two warps. The fields are usually filled with repeating geometric motifs, sometimes with considerable space between them, and borders may take the form of a bold pseudo-kufic. Colours favoured are blue, red and white, with some brown and yellow.

61

4

THE RULE OF LORDS AND SLAVES
Zangids, Ayyubids and Mamluks

The first Crusade captured Jerusalem in 492/1099. The Crusaders' purpose was to deliver the city from the Turks, who were less amenable to the pilgrim traffic than had been the Fatimids; however, in the event, Jerusalem was taken from the Fatimids, who had recently repossessed it. Many inhabitants were massacred. The Kingdom of Jerusalem was established, to join three other Crusader states, Edessa, Antioch and Tripoli. The Crusaders enriched themselves, learned to appreciate many of the comforts of Eastern life, and relayed them back to Europe. As they began to play a political role they did not invariably find themselves ranged with Christians and against Muslims. With deep suspicion between the western Europeans (the Franks) and their Byzantine allies, and between the Shiʿi Fatimids and Sunni Turks, there was room for a variety of alliances. From the mid-thirteenth century the advancing Mongols had also to be taken into account.

As the power of the Seljuks waned in Syria and Iraq in the late twelfth century, the caliphate enjoyed a period of revival, especially under al-Nasir (1180–1225). However, from the early twelfth century it was not the caliphs who faced the Crusaders, but various local governors who had achieved virtual independence. A Turkman dynasty, the Artuqids (1101–1312), held bases at Diyarbakır, Hisn Kayfa and Mardin. A wider political role was played by the Zangids, who flourished in the Jazirah (the 'island', Northern Mesopotamia) from 1127; they were also of more official standing, since ʿImad al-Din Zangi was an *atabeg*. An *atabeg* (Turkish 'father-lord') served as guardian to a young Seljuk prince who was the nominal ruler. *Atabegs* were selected from the amirs (military officers) who surrounded the young prince's father. The amirs in their turn were drawn from military slaves of high status, known in the Persian sphere as *ghulam* (youth) and in the Arab as *mamluk* (owned). Often Turks from the Qipchaq steppe, north of the Aral sea, the *mamluks* focused their loyalty upon their masters, and would maintain cordial relations when manumitted to become amirs.

ʿImad al-Din Zangi became governor of Mosul in 521/1127 and rapidly acquired Sinjar and Aleppo (Halab). In 1144 he began the destruction of the Crusader kingdoms by the conquest of Edessa, the most exposed. His son,

63 Minaret of the Great Mosque, Aleppo, completed in 487/1094. The minaret stands at the north-west corner of the mosque and unites classical and Islamic ornament. It became an admired model in Syria. The mosque, founded about 715 in imitation of the Great Mosque of Damascus, was rebuilt in 1158 and renovated after 1260.

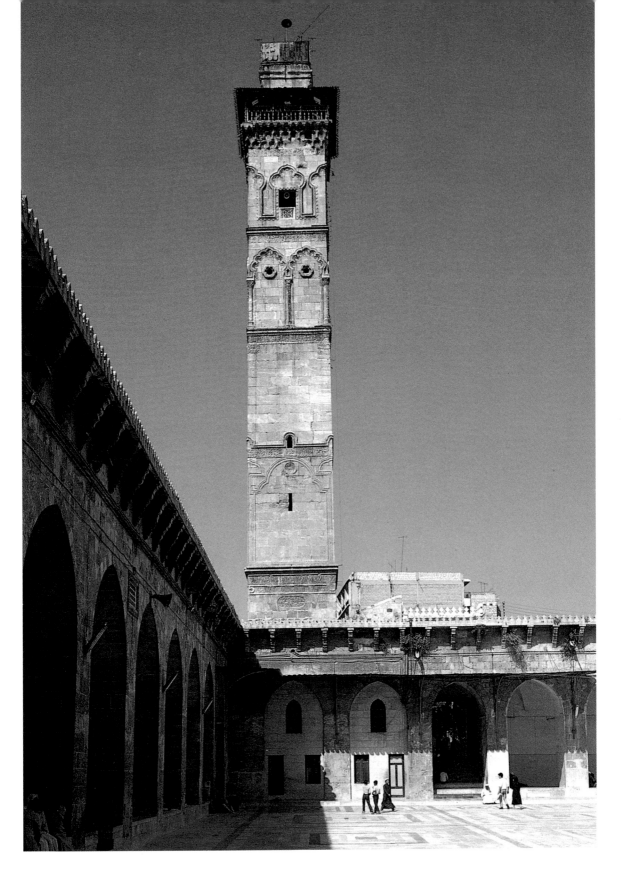

Nur al-Din (1146–73), continued the expansion of the state by conquering Damascus from its *atabeg* ruler in 1154. Nur al-Din was then called to assist Shawar, a Fatimid vizier who had been expelled; he sent to Egypt a force under a Kurdish general, Shirkuh, who was accompanied by his nephew Salah al-Din Yusuf b. Ayyub (Saladin). Shawar sought to offset his dependence on the Zangid force with assistance from the Franks. The Zangid army entered Cairo in 1169, but it was Shirkuh and not Shawar who became vizier to the Fatimid caliph. By 1174, advantage taken of the deaths of Shirkuh and of Nur al-Din Zangi, Salah al-Din ruled Egypt in all but name. As the last Fatimid lay dying, Salah al-Din directed the country back to Sunnism by causing the *khutbah* to be pronounced in the name of the ᶜAbbasid caliph.

Salah al-Din consolidated his position, and then, filled with religious fervour as leader of a Holy War (*jihad*), he reconquered Jerusalem in 583/1187, a blow from which the Crusader kingdoms were never to recover (though the city was briefly in Crusader hands again in the thirteenth century). Salah al-Din died in Damascus in 1193. Zangid branches continued to rule in Mosul, Sinjar and the Jazirah until the mid-thirteenth century, when the latter two lines were replaced by Ayyubids. In Mosul Zangid power passed in 1218 to the vizier Badr al-Din Lulu, who accepted Mongol suzerainty and ruled until 1261; his son succumbed to the Mongols in 1262.

The dominant power of the Near East, however, was now again Egypt. The Ayyubids based themselves in the revitalised country where Crusades were vainly launched against them. The *mamluk* system was practised in Egypt, and, in particular, large numbers were acquired in the 1240s by the Ayyubid al-Salih Najm al-Din. Amongst these was a powerful faction known as Bahri after their garrison on Raudah Island in the Bahr al-Nil (the Nile Sea). The death of al-Salih in 1249 was followed by a turbulent decade of transition: minors reigned, and the late sultan's widow, Shajar al-Durr (Pearl Tree), was herself briefly accounted sultan by the Bahri Mamluks. From the turmoil there emerged an able military leader, Baybars, a Bahri Mamluk, who assumed power after saving the state from Mongol invasion by a victory at ᶜAyn Jalut (Goliath's Spring) in Palestine in 658/1260.

Baybars I held power from 1260 to 1277; he is known as al-Bunduqdari (the bow-keeper), since *mamluks* often retained the *nisbah* which showed in what capacity they had served a prince. He ruled with great vigour, directing campaigns against surviving Ayyubids and the Crusaders and engaging in anti-Mongol diplomacy with European powers. Following the destruction of the caliphate in Baghdad by the Mongols in 1258, Baybars was able in 1261 to establish an ᶜAbbasid as caliph in Egypt, and to win for himself the title of Servant of the Holy Cities of Mecca and Medina.

Shortly after Baybars, whose Turkish personal name means Lion, the succession went to Qala'un, the Cormorant, another former *mamluk* of al-Salih and a very effective ruler. From 1279 to 1290, he confirmed the prosperity and political dominance of Egypt, in particular taking measures to secure the Red Sea route of the important spice trade. He also captured Tripoli from the Franks in 1289, and died while preparing for the siege of Acre, the last Crusader stronghold, which was taken by his son al-Ashraf Khalil in 1291.

The remaining Bahri period was passed under the rule of descendants of Qala'un with occasional interruptions from Qala'un's *mamluks*. The long reign of Qala'un's son al-Nasir Muhammad extended from 1293 to 1341, with two such intermissions in the early years. Al-Nasir was at last able to make a peace with the Mongols in 723/1323. Among Qala'un's grandsons, al-Nasir Hasan ruled from 1347 to 1351 and from 1354 to 1361.

In 784/1382 the Bahri Mamluks were overthrown by another group, named Burji from their residence in the citadel, most of whom were of Circassian origin. The succession of sons is rare in the Burji period. The Burji Mamluks were faced in the late fourteenth century with the threat of invasions by Timur, and in the fifteenth with the rising power of the Ottomans; further, their hold on the spice trade weakened following the Portuguese circumnavigation of Africa. Some revival was achieved under Qa'it Bay (1468–96) and Qansuh al-Ghuri (1501–16), but in general the state stagnated and declined. In 922/1517 the Ottoman Selim I defeated al-Ashraf Tumanbay using the firearms which the traditionally-minded Mamluks disdained.

In the afterglow of Seljuk kingship in the *atabeg* period the old royal imagery continued to be used upon artefacts, and indeed Baybars seems to have favoured a lion symbol. However, during the Mamluk period, when the identity of an amir was vested in the master-to-*mamluk* relation, a new set of signs arises. Sometimes known as blazons, these represent the division of service in which the young *mamluk* received his training before manumission: the round table of the taster, the cup of the cup-bearer, the penbox of the secretary, the napkin of the master of robes, the polo-stick of the master of polo, and the standard, sword, mace and bow of their respective bearers. The blazon, presented upon a shield which is usually round, might be used upon any object made for the amir. From the time of al-Nasir Muhammad an epigraphic equivalent to the blazon came into use for the sultan himself, with his name across its central sector.

Architecture

In Syria in the *atabeg* and Ayyubid periods, architecture flourished in the old stonework tradition. It received and absorbed ideas from the Persianate brick architecture produced for the caliphs in Baghdad, though without yielding much to them, and the principal developments which were transmitted on to the Mamluks were from indigenous themes.

The dawn of the period is marked by the addition of a minaret to the older Great Mosque of Aleppo. Begun in 483/1090 by the *ghulam* Aq Sunqur and completed in 487/1094 under Tutush, the brother of Malik Shah, the minaret is nevertheless entirely Syrian. The square shaft is divided into five registers, and, above a *muqarnas* cornice, its top is surrounded by a veranda. Much of the surface is of fine unembellished ashlar, but a rounded moulding is used to inscribe upon this variations on the theme of the polylobed blind niche. The architect Mufarraj al-Sarmini was of local origin, and the decoration can be seen as an Islamic development of that used on North Syrian churches, such as the fifth-century Qalᶜat Simᶜan.

The polylobed niche – in so far as it is found in Syria – is evidently an

abstraction from the classical shell-headed niche. The forms are seen together in the *mihrab* of the Artuqid mosque of 1204 at Dunaysir, where a rather classical shell-head is surrounded by a polylobed frame. The ribbed dome, which is a three-dimensional derivation from the shell-headed niche, is also found in Syria. However, in the twelfth century it tends to be used, not as the main dome structure, but as the culminating detail in a scheme composed of *muqarnas*.

When Nur al-Din Zangi had captured Damascus in 1154, he built there a *maristan* (hospital). In this building of modest dimensions but considerable charm, four *ivans* are grouped round a courtyard with a pool. The most striking feature is the entrance block of *chahar-taq* format. The central dome of this vestibule is a tall cone whose surfaces, within and without, are expressed as *muqarnas* – a type of *muqarnas* tower which had been used earlier in funerary monuments in Iraq. Nur al-Din's tower is capped with an elaborate ribbed domelet. The portal which admits to the vestibule has a tall but shallow *muqarnas* hood; this relates to the *muqarnas* dome as a negative to a positive form, or as a mould to the thing moulded. An interest in the possibilities offered by *muqarnas* is a feature of the period: another example occurs in a large brick structure in Baghdad which may be a palace of the caliph al-Nasir (1180–1225), where it is used to pack the vaults of a courtyard arcade.

Another Syrian theme of Roman and Byzantine antecedents used to great effect under the Ayyubids is that of alternating courses of limestone and basalt to give a light and dark colour contrast known as *ablaq* (pied). In interiors *ablaq* work was often carried out in veneers of re-used marble of various colours, and in a mosque this would be concentrated upon the *mihrab* and its framing. The looping or fret patterns in such frames recall the geometry of classical pavements in *opus sectile*, or Umayyad work such as the stone knot at Khirbat al-Mafjar.

Ayyubid architecture was practised in lands which had long been under Muslim rule and which were already provided with mosques. The achievement of the Ayyubids is thus seen in other types of religious building, such as the *madrasah* Firdaus, made for the widow of Salah al-Din's son al-Zahir in 633/1235–6 in Aleppo. This serenely symmetrical building has a single *ivan* at the entrance opposite a sanctuary under three domes, and an arcade on columns round three sides of the court. In the secular field, the greatest surviving work of the Ayyubids is the dramatic fortification of the citadel at Aleppo, built by al-Zahir in 606/1209–10 to face the Crusader threat. Crowning an ancient mound, the circumference wall is reinforced with square bastions, and the entrance block contains a masterly example of the bent entrance, with no less than six turns to deter storming.

Like the Ayyubids, the Mamluks directed their efforts in the sphere of religious building particularly to *madrasahs* and to *khanqahs* (dervish convents), but these were often components of complexes which might include mosques, hospitals, fountains and founders' tombs. The impulse of piety to endow such buildings to the glory of God and the benefit of mankind was always strong in Islam. In the case of the Mamluks a further factor operated, since surplus income from endowments could make provision for their sons, who could not inherit from them directly and who were debarred by their

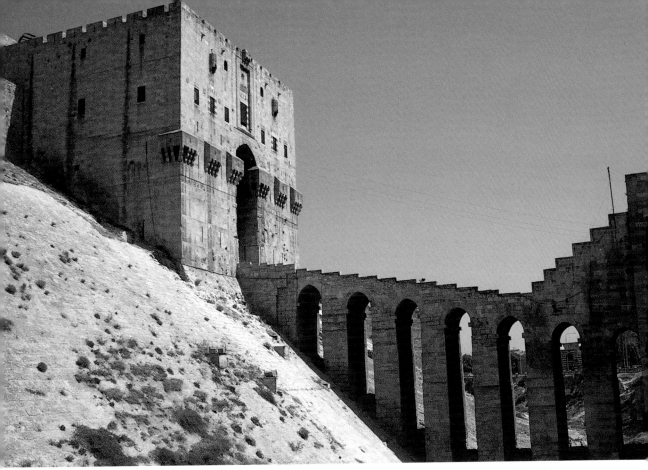

64 ABOVE Entrance to the citadel of Aleppo, largely constructed for the Ayyubid al-Zahir in 606/1209–10, the lower gate being rebuilt for the Mamluk Qansuh al-Ghuri in 1507. The wall is supported throughout its length by square bastions. The citadel is sited on an ancient mound; it contained a palace, a mosque, a well and numerous cisterns.

65 LEFT *Mihrab* of the *madrasah* Firdaus, Aleppo, 633/1235–6. The contrasting shades of marble used in the knot pattern are an extension of the *ablaq* style. Syrian designs of this type were introduced to Konya and became part of the repertoire of the Seljuks of Rum. Above the *minbar*, the zone of transition shows a complex mixture of *muqarnas* squinch and pendentive.

Muslim birth from becoming *mamluks*. Much of a great man's wealth could be made over to a religious establishment by being made *waqf*, a perpetual religious bequest. Related to this aspect of Mamluk foundations is the growing architectural emphasis upon the tomb of the founder, which tends to become the dominant feature, expressed on the exterior by the principal dome.

The complex constructed in Cairo for the Ayyubid al-Salih from 641–8/1243–50 marks a turning point. It was set on the east side of what had been the Bayn al-Qasrayn, the space between the Eastern and Western Fatimid palaces, and much of its detail, such as the use of angular niches, is still Fatimid in character. However, it was designed to fit a new function. A long façade united two *madrasahs*, the more southerly of which has now gone. The *madrasahs* were divided by a narrow corridor which extends back from the middle of the façade; the entrance to the corridor is surmounted by a tall minaret with a stilted ribbed dome. Al-Salih's tomb was added to the north-west of the complex in 1250 by Shajar al-Durr. The *madrasahs* each had two *ivans*, one at either end of rectangular courtyards, and the four teaching areas thus provided were devoted to the four separate schools of interpretation of Islamic law (*madhhabs*), Maliki, Shafi'i, Hanafi and Hanbali. Shortly before, in 1233, the caliph al-Mustansir had built a *madrasah* to contain all four schools in Baghdad.

Opposite al-Salih's complex and west of the Bayn al-Qasrayn, Qala'un built his hospital, *madrasah* and tomb in 1284–5. The hospital has been largely lost, but the other two buildings remain and they reveal an astonishing number of architectural references. The street façade of the complex is crowned with a row of stepped merlons; below these, pointed arches framing pairs of round-headed windows with oculi above them create a distinctly Gothic effect. Behind the façade rises the massive dome of the tomb. Within the complex, the four-*ivan madrasah* is to the south of a corridor. The dominant east *ivan* contains columns and two storeys of round-headed arches, so that it suggests a Syrian church or the Great Mosque at Damascus, an impression confirmed by the area above the *mihrab*, which is decorated in mosaic. To the north side of the corridor lies the tomb, a square chamber which contains a domed octagonal structure, supported upon four piers and four columns of pink granite. This evidently intends a reference to the Dome of the Rock. Below it, the cenotaph is of wood behind a screen in *mashrabiyah* work. In the east wall of the outer tomb chamber, the *mihrab* has a horseshoe arch and contains rows of shell-headed niches, and the walls have dados in *ablaq* marble. The chamber is further adorned with a ceiling of coffered wood and bands of floral stucco ornament, and is lit by stained-glass windows. Qala'un's complex reveals a confident eclecticism which is both a statement of Mamluk dominion in the present and a vision of his rule as a summation of the Islamic past.

The complex built by Sultan Hasan from 1356 to 1363 was sited on rising ground outside the city walls. Its monumental exterior refers to the scheme of fenestration of the Qala'un complex, though with more intervening wall space and sterner effect. The walls are headed by a mighty cornice in six ranks of *muqarnas*, above which stand merlons of trefoil form. The complex is

entered in the lower, north-eastern corner through a portal of overpowering height. Originally intended to carry two minarets, this portal has been shown to derive the main lines of its composition from that of the Gök Medrese in Sivas of 1271. Its *muqarnas* hood, however, leading to a towering ribbed semi-dome, refers to Syrian tradition. There are stone floral bands, and panels with chinoiserie lotuses – a recent introduction following the peace of 1323 with the Mongols. The colossal scale of the portal does not proceed simply from a taste for the grandiose; rather, it has been interpreted as part of a deliberate scheme of religious symbolism. The portal is compared to a *mihrab* by the use upon it of qur'anic verses often found on *mihrabs*, *surah* XXIV, *al-Nur* (The Light), 36–7: it is to be seen as a portal-*mihrab*, a metaphor for the gate to Paradise.

Within the building, the line of entry is turned through a vestibule and a dark narrow passage, so that the visitor is disorientated from the exterior world and attracted to the light of the courtyard beyond. The central space is devoted to a four-*ivan* mosque. The Mamluk treatment of the form is very different from the Persian, since the *ivans* do not here rise above the walls in *pishtaqs*, but instead the wall is extended up to the height of the *ivan*: a huge cuboid space is thus created. Within the *ivans* runs a large kufic inscription on a floral ground carved in stucco with descriptions of Paradise from *surah* XLVIII, *al-Fath* (The Victory). In the south *ivan* the *qiblah* wall is clad with coloured marbles. Unseen from the great courtyard, in the angles between the *ivans* are minor courtyards for the four *madhhabs*. Beyond the south *ivan*, and thus in a commanding position at the top of the slope, is the tomb chamber lit by stained-glass windows. The great dome rests upon pendentives which are covered with a system of wooden *muqarnas*.

In the Burji period the same architectural elements continued to be used, though generally less forcefully. In the later fifteenth century, however, Qa'it 67 Bay was a prolific and inspiring patron, his *madrasah* and tomb of 1474–5 being the masterpiece of his reign. The complex is relatively small and finely detailed within and without. A different attitude to the treatment of the exterior makes itself felt: the outer walls are no longer a façade which tends to conceal; instead they express the various volumes of the building, which are composed in a delicately poised asymmetry. The exterior is also more decorative, with horizontal stripes in *ablaq* masonry. These changes may perhaps owe something to the enhanced importance given to the exterior of buildings by tilework in contemporary Iran.

In the entrance façade, a flight of steps leading to a high portal on the north is balanced by an open loggia in the upper storey of the south. The loggia is that of a Qur'an school (*kuttab*), below which is situated a *sabil* for the distribution of water, so that both the moral and physical needs of the people were supplied. Within, the *madrasah* has a wide south *ivan* framed by a broken horseshoe arch; the lateral *ivans* are small, and that of the north is divided. The central area is sunken and under a wooden lantern. This lends the space a 3 rather domestic air, and indeed the format, known as a *qaʿah*, was also used in the grander domestic architecture. The tomb chamber to the south-west of the *madrasah* has a cenotaph and floor in black and white marble. The hood of the *mihrab* – at present overpainted in red and white – has contrasting zigzags

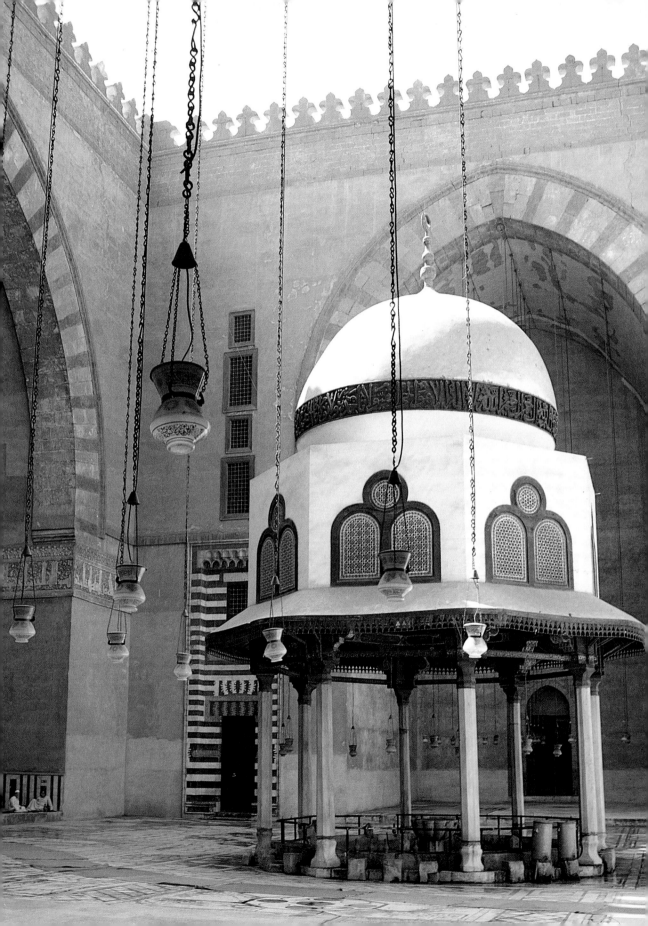

radiating from a centre to joggled voussoirs and an outer rim of interlocking
trefoils.

Carving in stone, wood, and ivory

Some figurative sculpture was made for secular buildings, the stucco of
Seljuk times being imitated in stone in the Jazirah. Figures can be dis-
tinguished upon an Artuqid bridge of the mid-twelfth century at Hisn Kayfa,
and in niches round an arch from Sinjar, which is probably of the time of Badr
al-Din Lulu; they carry the bows and swords of *mamluks* attendant upon a
prince. Built in 1221 for the caliph al-Nasir and destroyed in 1917, the
Talisman Gate of Baghdad was so called from the finely carved figures upon
it. At the crown of the arch a seated figure held the tongues of two serpentine
and knotted dragons, which occupied the spandrels. This may have signified
the containment of evil, in a general way, or may have had a contemporary
political reference. Dragon-fighters appear on an arch at Sinjar at this time,

68 Wood and ivory doors, Egypt, probably 14th century. The geometric wooden framing pieces contain ivory insets of the most delicate tracery. The design is closely related to contemporary manuscript illumination. New York, Metropolitan Museum of Art.

and dragons, intertwined but unrestrained, were carved over an arch in the Aleppo citadel.

Much fine woodwork will have been lost from palaces, but some pieces have survived in religious buildings. The cenotaph of Salah al-Din in Damascus, of handsome proportions and carved with an ornamental kufic inscription above bold geometric star forms, is now unfortunately painted. Richly carved Zangid *minbars* have been lost from Hama and Jerusalem, but many Mamluk examples are still *in situ*. Their sides are built up by small pieces of wood slotted together in geometric patterns which frame ivory plaques with floral carving. *Mashrabiyah* work continued, and screens sometimes show designs in silhouette.

A number of round ivory boxes have been identified as Mamluk since the name of the Mamluk al-Salih appears on one. Their sides are pierced with a delicate tracery, which suggests that they may have been intended to release perfumes. Ivory plaques with human figures are also known; these continue the Fatimid tradition, though they are less exuberant.

Metalwork

The wide-ranging tastes of the Artuqids are displayed in their patronage of metalwork. This was in part stimulated by the location of their state at the borders of the former Byzantine lands. In their coinage of the twelfth century a pragmatic use of Byzantine Christian imagery is followed by the adoption of classical and Sasanian symbols of sovereignty and of astrological motifs. The classical and Byzantine influence is also clear in a unique bronze dish in Innsbruck decorated in cloisonné enamel with a central roundel showing Alexander the Great carried to heaven in a chariot. Metal enamelling is a rare technique in the Islamic world, and the craftsman must have drawn on Byzantine skills. A confused inscription on the dish seems to refer to the Artuqid Rukn al-Daulah Da'ud (*c.* 1109–44). In the Islamic tradition, but showing a new power, are some door-knockers from the Ulu Cami of Cizre, now in the Turkish and Islamic Arts Museum, Istanbul, cast in base metal alloy in the form of pairs of serpentine dragons. Other objects are of less certain origin: a particularly fine steel mirror, whose circular back shows a rider with gold inlay, may have been made for either the Artuqids or the Seljuks of Rum.

In the second quarter of the thirteenth century the most important centre was Mosul. Its pre-eminence was perhaps owed to the acquisition of craftsmen from Khurasan who had fled westwards before the Mongols in the 1220s, but, since the earliest piece on which the maker uses the *nisbah* 'al-Mausili' is a small box of 617/1220 (Benaki Museum, Athens), the centre may have been active earlier. In the hundred years following, a score of craftsmen were proud to announce their Mosul connection, whether they were working in Mosul itself, in Damascus or in Cairo. Though the influence of Mosul was pervasive, only one piece, a ewer, positively states that it was made there, though six others were made for Badr al-Din Lulu or one of his amirs. The Mosul style is worked in brass with silver, or on a late example gold, inlay. The surviving objects are principally the appurtenances of a luxurious life; they include trays, caskets, ewers – now with long straight

spouts and high rounded shoulders – and basins with straight sides and flaring everted rims. The decoration tends to be divided into zones. The larger, flatter surfaces were often used for motifs with one or two figures engaged in some princely pursuit, such as receiving homage or hunting, which were set against a background of fine geometric pattern suggestive of architectural stucco. More restricted zones were used for inscriptions, or bands of either small abstract motifs or running animals. Scientific instruments were also made, such as astrolabes and celestial globes, and on these the figures of the constellations are both functional and decorative. The British Museum has two instruments by Mosul metalworkers. One is a celestial globe of 674/ 1274–5 by the astronomer Muhammad b. Hilal, which is engraved with the figures of the planets. The other, yet more rare, is a device of 639/1241–2 by Muhammad b. Khutlukh for the practice of geomancy, or divination by dots; rectangular in form and covered with small dials, it is nevertheless beautiful.

An interesting feature of some metalwork of the thirteenth century is the occasional intermingling of Christian iconography in schemes which are designed and executed in the Islamic manner. Such pieces were probably made in Syria, where examples of Christian art would have been to hand among large indigenous populations of Christians, and – though less obviously accessible – in surviving strongholds of the Crusaders. Some

69 Brass astrolabe made in Cairo in 633/1235–6 by ʿAbd al-Karim al-Misri ('of Egypt or Cairo'). Astrolabes were employed to make astronomical observations and for such practical purposes as telling the time and assessing the distance and height of objects. In use the astrolabe hangs from its ring. A disc with appropriate scales is inserted into the frame to adapt the instrument for a given geographical area. An openwork plate revolves over this, its inner circle representing the zodiac and its outer circle other constellations. On the back is a pivoted pointer for readings. London, British Museum.

107

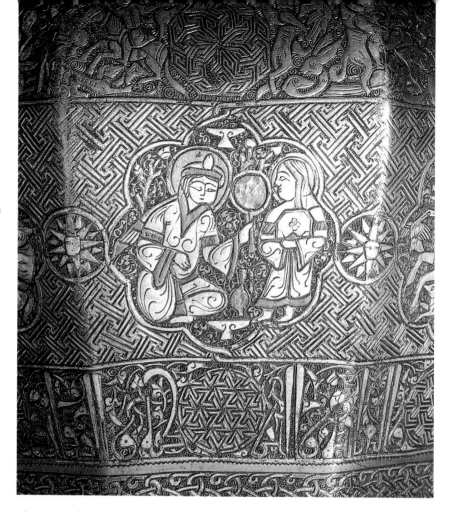

70 Detail of the 'Blacas' ewer, in brass with silver and copper inlay, made at Mosul in 629/1232 by Shujaᶜ b. Manᶜah al-Mausili. A lady studies herself in a mirror of polished metal. Her attendant may be holding a jewel casket. The ground of small fret patterns is typical of Mosul work. London, British Museum.

71 OPPOSITE LEFT Detail from a brass basin with silver inlay, known as the 'Baptistère de St Louis' and made in Egypt (or Syria) in the late 13th or early 14th century. The drawing has a distinction beyond anything found in Mamluk painting. The horseman has oriental features, and wields a short bow which would be made of laminated horn and drawn with the thumb. The bowl was used for the baptism of the kings of France. Paris, Musée du Louvre.

pieces may have been made for Christian patrons. The most celebrated object with Christian scenes is a large canteen, now in the Freer Gallery of Art, Washington DC, made at an unknown centre about the mid-century. On the curved face of its round body, this shows a Virgin and Child, Nativity, Presentation and Entry into Jerusalem. On the flat rear face is a ring of saintly figures under arches, and an inner ring showing a battle or tournament in which some horses have the caparisons used by the Franks.

Metalwork also flourished under the Mamluks, especially in the Bahri period. The craftsmanship was derived from that of the Zangids and Ayyubids, but there is a shift in iconography away from princely motifs and towards a more prominent use of calligraphy. This may result from the fact that the Mamluks were beyond the ambit of Persian and Seljuk influence, and from the fact that many objects were dedicated to religious institutions. A typical example of this style is a candlestick (now unfortunately in two pieces, in the Museum of Islamic Art, Cairo, and the Walters Art Gallery, Baltimore) made in the time of al-Malik al-Ashraf (1290–3) for Kitbugha, who was to succeed him. Traditional features on this are an animated inscription on the neck, astrological roundels on the drip tray, geometric roundels, and even bands of knotted kufic – which seem rather old-fashioned for the time. New features are an inscription in *thuluth*, whose ascenders surround the base as though with a rank of spears, and roundels with the blazon of the cup-bearer (*saqi*) in copper on a silver ground.

That a courtly figured style also existed is clear from two basins in the Louvre, made by Muhammad ibn al-Zayn, the one with convex sides and the other with straight, which are datable to the later thirteenth or early fourteenth century. In particular, the straight-sided basin, known as the 'Baptistère de St Louis', is one of the greatest examples of Islamic metalwork. Instead of the ascenders of an inscription, the body is ringed with figures: four large roundels with horsemen separate two rows of amirs and two lines of servants. They are drawn with detailed attention to their clothing and attributes in the form of sword, bow, hawk, hound, cup, dish. Faces are individualised, and it has been suggested that a bearded man in a distinctive costume must be a certain amir named Salar. Salar may have commissioned the basin, but this is uncertain. Fauna in the running bands now include cheetah, elephant, unicorn, tiger and camel; and, where the base of the interior of many Mamluk basins is covered with fish to indicate their function as a recipient for water, in this example there is a whole aquarium of marine creatures.

From the Burji period there remain items of military equipment, such as iron helmets, brass drums and steel standards; also swords with curved blades. A steel of high carbon content was used for fine blades. When exposed to acid, it revealed a mixed structure of bright cementite and greyish pearlite in a watered or moiré pattern, known as damascening. Further decoration might be added with inlaid gold.

72 BELOW Steel axe with gold inlay, made in Egypt (or Syria) for Muhammad b. Qa'it Bay (1495–8). In the middle of the blade is Muhammad's epigraphic blazon in openwork, and the name Muhammad is written in seal kufic on the socket. The lower end of the blade is supplied with a flange to buffer it from the shaft. Vienna, Kunsthistorisches Museum.

Pottery

Unglazed pottery, as a cheap material for domestic uses, always predominates in quantity over glazed pottery, but at some moments it is raised to the level of a fine ware. The traditional storage jar is the *habb*, large and with handles at the shoulder. Examples from Iraq with applied ornament may be datable as early as the ninth century, but it is in the Ayyubid period that *habbs* attain a truly majestic form, with applied decoration giving inscriptions, scrolls and excerpts from the Seljuk sculptural repertoire. Another type of vessel which may combine practicality with evidence of the user's status is the flask. Often known by the restricted but evocative name 'pilgrim flask', this is essentially transportable, with handles at the shoulder, rounded form, flattened sides and no foot-ring. An example in the National Museum, Damascus, which must have belonged to the amir Toquztimur, a governor of Damascus who died in 1345, bears a composite blazon with an eagle, identified as the badge of Sultan Nasir al-Din Muhammad, above the cup-bearer's cup. Less ornamental and teasingly enigmatic in purpose is a class of vessels described as 'sphero-conical' which, it has been suggested, may have served for the transport of volatile liquids or of mercury, as grenades for Greek fire, or as fire-blowers.

In the field of glazed pottery, work for the *atabegs* was closely related to that produced for the Seljuks, and the area of origin of some types and pieces therefore remains in doubt. A small but striking class of fritware is known as 'lakabi', examples often taking the form of a large shallow dish with an everted rim, a shape favoured in Syria. The decoration is concentrated on a central carved motif or group – an eagle, confronted birds, a dancer and musicians – and the motifs are glazed in polychrome to contrast with the white body under a colourless glaze. It was the aim of the painters that the coloured glazes should be restrained by incisions and ridges in the clay, but too often they have overrun their borders, so that the grand simplicity of the designs is impaired by an inadequate technique.

Lustre and underglaze-painted wares were both produced in Syria. Examples of the former, said to have been found at Tell Minis, clearly derive from the Fatimid tradition, but are datable to the mid-twelfth century, suggesting that craftsmen were emigrating from Egypt even before the collapse of that dynasty. But the actual centre of production of these pieces may have been Raqqah, which was to be the chief producer until it suffered at the hands of the Mongols in 1259. The transparent glazes of Syrian pottery are less fine than the Persian, and characteristically gather in heavy greenish droplets round the exposed foot-ring; the lustre is of a dark chocolate colour. By contrast, the drawing has a rapid and whimsical quality. Whether in comma-like leaflets or in the curving limbs of beasts and birds, the line has much greater variation, suggesting the use of a more flexible brush. Decoration tends to be more sparse, so that individual motifs claim a greater share of the attention; the emphasis on the speedy flexible line also means that it is less usual for the design to be in reserve on a lustre ground, though this also occurs.

Underglaze painting was practised in Raqqah, and also in Aleppo, Damascus and Fustat. There are shallow bowls with everted rims, rounded bowls,

bowls with flared sides in the Seljuk manner, footed cups, and jars with high shoulders. The painters made effective use of the fact that their black pigment remained stable under the glaze, while their cobalt blue tended to diffuse; they had also a dull red and a green verging on black. The designs of bowls often employ radial panels, and stripes are favoured, reflecting architectural *ablaq*; there is also some reference to the repeating patterns of metalwork. In the Burji period pots are found with signatures or workshop names such as *al-Shami* (of Syria) or *al-Taurizi* (of Tabriz), the latter suggesting a movement of potters into the Mamluk lands.

Glazed jars were evidently a superior form of storage, and they were often used as containers for rare substances in the shops of apothecaries. Fine jars from the later thirteenth and the fourteenth centuries were made in Damascus, as stated on an example (in a private collection) made for one Asad al-Iskandarani by a decorator named Yusuf. Their decoration is in blue and black underglaze, or blue glaze with golden lustre drawn with Syrian dash. Other jars, cylindrical but slightly waisted and thus easily taken from a shelf, are particularly associated with the export trade to Sicily as containers for spices or drugs; they came to be imitated in Italy with the name *albarello*. Damascus production was probably seriously affected by the onslaught of Timur in 1401.

In the fifteenth century it became fashionable to use blue alone in under-glaze painting. Motifs were borrowed from imported Chinese porcelain, though they were usually not copied exactly. Vessels continued to be made, but hexagonal tiles were also produced, the earliest datable series being those in the tomb of Ghars al-Din al-Khalil al-Taurizi in Damascus, built before his death in 1430. Attempts were also made to imitate the subtle grey-greens of Chinese 'celadon' glazes, but colours remain obstinately bright.

The potters of Mamluk Cairo produced quantities of a ware whose reddish body is covered with a white slip with *sgraffiato* decoration. It is painted in brownish slips under a transparent glaze which is often amber. A frequent shape is a flared cup on a high foot. Some examples bear inscriptions and blazons.

Glass

74 Fragmentary thin glass flask bowl with gilded decoration, made in Syria between 1127 and 1144. The inscription shows the beginning of the *laqab* of 'Imad al-Din Zangi. The dancer recalls Fatimid style, while the eagle is typically Syrian. London, British Museum.

The period saw a revival of interest in a technique of glass decoration which had been employed in ancient Egypt. Small bottles and phials for scent, made in deep purple or blue glass, were heated to a malleable condition, trailed with threads of white glass and rolled on a smooth surface (marvered) until the decoration was flush with the body. As a variation the threads might be combed into rippling patterns, or the wrapped vessel might be reshaped in a fluted mould.

The major development, however, was in the area of decoration on clear glass. An important piece from the second quarter of the twelfth century, which remains to us in fragments, is a clear glass bowl with a dancer, an eagle

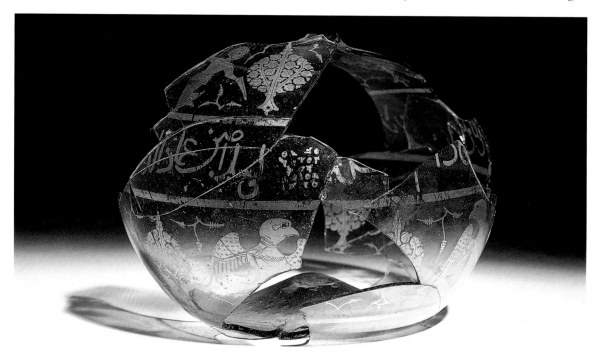

and trees in gilding, and just enough of an inscription to show that it was made for ʿImad al-Din Zangi. The gold would have been laid on with an adhesive and fired lightly to bond it to the surface; details were then scratched through it. The drawing relates back to the Fatimid period.

The Zangi bowl looks to the past and seems unaware of the fashion for enamelled and gilded decoration which was to follow. In the new technique clear glass vessels were gilded and decorated with glass paste in red, white, blue, green and black, and were then heated until this fused on. The gilding, which has a tendency to wear off, is flat; the enamel, which often employs a thin red outline, has a distinct relief. In origin this technique may owe something to the lustre painted glass of the Fatimids, to the trailed work, to cloisonné enamel in metalwork and to the *mina'i* pottery of Iran. A sparing use of enamel on a long-necked bottle in the Museum of Islamic Art, Cairo, made for Salah al-Din Yusuf, the last Ayyubid of Aleppo (dethroned 1260), suggests that the main development may post-date this period. Other centres of work were Damascus and Cairo.

Bottles were made for wine, or to sprinkle rosewater. There are narrow beakers with everted rims, a shape – perhaps derived from the vessels used in a polycandelon – which would tend to be unstable while standing, but secure in the hand. There are also rarer forms, such as straight-sided basins which follow the metal prototype, and a celebrated piece in the pilgrim flask format, with arabesques and mounted hunters (British Museum). Most numerous are the mosque lamps with flaring neck, bulbous body, glass loops for suspension and foot-ring. These may bear the name and blazon of a donor, and often *surah* XXIV, 35, which compares the light of Allah to a shining niche which contains a lamp in a glass globe.

Arts of the book

Arab schools of book painting blossomed in the early thirteenth century. To what extent illustration had been practised before this period is a vexed question, but it is quite clear that here two different approaches to illustration mingle. Firstly, the Seljuk tradition is continued in pictures of 'moonfaced' rulers, who may be shown in conceptual settings symbolic of power. Secondly, a new style shows the Arab population, with aquiline faces, loose garments and eager gestures, in settings which may be minimal, but which are naturalistic in intent. Some of the works illustrated were of an instructional nature, and this may have served to justify the use of pictures; however, the lively spirit of the painters transcends the limits of utility.

The earliest dated work in the series is a *Kitab al-Diryaq* (Book of Antidotes; now in the Bibliothèque Nationale, Paris), from the Greek of Nicander, which was copied in 595/1199 and whose richly worked pages are evidently intended to please as much as to instruct in the treatment of snake-bite. The Seljuk heritage is seen in an extraordinary double frontispiece in which pairs of serpentine dragons encircle female figures who sit supporting moons, while winged angels, whose immediate antecedents are Buddhist, flutter in the corners. Within the manuscript, some princely figures resemble those in *Varqah u Gulshah*. Others, the learned doctors who can cure snake-bite and the workers in fields and gardens who are exposed to it, are in Arab style: their faces, sometimes shown in profile, have an aquiline nose, and their heads are angled so that their eyes gaze at identifiable objects. The lordly figures are set against red backgrounds, which may derive from wall-paintings; the other settings are indicated simply with a ground line and a few trees, but the work-a-day world is sufficiently clear in a scene of threshing and winnowing.

The prestige of the eastern style of illustration is seen in the frontispieces to some surviving volumes of the twenty-piece *Kitab al-Aghani* (Book of Songs), completed in 1220, in all probability for Badr al-Din Lulu. A volume in the Millet Library, Istanbul, has a striking portrait of the patron, identified by his *tiraz*, shown frontally, in fur-rimmed cap, sitting on a folding metal throne and holding a bow and arrow – weapons of Turkish connotation. Smaller courtiers and angels are in attendance.

Besides Mosul, the locations of two other centres of book production are known. One is the Artuqid territory of Diyarbakır, where al-Jazari's *Book of the Knowledge of Ingenious Devices* was written in 602/1205; the manuscript is now in the Topkapı Sarayı Library. Reflecting the mechanical wonders made for the caliphs, this describes automata devised by the author for the delight of the Artuqids. Combining architectural, human and animal forms, these functioned as clocks or delivered wine. The other centre of book illustration is Baghdad, where a *Book of Farriery* was copied in 605/1208–9. In both cases another illustrated copy was made in the following year, so it is evident that the desire for such books extended beyond a first patron.

The illustrated works which achieved the greatest popularity are three: *Kalilah wa Dimnah*, *De Materia Medica*, and the *Maqamat*. *Kalilah wa Dimnah* is known to have been illustrated in earlier periods, and thus it is not surprising that a copy in the Bibliothèque Nationale which is judged to date between

76 Frontispiece with prince and attendants, from a *Kitab al-Diryaq*, probably from Mosul, second quarter of the 13th century. The prince, about to be regaled with kebabs, is surrounded by his personal retinue, the *khassakiyah*. The attendants hold objects, such as a hawk, a sword, a cup and a polo-stick, which indicate their office. Minstrels play in a gallery. Strips with hunters and travellers derive from a pictorial tradition similar to that of *Varqah u Gulshah* (Fig. 52). Vienna, Nationalbibliothek.

1200 and 1220 should have some features which suggest a long tradition. The eponymous crafty jackals and other animals are drawn with a rapid, even a careless line, which nevertheless brings out the character attributed to them with great clarity: it is as though the painter were perfectly used to his task and could perform it with great verve and without hesitation. The ancient format of confronted beasts with a central tree between them is sometimes used, and various plants owe more to traditional illumination or stucco than to the new naturalism of the thirteenth century.

The *De Materia Medica* (*Kitab al-Hashayish fi'l Tibb*, or 'Properties of Plants', *Khawass al-Ashjar*) is translated from the Herbal of Dioscorides. The most celebrated copy, now in the Topkapı Sarayı Library, shows a debt to the classical world not only for the text, but in its illustration. Copied in 626/1228 by a scribe with the *nisbah* 'al-Mausili', the manuscript opens with a double frontispiece in which, under spandrels of mosaic supported by columns, the author is approached by two students. The author is in classical costume, save for the addition of a turban, and the folds of his pale robes are shown by an elaborate convention of shading. The two students wear Arab gowns, whose folds are indicated in a more linear manner. A similar contrast is evident in the depictions of plants, the vine being in a naturalistic style while other plants are shown flat, symmetrical and pattern-like. It would seem probable that the painter had access to a Byzantine model from which most of the illustrations were missing.

Byzantine painting of metropolitan character is not, however, the most important of the East Christian influences which bear upon Arab painting; more significant is the relation with the simplified and stylised illustrations of Syriac Gospels. Borrowings from these can be found in matters of composition, posture and shading technique, but the traffic is not all one way, and figures with the facial features and sprightliness characteristic of the best Islamic manuscripts are also to be found in the Gospels. How the Arab style evolved remains something of a mystery, but it has been suggested that an important contribution was made by the shadow theatre which is known to have been practised at the time. Figures which seem to be on the verge of speech and movement, and settings indicated by isolated objects or contained in a 'proscenium' frame support this. However, the problem remains as to whence the drawing of the shadow theatre was itself derived.

The work which takes us most deeply into the society of the time is the *Maqamat* (Sessions) of al-Hariri. This is a text divided into fifty parts and designed to instruct its readers in literary style. Opportunities for illustration were offered by anecdotal stories concerning a picaresque hero named Abu Zayd. Within this framework the *Maqamat* takes us through a world of mosques, governors' palaces, taverns, libraries, slave-markets, desert camps, pilgrim caravans, and travel in Eastern waters. The best-known manuscript of the *Maqamat*, now in the Bibliothèque Nationale, was copied in 634/1237 by Yahya b. Mahmud al-Wasiti and also illustrated by him. It is usually attributed to Baghdad, but this is not certain.

Painting was certainly practised in Baghdad after the Mongol invasion. A copy of *Rasa'il al-Ikhwan al-Safa* (The Epistles of the Sincere Brethren; now in the Library of the Süleymaniye Mosque, Istanbul) was made there in

686/1287. This has a double-page opening showing the authors and their attendants in an architectural setting. The drawing is finely executed, but has lost some of the liveliness of the early work, and the palette is cooler than the earth tones of the earlier thirteenth century.

Copies of *Kalilah wa Dimnah* and the *Maqamat* continued to be produced under the Mamluks, but, though there are felicitous moments, the Mamluk rendering of the human figure was never so exciting as that of the earlier period. Faces, in spite of some trace of the large Fatimid eye, tend to be inexpressive. A class of illustrated work which is, however, interesting in relation to Mamluk society consists of books of instruction in *Furusiyah*, horsemanship and its concomitant knightly code. In these cavalry manuals impassive riders are seen neatly performing equestrian feats. Greater vigour is displayed in the illustrations to a copy, sold at Sotheby's in 1990, of Qazvini's ʿAjaʾib al-Makhluqat (Wonders of the World, approximating to an illustrated encyclopaedia), its boldly drawn animals being close to those on the 'Baptistère de St Louis'. Lastly, at the close of the period in 916/1511 the *Shahnameh* was translated into Turkish for the penultimate Mamluk, Qansuh al-Ghuri, and illustrated in a style with Ottoman traits.

Related by their material to the arts of the book, a small number of playing cards have survived, which are datable about the turn of the thirteenth century. Of large rectangular format, they are in suits of cups, coins, polo-sticks and swords, with court cards identified in writing as king, first and second governor, and assistant. Card games appear to have originated in India and passed via the Mamluk territory to Europe, where they are first recorded in 1377.

The heart of the achievement of the Mamluks in the field of manuscripts lay not in secular works but in the production of Qurʾans, copies made on a grand scale often being presented as endowments to religious foundations. Much use was made of a format, also known in earlier centuries, in which the Qurʾan was divided into thirty parts (*juzʾ*, plural *ajzaʾ*) so that it might be read each day through a month. Occasionally seven-part Qurʾans were made also. The volumes would be stored in finely decorated cabinets or boxes, with the appropriate number of compartments. A particularly fine seven-part Qurʾan in the British Library was made for Baybars al-Jashnagir (the Taster) in 1305–6 in the reign of al-Nasir Muhammad; it was most probably intended for the *khanqah* which Baybars was founding, but, after he had interrupted the reign of al-Nasir Muhammad in 1309–10, the foundation was closed and the endowments confiscated – a circumstance which would account for the fine condition of the manuscript. The text was copied in *thuluth-ashʿar*, a gold script with a fine black outline, with six well-spaced lines to the page – the even number being exceptional. Frontispieces which announce the number of the volume are illuminated in gold, red, blue and white in designs which distinguish a frame of bold arabesque on a hatched ground from a central field containing a strong geometrical motif.

The zenith of Mamluk qurʾanic illumination is seen in three Qurʾans copied about the mid years of the reign of al-Ashraf Nasir al-Din Shaʿban (1363–76). Two of these the sultan endowed to the *madrasah* founded by his mother, while the third bears the name of one of his amirs, Arghun Shah. The three

77 OVERLEAF Right-hand side of the double frontispiece of a Qurʾan made in Cairo about 1368. It was one of a number bequeathed by Sultan Shaʿban to his mother's *madrasah* on 15 *shaʿban* 770 (25 March 1369). Cartouches above and below the central field contain *surah* XXVI, 192–4, and the border round it *surah* XXXV, 29–30; these speak of the fundamental place of the Qurʾan. A sixteen-pointed star radiates to a polygon derived from a square rotated three times through 22.5 degrees. The illumination shows the incorporation of lotuses and peonies into traditional arabesque. Cairo, National Library.

are written in *muhaqqaq*. Their superbly illuminated frontispieces are much more refined than those of Baybars' volumes, and they have adopted lotus and peony motifs of Chinese origin. The designs, dominated by a central star-polygon and combining dynamism with order, and complexity with clarity, are masterpieces of religious art.

The bindings of Mamluk manuscripts were worked with complex but sober patterns. Designs usually consist of framing bands and a central geometric motif. The ornament in doublures was sometimes stamped with a block.

Textiles and carpets

The textile production of the Islamic cities is reflected in words current in Europe today: muslin from Mosul; damask, the self-patterned weaves of Damascus; and silks from Baghdad, whence baldachin. Also, Baghdad's ʿAttabiyah district made a plain weave which produced the textile term tabby, and tabby fabrics could be steamed into a moiré (*mukhayyar*, arbitrary) pattern – whence the usage to describe the coat of a cat.

Survivals from the period are still chiefly fragments, but there are a few garments: shirts, drawers in striped silk, coats, and quilted caps from offcuts of fabric. Most pieces are Mamluk. On linen and cotton block-printing was

78 ABOVE LEFT 'Abu Zayd and his son rob drugged guests in a caravansaray', from a *Maqamat* illustrated by al-Wasiti, probably Baghdad, 634/1237. The sleepers' abandonment contrasts with Abu Zayd's concentration. Paris, Bibliothèque Nationale.

79 ABOVE RIGHT 'The lion advised by his mother', from a *Kalilah wa Dimnah*, Syria (or Egypt), 755/1354. The characters of the wise lioness and inexperienced lion are conveyed by their posture. The manuscript was acquired in Syria by Edward Pococke, first professor of Arabic at Oxford. Oxford, Bodleian Library.

80

80 ABOVE Fragment of a child's coat in silk with addorsed harpies. Egypt (or Syria), 14th century. Costly fabrics were used (or re-used) as economically as possible, so an asymmetrical placing of the pattern was sometimes inevitable. Inscriptions read 'the sultan, the king, the victorious', and 'the wise, the able, the just'. Berlin, Museum für Islamische Kunst.

81 RIGHT The 'Simonetti' carpet, Egypt, later 15th century. Very probably of the reign of Qa'it Bay, this Mamluk carpet is both exceptionally fine and well preserved. It is also unusually long (9 m). The very complex design must have been worked out on paper. The play of positive and negative in form and colour creates the effect of dissolution of the surface. New York, Metropolitan Museum of Art.

used for inscriptions and ornament, the technique perhaps learned from trade connections with Western India. There also survive fragments of appliqué, which would have been used for ceremonial tentage, as it still is today.

Among the grander silk fragments a number in the name of al-Nasir (1293–1340) show new developments. One example, in the Kunstgewerbe-museum, Berlin, was probably part of a gift made to him on the occasion of the treaty with the Mongols in 1323. It is a lampas which follows a traditional Persian design with large addorsed birds in dodecahedrons, but the interstices are now filled with the Chinese motif of a dragon. Other pieces in the name of al-Nasir are striped horizontally, plain bands alternating with bands of animals and bands of inscription, the latter showing the steady succession of ascenders characteristic of Mamluk epigraphy.

A new type of design which emerged in the period and which would continue into Ottoman times is the ogival lattice, in which almond-shaped motifs with ogee tops and tails are set in a diaper pattern. Such designs may have been derived from the arts of the book. By the fifteenth century lattice patterns include motifs which seem to be derived from the Chinese lotus. A fine example in the Cleveland Museum of Art is a silk once used in Spain as a mantle for a figure of the Virgin. In gold and white on a ground of blue, this alternates lotuses with drop-shaped motifs, while smaller rosettes bear the word *al-Ashraf*, a title of Qa'it Bay (1468–96). Pieces such as this have a relation to textiles produced in Spain and Italy, but, since exchanges in this field between the Mamluks and Europe have not yet been fully charted, it is not always clear in which direction particular influences flowed.

The Venetian traveller Barbaro mentioned the existence of a carpet indus-try in Cairo in the 1470s, and this is thought to refer to the centre of production of Mamluk carpets. These beautiful works of highly sophisti-cated design seem to make a sudden appearance in the late fifteenth century, and it has been suggested that they were made by émigré craftsmen from Iran. The knot used is indeed the asymmetrical type, favoured in later centuries by Persians rather than by Turks, in which the end of wool is looped round one of a pair of warps but merely passes behind the other. Mamluk carpets have a lustrous pile in red, green and light blue, with small quantities of cream and tan in the more refined examples. Unlike the Seljuk carpets, whose relatively simple repeating patterns relate them to a nomad tradition, Mamluk carpets have complex centralised designs which bespeak the use of cartoons in an urban milieu. Sources which may have contributed to their design are Coptic textiles, manuscript illumination, woodwork, and poss-ibly even classical floor mosaics. Elaborate schemes are composed of stars and polygons, with borders of cartouches. The feature which definitively estab-lished the carpets' origin as Egypt is their widespread depiction of the papyrus umbel; other motifs found occasionally are palm-tree, cypress and cup.

81

121

5

THE LAST EASTERN INVADERS
The Mongol and Timurid empires

Abreak between the worlds of early and of later Islam was effected by the Mongol invasions of the thirteenth century. The ʿAbbasid caliphate was brought to an end – an event of greater psychological than material impact – and the Eastern province of Khurasan received an economic blow from which it was never to recover. To the Christian powers the Mongols represented a source of hope, a potential new ally who might league with them to destroy Islam, but this was to prove illusory. In the field of art, a change is seen from the period of recovery at the end of the thirteenth century onwards, as ideas and goods brought in from China – also under Mongol rule – began to extend an influence which was never entirely to cease.

The Mongols were nomadic pastoralists, used to rugged conditions and the stern discipline imposed by them. In the tradition of the steppes, groups would coalesce round a military leader and tend to fall apart on his death. In 1206 such a leader was recognised as supreme lord of the Mongols at a *quriltay* (tribal council) south-east of Lake Baikal, and accorded the name of Chingiz (Genghis) Khan. He first attacked northern China, and then turned his attention westwards. In 1220 the Khwarazm-Shah Jalal al-Din Mingirini fled from the advancing Mongols, who swept on to ravage the cities of Balkh, Herat and Nishapur.

Chingiz died in 624/1227, and according to tribal custom his territories were divided among his male relatives. Batu, a grandson, held the Qipchaq steppe, where his people came to be called the Khanate of the Golden Horde. Chaghatay, a son, received Transoxiana and lands east of it. Another son, Ugaday (Ögedei), received the homeland, and with it the title of the paramount ruler, *khaqan*. Ugaday consolidated the empire and established its capital at Qaraqorum on the Orkhon river, but his line was displaced by other Chingizids, and in 1260 Qubilay (Kubla Khan) transferred the capital to Khan Baligh (Beijing/Peking), where he was visited by Marco Polo. The Yuan dynasty, descended from Qubilay, ruled China until 1368.

Iran was not at first of great importance in the Mongol scheme of things, but in 1256 Hulagu (Hülegü), a brother of Qubilay, traversed it in a second campaign of destruction. The Ismaʿili Shiʿi sect of the Assassins were dislodged from their castles; Baghdad was sacked in 1258, and the caliph

82 The Mausoleum of Uljaytu, Sultaniyah, dedicated in 713/1313–14. The mausoleum is related in form to the Dome of the Rock, perhaps indicating that Uljaytu wished to assert the legitimacy of his rule as opposed to that of the Sunni Mamluks then ruling in Jerusalem. A band of seal kufic at the base of the dome reads 'Allah, Muhammad, ʿAli'; five niche-shapes containing the word 'everlastingness' are set above this. There are indications that the mausoleum was attached to other buildings, now lost. The photograph predates restorations carried out in the 1970s.

Mustaʿsim was killed (probably trampled to death in a carpet to avoid the shedding of his blood); and armies advanced into Syria until the defeat of 1260 at ʿAyn Jalut. Hulagu established a capital at Maragheh in north-western Iran, where his descendants were to rule as Il-Khans. Hulagu slowly began to assimilate the ways of the settled lands, a mark of which was his building of an observatory at Maragheh.

Chingiz had been a shamanist, and Hulagu inclined to Buddhism. Several wives of the Chingizids were Nestorian Christians, and, in the interests of diplomacy, Hulagu's successor Abaqah (1265–81) married a Byzantine princess from Trebizond. However, Islamic influences eventually reasserted themselves: Ghazan, who gained power in 694/1295, was already a convert, and he forthwith declared Islam the religion of state and decreed the destruction of the temples of Buddhists and Zoroastrians. His brother and successor,

Uljaytu (Öljeitü, 1304–16), was baptised a Christian, but thereafter became a Buddhist, then a Sunni Muslim, and in 709/1309–10 he converted to Shiᶜism. He was an important patron at a period of new departures in Islamic art.

The Mongols were obliged to draw most of their bureaucrats from the subject population, and Rashid al-Din, the great vizier who served both Ghazan and Uljaytu, was probably of Jewish origin. Ghazan Khan, who stood at the junction of the non-Islamic and Islamic periods, required Rashid al-Din to complete a history of the Mongols, and Uljaytu commissioned him to write the *Jamiᶜ al-Tawarikh* (World History), which would provide a historical perspective for the Mongol achievement. The vizier acquired great wealth and created an entire suburb of Tabriz, the Rabᶜ-i Rashidi, employing within it scholars, doctors and craftsmen. Rashid al-Din was executed in 1318, accused of having poisoned Uljaytu. This occurred in the early years of the reign of Abu Saᶜid (1318–35), the last Il-Khan to hold effective power.

After the Il-Khans, successor states struggled for the control of Iran. In the second quarter of the fourteenth century the Inju dynasty ruled Fars, where they had previously been governors. In 1353 they were displaced by the Muzaffarids, a dynasty of Arab origin, whose power lasted until 1393. Meanwhile in Iraq and north-west Iran, the Il-Khans were followed by the Jalayrs. Sultan Ahmad Jalayr, a patron of supreme importance in the history of the arts of the book, came to power in 1382 and lived an eventful life until 1410, when he was killed by a Turkman ally.

The last great Central Asian conqueror was Timur, called *lang* (lame) from an injury received in a raid, and hence known in Europe as Tamerlane. Born in 1336 at Kish near Samarqand, a region where Mongol and Turkish strains mixed, Timur was a member of the Barlas tribe, which had served Chagatay. In 1370, having already shared in the capture of Kish and Samarqand, he acquired the throne of Balkh, and with it a Chingizid wife, Saray Mulk Khanum. For ten years Timur's campaigns were local, directed against Khwarazm and Mughulistan (Mongol lands between Lake Balkhash and the Tien Shan); from 1381 he ranged through Persia, the Caucasus, Iraq and Syria. Baghdad was captured in 1393 and 1401, Delhi in 1398, and in 1402 the Ottoman Bayezid I was defeated at Ankara. From his forays Timur carried back wealth, scholars and skilled craftsmen to enrich his capital at Samarqand. A vivid picture of princely life in Samarqand is provided by Clavijo, an ambassador there in 1404 on behalf of the king of Leon and Castile. Timur died in 1405 at Utrar, when setting out in winter to attack China.

The succession to Timur's empire was eventually secured by his son Shah Rukh, who was governor in Herat, but neither he nor later Timurids could hold the entire territory. Shah Rukh, with the support of his powerful wife, Gauhar Shad (Lucent Jewel), ruled in Herat until 850/1447. Under royal patronage the arts flourished there as never before. During this period Shah Rukh's son, Ulugh Beg, was governor in Samarqand. Fars was at first under a nephew, Iskandar, and then under a son, Ibrahim; but by the mid-fifteenth century Western Iran was – part yielded and part lost – in the hands of a Turkman group, the Qara Qoyunlu, people of the Black Sheep. The Qara Qoyunlu in their turn were overthrown in 874/1469 by the Aq Qoyunlu, people of the White Sheep. Aq Qoyunlu rule, based on Tabriz, lasted until the

end of the century, when it dissolved in chaos, giving place to the advent of the Safavids.

In the Eastern lands Timurid princes struggled for the control of Herat. By 1470 the city was securely in the hands of Husayn Bayqara, who came of the same Timurid branch as Iskandar; it then enjoyed a second period of prosperity and creative splendour. Husayn died in 1506 and in the following year Herat was taken by the Turco-Mongol Uzbeks (Özbegs). In the last days of Timurid rule, the city was visited by Babur, a Timurid prince in straitened circumstances, who was to found the Mughal dynasty in India.

Architecture and tilework

Uljaytu completed a great city in north-western Iran, begun by Ghazan and named Sultaniyah. Almost the sole remaining part of this is his mighty tomb (1307–13), whose dome, blue and reaching a height of more than 50 metres, can be seen at a great distance across the plains. The dome is set upon an octagonal chamber. The internal walls are hollowed by eight immense vaulted niches which, at second-storey level, have loggias looking inwards and linked to one another by a passage in the thickness of the wall. On the exterior another and higher gallery has triple-arched loggias looking outwards. Upon the flat roof of the gallery, round the base of the dome, eight pinnacles, like small minarets, stood at the angles of the octagon. A single-storey chamber abuts the south side; both the suggestion that this was related to an intention of Uljaytu to transfer the tombs of the Shiʿi martyrs ʿAli and Husayn to his mausoleum, and the suggestion that it resulted from a return to Sunnism on his part are now discounted.

The dominating dome with its surrounding octagon distantly recalls the Dome of the Rock, but it is more intimately related to the Eastern Islamic mausolea. The octagonal plan of Sultaniyah can be seen as a square with chamfered corners, and indeed on the northern face the lowest level of the structure remains square in plan. Thus, with its gallery in the upper wall, it is related to the Samanid mausoleum and to the tomb of Sultan Sanjar. It can also be seen as a distant ancestor to the Taj Mahall.

The profile of the dome of the mausoleum resembles the parabolic form used by the Sasanians, though it is more pointed. The dome is constructed of an inner shell and an enclosing sheath; these are united at the base, but thereafter, as the fabric of the inner shell becomes progressively thinner towards the apex, they are linked by a cellular structure. This makes for great stability, and it is unlikely that the eight pinnacles surrounding the dome contributed significantly as counterweights to its thrust.

The interior of the mausoleum was originally decorated with princely richness, using a wide range of techniques. The older sorts of decoration which involved relief – moulded and carved stucco, and carved terracotta – were joined by several sorts of tilework in turquoise or cobalt blue. Extensive use was made of banna'i (builder's) technique, in which tiles resembling glazed bricks were set against grounds of plain brick to form words in a large-scale version of seal kufic, a script with squared angles. There was also tile strapwork and full tile mosaic. Not long after its completion much of the decorative scheme was covered with plaster bearing painted inscriptions and

83 Fritware tiles with carved and glazed decoration, Shah-i Zindeh, Samarqand, 762/1361. The tiles frame the entrance to a tomb known from its inscription to be that of a woman. She has been identified as Qutluq Aqa, a wife of Timur, but this is doubted. The exquisite carving, which goes some centimetres deep, is in the arabesque mode and seems untouched by chinoiserie style.

ornaments. The qur'anic inscriptions, which refer to the Kaᶜbah and to Mecca, suggest that the new scheme may have been introduced in 1315, when Uljaytu could envisage the capture of the Hijaz.

Uljaytu also contributed to existing buildings. At the Masjid-i Jumᶜeh of Isfahan his stucco *mihrab* is dated 1310 and introduces Shiᶜi expressions into this bastion of Sunnism. Finely worked in lower relief than had been usual in earlier periods, it has a lace-like quality. The arch form used is of the classic Persian type which is drawn from four centres, two level with the spring and two lower. During the fourteenth century, experiments are made with arches of exotic profile. A stilted and flat-topped arch is used structurally; an ogee with a zigzag break at the meeting of its curves, which must aim at a Chinese effect, is found as a stucco ornament; and forms with *cyma recta* curves, conveying the effect of capitals in the shape of vases, are sometimes used in ceramic *mihrabs*.

The potteries of Kashan survived the Mongol invasion and continued to serve Western Iran. From 1200 to the end of the Il-Khanid period, a number of full-scale ceramic *mihrabs* were made with lustre decoration. Their various components were moulded separately and decorated before assembly; cobalt and turquoise blue was used on their raised inscriptions. These very demanding pieces were a speciality of a family of potters descended from one Abu Tahir, amongst whose members was the Abu'l Qasim whose treatise has been mentioned earlier. Friezes with qur'anic inscriptions on grounds of lustre ornament were also made, and these are particularly associated with Shiᶜi shrines. Lustre tiles were made for dados, a fine set in star-and-cross form being made in the early 1260s for the shrine of Imamzadeh Yahya at Varamin. These have brilliantly inventive leafy designs; however, it seems that other tiles with human figures, animals and secular verses were not, as might be supposed, confined to use in palaces, but were sometimes also employed in similar religious contexts.

In Samarqand an idea of the range and beauty of tilework of the Eastern Islamic area is conveyed by a handful of small tombs which open on to an alley leading to a shrine known as the Shah-i Zindeh (Living King). The shrine is the tomb of Qutham b. ᶜAbbas, a cousin of the Prophet, deemed to have escaped underground from infidel attackers and to have remained living there. The tombs are simple dome-on-square structures, some bearing inscriptions naming female members of Timur's family. The post-Mongol revival of the shrine is indicated by the cenotaph of Qutham, which is dated 735/1334-5. The stepped cenotaph is tiled in 'lajvardina' (*lajvardineh*). This comparatively rare ceramic decoration – 'lapiz lazuli' in colour, though not in substance – consists of a cobalt blue glaze with red and white enamel and applied gold leaf. An undated tomb at the site has beautiful panels composed of units of lajvardina, resembling a patchwork quilt. Other tiles, of the mid- to late fourteenth century, have crisply carved relief decoration, and are glazed in opaque turquoise, with blue, white and purple. In this technique several colours can be used on a single tile, since the depth of the cutting is sufficient to separate them. Inscriptions are in kufic and a wayward cursive script; motifs include arabesque scrolls, but chinoiserie ornament is also much used with semi-naturalistic flowers of lotus or peony, which some-

84 Fritware tile mosaic, Shah-i Zindeh, Samarqand, 808/1404-5. These tiles are from the reveal of the entrance to a mausoleum built by Tuman Aqa, a wife of Timur, and perhaps intended for a child of hers. She also commissioned a *masjid* beside it. A pinkish stone or ceramic is used in addition to the segments of glazed tile.

times spring from vases. On the mid-century tomb of Khwajeh Ahmad carved tiles are accompanied by a band of blue star-tiles with underglaze painting. Other tombs use *cuerda seca* tiles; in these cobalt blue is dominant, with bright yellow, dull red and lettuce green making an appearance. The use on some tombs of tile mosaic incorporating dates from 1385 to 1405 reflects Timur's acquisition of craftsmen from Central or Western Iran. Cobalt blue is used, with turquoise, white, green, amber, and a pinkish stone or plaster. In this laborious technique, the patterns are elaborate but more controlled than those of the carved works, and motifs are predominantly from the Islamic heritage of geometry and arabesque.

Much of Timur's Samarqand was seen a century later by his descendant Babur, who described it in his memoirs. Timur had built the four-storeyed Gök Saray (Blue Palace) and had laid out gardens which contained lesser pavilions. An avenue of white poplars was planted from the Turquoise Gate to the Bagh-i Dilgusha (the Heart-Lifting Garden), in which a kiosk was painted with pictures of his triumphs in Hindustan (India). The gardens would have been of a format used in Iran since pre-Islamic times, in which the need for water dictated the use of a grid of irrigation channels: two main crossing channels would divide a plot in four, and hence they made a *chahar-bagh*, a four-part garden.

The sole remnant of Timur's secular architecture survives not in Samarqand but in his second city, Kish or Shahr-i Sabz (Green City). A huge portal *ivan*, whose vault has fallen, remains from the Aq Saray ('white', Noble Palace), which, begun in 1380, was still unfinished when Clavijo saw it in 1404. The portal is orientated north, perhaps to face Samarqand, and is typical of the gorgeous ostentation of Timur's buildings. The forward corners are flanked by tapering towers, equivalent to minarets, and between these is a wide front *ivan* with a narrower vault at its rear. Thus the outer side walls of the unit recede inwards in two large steps, and the portal block would have seemed to thrust itself forward from whatever façade was behind it, throwing its arms open in welcome or threat. The outer faces of the portal are decorated in *banna'i* work; on the front and inner faces there is some use of mosaic, but much of the tiling is in *cuerda seca*. Spectacular panels on the inner faces of the *ivan* have tall ornamental kufic inscriptions, in black rimmed with applied gold, on grounds of dark blue with golden lotuses. *Cuerda seca* was also used on the cable moulding, like giant's barley-sugar, which rimmed the arch of the *ivan* and which was an important decorative feature of both Mongol and Timurid architecture.

Ivan blocks which reach forward are also found in the Bibi Khanum (Queen Lady) Mosque in Samarqand, used for the entrance and for the *qiblah-ivan*. The Great Mosque was built for Timur, opposite a religious foundation of his senior wife Saray Mulk Khanum, between 1399 and 1404, financed by the spoils of his Indian campaign. The mosque is of four-*ivan* plan, the side *ivans* being of minimal size and backed by dome-on-square units. The Bibi Khanum displays a new spirit in religious architecture, since it was designed to look as striking and well-ordered outside as in. As would be the case in many later Timurid buildings, dramatic external façades were created from the contrast between tall units of construction and the lower

level of the enclosing wall. Thus a tower or minaret rose from each corner of the enclosure, two from the forward corners of the entrance block, and two from the forward corners of the *qiblah-ivan*. The blue-tiled domes of the side units and the dome before the *mihrab* would have been clearly visible from the exterior. These domes, having long been broken, are now entire again, since the mosque has been heavily restored in recent years. The bays round the central courtyard were roofed with small domes supported on columns of stone, stonecutters from Azerbaijan and from India having been drafted in to work upon them. The outside of the mosque was decorated in *banna'i* technique, the drum of the *mihrab* dome in kufic, and those of the side domes in cursive script. The faceted and tapered minarets before the *qiblah-ivan* have inserts of tile mosaic, used much as terracotta had been at an earlier date.

5 The Gur-i Amir (Lord's Tomb) at Samarqand was built for Muhammad Sultan, a grandson of Timur who died on campaign in 1403, but it came to be used for Timur himself, for Shah Rukh and for Ulugh Beg, who renovated it. Timur's structure is an octagon; two minarets set wide before it are now embedded in later work. A high collar-like drum rises abruptly from the octagon and is crowned by a brilliantly assertive dome, tall, overhanging, ribbed and tiled, principally in turquoise with lozenge patterns.

The chamber within the octagon is square with four tall niches with *muqarnas* hoods in its walls. The cenotaphs lie surrounded by a low marble rail. The interior dome rises no higher than the lower part of the drum, but concealed in the space between this and the outer dome is a central shaft with a ring of flanges which anchor the latter to the former, somewhat in the manner of the spokes of an umbrella. Decorative materials in the chamber range from alabaster in the dado to painted papier mâché in the vaults.

In 1417–20 Ulugh Beg built a *madrasah* on Samarqand's central square, the Rigistan (Place of Sand). Its plan has the symmetry and clarity which was to typify the fifteenth century: an entrance in the north leads to a four-*ivan* court, to the south of which was a shallow prayer hall with vaults perpendicular to the *qiblah* wall. Another of the prince's buildings has survived less well. Like Hulagu before him, Ulugh Beg was profoundly interested in astronomy and in 823/1420 he built an observatory, which in 1437 produced an important set of tables, a *zij*. The remaining arc of the great sextant, which was a structural part of the observatory, shows that the vanished building would have been three storeys high.

At the same period, at the new seat of empire in Herat, patronage was exercised by Shah Rukh and Gauhar Shad. Shah Rukh's dynastic pride was displayed in a panegyric inscription in *cuerda seca*, set in the wall of the Herat citadel in 818/1415–16 following renovations, which celebrates the pure lineage of the Timurids, praising Shah Rukh and his five sons with all the poetical resources of the fifteenth century. Gauhar Shad is not mentioned in this, unless robed in one of its metaphors, but she is found as the patroness of a mosque added in 821/1418 to the shrine of the Imam Riza, a descendant of the Prophet, at Mashhad, the inscription which records this being designed by her own son, Baysunghur. The mosque was the work of the architect Qavam al-Din, but, since the shrine is one of the most venerated in Persia, it has been subject to considerable restoration over the years. At Herat Qavam al-Din

85 The Gur-i Amir, Samarqand, 1404. Clavijo tells us that Timur visited the recently constructed mausoleum in October 1404, on the anniversary of the death of Muhammad Sultan. Timur himself was buried here, and also his sons, Miranshah and Shah Rukh, his grandson Ulugh Beg, and Sayyid Barakah, his spiritual guide. The mausoleum forms the south face of a courtyard; a *madrasah* and a *khanaqah* faced each other from the east and west sides.

built for the queen a *madrasah*, and in all probability the mosque it accompanied, in the area of an old open place of prayer, the Musalla. The complex seems to have been intended to rival the *madrasah* of Saray Mulk Khanum and the Bibi Khanum Mosque of Samarqand. The mosque was built from 820/1417 to 841/1437–8, and the *madrasah* was completed in 836/1432. Both buildings were already in a dilapidated state when they were blown up in 1885 lest they should offer cover to an anticipated Russian attack. There remained two minarets from opposing corners of the mosque, and a minaret and domed chamber from the *madrasah*. The lower sections of the minarets of the mosque were decagonal and decorated with underglaze-painted tiles, while the greater part of each shaft was sheathed in an exquisite lattice with lozenges of mosaic separated by rims of white marble.

The domed chamber of the *madrasah* would have stood at its south-west corner, and had a small bay extending from its south wall. The exterior of the dome referred to that of the Gur-i Amir, though with ribs set less closely together. The interior, however, shows the use of a newer sort of vaulting. Four arched ribs, parallel to the plane of the walls, intersected in the corners and lesser arches sprang across them in the squinch position, forming kite-shaped pendentives. These and subsequent fan-shaped compartments were filled with shallow *muqarnas*. Above the vault the dome is triple. Baysunghur was buried in this chamber in 837/1433, to be followed temporarily by Shah Rukh, and then by Gauhar Shad.

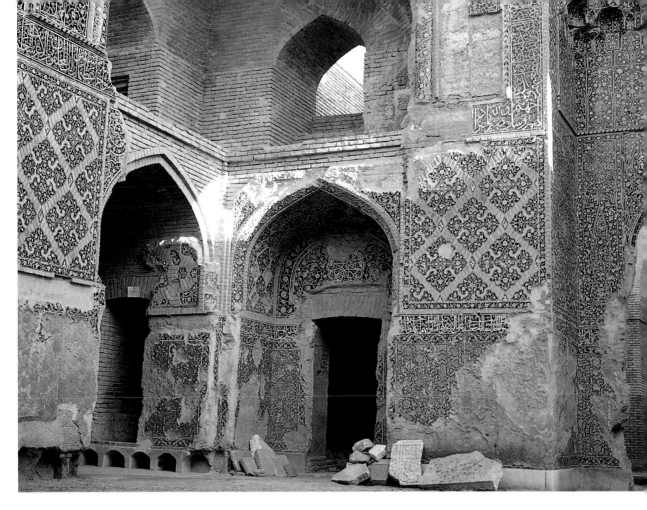

A complex which survived better is the shrine of the eleventh-century mystic Khwajeh ʿAbdallah Ansari, set in the foothills above Herat at Gazur Gah. The principal building was constructed on the order of Shah Rukh between 829/1425 and 832/1429, whether entirely from motives of piety or in part to dignify his capital; it may have been the work of Qavam al-Din, but this is not known for certain. The central shrine resembles a four-*ivan madrasah* but was described as a *hazirah*, meaning the enclosure round a tomb. The building was orientated east-west and was entered through a portal in the centre of the west façade – that is from the *qiblah* direction. The portal bay has five inner facets, as though it were half an octagon. A mosque hall and an assembly hall flank the portal, and cells for devotees surround the western half of the courtyard. The tomb of the holy man is located in the eastern half of the courtyard, and, since there are no cells beyond the side *ivans*, this area would have been even more tranquil than the western end. The eastern courtyard façade is dominated by a tall, though shallow, *ivan*, which forms a frame behind the tomb. The *pishtaq* of the *ivan* has an open gallery overlooking the courtyard, whose specific purpose is not clear. The east *ivan* is further distinguished by having the finest tilework of the ensemble. This includes large panels whose interlaced script suggests a mystical diagram. A cursive inscription runs round the panels, its ascending letters headed inwards and extended to form a grid. The divisions of the grid are filled with seal kufic, reiterating the praise of Allah.

86 The Blue Mosque, Tabriz, 870/1465. Officially named the Muzaffariyah from the *laqab* of Jahanshah, the mosque may also have functioned as a *madrasah*. The central dome has fallen, but much splendid tilework remains. The contrast of brick and glazed tile is an important feature of this interior, with an unglazed inscription in relief on a tiled ground and brilliant palmette crosses set off against brick.

The *hazirah* thus employs a four-*ivan* scheme with strong emphases at the entrance and at the *ivan* opposite the entrance, but the latter is not here the *qiblah-ivan*. In the late fifteenth century Husayn Bayqara made the *hazirah* the royal burial ground in preference to a *madrasah* which he had built in the Musalla area. Later still, Mughal architecture was to adopt from this or similar Timurid buildings features such as the portal bay and the *ivan* as screen.

The Turkman rulers of Western Iran were also patrons of architecture. Even less remains of this than of Timurid work, but a beautiful surviving building is known as the Firuzeh-i Islam (Turquoise of Islam) or Blue Mosque of Tabriz. This was completed in 870/1465, either by Jahanshah Qara Qoyunlu or his daughter Salihah Khanum. Though built of brick, the mosque looks towards the architecture of Anatolia. Its plan is an inverted T, and its central space was covered by a dome; it is thus related to the *madrasah* form evolved under the Seljuks of Rum, which by this date had been taken up by the Ottomans. The central dome was set upon eight equal arches supported by piers. The sumptuous tilework of the Blue Mosque embraced a range of techniques. Tile mosaic was used on the portal and round the arches of the interior. Dark blue hexagonal tiles lined the central dome, and purple tiles with gold design lined the smaller dome before the *mihrab*. Effective use was made of the contrast of glazed and unglazed work in a relief terracotta inscription on a ground of mosaic and in mosaic motifs inset into brick grounds. Particularly interesting are large inset palmette crosses whose dark blue grounds are thinly rimmed with turquoise so that they seem to glow. The frill-edged drawing of these motifs forms a mid-point between chinoiserie influences in early Timurid design, as seen in the Shah-i Zindeh, and early Safavid manuscript illumination.

Pottery

Abu'l Qasim's treatise makes it clear that by 1301 enamel decoration for pottery in the *mina'i* technique had been superseded by lajvardina. Some surviving lajvardina tiles show birds and dragons, but non-figurative designs were preferred on pottery. On the cobalt grounds, motifs are outlined in white and filled with small-scale white and red detail, with small patches of gold leaf. The production of this ware was probably not extensive. The expensive cobalt and gold leaf and the need for a second firing to fix the enamels would have made it costly, but perhaps more important was the development of other forms of decoration of more distinctively 'Chinese' character. A curious note on lajvardina is the fact that in 1308 the Khalji ruler of Delhi sent a quantity of this Persian ware to Rashid al-Din in Tabriz: was he perhaps turning out items he considered old-fashioned?

A new ware of the fourteenth century goes by the name of a find-site, Sultanabad, though it was probably manufactured in Kashan. Less dense in body than Kashan products of the thirteenth century, it ranges up to quite large vessels. Some bowls have an angular profile and a flat rim. In one variety of 'Sultanabad' the decoration is executed in cobalt and turquoise blue, with black outlines and areas of the white body reserved. In another there is a return to the use of slip, which, in grey or greenish grey, is used for a ground

upon which motifs are painted in a white slip with black outlines added. The effect is entirely different from anything previously made by an Islamic potter. The two levels of slip are used to create a surface texture, while the grey ground contributes an illusion of recession. At the same time there is a fundamental change in the treatment of the vegetal ornament. It is no longer the stylised calligraphic arabesque scroll descended from classical ornaments, but aims at a random and naturalistic effect, as though the viewer looked into a bowl of leaves. Drawn with an interrupted line, the leaves are separate, stubby and trilobed, and among them nestle lotuses. The leaves may form a background to birds, often the Chinese phoenix with flowing plumes, which was adopted at this period to represent the *simurgh*, the beneficent bird of Persian legend. Human figures are also shown, both Mongol overlords and Persian subjects. The Mongols sometimes sit on folding seats and are distinguished from the turbaned Persians by a headdress which resembles a sou'wester, with fluffy feathers at the back, said to be those of owls.

The eastern references of the Sultanabad style are very evident, but they are not the result of straightforward imitation, for China never decorated pottery in this manner. Instead the media which introduced the motifs were probably carved lacquer, supported by textiles – which would account for an impression of softness in the design – and drawings, which might account for the *grisaille* colour scheme.

87 Fritware 'Sultanabad' bowl with *simurghs*, from north-western Iran, first half of the 14th century. The Chinese phoenix – whose depiction seems to derive from an oriental pheasant – was soon accepted in Iran to represent the auspicious *simurgh* of Persian legend. Sultanabad wares make little use of inscriptions. Oxford, Ashmolean Museum.

The next phase in the connection with China is even more curious. Down the centuries the Islamic potters had admired the productions of the Chinese, but the compliment had hardly been returned. However, it appears that about the late thirteenth century the kilns of South China began to take notice of Islamic pottery decoration, and also of shapes derived from Islamic metalwork, the originals for both having been imported by small communities of Muslim merchants in coastal cities. The Islamic decoration would have been predominantly in blue and black, but the high temperatures necessary in the Chinese porcelain kilns precluded the use of black, and thus blue came to be used alone on white porcelain bodies. Blue-and-white porcelain thus came into being. It was not accepted by the Chinese court until the fifteenth century, but was an export ware directed to South-East Asia and back to the Middle East. In the course of the fourteenth century in Syria and Persia, the motifs on imported blue-and-white reinforced the taste for chinoiserie which had been developed earlier by textiles and drawings.

By the later fourteenth century the Middle Eastern potters in their turn had begun to imitate the Chinese wares, and they continued to do so into the fifteenth century and beyond; Mashhad was a centre of production at least as early as 848/1444–5, as shown by a spittoon in the Royal Museum of Scotland, Edinburgh. Though motifs of Chinese derivation such as the lotus show a distant kinship to Sultanabad, the design conception of blue-and-white is very different since the role of the white ground is of such importance. On the rather scarce objects of the fifteenth century the blue decoration has a misty quality; it is carefully drawn with a stylised naturalism, and shows lotus scrolls, peonies, dragons and *simurghs*. Shapes include simple hemispherical bowls, round-bodied jugs with high neck-rings (*mashrabeh*), and candlesticks. The ware is in fact more frequently seen in manuscript illustrations than in reality, but a teasing question attends the pictures since we cannot always be sure whether, for example, the representation of a long-necked flask intends a Chinese import or a local manufacture.

88 Fritware bowl with underglaze painting in blue, Iran, 15th century. The bowl closely imitates a Chinese type, though the drawing is a little stiffer. The blue on Middle Eastern wares usually has a warmer quality than that used by the Chinese. Bowls such as this are seen in 15th-century Persian miniatures. London, Victoria and Albert Museum.

Metalwork

The tradition for inlaid brass was continued in the fourteenth century in objects such as bowls, candlesticks and caskets on four feet, but it is often a matter of debate where the work was done. One of the Inju rulers of Fars, Abu Ishaq (1341–56), was a patron, and the figure drawing on some pieces reflects the vigorous but summary style of Inju manuscripts. On other pieces a greater concentration of Mongol headgear – feathered 'sou'westers', and caps with down-turned brims or in 'jelly-mould' form – suggests Baghdad. Willowy figures are indicative of a late fourteenth-century date.

From the more obscure region of the Caucasus cauldrons survive from the fourteenth century. These have four flanges projecting from their rims to provide a grip for pouring. The Caucasian metal industry was to continue into the nineteenth century, when chain-mail armour was still in use and possibly still in manufacture.

Huge vessels, like cauldrons in shape but intended to contain water in mosques, are associated with fourteenth-century Herat. An example in the Masjid-i Jami' of that city is dated 776/1374–5, and a similar piece, now in the Hermitage, was commissioned by Timur in 801/1399 for the shrine of Ahmad Yasavi at Turkestan. Both of these have polylobed handles on the side, and were cast with relief inscriptions and arabesques. Timur also provided the shrine with six large oil lamps in brass with bold inlays of silver and gold. Composed of base, stand and oil vessel, the lamps follow a type

89 BELOW LEFT Brass candlestick with dragon heads, Iran or Transoxiana, 15th century. The conception of dragons with light (and probably smoke) issuing from their mouths may be decorative, or it may have had a symbolic meaning. Copenhagen, David Collection.

90 BELOW RIGHT Brass jug (*mashrabeh*) and cover with gold and silver inlay, made in Herat in 900/1494–5 by ʿAzizallah Shaykh Vali. An inscription round the neck refers to the days of the reign of Sultan Husayn, who is described as sultan of the Turks, Arabs and Persians, and as divinely supported. Sold at Sotheby's, London, 11 October 1989, lot 99.

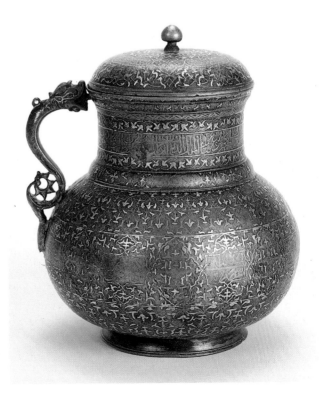

used by the Golden Horde. Timur's principal wife, Saray Mulk Khanum, evidently had a taste for collecting exotic metalwork. Clavijo noted at the entrance to her quarters doors in gold and enamel with figures of Saints Peter and Paul, which were booty from the Anatolian campaign, and within, a golden tree with jewelled leaves and birds in gold and enamel.

A fifteenth-century piece, which has no ornament beyond that which derives from its function, is a small celestial globe in the British Museum, dated 834/1430–31 and presumed to have been made for Ulugh Beg. It is made of brass with stars marked in silver with engraved identifications. Among decorated fifteenth-century objects such as bowls, round-bodied jugs and torch-stands, a change in style becomes apparent. The ornament continues to follow the fashions of the day in manuscript illumination and in script, but figurative motifs are omitted, probably because the increasing refinement of manuscript painting made imitation in metal impracticable. As a result, surfaces are now covered with intricate repeating patterns, with inscriptions and verses in cartouches.

Carving in wood, stone and jade

Carving of the period has great richness, as chinoiserie flowers and leaves are added to the traditional arabesques. Wooden doors remain *in situ* in a number of Timurid monuments, for example at the shrine built at Turkestan after 1397 for Khwajeh Ahmad Yasavi, a holy man for whom Timur had a particular veneration. On a more delicate scale, wood is the material of a box made for Ulugh Beg with chinoiserie ornament of dazzling verve. Two important pieces of early Timurid stonecarving remain in Samarqand. A *rahlah*, made to support Qur'ans of exceptional size, now stands in the court of the Bibi Khanum Mosque. Its sides are carved in low relief to resemble a contemporary bookbinding. The other piece, which now lies in the court-yard of the Gur-i Amir, is a large slab, perhaps the dais for a throne. It is covered with a network of arabesques, which again reflects the arts of the book. From the mid-fifteenth century a more complex play of many-layered

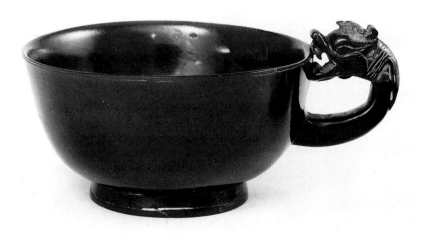

91 Dark green jade cup from Iran or Transoxiana, first half of the 15th century. A jade cup was thought to break on contact with poison. London, British Museum.

THE LAST EASTERN INVADERS

ornament, which owes something to both the Persian stucco tradition and to Chinese lacquer, was used by the Timurids for cenotaphs in black schist laid over the graves of notables. A very powerful effect is created by the contrast of the austere material with the opulence of the lotus ornament.

A plainer style which left much of an object polished but undecorated was usually used to display the beauty of jade. In white, green or greenish black, jade was obtained from Turkestan; it had long been favoured by the rulers of China, and was credited with protective and curative qualities, in particular the detection of poison. Datable to the Timurid period are a number of shallow cups with dragon-head handles which follow a type earlier made in gold for the Golden Horde. Similar dragon heads were used for the quillons of swords. Some jade objects bear the names of specific patrons. Now in the Gulbenkian Foundation, Lisbon, is a very beautiful jug of the round-bodied type with a dragon handle, made for Ulugh Beg in white jade. In 828/1424–5 the same ruler installed a superb slab of black jade in the Gur-i Amir as a cenotaph for Timur. An inscription making important genealogical claims was carved into the piece, but the greater part of the upper face is plain – a polished black surface which Art Deco might strive in vain to match.

Arts of the book

Magnificent copies of the Qur'an were made for both Uljaytu and Rashid al-Din. Some volumes were commissioned for Uljaytu's mausoleum, but one copy found its way to Cairo, where it influenced Mamluk style. The scripts used were *muhaqqaq*, or the less forceful *rayhani*, which has slim ascenders and vowels written with a finer pen. In richly illuminated *sarlauhs* geometric units filled with arabesque are repeated, as though they were excerpts from an endless pattern. On some leaves much of the ground is left in reserve under a tracery of gold, blue and black, so that the effect is very chaste and cool.

During the course of the century chinoiserie elements appear in illumination. In particular, in manuscripts produced in Shiraz from the late fourteenth to early fifteenth centuries, sprays of soft leaves, comparable with those on Sultanabad pottery, are drawn on grounds of blue and reserve. Otherwise, however, the arabesque reasserts itself, drawn with infinite fineness and clarity, and contained in subtle schemes of borders, rectangles and cartouches. The blue of lapis lazuli is the colour which shines from these pages, but it is made to coruscate by the addition of details in gold, white, black, green, red and brown.

From the late fourteenth century chinoiserie is also found in bookbindings. The central medallion and cornerpieces of the usual cover design, which had earlier been composed of straight-line and circle geometry, assumed the curving-bracket outlines associated with the Chinese 'cloud collar', which was at that time being adopted in costume. Lotuses and soft leaves also appear, especially in traceries of cut and stamped leather laid over blue or gold painted papers on the inner faces of the bindings. As the fifteenth century progressed, examples of leather filigree of astonishing delicacy were devoted to arabesque or to the chinoiserie menagerie of dragons, *simurghs*, deer, lions, apes and fish. In the late fifteenth century chinoiserie begins to be used on

92 Leather binding of a *Divan* of Khujandi, Iran, 856/1452. The manuscript was copied for the Timurid Sultan Muhammad b. Baysunghur, but the binding bears the name of his brother Abu'l Qasim Babur. The leather has been worked with fine instruments and is laid over paper painted blue and gold. Around the central dragon, dragonlets form cornerpieces of split-palmette or approximately *cyma recta* shape. Istanbul, Topkapı Sarayı Museum.

93 OPPOSITE Illuminated *sarlauh* to a *Khamseh* of Nizami, Herat, 900/1494–5. The manuscript appears to have been made as a diplomatic gift to the Timurid ruler of Samarqand, ʿAli Farsi Barlas. One of the most perfect pages of Persian illumination, this balances complexity with clarity. The white looping lines which organise the composition are in the tradition of the stone knot at Khirbat al-Mafjar (Fig. 9). The text is in *nastaʿliq*. London, British Library.

lacquer covers. For these, pasteboard was coated with gesso, which was then painted with opaque colours and transparent varnishes, the latter sometimes laid over small fragments of glinting mother-of-pearl.

A new script of the late fourteenth century is *nastaʿliq*, developed by Mir ʿAli b. Hasan al-Tabrizi, a Jalayrid scribe who may also have served Miranshah b. Timur. Derived from a combination of *naskhi* with *taʿliq*, a script with wriggling horizontal curves, its most characteristic features are very short ascenders and the incorporation into some letters of a diagonal line which sweeps down from right to left. The sweeping stroke is particularly evident in the case of the letter *sin*, which is written without teeth. From the mid-fifteenth century the diagonals are thickened and other lines thinned. *Nastaʿliq* is rhythmical and graceful, and was the script *par excellence* for the copying of Persian verse.

In the course of the fourteenth century a new style of Persian painting was formed, largely under Chinese influence, and in the fifteenth century this style found its classical expression. The meeting of the old and the new took place at different times in different centres. A bestiary in the Pierpont Morgan Library, New York, the *Manafiʿ-i Hayavan* (Uses of Animals), copied at Maragheh in the last years of the thirteenth century, has one animal style derived from the Arab *Kalilah wa Dimnahs*, and a new style of Chinese type in which animals of a more naturalistic hairiness are set in landscapes with Chinese traits, such as the close-up view of a tree-trunk or spray of willow. Of about the same period, and probably from Baghdad, are a number of 'small' *Shahnamehs* with highly accomplished illustrations in horizontal

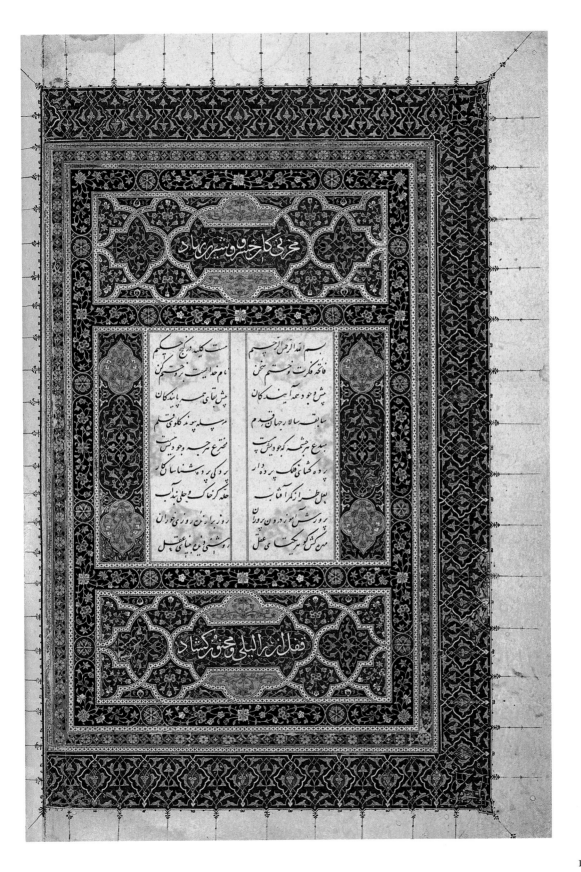

format, in which warriors of very eastern appearance gallop briskly over grounds of gold to encounter Chinese quadripedal dragons or other enemies. However, until the 1340s manuscripts continue to be made for the Inju dynasty in Shiraz in which arbitrary red backgrounds suggest an older tradition, and dragons tend to be of the older bipedal or legless serpentine breeds.

The Mongols' desire to define their place in the world and the legitimacy of their rule is shown by their patronage of historical writing. Rashid al-Din's *Jami' al-Tawarikh* was to cover the history of Turkish and Mongol tribes, the Jews, the Prophet and the caliphs, the Indians and the Franks; copies were to be made in the scriptorium of the Rab'i-Rashidi and broadcast about the empire. Two substantial fragments with contemporary illustrations survive from 706/1306–7 and 714/1314–15; the first is in the University Library, Edinburgh, and the second, formerly owned by the Royal Asiatic Society, is now in a private collection. The manuscripts are large, and their illustrations are in a horizontal format. Many figures have somewhat eastern features and clothing, and landscape is indicated by a few items against a plain ground, suggesting a connection with Chinese scroll painting. The palette is more restricted than had been usual in the Middle East; it makes a strange double effect of *grisaille* and colour, since the drawing in thinned ink is tinted in washes of clear red and blue, with a duller green. Some silver was also used for highlights, but unfortunately this has oxidised into grey streaks. The subject-matter includes many scenes of advancing warriors clad in scale armour and mounted upon shaggy ponies, and of kings seated upon thrones amid their advisers. There are also scenes of more specific character in which the painters can be seen to draw upon the pictorial traditions of many different communities: Nuh (Noah) afloat; Ibrahim (Abraham) visited by strangers, at a very palatial abode; the grove where the Buddha resided, shown by a close view of tree-trunks; the East Christian annunciation to the Virgin Mary at the well; or the Prophet Muhammad brought to the gates of heaven by the *Buraq*, a gazelle-like creature with a female face.

The *Jami' al-Tawarikh* was followed by a copy of the *Shahnameh* of similarly large scale, which, by a strange irony, is now known by the name of the dealer who divided it, Demotte. Firdausi's text relates in majestic verse the glory and the passing of the kings of ancient Iran. The illustrations to the Demotte manuscript portray these events, enthronements and battles, heroic deeds, love and death, marvels and mourning, with a grandeur and pathos never matched before or since in Persian painting. While illustrations in the *Jami' al-Tawarikh* suggest an interested detachment, those of the *Shahnameh* solicit the viewer with a hypnotic force. The paint is used with a greater density in dark and rich colours; and there is a distinct evocation of space rendered by overlapping layers in the compositions and graded shading in the skies. The figures are endued with a strong sense of dignity and of physicality, whether motionless or caught in demonstrative gestures. As they regard one another the web of eye-lines between them implies both space and drama. Backgrounds contain more detail than before, marked in landscapes by Chinese pines and willows and in interiors by exotic arch-forms and lacquered furniture. But this is not all, for the backgrounds now begin to feel

with the characters and to reflect the drama: sullen rock formations impend over an execution or describe a dragon's lair, boulders in the Land of Darkness have an incandescent glow, and a flowering tree with a broken branch comments on a slaying.

The Demotte *Shahnameh* was probably planned when the Il-Khan Arpah (736/1335–6) succeeded Abu Saᶜid against considerable opposition. The choice of topics for illustration, which emphasises the question of legitimate rule, would have seemed an apt commentary on contemporary affairs. For instance, the proposition that kingly qualities rather than direct descent make for legitimate rule, as shown in 'The enthronement of Zav', would have been welcome. Painting of the period of the *Shahnameh* has long been recognised as marking a new departure. Dust Muhammad, a painter writing in 951/1544 for the Safavid prince Bahram Mirza, ascribes the origin of classical Persian painting to the reign of Abu Saᶜid, in whose time, he says, Ustad (Master) Ahmad Musa 'drew the veil from the face of painting, and invented the way of painting which is current now'. Dust Muhammad then traces the pupils of Ahmad Musa through the fourteenth century and into the fifteenth; he mentions illustrators of manuscripts, and also specialists in *qalam-i siyahi*, pen-drawing in black ink, which presumably follows Chinese models. Which pictures might be attributed to these artists, and in general how painting unfolds in this period, is a matter of hot debate. The painters' work may be represented amongst a plethora of separate paintings, drawings, designs for embroidery or leatherwork, rough sketches and exercises, most without date or name attached, which have been preserved in a number of albums, now in the library of the Topkapı Sarayı in Istanbul, or in Berlin.

Some of the most powerful, but most puzzling, album paintings form a group with two subdivisions. On rough paper and without background, these pictures either show muscular demonic figures, often dancing ecstatically, or groups of nomads going stoically about their business. The group has acquired the name Siyah Qalam (Qalem), not because they are pen drawings, but because the name Muhammad Siyah Qalam has been added to some of them. In fact, the pictures are by several hands and extend in period from the fourteenth century, where energy and shading procedures relate examples to the Demotte *Shahnameh*, to the fifteenth century, when the demons become suaver and more calligraphic. The original home of the style remains an enigma, but various areas north and east of Iran, touched by shamanism and Buddhism, have been suggested.

The classical period of Persian painting begins in the late fourteenth century with the patronage of Sultan Ahmad Jalayr. A manuscript which contains three verse romances by Khwaju Kirmani was copied for him in Baghdad in 798/1396. The nine illustrations may be slightly earlier. They now engross the full page, though islands of text remain within them; the palette is lighter and brighter than before, with a preference for areas of cool blue, green and turquoise, set off by touches of vermilion and yellow. The tone is overwhelmingly romantic. The figures, now much smaller in the picture, are elegant and refined, but retain a naïve freshness. The settings, whether gardens and forests or palace interiors, reveal in idealised form the world which Sultan Ahmad knew.

94 'Mahmud b. Sebuktegin of Ghazni crosses the Ganges', from the *Jamiᶜ al-Tawarikh*, Tabriz, 706/1306–7. As an empire builder, Mahmud could be seen as a forerunner of the Mongols. The rare use of a profile conveys his forceful character as he advances on his pacing horse. The composition with diagonal pontoon bridge is of Chinese origin, and was to be revived under the Mughals. Edinburgh University Library.

95 'Isfandiyar reproaches his father Gushtasp', from the Demotte *Shahnameh*, Tabriz, about 1336. Gushtasp has not fulfilled a promise to abdicate in favour of his son. The political and personal drama is conveyed by the position of the participants: the son isolated on the left, the father endeavouring to look at ease, and the watching courtiers and women. At this period illustrations often have a stepped upper line. Florence, Harvard University Centre for Italian Renaissance Studies.

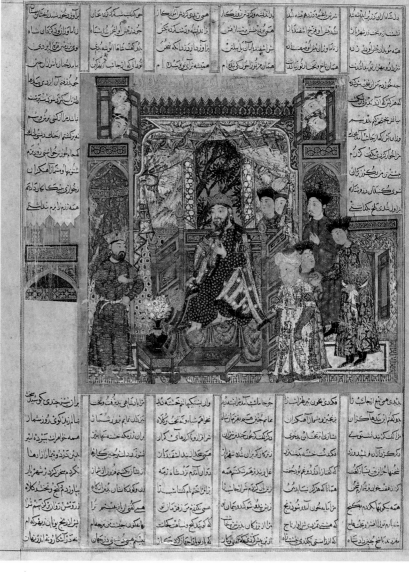

96 OPPOSITE 'The wedding night of Humay and Humayun', from a *masnavi* (romance in couplets) of Khwaju Kirmani, Baghdad, copied in 798/1396; the illustrations are approximately contemporary. The bridal sheet is displayed to prove that Humayun was married as a virgin; attendants scatter coins in celebration. Meanwhile, Humay receives congratulations. In the upper left the signature of Junayd, a pupil's pupil of Ahmad Musa, is found in red in the glazed tracery window. London, British Library.

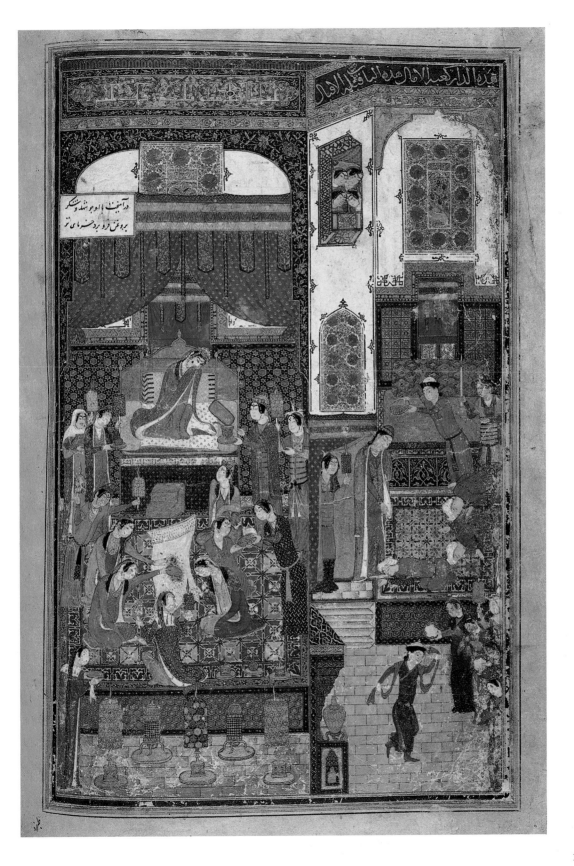

97 A painting of a conjuror or soothsayer, probably from Central Asia, first half of the 14th century. The chinoiserie quality of the strange flower and vase point to a 14th-century dating. Later attributions to Muhammad Siyah Qalam are found on pictures in this group. It is probable that painters of the Demotte *Shahnameh* derived some of the weight and energy of their drawing from pictures in this style, and also borrowed some technical features such as the manner of depicting folds. Istanbul, Topkapı Sarayı Library.

The history of painting in the fifteenth century is complex, threads of tradition moving from one centre to another when princes acquire painters as part of their booty at the conquest of cities, or occasionally by more peaceful means. Timur carried off Jalayrid painters to Samarqand, but their line is hard to trace. His grandson Iskandar was also served by Jalayrid painters during his governorship in Fars in 1409–14.

The range of Iskandar's interests is shown by a group of manuscripts made for him which contain not only selections from epics, romances and lyric poems, but writings on religious law and the sciences. On highly polished paper, the illustrations follow the Jalayrid style, but with a softer touch. Amongst them are the earliest known versions of many classic compositions, and the exquisite illumination in some margins contains motifs of Islamic, Chinese or even European origin.

After the fall of Iskandar, raw-boned and reduced styles were practised in Western Iran. The mid-century sees the appearance there of a competent but unexciting mode, known as Commercial Turkman, which is characterised by stocky figures; later, a more exotic flowering, which occurs under the patronage of the Aq Qoyunlu court, is known as Royal Turkman. Meanwhile, the best of Iskandar's painters had been taken to Herat where, for the princes Baysunghur and Muhammad Juki, they perfected the classical style. The gouache colour is laid on in clearly defined patches which are allowed to dry before detail is added. Clarity in draughtsmanship and the delicate poise of elements in the composition balance the lyricism of colour and romanticism of subject-matter. After the *Shahnameh*, the most favoured text was the *Khamseh* (Quintet) of Nizami, a poet of the twelfth century. This includes four narrative poems whose setting is the pre-Islamic world: *Khusrau u Shirin*, the story of Khusrau II Parviz and Shirin, an Armenian princess; *Majnun u Layla*, a story of tragic love in Arabia; *Haft Paykar* (The Seven Beauties), a

framework story in which princesses tell tales to the Sasanian king, Bahram Gur; and the *Iskandarnameh*, the story of Alexander the Great.

In the later fifteenth century the classical style flourished again at the court of Husayn Bayqara, where the best paintings have an added breadth of sympathy and depth of feeling. This further dimension is attributable to the work of the painter Bihzad, which made such a profound impression upon his contemporaries that his name became a byword as the supreme Persian painter.

98 *Divan* (Collected Poems) of Sultan Ahmad Jalayr, probably copied in Baghdad and probably of 805/1402–3. The poems, in an early *nasta'liq*, each include in gold the name of the royal author, Ahmad. The exquisite marginal ink drawings are widely thought to be contemporary, but an alternative view holds that they are a pastiche executed in the 17th century by Persian painters in Turkey. Whichever is correct, the drawings convey a fascinating picture of nomad life. Washington DC, Freer Gallery of Art.

Textiles and carpets

Since textiles are eminently portable there is every probability that they were a potent force in the introduction and dissemination of chinoiserie motifs, and it is known that an important gift of Chinese silks was brought back by a returning embassy of Ghazan Khan in 1298. However, few textile fragments which can be securely attributed to fourteenth-century Iran survive, and for the most part we must be content to follow developments as reflected in manuscript illustrations. In both the *Jamiᶜ al-Tawarikh* and the Demotte *Shahnameh* textiles with a 'Sultanabad' look appear. Other garments have embroidered cloud-collars, or squares of chinoiserie pattern upon the chest. Some fabrics have small repeating motifs and a few are checked, but the majority are plain. In the fourteenth century *tiraz* bands were still worn by Arabs or Persians, but the form was coming to an end.

Clavijo's account of Timur's court shows the ladies maintaining the Mongol tradition of wearing red as an auspicious colour. They also retained the *boghtaq*; this was a spectacular headdress which Clavijo describes, worn by Saray Mulk Khanum, as resembling a man's jousting helmet and requiring attendants to hold it upright. In the early Timurid period fabrics in pictures

often have a repeating pattern of a triangle of gold dots; Timur had used the triple dot as an emblem, but it was not exclusive to him and had indeed been represented earlier on costumes in lustre pottery. In the late fifteenth century garments are usually shown in plain fabrics.

Textiles were also employed for tentage. Ghazan Khan is reported to have used a tent in cloth of gold, so complex that it took a month to pitch. Clavijo's wondering description of the tents of Timur includes mighty works, suspended with poles and guy-ropes, which imitated castles and fortifications. They had silken walls, crimson hangings with golden spangles, and figured ornaments. He also describes another form of tent which was supported on a cylindrical frame and capped with a ring of wooden struts. This is the usual tent of Central Asia, and it is shown in a number of illustrations from the late fourteenth century onwards. In Europe it is sometimes called a 'yurt', but this word properly means the home camping-ground; a better description is frame or trellis tent, since the cylindrical wall has a trellis structure. The struts which form the domed roof of the tent are inserted into a central wooden wheel, and the whole is held together by woven bands. The tent of a nomad of the steppes would have been covered with felt, but in princely use richer fabrics were employed.

Illustrations also offer a record of carpets. In the Demotte *Shahnameh* one example has an animal motif, while others have kufic borders and fields of knot motifs or of barbed chevrons. The chevron ornament, used as a border round a field of triple dots, is found on an existing carpet in the Fitzwilliam Museum, Cambridge, which may derive from Timur's Samarqand. In the late fourteenth century carpets are represented as having fields of squares, brightly and variously coloured, and separated by knot patterns; pseudo-kufic borders are sometimes used. Pictures of the late fifteenth century from Herat show a change of taste, with curvilinear designs derived from manuscript illumination and more sophisticated colour schemes. The Masjid-i Jamic of Maybud, near Yazd, is reported to possess a carpet in a flatweave technique (*zilu*), dated 808/1405.

98

99 OPPOSITE, LEFT
'Manizheh watches Rustam rescue her lover Bizhan', from a *Shahnameh* made for Muhammad Juki, Herat, before 1444. The picture has a diagrammatic quality: night is not dark, and the pit is shown in section. London, Royal Asiatic Society.

100 OPPOSITE, RIGHT
'Bahram Gur slays the dragon' from a *Khamseh* of Nizami, Herat, copied in 846/1442–3; the illustration probably dates from 898/1493, 'painted by the slave Bihzad'. The dead tree symbolises the destructive nature of the dragon. London, British Library.

6

FERVOUR, OPULENCE, AND DECLINE
Iran under the Safavids and Qajars

T he Safavid conquest was of fundamental importance for modern Iran (an ancient name revived in 1935 for the country long known in the West as Persia), since Shiᶜism was established as the national form of Islam and since the country then became an entity and not a component part of an empire. After flourishing periods in the sixteenth and seventeenth centuries, Iran suffered stagnation, increased competition from Europe and devastating warfare in the eighteenth. There was some degree of revival in the nineteenth century under the Qajar dynasty.

Shah Ismaᶜil Safavi conquered Tabriz in 907/1501 at the age of fourteen. A charismatic figure who answered the need of the times, for the chaos of late Aq Qoyunlu rule had led people to look for a saviour, he is reported to have been of pleasing appearance, red-haired and left-handed. Ismaᶜil was descended from a dynasty of shaykhs in Ardabil, and on his mother's side from the Aq Qoyunlu. Imprisoned in early childhood by his royal relations, he was taken for refuge in 1494 to the little territory of Lahijan, south of the Caspian, where he was reared in the doctrine of Shiᶜism. Shiᶜism was acceptable to the semi-nomadic tribes of north-western Iran and, when Ismaᶜil emerged from hiding, they rallied to him; the doctrine was gradually propagated throughout Iran and came to be an important element in the formation of a sense of national identity. Even before the advent of Ismaᶜil, a tendency towards Shiᶜism had been growing among the Safavids, and the family, who were probably Kurdish, had come to see themselves as descendants of ᶜAli and had been hailed as divine. It was Ismaᶜil's father, Haydar, who had instituted the distinctive cap by which the Safavids were to proclaim their Shiᶜism in the sixteenth century. Within the turban the *taj-i Haydari* (cap of Haydar) rose in a high central peak which had twelve ribs running up it to symbolise the *imams* of Twelver Shiᶜism. In the early days the cap was always red, and the followers of the Safavids were known as *qızılbash* ('red-head' in Turkish).

Shah Ismaᶜil at first seemed invincible. After gaining control of Iran his greatest military feat was the destruction in 916/1510 of Shaybani Khan Uzbek and the capture of Herat. But a nearer threat to Ismaᶜil's capital at Tabriz was posed by the Ottoman Selim I, who resented Shiᶜite stirrings in his eastern lands. In 1514 Selim defeated the Safavids at the battle of Chaldiran

and sacked Tabriz. Isma'il was shown to have less than divine power, and it is said that he never smiled again. He died after a hunting trip in Georgia in 930/1524 and was succeeded by his son, Shah Tahmasp, then aged ten.

As an infant, Tahmasp had been nominal governor of Herat and thus directly in touch with the legacy of Timurid culture; in his early reign he practised both calligraphy and painting, but he was later increasingly haunted by religious scruples and in an edict of 1556 he renounced and banned painting. Tahmasp was at first under the domination of the Turkman *qizilbash*, but his later appointments of Persians to office show the beginning of a rift between the state and the tribes. In external relations he tussled with the Uzbeks for control of Herat; he received the Mughal Humayun in his exile from India in 1544; and, on the western front, having twice more suffered the occupation of Tabriz by the forces of the Ottoman Süleyman, he moved his capital to Qazvin in 1548. Diplomatic contacts were made with European states, but they were far from cordial. Tahmasp's death in 984/1576 was followed by a period of struggle and the brief reigns of two sons. In 1587 his grandson Shah 'Abbas came to the throne to be the most brilliant of the Safavid rulers.

Shah 'Abbas had also lived his early life in Herat, and while there had been fortunate not to be put to death on the orders of his father. On assuming power he showed himself an efficient administrator, though the means often included the summary execution of dissidents. Division was engineered in the ranks of the *qizilbash* by the introduction of a new concept of supratribal loyalty, *shahi-sevani* (devotion to the royal power). New troops of cavalry were created, many of whom were Georgian or Circassian: they were of *ghulam* status, but that they ranked on a par with the *qizilbash* was demonstrated when one of their number, Allahvardi Khan, was raised to the governorship of Fars. The army received training in the use of artillery from an Englishman, Sir Robert Sherley, and with this new force Shah 'Abbas drove back the Uzbeks and the Ottomans. He nevertheless preferred to move his capital from Qazvin to Isfahan in the Persian heartlands, where from 1005/1596–7 he constructed a new city. To draw wealth to this new centre he transported 3,000 Armenian families from Julfa in Azerbaijan to a suburb named New Julfa, so that the city could benefit from their commercial skills, especially in the matter of the silk trade.

Isfahan was the wonder of visitors from the East and West alike. Embassies were received from the Mughal Jahangir, from the Qutb Shah of Golconda in the Deccan, from the Tsar of Muscovy and from the rulers of Europe. 'Abbas was not constrained by bigotry: he liked to entertain European travellers and to go about his capital incognito, he permitted Christian monastic orders to open missions, and he drank wine freely. Nevertheless, he maintained a firm and autocratic grip on affairs. He died in 1038/1629.

After the disastrous reign of Safi, the grandson of 'Abbas and the first of the Safavids to have passed his early years within the harem, the rule of Shah 'Abbas II from 1642 to 1666 reflected aspects of that of his namesake in its efficient government, openness to European influence and wholehearted indulgence in the pleasures of life. But from this time onwards Iran began to sink towards misrule. In the late century the economy, which hitherto had

prospered, began to decline, a factor in this trend being the diminished importance of the overland silk route following the development of sea trade by the European powers.

A terrible blow was struck in 1722. Mir Vays, an Afghan tribal leader of Qandahar, had declared his independence; his son, Mir Mahmud, invaded Iran and after a siege of seven months captured Isfahan. Safavid rule was in effect brought to an end, but the struggle to restore Tahmasp II to power was carried on by a member of the Sunni Afshar tribe. When the shah had proved incompetent and his infant son had died, the Afshar himself accepted rule in 1148/1736, taking the regnal name of Nadir Shah. Nadir Shah went on the offensive, retook Qandahar, and in 1739 sacked Delhi. He then lapsed into despotic rule, and was assassinated in 1747. From the ensuing chaos there emerged Karim Khan Zand, a feudal lord in Fars. He ruled the greater part of Iran from 1750 to 1779. His successors contested the country with Agha Muhammad of the Qajars, whose power-base was in the more prosperous north of Iran, and lost. Agha Muhammad, a eunuch, was followed in 1797 by his nephew Fath ᶜAli Shah, who, though his imagination was stirred by the glories of pre-Islamic Sasanian Persia, was obliged to cede Armenia to Russia by the Treaty of Turkmanchay. The late Qajar period was marked by ever-increasing European influence, as shown by the Anglo-Russian agreement of 1907 which asserted two spheres of interest in the country. In 1925 the Qajars were displaced by the Pahlavis, who ruled until 1979.

After their capture of Samarqand at the beginning of the sixteenth century, the Uzbeks, based in Bukhara, had posed a threat both to Iran and to the India of the Mughals, but, in spite of battles which tossed the rule of territories to and fro, the threat was never fully realised. Uzbek power waned, and Central Asia lived a life which saw much less change than that of Iran, until the area was penetrated by Russia. The Janids, whom Ivan the Terrible had dislodged from Astrakhan in 1556, ruled Bukhara in the seventeenth and eighteenth centuries, to be followed by the Mangits in the nineteenth. Meanwhile, a dynasty of Uzbek *khans* held Khiva. In the early eighteenth century a *khan* of Khiva accepted the suzerainty of Peter the Great as a support against the Janids and the Turkman tribes; however, relations soon cooled. In the late eighteenth century Khiva flourished, but the Russian advance of the nineteenth claimed Tashkent in 1865, Samarqand and Bukhara in 1868, Khiva in 1873, and Marv, the centre of four Turkman *khans*, in 1884.

Architecture

As the master of Tabriz, Shah Ismaᶜil was able to enjoy the splendours of its Turkman buildings, the palaces of the Aq Qoyunlu, known to us only from the accounts of a handful of European travellers who speak of gateways, gardens, pools, and work in blue, gold and marble. Ismaᶜil therefore had no pressing need to build his own capital city, and the frequent military campaigns of his early reign were a further reason not to expend a particular effort upon an art which was not portable. Thus it happens that the surviving building which best expresses the spirit of the early Safavid period is not a royal foundation, but a work commissioned by the vizier Durmish Khan: it is the tomb of Harun-i Vilayat at Isfahan, dated 918/1513. The identity of the

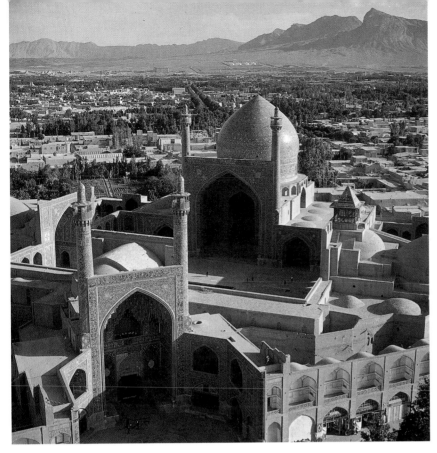

holy man for whom the tomb was built is not clear, and it seems probable that the vizier found his opportunity for patronage in the revival of an earlier shrine. The principal structure, an octagon surmounted by a bulbous dome clad in recent tilework, is set in a small courtyard. It is not this which claims the attention, but the entrance portal which leads to it. Here, in brilliant tile mosaic, the vizier has expressed his homage to Ismaʿil as ruler and religious leader, referring to him as *ghazi* (warrior for the faith), as caliph, and as descendant of ʿAli. Above the inscription Chinese clouds in white are wreathed around two confronted peacocks. This unusual use of living creatures on a religious monument must have symbolic intent, and it is clear that the gateway is speaking of Paradise and implying that Ismaʿil, like his forebear ʿAli, is the door to it. The reverence for Ismaʿil as a religious figure is taken even further in an inscription on a nearby mosque known as the Masjid-i ʿAli, built in 929/1522. Here it is declared that the name Ismaʿil appears in the Qur'an 'as many times as there are *imams*', which is to say twelve: it is thus implied that Ismaʿil is the paradigm of Twelver Shiʿism. The interior of the *masjid* has deep bays in the walls, like those of the Blue Mosque of Tabriz, and the line of its squinches descends to the ground in a manner which would be taken up later in the Masjid-i Shaykh Lutfallah. An interesting secular monument of the reign is at Khoy; it is in the form of a minaret set with the horns and skulls of the game which the shah loved to hunt. Ismaʿil was buried in a modest tomb at Ardabil.

Little survives of the buildings of Shah Tahmasp, but the remains of a palace of about 1560 at Nayin still display a rich decoration. In the largest *ivan* a new ornamental procedure uses a thin layer of white stucco carved to reveal

a darker ground behind it. The walls above the dados have royal scenes of hunts, polo, picnics, subjects from the romances of Nizami and Jami, and lines from Hafiz, while the smaller segments of the complex net of squinch forms in the vault are filled with chinoiserie dragons, *simurghs*, duck, and at the apex a group of eight angels.

The most famous and complete assemblage of Safavid buildings is that erected by Shah ᶜAbbas in Isfahan after 1598; it shows a new interest in planning. The first major project was the Chahar Bagh, a majestic avenue which formed a connection between the older settlement round the Masjid-i Jumᶜeh and the river, continued over this, by way of the Allahvirdi Khan bridge of 1011/1602, to Armenian New Julfa, and on to a vast garden. The Chahar Bagh (so called because it ran through the land of four orchards and not because it was square in plan) had a water channel running down its centre with fountains and cascades, and flower-beds. On either side ran a row of *chinar* trees (oriental plane) and pavilions. Somewhat to the east of the Chahar Bagh and running approximately north-south is the Maydan, a great rectangular space 512 metres by 159. This was the heart of Shah ᶜAbbas's new city, where markets were held, polo played, troops reviewed and executions performed. A two-storeyed enclosing wall acted as a background to these activities; in its lower level a succession of vaulted spaces were used for shops, while above were similarly arched shallow spaces purely for visual effect.

The worldly and other-worldly purposes of the Maydan are typified by the great tiled portals in the short north and south sides, the one leading to the bazaar and the other to the Masjid-i Shah. On the east side, but at approximately a third (or a golden section) of the distance from the south end, is situated a royal oratory, the Masjid-i Shaykh Lutfallah. Opposite this on the west side is a palace pavilion, the ᶜAli Qapu, a name which does not refer to the Prophet's son-in-law but which means High Gate. The ᶜAli Qapu was both the gate to the royal gardens and a pavilion whence the shah could watch events in the Maydan, but it was also a palace gate in the ancient oriental tradition, where ambassadors would be received and business transacted. The building is in two parts. A structure to the height of the Maydan wall supports above it a *talar*, an open hall with a roof on wooden columns and a pool at its centre. This gives an excellent view over the Maydan, and, looking eastward, avoids the glare of the afternoon sun. Behind this section rises a cuboid block – which has been rather unkindly compared to a 'boot-box'. Enlarged from a Timurid pavilion, the rear section contained offices, a reception hall backing the *talar*, and above that a music room ornamented with stucco niches in the shape of glass or porcelain vessels. The ᶜAli Qapu is richly decorated with gilded stucco and stained-glass windows. As the Italian traveller Pietro della Valle noted in 1617, there were also wall-paintings representing men and women. These were sometimes shown drinking, sometimes embracing, and some wore European hats.

The Masjid-i Shaykh Lutfallah, built from 1011/1602–3 to 1028/1618–19 in honour of a shaykh who was father-in-law to Shah ᶜAbbas, has the form of a dome-on-square, and is indeed much like a tomb without a cenotaph. From a tiled entrance façade, of the height of the enclosure wall of the Maydan, an *ivan* leads to a dim vaulted corridor which runs outside two sides of the square

structure until it reaches an entrance in the north-east wall opposite the *mihrab*. The corridor marks a transition from the outer world of the Maydan to a chamber which is instinct with the Islamic vision of the other world. A bluish light enters through tiled grilles in the drum, slightly muting the rich tilework which covers the walls. The transition from cube to dome is performed with majestic grace: the system of support is illustrated by eight great arches of turquoise tilework in cable form which rise from a low dado to the full height of the wall, four in the position of squinches and four against the side walls; between them are kite-shaped squinch-pendentives, and the walls appear as though a rich textile were draped over this frame. White tile inscriptions rim the inner sides of the arches and the base of the drum. Within the dome, ranks of units of tilework of ogee-mandorla form are set in a lattice of plain brick and diminish in size until they meet a central sunburst patterned with a tracery of arabesque.

Seen from the exterior, the dome of the Masjid-i Shaykh Lutfallah rises with a minimum of swell over the drum and sweeps smoothly over an elegant hip to a relatively low point; it is covered with tile arabesques. Such work on the varying curvatures of a dome would have required a highly skilled designer, and it became a proud feature of Safavid architecture. In this example a brilliant optical illusion is also achieved, for the dome appears as though covered in pale chased gold, while the greater part of the surface is in fact buff brick, with glazed scrolls of white rimmed with black and secondary scrolls of light blue. The impression of radiance derived from the juxtaposition of brick and rimmed and curvilinear colour was probably learned from the Blue Mosque of Tabriz.

The dome of the Masjid-i Shaykh Lutfallah does not stand directly behind its entrance *ivan*, but is offset to the south. This marks the fact that the north-south orientation of the Maydan does not agree with the *qiblah* direction (south-west), but is set at 45 degrees to it. Why the Maydan was planned thus is not clear: whether Shah ᶜAbbas was constrained by existing land rights, or wished to obtain shade for the ᶜAli Qapu, or simply to raise a problem in order to enjoy the elegance of its solution. However that may be, a change of direction is achieved at the mosque by interposing a triangular space between the back of the entrance *ivan* and the corridor. The same problem was solved by the same method when the great Masjid-i Shah was built at the south end of the Maydan between 1021/1612–13 and 1040/1630. A majestic entrance portal in the middle of the south side of the Maydan has a high *pishtaq* with twin minarets topped with roofed balconies (*guldasteh*, 'bouquet'). The portal leads to the back of the north *ivan* of a four-*ivan* mosque, but the rear of the *ivan* is again triangular in shape, and the axis of entry is again bent, like a ray of light passing through a prism. Within, the courtyard is broader than it is long, the façades are richly tiled, and another *pishtaq* with minarets fronts the sanctuary. The dome, which is double, is set on a high drum; bulbous at the base, it sweeps to a high point. The decoration of the Masjid-i Shah marks the climax of the development towards smooth surfaces clad in polychrome tilework. The entrance portal is executed in a brilliant tile mosaic, which gathers resonance from the shade of its north aspect. The main body of the mosque, however, is treated with overglaze-

102 OVERLEAF The interior of the dome of the Masjid-i Shaykh Luftallah, Isfahan, 1025/1616. The turquoise cable moulding of an arch is seen below the dome, in which concentric rings of thirty-two lozenges diminish in size as they approach a centre which gives an impression of luminosity. The design, which suggests both movement and stillness, is a powerful though not an explicit vehicle of religious symbolism, speaking of the harmony of the universe.

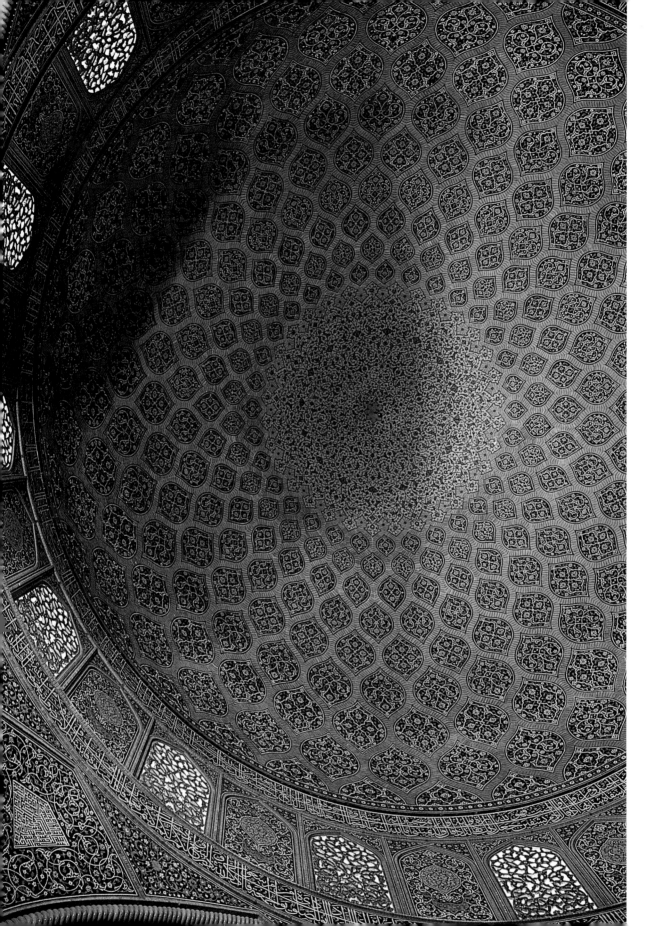

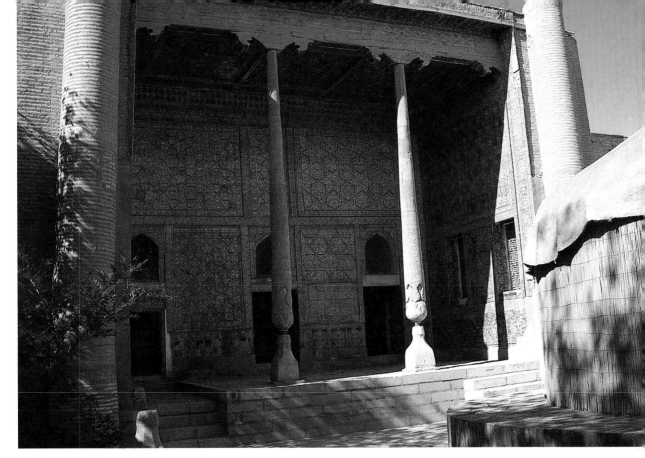

painted tiles which are sometimes described as *haft rangi*; more than satisfactory at a distance, these lack the splendour of tile mosaic in a close view. The Masjid-i Shah is thus perhaps best viewed from the vantage point of the ᶜAli Qapu, whence the suavity of its forms is seen robed in a haze of blue.

The development of Isfahan continued under Shah ᶜAbbas II, two monuments in particular showing a sophisticated mingling of interior and exterior space. Perhaps in part a renovation, his Chihil Sutun (Forty Columns) pavilion is set at the head of a long rectangular garden pool, which reflects the eighteen tall columns of its *talar*. There is a pool in the centre of the *talar*, behind this a throne room with another central pool, and behind this again a triple-domed hall of the time of ᶜAbbas I – it is somewhat as though the elements of the ᶜAli Qapu had been laid out flat. Like the ᶜAli Qapu, the Chihil Sutun was decorated with wall-paintings, and also with a mosaic of fragments of mirror-glass imported from Europe. The other great monument of ᶜAbbas II is both elegant and utilitarian; it is the Khwaju bridge of 1060/1650. The bridge stands on a masonry barrier and functions in part as a dam, its twenty-four water-level arches being furnished with sluices. Its superstructure provides a vaulted walk on either side of a central roadway for horses and wheeled traffic. In the centre of the bridge is an octagonal pavilion from which the shah could watch water sports and displays.

The development of architecture in Central Asia in this period is in many respects parallel to that of Iran, but tends to be more conservative. In default of early sixteenth-century buildings in Tabriz, the fine Mir-i ᶜArab Madrasah built in Bukhara in 942/1535–6 illustrates the heritage of the fifteenth century. Its façade is distinguished from those of earlier *madrasahs* in Bukhara

103 The Kurnish Khaneh (Audience Hall) of the Kuhneh Arg (Old Citadel), Khiva, 1804–6. The tapered wooden columns of the *talar* are a traditional form in Transoxiana; at this period the lower end of the column is sharply constricted above the base. In the small courtyard a round plinth is provided as the site for a frame tent; the example shown has a covering of canes round its trellis, which permits the movement of air.

by the depth of its two storeys of niches and by the fact that the entrance *ivan* has a five-faceted bay, but above all by its copious use of tile mosaic. It retains emphatic corner buttresses, and over its tombs rise the turquoise domes to which Central Asia remains faithful. By the 1650s the tilework of Bukhara's ᶜAbd al-ᶜAziz Madrasah declares its date by a more extensive use of yellow motifs on a blue ground, and suggests a relation with Iran in its use of multicoloured tiles and broad arabesques, but it also displays panels in which vases of flowers in cut mosaic are rendered with fluent naturalism.

At the same period the Rigistan in Samarqand was renovated with the addition of two new buildings. The earlier, the Shir Dar of 1045/1635–6, in part reflects the façade of Ulugh Beg's Madrasah of 1417 opposite, with a high portal and corner buttresses in the form of minarets. Much of its exterior is covered in the fifteenth-century manner with *banna'i* inscriptions, but it receives its name from the tile mosaic motifs in its spandrels which show, with a boldness which verges on the brash, the astrological symbol of lion-and-sun, though in the form of tiger-and-sun (a variant permitted by the word *shir*). This ebullient building employs two small domes which, being ribbed, reveal their debt to Timurid architecture. The profile of these domes, however, is closer than usual to the pointed form used by the Safavids, a shape which probably failed to find favour in Sunni Central Asia on account of an association with the bulb-shaped Safavid turban symbolic of Shiᶜism. The other building, the Tila-kari (Goldwork) Mosque-Madrasah of 1646–60 is much more sedate, though, owing to its having a south-east façade on to the Rigistan, when the *qiblah* direction is to the south-west, it has the peculiarity of raising its sanctuary dome to one side of its entrance portal.

In Khiva from the late eighteenth century and throughout the nineteenth, the traditional building forms are repeated: classical *madrasahs*, thick-set tapering minarets, and palaces with small *talar* porticoes on carved columns. At a time when tilework was running riot in Qajar Iran, with pictorial tiles and aggressive geometrical pattern, the tilework of Khiva is predominantly a chaste blue-and-white, a tribute to local fourteenth-century style, though now executed with fine but dense and restless arabesques.

Pottery

A wealth of pottery survives from the Safavid period, and some headway has been made in its classification by type, date and place of origin. A group of wares which is long-lived, extending from the fifteenth to the seventeenth century, and possibly disparate in origin is known by the name 'Kubachi', since numerous examples were found used as decoration in the houses of a village of that name in the Caucasus. It is thought that these wares were not made locally, but that they came by way of trade for the local production of arms and armour, and that the original source was probably often Tabriz. The vessels, usually wide dishes with an everted rim, have a light porous body which is often reddish, and are covered with a white slip. Their glaze is often crazed. However, the technical failings are redeemed by the liveliness of their heterogeneous decoration. Designs in black under turquoise, blue or green glazes show their descent from fourteenth- and even thirteenth-century types. Decoration in blue-and-white, with some black additions,

104 Fritware *qalyan* in the form of a duck, probably Mashhad, 17th century. The duck is decorated in underglaze blue and black. A mate to this exists in the Victoria and Albert Museum and *qalyans* are also found in the shape of cats or elephants. This playful animal style is derived from a Chinese drinking vessel, the *kendi*. London, British Museum.

shows a knowledge of that on Chinese porcelains of the fifteenth or sixteenth centuries which ranges from familiarity to a nodding acquaintance. Some pieces of about 1600 are polychrome with a weak red or yellow slip added to the palette; they appear to be influenced by the 'Rhodian' style of Ottoman Iznik, though they often show figures or the heads of men or women.

Kirman was almost certainly the centre of production of a ware which has a white body, more dense than that of Kubachi, a white slip, and a glaze which tends to have minute bubbles. The decoration takes the form of sprays of blue leaves and flowers. It seems to represent a continuation of the fifteenth-century blue-and-white style, and indeed the drawing of the sprays recalls the leafy type of illumination practised in south-western Iran in the early fifteenth century. As in the Kubachi pieces, there was an inclination in the seventeenth century to add more colour. In the Kirman wares additional dull red and dull green slip ornament is usually confined to cartouches, while the main surface is in blue on white. Another change is the introduction of scenic excerpts from contemporary Chinese export porcelains. A variation on the theme of decoration in two distinct manners is the combination of Chinese motifs in the centre with a border of black cartouches with Persian verses incised through them. The use of slip was not confined to detail. Some wares have a slip, often blue, which is cut through to reveal the white ground; others have a covering of olive or greyish slip intended to imitate Chinese celadon. Among the Kirman wares, vases are found with nozzles for individual flowers, a form which traders of the Dutch East India Company would have acquired via the port of Bandar ʿAbbas and which would make a contribution to Delft tulip vases of the late seventeenth century. The British Museum has vessels, presumably intended as vases, which reproduce in blue-and-white the high-heeled slippers of the period.

105 Fritware dish with carved slip, probably Kirman, 17th century. The glaze is clear and the decoration is carved through a blue slip, thus the technique is Persian though the lotus design shows Chinese inspiration. Copenhagen, David Collection.

Production is thought to have continued in Mashhad with a white and hard ware whose glaze is thin and clear. Decoration is in blue, often with a black outline, which makes a much more clear-cut impression than the work of Kirman. The drawing is much closer to that of Chinese exports and has indeed sometimes been passed off as such. The more authentic effect may mean that potters or designers had seen Chinese examples. Ibrahim Mirza, a nephew of Shah Tahmasp and patron of arts, who had a collection of Chinese porcelain, was governor of Mashhad from 1556; and Shah ʿAbbas gave a gift of porcelain to the shrine at Mashhad in 1015/1606–7, as he also did to the

shrine at Ardabil in 1611. Forms of pottery attributed to Mashhad are various and include dishes, bowls with rounded sides, ewers of teapot shape and examples of the *qalyan* (the hubble-bubble pipe in which tobacco smoke is drawn through water) in the shape of all manner of flasks, birds and beasts.

Three types of ware bear witness to a seventeenth-century revival of interest in the fine pottery of the twelfth and thirteenth centuries. In each case the body is white and dense and the glaze shiny. One type has lustre decoration, perhaps revived in its original centre of Kashan. The lustre often has a reddish tone from a high copper content, and it is applied over grounds which are white, blue, or occasionally yellow. The drawing, usually of leafy sprays, lacks vigour. The second category has bright monochrome glazes in green, amber or purple, applied to objects which may imitate metalwork forms or have decorative scenes in relief. It is this type of vessel which the young courtiers in the early seventeenth-century drawings by the painter Riza-yi ʿAbbasi have on hand for their refreshment, and a tentative attribution is sometimes made to Isfahan. The last group has a very clear glaze over a very white body and may be carved or pierced in the twelfth-century manner; it was known in Europe as 'Gombroon' after the former name of Bandar ʿAbbas.

From the seventeenth century large schemes of pictorial tiles were made for dados and spandrels. Busts and figures are known in Kubachi style, and *fêtes galantes* which reflect the billowing line of the seventeenth-century court artists. The favoured colours are blue, white, green and yellow. Pictorial work of a very painterly character continued under the Qajars, with floral designs in brilliant pinks and yellows or sepia imitations of prints and photographs.

Jade and metalwork

A jade jug in the Topkapı Sarayı is inlaid in gold with the name of Shah Ismaʿil and fine spiralling scrolls. It is of the classic Timurid *mashrabeh* shape, and has a dragon handle in gold – it may, indeed, be a reworked Timurid piece. Its decoration suggests that the enthusiasm for inlaid jade which was to be shown by the Ottomans, and later by the Mughals, may have been derived from the Safavids.

After this period jade is little used in Iran, but the round-bodied jug form continues to be made in metal. Another class of object found in the fifteenth century but particularly characteristic of the Safavid period is the torch-stand of pillar shape (*mashʿal*), which was used at outdoor gatherings at night. These are frequently inscribed with verses which employ the poetic motif of the moth attracted to the candle flame. An item which must refer to the religious climate of the time is the *kashkul*, a boat-shaped vessel derived from the dried-gourd begging bowl of the wandering dervish, though when in metal evidently intended for a more well-to-do clientele. There are also bowls in brass or tinned copper. Decoration continues the Timurid trend to small-scale repeating patterns and inscriptions in cartouches; it is usually engraved, and the ground of designs is often darkened with hatching or with an applied black substance. Human figures are rare, but are found occasionally, as on a copper disc from an astronomical instrument of about 1600 in the

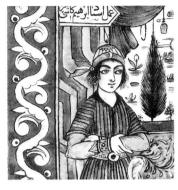

106 Fritware tile painted in underglaze colours, showing a serving boy. Iran, about 1820–30, the 'work of Ustad Ibrahim Kashani'. The dominant colours are black and blue, with dull green, brown, yellow and purple. The tile comes from the upper left-hand corner of a court scene; the folded arms of the boy were the proper posture for a servant. The signature demonstrates that the Kashan *nisbah* was still a matter of prestige in the 19th century. Private Collection.

Victoria and Albert Museum, which is engraved and gilded with angels, astronomers, hunters and the zodiac symbolised in the body of a man.

Steel was the material of flat cartouches cut into openwork with inscriptions in fine *nastaʿliq*; these were probably for application to cenotaphs, doors or other architectural features. Steel was also used in a range of fine weapons. Though the damascening of blades had been practised in earlier periods, survivals are more numerous from the later centuries. Transverse cuts were sometimes used in the course of forging to produce a pattern of bars known as 'Muhammad's ladder'. In view of the hardness of steel, the decorative inlay of gold on weapons is often of a superficial type known as *kuftgari* (beaten work), where the gold was hammered on to a roughened surface.

From the nineteenth and twentieth centuries comes heavy silver jewellery, which was worn by the Turkman women. It may be parcel gilt and studded with cornelians and sometimes turquoises.

Glass

Though glass is not a major feature of the period, the rosewater sprinklers of the eighteenth and nineteenth centuries deserve mention for their elegant shapes. Mould-blown, sometimes ribbed and often in blue glass, they have round bodies, undulating swan-necks and mouthpieces which resemble the cup of an exotic flower.

Arts of the book

Early Safavid painting proceeds directly from a style practised for the Aq Qoyunlu, known as Royal Turkman. Indeed, the grandest of the Royal Turkman manuscripts, a *Khamseh* of Nizami in the Topkapı Sarayı Library whose copying was completed in 886/1481 for Sultan Yaʿqub, contains both Aq Qoyunlu and early Safavid illustrations. In both the colour is brilliant, the compositions densely packed and full of movement, and the drawing considerably influenced by fourteenth-century album styles. In the Turkman pictures these elements convey richness with a hint of decay, but in the Safavid the turmoil of a new birth. This is partly owing to a tendency to instability in the Turkman compositions, but chiefly it derives from the Safavid figures, which radiate energy and optimism. The Safavids have more open postures, and the men wear the *taj-i Haydari*, which conveys an impression of power. At this early period the cap is shown only in red; it reaches the thickness of an arm and the ribs upon it signifying the twelve *imams* are clearly visible. The helmets of warriors are provided with a hole through which it emerges like a smoke-stack. A curious indication of the development of the *taj* is seen in Asafi's *Jamal u Jalal*, the quest for the princess Beauty by the prince Splendour. The manuscript, in the Uppsala University Library, was copied in Herat in 908/1502–3, whence it was apparently taken to Western Iran. Its first illustration shows figures with a low cap in the turban, but in the following three or four pictures the cap rises, like a hyacinth from its bulb. The gradual progression suggests that the illustrations were made in Western Iran just when the *taj* was becoming general, rather than that illustration started in the Herat region, as has been suggested. Whether Shah Ismaʿil himself was the patron of the additions to the Nizami and of *Jamal u*

Jalal is not known, but it seems probable. It is even more probable that four pictures from an uncompleted *Shahnameh* were made at his command, since they have the amplitude of a royal work and an intensity which would reflect his character. It may be that the volume remained unfinished as a gesture of remorse or despair after the defeat at Chaldiran in 1514.

A magnificent *Shahnameh*, the most sumptuous of all Persian manuscripts, was made for Isma'il's successor, Shah Tahmasp; now known as the Houghton *Shahnameh* and partly dispersed, this work contains a picture dated 934/1527–8. The epic heroes are as usual in contemporary dress, and the cap within the turban now rises like a slim rod. Significant changes have also come about in the style of painting, which is now calmer and more meticulous though still full of detail, and in a wide and harmonious palette. The factor of vital importance for this change was the appointment of Bihzad – transferred from Herat to Tabriz – as director of the royal library in 928/1522. Though elderly, Bihzad would have been very influential. Thus a line of tradition from the classical refinement of Herat blended with the Turkman vigour. The changes are also in part attributable to the character of Tahmasp and to the altered circumstances of the state. Rulers frequently commissioned a *Shahnameh* early in their reign, but in the case of Tahmasp it seems particularly probable that he would have sought reassurance of the legitimacy and security of his rule by immersing himself in the world conjured up by illustrations to the Persian epic.

From the outset of the Safavid period an important change occurs in convention for the illustration of the Prophet Muhammad and of his family: the faces are now veiled in white. This is found in an illustration of Muhammad's ascent into the heavens (*Mi'raj*) in a *Khamseh* of Nizami copied for Tahmasp in 949/1543. The picture, which is of great power, is considered to be the work of Sultan Muhammad, a painter who retained the early Safavid fervour while acquiring the penetration and finesse of Herat, and who is reported to have given lessons to the shah himself. The veiled Prophet, haloed with leaping fire, a throng of angels around him, is swept upwards into a sky of the purest lapis lazuli. Between the angels curl white clouds of Chinese origin, and – a new feature – a haze of naturalistic cloud surrounds a planet which the Prophet has passed. Other pictures in this manuscript have attributions upon them to various artists of the royal atelier, and the work of other craftsmen was lavished upon it. It was copied in the beautiful *nasta'liq* of Shah Mahmud Nishapuri, and the margins are filled with chinoiserie work in gold. The arabesque illumination, in fine lapis and gold, again shows the meeting of elements from the Herat and Turkman styles, and it makes use of a new Safavid feature, a broad strap-like stem.

Shah Tahmasp was not alone in fostering painting. Two of his brothers were also patrons, Sam Mirza and Bahram Mirza, for whom Dust Muhammad wrote the account of Persian painters which has been mentioned before. This important source – which also covers calligraphers – was the preface to an album composed for Bahram in 951/1544–5. Bahram's son Ibrahim Mirza inherited his father's interest. In 1556, when Tahmasp turned against painting and produced his edict of sincere repentance, he also sent Ibrahim to govern Mashhad. Ibrahim took with him the calligrapher Shah Mahmud and artists

107 OVERLEAF, LEFT
A *Shahnameh* subject, 'Sleeping Rustam', probably painted in Tabriz, about 1514. Rustam sleeps soundly while his faithful horse Rakhsh defends him from a lion. The sense of confidence amidst dangers reflects the early days of Safavid conquest; the picture is probably the work of Sultan Muhammad, said to be the painter who best expressed the ethos of the *qizilbash*. The absence of rulings between the columns of verse shows that the picture is not from a completed manuscript. The rocks contain grotesque faces. London, British Museum.

161

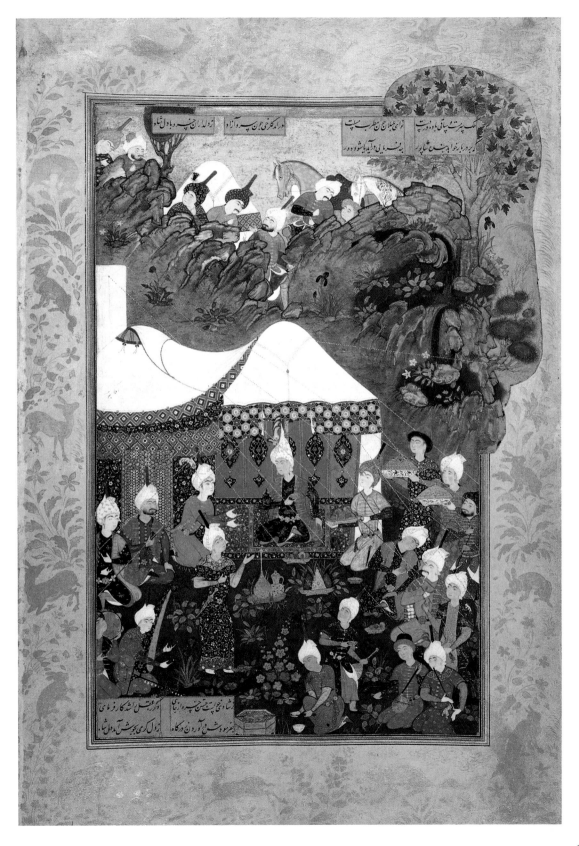

163

109 'Rider in the rain', album drawing in Isfahan style, about 1620. The drawing is signed by Riza-yi ʿAbbasi, who uses the humble epithet *kamineh*, 'the defective'. The plump young man in the fashionable European-style hat might come of nomad stock, but he is gravely discomfited by a shower of rain. The horse's nostrils are split in the old nomad manner. The sweep of the rider's cloak and the textures of flesh and rain are managed with superb economy. London, British Museum.

108 PREVIOUS PAGE 'Shapur makes his report to Khusrau', from a *Khamseh* of Nizami, copied in Tabriz for Shah Tahmasp in 949/1543; picture by Aqa Mirak. Encamped in Armenia, where he has come to seek the princess Shirin, Khusrau whiles away the time until Shapur returns from a mission to engage her interest. The elegant aristocratic style is typical of the work of Aqa Mirak, whose name appears on a tent roof. Khusrau dominates the scene, wearing the high Safavid *taj* and a robe with chinoiserie pattern; Shapur, his boon companion, must be the youthful figure before him in flowered black. The picture is stuck into a framing margin of chinoiserie work in brush-gold. London, British Library.

from the royal studio and set them to work; he also employed Qadi Ahmad, who was later to produce another valuable account of the arts of the book. The principal manuscript produced for Ibrahim at Mashhad was the *Haft Aurang* (Seven Thrones) of Jami (Freer Gallery of Art, Washington DC), which was copied between 963/1556 and 972/1565. Its pictures mark a change which is not so much one of style as of attitude. Superficially the illustrations to Jami's stories are very similar to those in works for Tahmasp; they are complex compositions of a high level of finish, but there are more figures which are slightly grotesque, more youths with a slightly louche, pussycat smile, and a palette which admits more brown or purplish tertiary colours. The eye is pulled restlessly over the page from detail to detail. It is as though the painters had lost confidence in the power of the ostensible narrative subject to interest the viewer, and were searching for other means to hold the attention. Innocence had been lost: the classic works would continue to be illustrated but only as a vehicle for the painters' skill; they seem no longer to have a mythic hold on the imagination. The future of painting was to lie in more realistic subjects, though their treatment often disguises that realism from us.

When manuscript painting emerges in Qazvin in the last quarter of the century the tertiary palette has become more marked and compositions simpler. Purplish mountains form a background for many actions, and an impression of instability is created by areas of turbulent cloud; ancient *chinar* trees lean dangerously, and the human figures themselves are sometimes slightly inclined. From about the mid-century and flourishing in the Qazvin period there had developed a new interest in single pictures for collection in albums. Prompted no doubt by the interruption in royal patronage, the fashion for pictures which could be purchased individually provided a means

of survival for the artist, by offering courtly connoisseurs an area of interest less costly than the complete manuscript. Artists who worked in this field included Mirza ᶜAli, the son of Sultan Muhammad; Siyavush, a Georgian; and Sadiqi Beg. Some subjects are ink drawings which continue fifteenth-century themes such as the lion-hunter, the dragon-hunter, the *peri* (fairy), or, a more recent entrant to the decorative menagerie, the pheasant. Predominantly, however, the subjects are people, sometimes in couples, in which case their relation is often flirtatious, but more usually single figures. They are rendered in ink or in colours. The earliest examples, men or women kneeling or standing, resemble simple excerpts from a narrative illustration, but gradually they take on a confidence which would defy any further context. An example from the latter years of the century is a brilliant ink drawing by Sadiqi in the Museum of Fine Arts, Boston, of a turbaned man sitting cross-legged and glancing to one side with elegant hauteur.

The greatest and most influential artist to work for Shah ᶜAbbas appears to have signed himself Aqa Riza in the earlier part of his long career and Riza-yi ᶜAbbasi later. Riza's relations with his royal patron were not always happy, and his instincts were not those of a courtier, for he developed a taste for wrestling, low company and, worse still, for independence. But this un-fettered character perhaps reveals itself in the breadth of human interest and the penetration of the best of Riza's work. Besides the dreaming courtiers, there are keen-eyed mystics and gleeful mountebanks. The line of Riza's ink drawings has an absolute calligraphic mastery conveying texture, form, movement and even personality. His coloured figures, which must often be portraits, are more restrained, and lay more emphasis on the fashions of the day, the rich textiles, the carelessly draped turban, the European hat. Effete

110 Calligram in the form of a horse, Iran, 1266/1849–50: 'Bismillah. While the succession of days and nights continue their piebald course through time, O king, may the face of the earth be under the hoof of your white horse, the shoe on your night-black hoof be the crescent moon of New Year, and this golden constellation of the firmament the ornament of your saddle. Born to palace service, the aged Sayyid Husayn ᶜAli executed this calligraphy. 1266.'

111 'Bilqis receives a love-letter', album painting in Qazvin style, about 1590. By tradition a hoopoe was the messenger of love between Bilqis, Queen of Sheba, and King Solomon. Bilqis has evidently been roused from a love-lorn reverie; the viewer's eye is drawn between her brooding face and the bird. Her gown is patterned with a finely drawn scroll with heads, a design known as *vaqvaq* after a fabulous talking tree in the *Shahnameh*. An attribution to Bihzad in the upper right corner is posterior. London, British Museum.

figures are often presented standing in a curved posture which accentuates their well-fed waists.

A follower of Riza in the mid-seventeenth century is Muᶜin Musavvir. His sturdy figures, with martial moustaches and peg-top caps in their turbans, bustle with an air of energy, competence and optimism. But they are in fact the last examples of Persia's traditional narrative and calligraphic styles. In the later seventeenth century Muhammad Zaman, working under the influence of European prints, produced figures with a careful solid modelling but failed to convey textures and space.

Paintings on the walls of the Chihil Sutun survived better than those on the ᶜAli Qapu. One style, derived from that of Riza-yi ᶜAbbasi and datable about 1640–50, is used for festive gatherings, episodes from romance and single figures. A second style is seen in a large historical painting in which Shah Tahmasp receives the exiled Mughal ruler Humayun in 1544. This appears to date from about 1660, and reflects European oil painting, with considerable effects of space and volume, though its iconography is purely Persian. Another picture, with a scene of Nadir Shah's Indian campaign, must post-date 1739. A number of single figures on canvas in the European manner were also produced. In the third quarter of the eighteenth century a new Europeanising style began to form under the Zands and came into full bloom under the Qajars. Fath ᶜAli Shah (1797–1834) is portrayed, resplendent in pearled crown and black beard, in numerous oil paintings which have the quality of royal icons. Also decked with pearls but less formal in pose are many pictures of palace dancing girls and musicians. The palette, which stresses red, black and white, is singularly different from that of the previous

manuscript tradition. The rendering of the faces, with heavy black eyes and black curls on the cheek, recalls the type of beauty admired by the Sasanians – and, indeed, Fath ʿAli did also endeavour to revive rock sculpture in the Sasanian manner. The bold Qajar mode is used in some manuscripts, but a much more subtle style of portraiture in the traditional gouache on paper was also practised. It shows a degree of assimilation of European influence otherwise found only in Mughal painting.

Late developments in the field of calligraphy are *shikasteh* (broken) script, flourishing from the seventeenth century, which is often disposed on the page in swirls, and, from the eighteenth century, the calligram which uses script to depict a person or animal.

Lacquer

The late fifteenth-century taste for lacquer bookbindings continued under the Safavids. Usually the designs employed the decorative repertoire of chinoiserie animals in their landscapes of trees and rocks. Though the ultimate models for this were in ink on paper, the lacquer craftsmen produced

112 ABOVE LEFT 'Girl acrobat', oil-painting in Qajar style, about 1830–40, shaped to fit a wall-niche. The acrobat is treated as though she were a species of exotic performing bird. London, Victoria and Albert Museum.

113 ABOVE RIGHT 'Portrait of Shahzadeh ʿAli Quli Mirza', album painting by Yusuf in Qajar style, 1280/1863. The prince was Minister for Science, Commerce and the Arts. Some use is made of European shading conventions. London, British Library.

114 Mirror case lacquered with birds and flowers, by "Ali Ashraf", Iran, 1153/1739–40. The name ‘Ali Ashraf is found from the 1700s to the 1780s and it is to be supposed that the later occurrences may be copies. Variations on the bird-and-flowers motif are found on a number of 18th-century silks. Edinburgh, Royal Museum of Scotland.

dazzling effects with gold drawing on a black ground. At first, the black ground was also used for the rarer designs which drew on contemporary illustrations to show human figures in several colours. Favoured subjects for these covers were princely picnics, with attendants, musicians, dancers, cooks and, in some examples, a pavilion incorporating a tree house. By the eighteenth century figurative scenes are simply varnished paintings with normal backgrounds.

Lacquer decoration was also used for doors, mirror-cases and penboxes. Eighteenth- and nineteenth-century work includes court scenes, portraits and reflections of Christian pictures. Much-used motifs are bunches of bright naturalistic flowers, sometimes accompanied by birds.

Textiles and carpets

In the sixteenth century men wore the *taj-i Haydari*, and, over their principal robe, they often added a surcoat with a frogged fastening. Grand ladies sometimes wore, added to the usual female kerchief, a tiara with three delicate prongs over the brow, or one with a sweeping tail at the back reminiscent of a sou'wester. Shah ‘Abbas I introduced a new and lower type of *taj*, shaped like a top, but even more characteristic of his reign is a loose turban which recalls a rakish style of the fourteenth-century Muzaffarids. A hat with a wide up-turned brim which droops to one side is also found. The *kurdi*, a short coat with a nipped-in waist, became fashionable. Men sometimes wore trousers, and in pictures the striped drawers of women are sometimes revealed. Nadir Shah wore a cap with four points which may have indicated his Sunni allegiance to the first four caliphs. Fath ‘Ali Shah introduced a high gem-studded crown, and the female entertainers of the Qajar period were bedizened with tiaras, jewelled garments and filmy shifts, and sometimes affected Indian costume.

Persian presents us with the word taffeta, from *tafteh* (woven), for a plain weave silk, but the most arresting silks of the Safavid and Qajar periods are compound weaves, lampas and velvet, in which the warps and wefts supplementary to the main structure permitted the use of sophisticated designs, a rich palette and varying textures. From the mid-sixteenth to the early seventeenth century, the weavers borrowed motifs from manuscript illustrations, and the silks were covered with multiple images of hunting parties, of Majnun in the wilderness surrounded by animals, or of Khusrau finding Shirin bathing in the pool. A coat with figures of the Riza-yi ‘Abbasi type, now in the Royal Armoury in Stockholm, was given by the Tsar of Russia to Queen Christina in 1644; it is in velvet with voided areas and the use of thread wrapped in metallic foil. In the later seventeenth and eighteenth centuries weaves tend to become less complex, with extra ornament often added in the discontinuous brocade technique. Relatively naturalistic flowers are repeated on metallic grounds, which may have a lattice of indentations pressed into them by means of rods. From the mid-eighteenth century the repeating motif is sometimes a bird with a flower or in a small-scale flowering tree. This class of motif, similar to some designs for lacquer covers, is of European origin, though it would recall the rose and the nightingale of Persian poetry. In the Qajar period there is much use of a motif like a

115 Silk lampas with Layla and Majnun, designed by Ghiyas (Ghiyath). Probably Yazd, late 16th or early 17th century. The satin ground is dark brown (faded from black), with details in silver, yellow, sky-blue, white and pink. The motif is the visit of Layla to Majnun in the wilderness, from the *Khamseh* of Amir Khusrau Dihlavi. The repetitions are managed with great skill to give the impression of a continuous scene. The name Ghiyas appears on the side of the camel litters; it refers to Khwajeh Ghiyas al-Din ʿAli Yazdi, a textile designer who became a courtier of Shah ʿAbbas. Brussels, Musées Royaux d'Art et d'Histoire.

billowing comma, known as *buteh* (bush), which was probably introduced from India and which in Britain acquired the name 'paisley' from the location where Indian shawls were copied. Both *butehs* and flowers are sometimes organised in stripes.

The Persian court carpets of the sixteenth century are among the most magnificent ever produced. In design they follow the fashion evident in late fifteenth-century miniatures for schemes derived from the arts of the book, their use of curvilinear motifs being facilitated by the soft effect of the Persian asymmetric knot. They are usually classed by a number of types of design, the foremost group being the 'medallion' carpet. This follows the format of book covers and *sarlauhs* in having a central *shamseh* (sun-disc) or star, framing bands, and sometimes cornerpieces. The greatest of these carpets was offered by Shah Tahmasp to the funerary mosque of Shaykh Safi at Ardabil. The carpet is of majestic proportions and fine workmanship, but it is revered less for this than for the transcendent quality of the design, imbued with Islamic spirituality. The lamps which hang as pendants from the central star imply that this is the dome of the firmament of heaven, and that the believer bowing in prayer touches his head to its threshold.

Other types of design have complex lattices which may be interspersed with small medallions or with vases. More pictorial carpets show hunting

116 RIGHT Silk double cloth with brocaded wefts in flower pattern, probably Yazd, 17th century. Double cloth is a compound structure of two colours in a plain weave. Front and back have the same design with colours reversed. London, Victoria and Albert Museum.

117 BELOW The 'Wagner' carpet, Central Iran, second half of the 17th century. Garden carpets probably developed from the town-planning activities of Shah ᶜAbbas, since they are in effect picture maps. Glasgow, Burrell Collection.

7 scenes which include dragons and other fauna, or gardens laid out like picture maps with criss-cross water channels. A type of carpet made in the workshops of Shah ᶜAbbas includes areas of flat weave in thread wrapped with silver or gold; it acquired the mistaken description 'Polonaise' after an example was exhibited by the Polish Prince Czartoryski in Paris in 1878.

An area of carpet-making with connections to both Iran and Turkey but also a strong indigenous tradition is the Caucasus. In its most renowned products, lattice schemes in strong primary colours resolve themselves into seething masses of dragons. This powerful mixture of the primitive and the sophisticated may reflect the taste of the late fifteenth-century court of the Shirvan-Shahs. In later centuries work of vigour and intricacy was produced among tribes such as the Shah-sevan, the Afshar and the Qashqa'i; the designs can sometimes be related to court textiles.

Some of the latest products of the period were the most deeply rooted in the past, the carpets and other necessaries of the nomad life made in the nineteenth and twentieth centuries by the Turkman tribes of north-eastern Iran, Central Asia and Afghanistan. The Turkman used – and some still use – the frame tent. They made tent girths to secure the structure, and rugs which imitated panelled wood for use as doors. Carpets were spread on the floor, and bags in knotted pile were used to store bedding and clothing, for the tools of weaving and for valuable stores such as salt. When the Turkman migrate, or when they attend a wedding, their camels wear ornaments in knotted pile. The designs used show scant influence from the Persian court tradition of
18 carpets and textiles after 1500, but their repeating patterns of geometric motifs or octagons link them to Seljuk and early Ottoman carpets, and to the carpets of the earlier fifteenth-century Persian miniatures. The repeating

118 Turkman carpet from Transoxiana, 18th century. The carpet, which is exceptionally rich in colour, is attributed to the Yomut tribal group. The solid-looking 'gul' with four blunt arms and points in the interstices is a form sometimes called 'archetypal', from which other 'guls' may have been derived. Unusually, the floral motifs on the skirts appear to be borrowed from a textile in a court tradition. Washington DC, Textile Museum.

172

motifs are known as 'gul', a word which has been interpreted in different ways: it may be *göl*, lake in Turkish, and a representation of the ancient home camping-ground of a tribe; or it may be *gul/gül*, rose in Persian and Turkish, and thus possibly derived from old textile rosette patterns. In principle each tribe would have its 'gul', but by conquest or intermarriage those of the powerful Yomut and Tekke tribal groups came to predominate. These complex symbols in brown, ivory and blue are set in a regular grid against grounds in rich tones of red, chestnut or mulberry.

The greatest achievement of the town-dwellers of Central Asia in the nineteenth century was in *susani* (needlework) produced by the women. Pieces were made for various furnishing functions, but especially to decorate the marriage bed. White cotton fabric is embroidered in silk in couching and chain-stitches. Designs, which appear to derive from ancient Buddhist lotus ornament, have dark green tendrils amid which large circular flowers in tones of red swirl like suns.

119 The 'Ardabil' carpet, Iran, probably Tabriz, 946/1539–40. Measuring 10.97 × 5.34 m, the carpet has 340 knots to the square inch. The ground is midnight blue with a design in mid-blue, light blue, turquoise, light green, cream, yellow, salmon, plum and black. A cartouche bears the legend, 'Except for thy heaven there is no refuge for me in this world; other than here there is no place for my head. Work of the slave of the court, Maqsud of Kashan, 946.' The uneven size of the pendant lamps is probably an optical device, since they appear more equal when viewed from the end opposite the cartouche. London, Victoria and Albert Museum.

7

EAST AND WEST OF THE BOSPHORUS
The Ottoman empire

120 Fritware mosque lamp painted in underglaze blue in the 'Abraham of Kütahya' style, Iznik, early 16th century. The lamp is one of a number associated with the tomb of Bayezid II (d. 1512); in such a setting its function would have been symbolic and it would not have been required to shed light. The inscription contains part of *surah* LXI, *al-Saff* (The Battle-Line), 13, speaking of Allah's gift of victory. The counterchanged palmettes are decorated with a mixture of *hatayi* and *rumi* motifs. London, British Museum.

The Ottoman empire grew at the geographical junction of Europe and Asia, and its art drew on sources Eastern and Western. The Eastern sources were the heritage of the Seljuks and the more distant Turkish tradition of Central Asia, together with Timurid style and the proceeds of Cairo and Baghdad and two sacks of Tabriz. Its Western sources include Byzantium, the Italian city states, the Balkans and later France.

The Ottoman dynasty, which ruled in an unbroken line for more than six centuries, is so called from an Italianate form of the name of the founder ᶜOsman (Arabic ᶜUthman). The final breakdown of Seljuk power in 1307 had left Anatolia divided between a number of principalities, known as *beyliks*. ᶜOsman and his people were not at first the strongest group amongst these, but their base was in the extreme north-west of Anatolia nearest to the shrunken remains of the Byzantine empire; they were thus a front-line state in respect of war against the infidel. The Ottomans duly went about their duty to carry warfare into the Dar al-Harb by *ghaza* (raiding), with consequent acquisition of booty, and anyone else who wished to acquire the proud title of *ghazi* was obliged to pass through Ottoman lands and would have been required to make some contribution for the privilege. The state grew. In 726/1326, under Orhan, Bursa was captured from the Byzantines, and Iznik in 731/1331. This gave the Ottomans two strong points on the southern shores of the Sea of Marmara. In the mid-century they crossed the Dardanelles, and in 762/1361 captured Edirne (Adrianople) in Thrace, whence raiding proceeded into the Balkans. There was also expansion eastwards into Anatolia. By the end of the fourteenth century Bayezid I (Yıldırım Beyazit, 'the Thunderbolt'), was seen as the heir to Seljuk power, and had been granted the title *sultan al-rum* by the caliph in Egypt. He seemed on the point of capturing Constantinople itself, but his defeat by Timur at Ankara in 1402 delayed the Ottoman advance.

Constantinople was finally taken on 29 May 1453 by Mehmed Fatih (Muhammad II, 'the Conqueror'). The city, which gradually acquired the name Istanbul from the Greek *eis ten polin* (to the City) became the capital of the Ottomans. The empire was established at the point where the continents of Asia and Europe meet, with the strategic waterway of the Bosphorus

between them. The Ottoman sultans would thus always have to take the politics of both spheres into consideration. Mehmed could now style himself *qaysar-i rum* (Caesar of Rome), but the imperial dignity began to distance ruler and subject. In religion the somewhat heterodox tradition of the frontiers, typified by the Sufi brotherhoods, gave way before high Islamic orthodoxy, typified by the *ulama*, the men of learning, though the former groups did not lose all influence. Adherents of other religions whom the Ottomans now ruled were grouped in *millets* which could exercise their own personal law. Mehmed also restricted the power of the warrior aristocracy by using slaves as servants of the state, in the *ghulam* or *mamluk* tradition. A levy (*devşirme*) was made of boys from the Christian provinces of the empire. Those who would be suitable as soldiers were trained to enter the janissary (*yeniçeri*) regiments of infantry, an important component of the victorious Ottoman armies; others were selected for training in the palace schools and eventually became officers and administrators, some even reaching the rank of grand vizier. Mehmed continued to acquire territory, and his son Bayezid II (1482–1512) challenged the naval power of Venice.

In the sixteenth century the Ottoman empire achieved its greatest glory. The important victory over the Safavids by Selim I (Yavuz, 'the Grim') at Chaldiran in 920/1514 permitted a temporary occupation of Tabriz, and with it access to a new stock of treasures and of craftsmen. This was followed by the defeat of the Mamluks in Syria in 1516, and in Egypt in 1517. Selim thus gained control of the Eastern Mediterranean, and overlordship of the Holy Cities of Mecca and Medina; relics of the Prophet Muhammad were taken to Istanbul, as was the ʿAbbasid caliph al-Mutawakkil, who had previously lived under Mamluk protection. Selim's son Süleyman adopted for himself the title Caliph, implying thereby that he claimed a supranational leadership of Sunni Islam. Süleyman II, surnamed by the Ottomans Qanuni, 'the Law-giver', but in the West 'the Magnificent', ruled from 1520 to 1566. At the outset of his reign he triumphed over the Hungarians at Mohács and in 1529 he reached Vienna; this was followed in 1534–5 by the second capture of Tabriz and the acquisition of Iraq and of Tunis. Accompanying a campaign into Hungary when he was old and sick, Süleyman died just before the fall of Szigetvár. Expansion slowed under Selim II (1566–74) and Murad III (1574–95), and though the later sixteenth century was culturally a flourishing period, it saw inflation, civil disorder in Anatolia and the growth of corruption in the Janissary corps.

Decline continued in the seventeenth century, and in various ways the empire turned in upon itself. The eastern transit trade was depressed by the European use of the sea route round Africa. The sultan's sons, who had previously begun their careers as governors of provinces, were now educated exclusively in the harem and ceased to gain experience in administration and warfare. The power of a conservative *ulama* increased. There were still some victories to celebrate, and the empire achieved its greatest extent in 1683 when the Ottomans reached the gates of Vienna for a second time; however, gains could not always be maintained. By the treaty of Karlowitz in 1699 the Ottomans' territory retracted as far as Belgrade.

In the eighteenth century an urgent threat was posed by the advance of

Russia. However, Ahmed III (1703–30) surrendered much of the direction of diplomacy to his grand vizier, whose residence was the Bab-i ᶜAli (High Gate or 'Sublime Porte'), and gave himself up to pleasure and luxury, the last twelve years of his reign being known as the *lâle devri* (tulip age) on account of his tulipomania. At this period there was more openness to Western invention, and a printing press was set up in 1727 – to be closed, however, in 1742. Following warfare from 1768 to 1774, the loss of the Crimea to Russia was recognised in 1792. This was in the reign of Selim III (1798–1807), who made strenuous efforts to modernise his state but was at last deposed by the Janissaries. His successor Mahmud II succeeded in suppressing the by then uncontrollable Janissaries in 1826: another reformer and under strong French influence, he founded an official gazette and introduced a more European style of costume. The events of three years closed the Ottoman period: the abolition of the sultanate in 1922, the inauguration of the republic in 1923 and the abolition of the caliphate in 1924.

Architecture

The basic unit of Ottoman building is the dome-on-square, and the drama of the development of the Ottoman mosque lies in progressive experiments to proceed from this unit to a building covering the greatest possible floor space. Mosques from the earliest days of the dynasty consist of the basic unit with the possible addition of a portico, known as the *son cemaat yeri* or 'place of the latecomers'. The Hajji Özbek mosque of 734/1333 at Iznik is of this type. Its only interior adornment is a system of triangular pendentives in the zone of transition; the exterior, however, is in alternating courses of stone and brick, a Byzantine technique which was both decorative and economical. In 802/ 1399–1400 Bayezid I built an Ulu Cami at Bursa which – following Seljuk precedent – covered a large space by the use of multiple interior supports, twelve piers which separate twenty domed bays. The exterior walls are articulated with pairs of windows under arches, suggesting an influence from Venice.

Meanwhile, another form of royal mosque has an inverted T-plan which is closely related to that used in Seljuk *medreses*. The crosspiece is formed by a portico of five bays followed by a vestibule, and the stem is represented by a central domed unit and another beyond it with the *mihrab* in its further wall. The floor of the bay before the *mihrab* is raised to form a dais, and the lower central bay has a fountain in its centre. To the sides are rooms which may be provided with small niches for books and typically Ottoman conically hooded chimney-pieces; these may have been for the use of Sufi brotherhoods closely allied to the court. The most celebrated of these mosques is known as Yeşil (Green) Cami from its interior tile decoration; the structure, but not the decoration, was completed for Mehmed I in 822/1419–20. The portico was not built, but the mosque presents to the world an elegant façade in white marble. A high *muqarnas* portal resembles the Seljuk type, but windows on the upper floor have the flat-topped, hipped and stilted Bursa arch. From the vestibule the sultan ascended to a loge which overlooked the length of the interior, rather in the manner of a theatre box. The tomb of Mehmed, the Yeşil Türbe, was begun by his son Murad II in 824/1421, using the same

121 Interior of the Yeşil Türbe, Bursa, after May 1421. The tilework is brilliant; though the traditional turquoise and cobalt are still the dominant hues, leaf green and bright yellow create a new and vivid harmony, with a softening effect from gold and lavender. Both tile mosaic and *cuerda seca* are used. The design of the dados with large ogee medallions resembles work in the shrine of Qutham b. ᶜAbbas in the Shah-i Zindeh. The form of the *mihrab* derives from the Seljuk period, but the palmette crest is new and shows the influence of the Chinese cloud collar. It was Ottoman custom to display a turban on a cenotaph.

architect as for the mosque, Hajji Ivaz; it is an elegant domed octagon.

The architecture of the princely mosques, like that of the Bursa Ulu Cami, followed an additive principle. A large clear space could not be achieved until one spatial unit was made to contribute to another in a more organic manner: the key to this was the use of the semi-dome, a unit which is not complete in itself. In some buildings the *mihrab* bay of a т-plan mosque is reduced to a semi-dome, but in the Fatih mosque, built by Mehmed the Conqueror in Istanbul between 1463 and 1470 on the site of the Church of the Apostles (but rebuilt after an earthquake in 1766), a large dome and semi-dome are used as the central elements in a square plan. They are flanked on either side by three domed bays, and indeed they fit into a grid plan, the dome covering the space of four bays and the semi-dome that of two. Thus a larger free space was gained, and, since the height of a dome must rise in proportion to its span, the exterior began to show the characteristic Ottoman form of a pile of domes

with the central and largest at the top, a form which could be said to mirror the position of the sultan in an increasingly ordered and orthodox state. The mosque has a courtyard to the north, and is surrounded by a *külliye* (complex) which included *medreses*, *tabhane* (hospice), hospital, baths, caravansaray, soup kitchen and shops. Unlike the side rooms of the Bursa mosque, the ancillary areas are now held at a distance. The next imperial mosque in Istanbul, that of Bayezid II of 1505, adds to the Fatih plan a second semi-dome on the north or courtyard side, and its central dome rests on four great piers. There is thus a patent reference to the plan of the Byzantine church of Hagia Sophia, though the character of the central space is different, the church's side aisles being screened by a row of columns between its four piers and the mosque having single columns in this position. Structures which appear to be *tabhanes* are again attached to the mosque, flanking the northern bays, and in consequence the two minarets of pencil form at their extremities are widely separated.

The classical Ottoman mosque reaches its zenith in the buildings planned in the course of the sixteenth century by Sinan, an architect whose career started, by way of the *devşirme*, in the army. His Şehzade Mosque, built after the death in 1543 of Süleyman the Magnificent's son Mehmed, employs four semi-domes round its central dome, and was described by Sinan as the work of his apprenticeship. The Süleymaniye, the work of Sinan's maturity, built from 958/1551 to 964/1557, returns to the two semi-dome plan; its roof, which clearly expresses the interior, is one of the dominant features of the Istanbul skyline. Süleyman's tomb, an octagon surrounded by a veranda, is in

122 The Süleymaniye Mosque, Istanbul, by Sinan, 964/1557. The mosque is seen from the north corner; the courtyard is set to the north-west of the mosque proper, minarets rise at its four corners and it is entered by an imposing but restrained portal. To the left, the low curve of one of the two semi-domes can be seen supporting the base of the dome, and beside it a turret of pepperpot shape which lends weight to one of the four piers of the interior to counteract the dome's thrust.

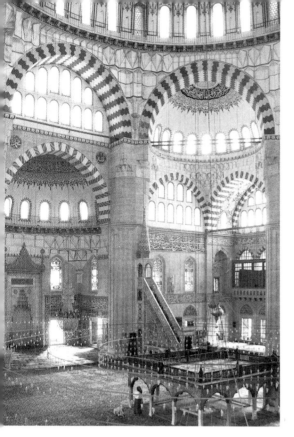

123 ABOVE LEFT The interior of the Selimiye Mosque, Edirne, by Sinan, 982/1574. The space is filled with light from the numerous windows. The *mihrab* is flanked by a tiled dado, and the *minbar* is carved in openwork in Marmara marble. The tribune in the centre (*müezzin mahfili*) was used for chanting; below it is a small fountain.

124 ABOVE RIGHT Fountain (*çeşme*) of the Küçük Efendi (or Fevziye) complex, Istanbul, 1241/1825. Set in an undulating wall, the fountain displays the preference of Ottoman Baroque for the curved line. On either side are entrances which lead to a library, suggesting a connection between water and learning. The complex was a dervish establishment (*tekke*), with a *semahane* for the ritual dervish dance.

a cemetery to the south (*qiblah*) side of the mosque, and that of Sinan himself, a small garden with a modest fountain kiosk at the corner, was eventually added in the *külliye*. Sinan's masterpiece, completed when he was eighty, is the Selimiye Mosque at Edirne, built between 976/1568–9 and 982/1574. At a distance the exterior of the Selimiye conveys a dynamic tension between the broad dome ringed with buttresses and four soaring minarets which surround it. The interior is no less majestic, but radiant and serene. The great dome of more than 30 metres in span is supported on eight massive piers which are linked to the side walls: the plan, a circle on an octagon in a square, is the apotheosis of the Ottoman development of the dome-on-cube. Small semi-domes have a minor role in the corners, creating a harmonious movement below the dome.

Between 1609 and 1617 Mehmed Aga, apparently a pupil of Sinan, working on a great mosque complex in Istanbul for Ahmed I, reverted to the four semi-dome plan. From the time of Ahmed III a new aesthetic appears which is known as Ottoman Baroque. In many ways this is the antithesis of the stern clarity of the earlier tradition. Instead of circles and squares, oval shapes are celebrated, walls undulate, eaves droop and swathe, and rocaille mouldings blossom in stone and marble. The style received an initial impetus from Europe – from the Rococo rather than the Baroque – but it developed its own Ottoman character. The Nuruosmaniye Mosque of 1169/1755 flaunts a courtyard with a rounded end and a colonnade of horseshoe arches, but it is still relatively sober in detail. More emphatically baroque are the tomb of Nakşidil, the mother of Mahmud II, of 1233/1818, the Fevziye complex of 1241/1825, and the Nusretiye complex of 1242/1826 – whose name, the Victorious, celebrates Mahmud's suppression of the Janissaries.

No Ottoman palaces survive from the pre-Istanbul period, though the castle of Rumeli Hisar on the Bosphorus, thrown up in the two years preceding the conquest, is a fine example of fortification. The Topkapı Sarayı, Palace of the Cannon Gate, was begun under Mehmed II in the third quarter of the fifteenth century. It became the residence of the sultans in the sixteenth and remained so until the mid-nineteenth century, building and renovation proceeding down the years. The palace is divided into two parts, one of which consists of a sequence of courtyards. Three of these diminish in size as they rise in importance, and are entered by imposing gates, the Bab-i Hümayun (Auspicious Gate), Ortakapı (Middle Gate) and Bab-i Saʿadat (Gate of Felicity); pavilions and cloisters are grouped around the courtyards, and ceremonials and the business of state were conducted in them. A fourth area, described as a courtyard, is a garden less clearly circumscribed; it was here that tulips were grown for Ahmed III, and at night-parties tortoises crept among them with candles attached to their backs. The other major section of the palace is the *haremlik*, a dense system of small courtyards and covered ways which contained both the female quarters and the private quarters of the sultan.

Some buildings of the palace date from the time of Mehmed II. The nobly severe domed units which now house the treasury, and which include a pillared loggia overlooking the Bosphorus, were built for him in 1468. A group of four domed units which later came to house the relics of the Prophet may also be of early date. Very different in character is a pavilion of 877/1473, the Çinili Köşk (Tiled Kiosk, now a museum of ceramics). This is outside the main courtyards, and was probably a place of leisure. Entered through an *ivan*, the pavilion has a central space under a dome on squinches in Timurid style. There are four corner-rooms, and a fifth room opposite the entrance extends outwards in a bay and may have been a vantage point from which to watch displays. Beside the second court a row of domed kitchens with mighty chimneys was built by Sinan after a fire in 1574, and he also designed a domed chamber in the harem later used by Murad III. Two octagonal pavilions with verandas on a platform beyond the third court commemorate the capture of Yerevan in 1635 and Baghdad in 1639 – the Revan and Bağdat Köşks. The baroque style is well represented in the harem.

Among civil works are fine dams and bridges, and, often raised by pious bequests, *hammams* and fountains. Some wooden mansions (*konak*) remain from the late eighteenth or nineteenth centuries. On several storeys with overhanging balconies on the exterior, their interior plan tends to correspond to the pattern of the Çinili Köşk with corner-rooms and intermediate areas and verandas between them. An example is the Çakır Aga Konak at Birgi of about 1800. Grand wooden mansions of similar type (*yalıs*) once lined the Bosphorus, and some surviving examples have recently been renovated.

Tilework and pottery

The royal mosques and tombs of the fifteenth century at Bursa have brilliantly tiled interiors. In the Yeşil Mosque and Tomb the tilework is in two modes which complement each other. The larger areas of the high dados are decorated with octagonal tiles, those of the mosque in cobalt blue edged

with white strip tiles, or in green with turquoise triangles between them. For the more important areas – the *mihrabs* of mosque and tomb, the royal loges of the former and the cenotaph of the latter – *cuerda seca* is used in blue, turquoise, green, white, black, lavender and yellow, the last sometimes a base for gold. The areas of *cuerda seca* contain inscriptions and bold palmettes and lotuses. The design of the *mihrab* in the Yeşil Türbe is particularly striking. A central panel under a canopy of gilded *muqarnas* portrays a mosque lamp hanging over a vase flanked by two candlesticks, while above the bands of inscription and ornament which frame the niche there is a band of cresting in triumphantly flamboyant palmettes.

The decoration of the dado in the Yeşil Türbe, turquoise hexagons with occasional large ogival medallions, is very like a scheme used in the shrine of Qutham b. ʿAbbas in Samarqand, and there is in general a strong current of the international Timurid style in these interiors, an impression which is supported by the evidence of inscriptions. The *mihrab* of the Yeşil Cami is signed by 'the masters of Tabriz'; and a painted inscription in the sultan's loge, dated 827/1424, refers to the designer ʿAli b. Ilyas ʿAli, a native of Bursa who is thought to have been carried off by Timur in 1402. A third inscription was designed by 'Mehmed al-Majnun (the Mad)'.

The body material of the Bursa tiles is red earthenware. At a date between 1435 and 1451 the Muradiye Mosque of Edirne was decorated with tiles whose body was white and more vitrified. This scheme resembles those of Bursa, but turquoise tiles are now contrasted with tiles painted under a clear glaze in dark blue with floral motifs of Chinese origin. The new material and decoration may have been introduced from Syria. Fifteenth-century tilework is again found in Istanbul on the Çinili Köşk, and indeed provides its popular name, *çini* meaning tile in modern Turkish, though in older contexts it implies pottery with Chinese decoration. The portico of the Çinili Köşk has tile mosaic in the Persian manner and the dado inside is in cobalt blue hexagons with fine applied decoration in gold.

Pottery of the earlier fifteenth century, known as Miletus ware, was made at that classical site, but also at Iznik. It has a body of red earthenware covered with a white slip, and, under a lead glaze, decoration is principally in a darkish blue, with some black, purple or dark green. Designs may be divided into panels, as in other Islamic wares of the fourteenth century, but some pieces show a version of Chinese floral decoration. An order recorded in the kitchen accounts of Mehmed II between 1469 and 1473 for *çini-i iznik* is understood to mean a new class of blue-and-white pottery of distinctively Chinese style, the forerunner of the great production of Iznik wares in the sixteenth century. Some blue-and-white tiles are found in the tomb in Bursa of Cem Sultan, the brother of Bayezid II, who died in 1495.

The pottery of Iznik in the sixteenth century has a white and hard composite body, less dense than that of Kashan but similar to it, and a further wash of the body material to produce a resplendent white ground for decoration under a clear and shining glaze. Three principal styles of decoration succeed each other through the century. A first style, which may extend into the 1520s, uses cobalt blue, with a few patches of turquoise on late pieces. The blue lotuses and wavering tendrils and clouds of the chinoiserie decor-

125 ABOVE Two fritware dishes painted in underglaze colours in the 'Damascus' style, Iznik, about 1550–70. The dishes have bracketed rims and 'wave and rock' borders derived from Chinese vessels. The designs are cool and airy, suggesting a perpetual gentle movement. The decoration on both is probably by the same hand. London, British Museum.

126 LEFT Fritware spandrels painted in underglaze colours in the 'Rhodian' style, Iznik, second half of the 16th century. The spandrels would have ornamented a niche in a palace. The relatively realistic flowers are placed in the elaborate profile with great skill. Copenhagen, David Collection.

ation are joined by ornament of the Islamic tradition, inscriptions and arabesque scrolls with split palmettes. The latter motifs are often in reserve against a blue ground, the colour suggesting a transposition from manuscript illumination. The two types of ornament were distinguished by the Otto-mans as *hatayi* (of Cathay or North China) and *rumi* (proceeding from Byzantium and ultimately Rome); the two varieties are found mixing to various degrees in other media. Objects made include large dishes with a flattish rim, basins of handsome scale upon high foot-rings, jugs and mosque lamps. These last would evidently emit very little light, so their function must have been primarily as a religious symbol, and it is probable that they were suspended in tombs.

A dated blue-and-white piece in the British Museum appears to have been made in Kütahya, another centre in Western Anatolia. A small spouted jug – a mass-cruet in spite of its dragon handle – it records in Armenian that it was made in memory of one Abraham of Kütahya, the servant of God, in 1510. The commemoration has been successful beyond anything that its sponsors could have imagined, since the blue-and-white pottery style is usually called 'Abraham of Kütahya' ware. That Kütahya was the place of production of the cruet is confirmed by another British Museum piece, also inscribed in Armenian, which states categorically that it was ordered from Kütahya in 1529. This is a flask whose long neck has been cut down. It is decorated in a particular class of blue-and-white pattern composed of multiple fine spiral-ling scrolls with small flowers and single-stroke leaflets, a type of pattern derived from manuscript illumination of about 1520. This variety, known by its formerly supposed origin, is called 'Golden Horn' ware.

Another style flourished in the mid-century. This was once thought to have originated in Damascus, but it has since been shown that the Syrian version is derived from Iznik. The objects are chiefly large dishes, but basins on foot-rings were also made. The background is usually in reserve, and a new palette includes the two blues, green from apple to sage, black, and a rather pale purple obtained from manganese. The decoration develops themes resulting from the acquisition of craftsmen or booty after the capture of Tabriz in 1514, or again in 1534. A renewal of Chinese influence is seen in the use of a wave and rock border and in some relatively close imitations of Chinese designs of the fifteenth century, most notably that of a trio of bunches of grapes found upon a number of dishes. More frequently, how-ever, the pattern employs a mixed array of real and imagined flowers, drawn boldly but with sensitivity. From the natural – or almost natural – world come tulip, fritillary, hyacinth, carnation, marguerite, prunus, pomegran-ates (shown split open) and miniature umbrella pine trees; and from the world of the imagination, composite flowers and – the most characteristic form – a curved plume-like leaf, known as *saz* and derived from the flower of the reed. Designs tend to be directional and often have a circular swirling motion, as though the flowers were swaying in the breeze of a paradisal garden.

Magnificent panels in this style, 127 cm in height, have been set into the outer wall of the Sünnet Odası (Circumcision Room, or room for additional prayer) in Topkapı Sarayı. Evidently drawn to a design from the royal studio (*naqqash-khaneh*, modern Turkish *nakkaşhane*), these show in shades of cobalt

blue with turquoise a torrent of *saz* fronds which shelter pheasants and cloud-deer. More sober is a mosque lamp in the British Museum, in cobalt, turquoise and black, with inscriptions, cloud-scrolls and *rumi* arabesques. Dated 956/1549, this is dedicated to Eşrefzade of Iznik, a holy man revered by the local potters. However, it passed to the Dome of the Rock at Jerusalem, probably during Süleyman the Magnificent's restoration which clad the building with tiles.

The third Iznik style sometimes goes by the name of 'Rhodian', since Rhodes was once thought to be its place of origin. Large dishes continue to be produced, also vases, jugs and a tankard derived from the wooden German *Humpen*. The colour scheme of this group includes red, a difficult colour to fire. Ranging in colour from dull to sealing-wax, it was achieved by the use of a slip, Armenian bole, which had to be applied thickly and which sometimes threw off the glaze in firing. The green of the Rhodian palette has a bluer hue, and the manganese purple is omitted. A few vessels are covered in a dull salmon or bluish slip. Flowers similar to those of the Damascus group appear, but there are fewer *saz* and fantastic flowers and more rose-buds and carnations. The design tends to be more naturalistic, as though a handful of flowers had been laid upon a dish. There is more use of a conceit – also found earlier – by which some stalks are bent backwards so that the flower will fit in the allotted space. Some objects, however, are covered with green scales, derived from the Chinese-Persian dragon tradition; some make use of the triple dot motif, ultimately related to the Buddhist *chintamani*, or three jewels; and some use a single element from a traditional arabesque pattern. A few vessels include what appears to be a European blazon amid sprays of flowers, and records confirm that orders from Topkapı Sarayı for tiles were sometimes delayed while commissions were completed for Europeans, who were obliged to pay more. In the late century some lively, but sloppily drawn animals seem to have been derived from Armenian illumination.

The best work of the second half of the sixteenth century went into tiles. Rhodian panels are first found in the Süleymaniye Mosque, and thereafter their use becomes extensive. In mosques the tiles often bear qur'anic inscriptions in fine calligraphy. Their decoration also differs from that of contemporary pottery in making more use of lattices of split palmette or *saz* and fantastic composite flowers. The drawing varies in sophistication from simple repeating borders, which sometimes appear to use a stencil, to brilliant schemes which extend over a large number of tiles. The interior of Istanbul's Rüstem Paşa Mosque, built after 1561, has a multiplicity of patterns, but that of the Sokollu Mehmed Paşa of 979/1571 makes a more concentrated effect. The tilework by the *mihrab* and in the sultan's loge of the Selimiye Mosque is exceptionally fine. A great many tiles from various periods of decoration and often not in their original location, are found in the harem of Topkapı Sarayı. Seventeenth-century tiles are of inferior quality, though panels in the Bağdat Köşk imitate those on the Sünnet Odası.

Armenian potteries at Kütahya continued to work in the eighteenth century. Among their products are tiles with religious subjects, dated 1719, intended for the Church of the Resurrection at Jerusalem but now in the Cathedral of St James. In the nineteenth century a red earthenware decorated

with slip was made at Çanakkale on the Dardanelles. Tile production continues at Kütahya, and in the early twentieth century was also transported thence to Jerusalem by Armenian potters.

Metalwork, jade and rock crystal

Much Ottoman metalwork is characterised by highly decorated surfaces. A rare survival from the time of Mehmed II is a magnificent domed lantern in silver, now in the Turkish and Islamic Arts Museum, Istanbul; datable to about 1460, it was found in the Fatih Mosque. Its six tapering facets are densely filled with raised *hatayi* flowers and clouds, and inscription bands carry the Verse of Light. Light from the lantern passing through areas of pierced work would have been patterned with shadow. The decoration of this piece corresponds to contemporary manuscript illumination in the Ottoman version of the international Timurid style. Timurid fashions were reinforced and Safavid styles transmitted by the booty acquired from Tabriz. A silver gilt jug in the Victoria and Albert Museum, probably of the reign of Selim, follows the round-bodied type made for the Timurids, but its arabesque decoration is now in repoussé. Its lid, with a rim of Ottoman crenellations, is considered a later addition. A jug of similar shape in the Topkapı Sarayı is made of rock crystal decorated with trilobed cartouches.

127 ABOVE Flask (*matara*) in rock crystal with gold fittings and inlaid gems. Ottoman, late 16th or 17th century. The shape imitates a skin water-bag. Istanbul, Topkapı Sarayı Museum.

128 RIGHT Silver gilt bowl with engraved and repoussé decoration. Ottoman, made before 1510. The dish is stamped with the name of ʿAlamshah, a son of Bayezid II, who died in 1510. The design of the bowl, with a central raised feature – here a crouching ram with an articulated head – set between four ornamental motifs, reflects metalwork produced in Iran in the 11th or 12th centuries. The four floral motifs on this bowl have a chinoiserie quality. Sold at Sotheby's, London, 25 April 1990, lot 447.

The development of metalwork in the sixteenth century was doubtless fostered by the fact that both Selim I and Süleyman I had been trained in goldsmithing, since it was the practice for a sultan to learn a craft. Metals were worked with multiple layers of pattern and were inlaid with jewels, ruby and turquoise or ruby and emerald, which were set in collar mounts whose bases were fashioned as flower petals. Plaques of jade and rock crystal, which might themselves be inlaid with gems, were applied. The highly decorated style reaches its opulent peak in work for Murad III. The objects made included jugs, caskets, mirrors, weapons, armour and turban-pins. A new application of jewelled metalwork was its use for bookbindings, a departure which may have been influenced by the example of Byzantine Gospels. Another typically Ottoman object is the royal water-pot (*matara*). This was carried by one of a sultan's principal attendants, while another carried his sword. The *matara* has a loop handle and sometimes looks much like a jewel-encrusted handbag.

An alternative metalwork style was very plain, relying for its effect upon elegant proportions. Brass was used, but the finer bowls, ewers and penboxes (*divits*) are in silver. Plain-style candlesticks sometimes have a candleholder in the form of a tulip: a brass example in a private collection, made for the governor of Galata in 905/1499–1500, corresponds to the first appearances of the tulip in manuscript painting. Another medium used was *tombak*, gilded copper, which has a warm glow. It is mainly found in domestic items, but also in some armour, such as helmets and chanfrons (horses' headpieces).

Much urban nineteenth-century metalwork favours Europeanising flowers and gadroons. However, adornments for country or tribal women include silver belts and caps with dangling coin ornaments which relate to the distant past.

Wood and ivory

Ottoman woodwork makes more use of veneers and inlays than of relief. Bodies of walnut or other fruit-wood were decorated in ebony, ivory and mother-of-pearl. Some fine examples are Qur'an boxes of the sixteenth and seventeenth centuries. These are divided into compartments to hold sections of the Qur'an, and their domed lids suggest that they were seen as shrines. Their ornament included bold ivory inscriptions in cursive script or seal kufic, geometric patterns, *rumi* cartouches and *hatayi* cloud-scrolls, and also small areas of minute marquetry. The different motifs tend to be discrete, the scrolls not being used to make links between them. The most striking Ottoman piece is a throne in the Topkapı Sarayı, thought to have been made for Süleyman the Magnificent, which has a crenellated back with a central *rumi* roundel in mother-of-pearl set with a turquoise, and a short ivory post at each corner of its side pieces: it could be dismantled for use on campaign. An object certainly made for Süleyman is a mirror signed by Ghani in 950/ 1543–4. The handle is of fluted ebony, and the ivory back is a triple-layered palmette, exquisitely carved with scrolls and flowers in relief and a poetic inscription. The mirror glass may have been imported.

A throne was made in the early seventeenth century for Ahmed I by the *sedefkar* (worker in mother-of-pearl) Mehmed Aga, who also designed the

129 Carved wooden turban-stand (*kavukluk*). Ottoman, late 18th century. The form is derived from a rococo sconce. The trio of columns shown in perspective at the side are similar to elements found in a number of late 18th-century wall paintings, and the central escutcheon is painted with a trophy of weapons. Sold at Sotheby's, London, 25 April 1990, lot 204.

Sultan Ahmed mosque and inlaid its doors and *kursi* (preacher's seat). The throne is of more upright form, with posts at the corners rising to support a canopy upon which is set a clock. The inlaid decoration is in tortoiseshell and mother-of-pearl set with gems. The design shows tulip, hyacinth, carnation and rose connected by thick scrolling stems.

Arts of the book

Ottoman calligraphers are regarded as the greatest of the later Islamic period, and sultans were proud to consider themselves their students. The fountain-head of this tradition was Yaqut al-Mustaʿsimi (d. 1299), a Turk who had been secretary to al-Mustaʿsim, the last ʿAbbasid caliph, and who had practised the six classical scripts. His influence extended through the centuries from Shaykh Hamdullah (1429–1520) to Ahmed Karahisari (1469–1566) under Süleyman the Magnificent and to Hafiz ʿOsman, who in the late seventeenth century instructed the future Ahmed III. Their work was directed to the copying of the Qur'an, the design of inscriptions for mosques and the production of single specimen pages for collection in albums. Their calligraphy is particularly strong in the dynamism and subtlety of the curved line.

A special feature of Ottoman calligraphy is the *tuğra*, a monogram giving the name of a sultan and of his father, together with the Turkish title *khan*, and the epithet 'ever victorious'. Names and titles are written densely enmeshed, with vertical strokes rising high above them and billowing loops to the left. The *tuğra* was used as the sign of the sultan on documents, coinage and inscriptions on buildings. The earliest surviving example (Istanbul Belediye Library), of 724/1324 in the name of Orhan Ghazi, on a grant of land to a freed slave, in unadorned, but by the sixteenth century the *tuğra* of an important document had achieved great visual authority, with writing in gold or blue and finely drawn ornament in the zones between the strokes.

Ottoman bookbinding in leather is of a very high order. A frequent cover design has borders, *cyma recta* cornerpieces and an ogival medallion in a plain dark brown field. Shagreen was sometimes used instead of the usual leathers. Other decorative techniques were used to embellish the pages of books of entertainment and albums. Two of these had been practised since the Timurid period: gold-sprinkling, in which fragments of gold leaf were scattered over the page, and cut-paperwork, formerly used for chinoiserie or writing, but from the sixteenth century for naturalistic flowers. A third technique, also used by the Safavids and Mughals, is marbling, *ebru* (from the Persian *abri*, clouded or variegated). The process is a form of printing. A tray of liquid made viscous with starch is used as a bed; colours which have been prepared with ox-gall to prevent their mingling are scattered on it and may then be worked over to produce patterns. Damp paper is laid over the colours to take the print.

The first pictures which are both dated and distinctively Ottoman in style are in a romance in Persian, the *Dilsuznameh* (The Heart-Searing Story; Bodleian Library, Oxford) copied in 860/1455–6 – shortly after the capture of Constantinople – in the old capital Edirne. The illustrations have a simple charm. Painted in rather cool colours, they have simple compositions which

are divided by a central vertical axis, and the hero and heroine have pale complexions and somewhat stiff necks. An interesting touch of Western influence is shown in a hint of aerial perspective in the representation of gardens. The *Dilsuznameh* thus already indicates an important aspect of Ottoman painting: that it borrows from European naturalism, but with circumspection and while maintaining its own preference for stylisation.

Mehmed the Conqueror, who had a thorough-going interest in what Europe had to offer, not only collected Florentine engravings but also invited Italian painters to spend time at his court. The most prestigious of his visitors was Gentile Bellini, who was in Istanbul from 1479 to 1480 or 1481. His oil portrait of Mehmed of 1480 (much repainted) is in the reserve collection of the National Gallery, London. The sultan is shown bust length, as though looking from a window, but the window is indicated by an ornamental arch and the ground is dark. Bellini emphasises the strong aquiline curve of the sultan's nose and the practical intelligence of his gaze. The Ottoman response to this picture is seen in a painting in one of the Topkapı albums which is generally attributed to a painter named Sinan. In traditional Islamic gouache, the figure of the sultan is of bust proportions but the painter has included rudimentary legs which are crossed as though the subject sat on the floor. Most of Mehmed's pictures must have been disposed of at his death; some with erotic subjects were sold in the market place.

A palace payroll of 1526 gives an interesting view of the *naqqash-khaneh* in the early years of Süleyman the Magnificent. It lists forty-one painters, some specialised in decorative work and some in representational. Several were acquired from Tabriz in 1514, while others came from different parts of the Ottoman empire, including the Balkans. The variety of styles which might be expected from these origins is evident in contemporary manuscripts, in elegant princely hunts of Persian origin on the one hand and laconic European topographical style on the other. Amid these elements an Ottoman fusion was forming. An important milestone is the account of Süleyman's campaign in Persian and Arabian Iraq (Istanbul University Library), which was illustrated in 944/1537–8 with picture maps. Among these is a bird's-eye view of Istanbul, redolent of the painter's pride in his capital city, which in its careful detail has great documentary value.

In the 1550s Süleyman instituted a manuscript project which would recount the glories of his ancestors of the house of ʿOsman in four volumes and celebrate his own part in presiding over and extending the empire in a fifth; this last volume, the *Süleymannameh*, completed in 965/1558, is in the Topkapı Sarayı. The illustrations show the sultan in war and peace as the still centre of brightly robed throngs of courtiers, attendants or soldiers. The painters who worked on this volume were grappling with the portrayal of recent historical events for which no specific models were available, and the compositions are inclined to become cluttered and static as they strive to convey the full magnificence of the different occasions. Nevertheless, the aims and scale of the work, and the necessity of selecting realistic detail to typify particular events were vital factors in the formation of the classical style. The style is seen at its peak in a history of Süleyman produced under his grandson Murad III in 987/1579. In the illustrations to this work the action

130 OVERLEAF, ABOVE *Tuğra* of Selim II, Istanbul, late 1560s. The *tuğra* reads *Selim Shah bin Süleyman Shah Khan al-muzaffar daʾiman*. It would have been written near the top of a scroll with a brief invocation of Allah above it. Below it come the introductory words to a decree (*ferman*), written in widely spaced boat-shaped lines (*sefine*) in the ornate *divani* (chancellery) script. Delicate and relatively naturalistic flowers are particularly associated with the work of an illuminator named Kara Mehmed. Sold at Sotheby's, London, 10 April 1989, lot 161.

131 OVERLEAF, BELOW Papercut, Istanbul, third quarter of the 16th century (mounted in an album for Murad III). The page may be the work of ʿAbd al-Hayy ʿAli, a master of cut-paper work, including cut calligraphy. The side sections of the upper register are painted. Vienna, Nationalbibliothek.

 یکی اوچ میل او لیدی دور میدان اکه دیون اوندو، کوسه سلیمان

132 'Khusrau visits the Qaysar of Rum', from a *Khusrau u Shirin* of Shaykhi (Şeyhi), Istanbul, about 1500. This is an Ottoman version of the Persian story. The face of the Qaysar ('Caesar', the Byzantine emperor) has been damaged, but can partly be made out in the under-drawing; it may well have reflected the face of the contemporary sultan, Bayezid II. The dark-skinned figure with the axe and gown kirtled into his belt is a *payk* or running footman. A touch of European influence is seen in the treatment of the sky and garden in the upper left. London, British Library.

unfolds with unhurried dignity and order. What is inessential is omitted, and what is essential is rendered in strong and stylised colour. In other manuscripts the classical history style gives glimpses of the life of the royal palace, or of processions mounted for the celebration of the circumcision of royal princes when the various trade guilds passed through the At Meydan (the Byzantine Hippodrome) displaying their skills, the bakers with a bread-oven on a float, the glaziers with a kiln.

A feature of the outdoor scenes in this style is the very schematic treatment of landscapes, which are rendered in thin uniform expanses of turquoise or blue with very plain grass tufts. This simplification of Persian landscape style, which is found progressively through the sixteenth century, probably results from the fact the Ottomans had much of their being – especially on campaign

133 OPPOSITE 'The burial of Süleyman' from *Tarikh-i Sultan Süleyman* by Luqman, Istanbul, copied in 987/1579. A golden Qur'an box is borne in front of the cortège. The burial will take place to the south of the *qiblah* wall of the Süleymaniye Mosque – the picture suggests that the enclosure wall was built in brick before being faced in stone. The completed tomb is that of Süleyman's wife Hürrem (Roxelane), who died in 1558; in it hangs a golden lamp. The pavilion on the right is for the training of reciters of the Qur'an. Dublin, Chester Beatty Library and Oriental Art Gallery.

– among the temperate landscapes of Europe. The old Persian landscape conventions for the depiction of dry lands were thus not supported by the painters' surroundings, and they tended to become stylised into a simple notation. This stylised landscape convention and the plangent palette were used with larger figures in the last decade of the sixteenth century for illustrations, sometimes of visionary intensity, to a life of the Prophet, *Siyar-i Nabi*, now divided between Topkapı Sarayı and other libraries, in which Muhammad and his family are frequently illustrated, though always with a white veil over the face.

Meanwhile a softer version of the classical style was used for romances in the Persian tradition, and a plainer version for works in the tradition of the Arab 'Wonders of the World', which lost nothing from the input of Byzantine marvels. In the 1560s and 1570s the sea-captain Haydar Reis – his painting talent perhaps developed in the production of charts – made album portraits of the sultans in which the use of a black ground may follow Bellini's portrait of Mehmed II. The tradition of pen drawing which had flourished at the Timurid and Safavid courts also continued. In these the *saz* leaf is much in evidence, either as a single convoluted motif or as the jungle through which the old Chinese dragon ramps, or blending with feathers in the wings of fairy cupbearers. These drawings sometimes bear the name of one of two artists of Tabriz – Shahquli, who joined the *naqqash-khaneh* in 1520 or 1521, or Vali Jan who came to Istanbul in 1587. Though both would have been trained in the Persian tradition, they evolved a distinctive Ottoman style. This is marked by strong black calligraphic lines – reminiscent of the curves of the *tuğra* – for the spine of the leaf or the dragon, and by a tendency for the *saz* to hybridise with European acanthus.

The seventeenth century produced a number of interesting single figure pictures, including several studies of the wistful ʿOsman II who was done to death in the Yedi Küle fortress in 1622, but on the whole energy was lacking. In the early decades of the eighteenth century, however, under the patronage of Ahmed III, the painter Levni developed a new style. A portrait of Ahmed shows him sitting on a highly ornamented throne of chair-like form. With a black spade-beard and an immense white turban topped with three black aigrettes set with jewels, he is an impressive figure, but the palette of yellow and pink and grey bespeaks the light-hearted mood of the times. This character is particularly evident in a number of single figures by Levni of about 1710 to 1720. Some of these are identified by labels as individuals, but for the most part they are types of the slave-servants of the palace, characterised by their costume and gesture. Levni chooses a low viewpoint which gives his figures an elegant length in the leg and distances their similar and faintly smiling faces. Levni also illustrated a *Surnameh* which records the fifteen-day celebration in 1720 for the circumcision of four of Ahmed's sons and of 5,000 poor boys, and the marriage of three daughters and two nieces. The procession of the guilds includes confectioners with gardens of spun sugar, and entertainments are shown with funambulists, jugglers and fireworks.

Single figures of women continue to be favoured in the eighteenth century. In the 1740s ʿAbdallah Bukhari draws women in the tradition of Levni, but

134 BELOW 'Dancer with castanets', album painting by Levni, Istanbul, about 1710–20. Levni uses the swirling movement of the costume to convey a dance of medium tempo; he shows the weights of the various fabrics, and hints at the solidity of the dancer's body. The traveller Lady Mary Wortley Montagu, writing from Edirne in 1717, describes an almost identical costume acquired for her own use. Istanbul, Topkapı Sarayı Library.

their dark and brooding gaze suggests a haughty independence of mind – indeed, some would appear to be prostitutes. Shortly afterwards Rafa'il the Armenian translates the form into oil painting, and shows women, or sometimes youths, who challenge the viewer with their gaze and who may sometimes hold an arrow, a bunch of grapes or a flask which is open to an amorous interpretation. In the late eighteenth century manuscripts were produced which illustrate poems by Fazil Husayn Andaruni – whose name indicates that he was educated in the palace school – on the characteristics of boys and women of various nationalities, the figures being dressed in the

135 'Scribe' from the *Zenannameh* (Qualities of Women) of Fazil Husayn Andaruni, Istanbul, late 18th century. The picture contrasts a superficial untidiness with the underlying sense of orderly calm in the scribe's work. The brushstrokes are touched with a European painterliness. Beside the scribe is his *divit*, a pen-case with an attached inkpot. The sky seen through the window is rendered in a European manner. London, British Library.

appropriate costume, even to a French lady in the costume of the Revolution.

In 1218/1803–4 Selim III had himself painted in oils by Konstantin Kapıdağı. A powerful figure in a red surcoat trimmed with leopard, the sultan sits leaning upon a bolster with one knee raised; it is as though the oil portrait exemplified by Bellini's Mehmed II had come to an accommodation with the oriental posture represented by the 'Sinan' picture. More oil paintings followed through the century.

From the later nineteenth century there survive examples of shadow puppets in stained leather, which were used backlit against a cloth. The puppets are in an ancient tradition which the Ottomans may have acquired from the Mamluks in the early sixteenth century, if they did not already practise it. The puppets were used for playlets concerning a mischievous hero Karagöz (Black Eyes), drawn as a caricature.

Textiles and carpets

More than any of the other Muslim societies, the Ottomans distinguished the ranks and functions of different members by their dress, and in particular by their headgear. The most distinctively Ottoman headcovering is the *keçe* of

the Janissaries. Of white felt, this is mounted on a metal band on the brow and hangs down the back. It is said to represent the sleeve of the holy man Hajji Bektash, who conferred his special protection on the Janissaries in the fourteenth century. Other military headcoverings are the high white plumes of the bodyguards, and the spread wings of the irregular troops known as the *deli* (mad). The sultans themselves wore large turbans: in the fifteenth century a round shape with a cap visible in it, from the late sixteenth an inverted cone, in the eighteenth a low wrapping on either side of a flap-topped cap, in the nineteenth a fez. Members of the *ʿulama* wore a large round turban; this is seen in exaggerated form in drawings of Nasr al-Din Hoca (Khwajeh), hero of many comic anecdotes of Sufi meaning.

The principal garment of sultans and courtiers was the kaftan, a long gown opening at the front, whose elegance and practicality were noted by Busbecq, an envoy from Austria in the mid-sixteenth century. More than a thousand kaftans of deceased sultans are preserved in Topkapı Sarayı, but unfortunately their chronology is unreliable since from time to time they have been inspected and repacked in error.

The most spectacular kaftans were in silk. This might be *atlas*, a monochrome satin, or a brilliant polychrome lampas, for which the Turkish term is *kemha* (Persian *kimkha(b)*, 'kincob'). The earlier Ottomans, like the contemporary Mamluks, may have favoured stripes. A silk fragment survives (Monastery of Studenica, Yugoslavia) striped with inscriptions referring to a Sultan Bayezid (thought to be Bayezid I, who died in 1402) and rows of geometric motifs and chinoiserie clouds. By the late fifteenth century, paintings show that the ogee lattice design had come into fashion. Used with floral motifs, this continues to be important throughout the sixteenth century. Some designs of the period include the *chintamani* triple dot, sometimes accompanied by a double wavy line. The Ottoman designers combined their floral and formal motifs in an analytical and additive manner with small elements decorating larger ones, layer on layer. A ruby red tends to dominate the colour schemes, with blue, green, white and threads wrapped in silver and gold. Two kaftans of about 1550 stand a little apart: thought to have been made for Mustafa and Bayezid, sons of Süleyman the Magnificent, they must represent some of the finest work of the *naqqash-khaneh*. Their luxuriant designs incorporate *saz* and fantastical flowers in the manner of the Damascus style of Iznik pottery. A fabric typical of the seventeenth century is *seraser*. The greater part of its surface is composed of metal-bound threads, and small amounts of light coloured silks were used to outline large motifs.

Plain velvet was known as *kadife*, and voided velvet, with areas of satin and metallic thread, as *çatma* (built up). It was used for kaftans, but also for wallets for the Qur'an, cushion covers, horse-cloths and bow-cases. The principal colour is usually a deep crimson with patterning in cream and touches of green. Patterns are relatively simple and there is much use of a large carnation motif. Padded embroidery in gold thread decorated velvet from the sixteenth to the nineteenth century. It was used for the *kiswah* sent annually to the Kaʿbah, and on military banners and insignia.

The tents of the commanders of the Ottoman campaigns were decorated in appliqué in cotton, silk and leather with such lavishness that the occupant

136 Panel from a child's
kaftan in silk lampas with
eight-pointed motifs.
Istanbul or Bursa, early
16th century. The kaftan is
thought to be one of a
number once draped over
the cenotaphs of royal
tombs in Bursa or Istanbul.
A date early in the 16th
century is suggested by the
relative simplicity of the
pattern, in which a circle is
still an important element,
and by the finials which
can be related to 15th-
century tilework. London,
Victoria and Albert
Museum.

137 Silk lampas fragment
with gilt thread brocade in
a design of undulating
stems. Istanbul or Bursa,
second half of the 16th
century. The design
employs motifs like those
on the 'Damascus' style of
Iznik pottery, but still
recalls an ogee lattice. The
saz fronds sweeping over
the stems and tulip-like
flowers passing below
them convey depth and
movement. The ornaments
on the *saz* illustrate the
Ottoman taste for
recombining natural
elements. Washington DC,
Textile Museum.

139 Quiver and bowcase in embroidered velvet. Ottoman, early 17th century. The bowcase is for a strung bow; the slit on the quiver takes an arrow for immediate use. The embroidery is in fine coiled gilt wire which is flattened with a hard instrument. Three metal mounts in gold and silver in the form of dragon heads hold dark cabochon-cut stones. Quiver and case were a gift to Gustavus Adolphus of Sweden in 1629 from the Tatar Khan of the Crimea. Stockholm, Royal Collection.

138 PREVIOUS PAGE Carpet with *saz* fronds, Istanbul or Bursa, second half of the 16th century. In the field, exquisite *saz* fronds are grouped so that they seem to grow in a thicket or spring from a vase, but this is an illusion created by the design, since there are no unifying stems nor container. The central medallion suggests an Iznik dish; like the cornerpieces with their naturalistic flowers, this has a stabilising effect. S-curved *saz* fronds at either end of the field recall a motif on a tilework panel at the Rüstem Paşa Mosque, Istanbul, after 1561. Paris, Musée des Arts Décoratifs.

might have thought himself in a garden pavilion. Flowers were also worked into a light form of shield made of silk-bound coiled wicker with a central metal boss, a structure used earlier by the Timurids. Military standards with tassels of horse-hair (*tuğ*) derived from the Ottomans' Central Asian past.

The large patterns of woven silks were imitated in simpler form in embroidery on large spreads or curtains of cotton or linen. The colours used are crimson, blue and green, in darning stitch, a laborious technique which sometimes produced rather frigid results. Fine embroidery in various stitches was also used for handkerchiefs, an indication of royal rank, and for *bohças* squares to cover turbans and similar objects. From the nineteenth century there survive towels in a long format with delicate embroidery at either end representing flowers, or occasionally landscape scenes. During the period of Ottoman rule and until the present day Palestinian women have practised cross-stitch embroidery, dresses of indigo-dyed cotton being worked with small motifs in red and other bright colours.

The practical and aesthetic qualities of Islamic carpets were appreciated in Europe as early as the fourteenth century. Thus it comes about that an invaluable guide to the dating of carpets is found in the European paintings which record them, under the feet of Madonnas and saints in the fourteenth and fifteenth centuries, and on the tables of the well-to-do in the sixteenth and seventeenth. The carpets shown are usually Ottoman; however, a Caucasian

origin is sometimes suggested for an existing rug (Islamisches Museum, Berlin) with stylised dragons and *simurghs* which corresponds closely to one in a picture by Domenico di Bartolo datable to the 1440s. Two important groups of carpets have acquired their names from artists active between the 1490s and 1540s. 'Holbeins' are found in the work of Holbein the Younger. They are distinguished as large- or small-patterned according to the size of their octagonal motifs, and they appear to be related to both Seljuk and Mamluk carpets. The colours used are red, yellow, blue, brown and white. 'Lotto' carpets, named from Lorenzo Lotto, have a grid of angular yellow arabesque on a red ground.

An influence emanating from manuscript illumination is clear in the carpets produced in Uşak in Western Anatolia and datable to the mid-sixteenth century. This is evident from three features: a new interest in the curvilinear; the use of a design on two levels, the lower of which is of flowering scrolls; and above all from the bold motifs which provide the qualifying names 'Star' or 'Medallion' Uşak. A borrowing from another medium is also to be suspected in the 'White-Ground' carpets which are mentioned in inventories throughout the sixteenth century. The models here seem to be the embroidered spreads mentioned above. Pattern motifs are laid out regularly over the field. The triple dot motif is sometimes used.

In the mid- to later sixteenth century carpets for the Ottoman court appear to follow designs from the *naqqash-khaneh*. The first centre of this production may have been Cairo, where the Mamluk tradition for fine work and the use of the asymmetrical knot would have facilitated the execution of curvilinear designs; later Bursa and Istanbul were probably centres. The refined motifs of the *saz* style, together with more naturalistic flowers, are rendered in a wide range of rich and subtle colours.

The rugs of Anatolia, which survive from the seventeenth century onwards, have vigorous designs which may contain reminiscences of the grander carpets. A design favoured for prayer rugs shows an angular arch against a plain ground, as though a *mihrab* opened on to infinity. Flatwoven rugs, called *kilims* (blankets), were made in tapestry technique. A few kilims are in very finely worked courtly style, but the majority were made by the villagers and nomads of Anatolia. These use strong colours and lively pattern in which stepped and saw-toothed lines are prominent.

8

EMPERORS IN HINDUSTAN
Sultanate and Mughal India

The river Indus, which flows through present-day Pakistan, gave its name, in the usage of the ancient Persians and Greeks, to the surrounding land and eventually to the major religion practised there: Hinduism. In the Middle Ages the name in the form Hindustan was used for the north of the subcontinent. The character of Islamic art in this region was deeply influenced by the Hindu artistic tradition, to which it also contributed in a continuing interplay.

Two and a half millennia BC the Indus valley supported a civilisation in which people lived in brick-built cities. This civilisation passed away, but the great skill which its people showed in sculpture – moulded, carved or cast – seems to have passed down the ages. From about one and a half millennia BC the Aryans crossed the Indus and established themselves in northern India. Under them the principal stories of the Hindu gods took form, and two great epic poems were created, the *Mahabharata* and the *Ramayana*. In the sixth century BC a great religious ferment took place in north-eastern India and the lowlands of present-day Nepal, and two major religions separated themselves from Hinduism: these were Buddhism and Jainism, atheistic systems which nevertheless evolved complex pantheons of symbolic divinities. The Jains rarely achieved territorial rule. Buddhist kings, on the other hand, saw Alexander the Great cross the Indus in 326, and continued in Bihar until the twelfth century. In the interim they lost ground to Hindu dynasties, which were usually of the princely and warlike Rajput caste.

Islam first touched the subcontinent when the Arab armies reached the Indus in the early eighth century and captured some surrounding territory. From 1000, Mahmud of Ghazni led a series of campaigns into India, but the crucial year for the Muslim advance was 1192 when Qutb al-Din Aybak (Aybeg) defeated the Rajput Prithvi Raj and captured Delhi.

Qutb al-Din, who conquered in the name of Ghiyas (Ghiyath) al-Din Muhammad of Ghur, was a slave, but from 1206 he ruled in Delhi as sultan. The period from Qutb al-Din to the Mughal conquest in 1526 is known for convenience as the Sultanate, though from the mid-fourteenth century independent Muslim states arose in the Deccan, Bengal and Kashmir. Delhi suffered a severe blow from Timur's invasion of 1398–9. From the mid-

fifteenth century, however, until the Mughal conquest, the city was in the hands of the vigorous Lodi dynasty.

The Mughals were led into India by Babur, a fifth-generation descendant from Timur. The name Mughal (variously spelt) is an Indian version of Mongol, and to dwellers in India it meant anyone from Central Asia. Babur, however, having been born in Central Asia, ranged himself with his father as a Turk, though he had formidable Mongol uncles since his mother was descended from Chingiz Khan. Babur came to power in Farghaneh in 1494 at the age of eleven, after his father's untimely death in a falling pigeon-house. He captured the ancestral capital of Samarqand three times, but was unable to hold it against the pressure of the Uzbeks in the north. Having acquired a base at Kabul in Afghanistan, he raided down into India, and after the battle of Panipat in 1526 secured Delhi. He died at Agra in 937/1530. Babur wrote his memoirs in his native Turkish. Illustrated copies of a Persian translation were made for his grandson Akbar, and – as with so many works of Muslim Indian history – the memoirs have also been translated into English. They open a window into the mind of a very fascinating personality, showing Babur's courage and lucidity in defeat and triumph, his rapid assessments of people and his interest in the natural world.

Babur was succeeded by his son Humayun, who soon faced insurrection and by 1540 was obliged to flee westward towards Sind, leaving his kingdom

140 Detail of the screen arcade, Quvvat al-Islam, Delhi, 594/1198. The springing of the central arch, higher and broader than the rest, is seen on the left; on the right, at a lower level, are the corbelled courses which take the place of voussoirs to form an arch. Under the qur'anic inscriptions run wavering stems of lotus, and beside them are scrolls in the Hindu tradition.

to the Afghan Sher Shah Sur. In the course of this flight a son, Akbar, was born at Umarkot in 1542. Humayun sent his wife and son to Kabul and went to appeal for aid from the Safavid Shah Tahmasp, at whose court he spent several months in 1544. He returned via Mashhad to Kabul, where he maintained his court until 1555 when he recaptured Delhi. Six months later in 963/1556 he received a mortal injury to the head when he fell in the stairway of his observatory pavilion in his haste to answer the call to prayer.

Akbar was left at the age of thirteen as ruler of an uneasy empire, but by the mid-1560s he was in control and able to direct his attention to conquests in Gujarat, Rajasthan and the Deccan. At this period he was troubled by the lack of a male heir, but he was assured by Shaykh Salim of the Chishti order that his prayers would be answered. Akbar sent one of his wives, the daughter of the Rajah of Amber, to give birth in the proximity of the shaykh at Sikri. In 1569 the hoped-for son was born and given the name of Salim; two years later Fathpur, the City of Victory, was founded at Sikri. Akbar had a deep but liberal interest in religion. He held religious discussions with Muslims, Hindus, Jains, Parsees and Sikhs, and also with Jesuits whom he invited to court from Goa. In 1582 he promulgated a syncretistic religion, the *Din-i Ilahi*, in which he was the representative on earth of the Divine Light. In 1585 Akbar moved his court to Lahore to face a threat from the Uzbeks: the change also facilitated the annexation of Kashmir. Akbar returned to Agra in 1598. In the last years of his rule, Salim became impatient to reign and set himself up in royal style in Allahabad, though he made a brief reconciliation with his father in 1603. Akbar died in 1014/1605.

The new king took the regnal name of Jahangir (World-Grasper). He was fortunate to receive a well-organised empire which enabled him to rule in splendour without great personal exertion. Like Babur he composed an account of his life, which shows him as the focus of court ceremonies but also reveals his interest in the arts and his scientific curiosity about natural history. The first year of his reign was troubled by the revolt of his son Khusrau. But in 1614 another son, Khurram, who was later to reign as Shah Jahan (King of the World), rose to high favour by the defeat of the greatest among the Rajputs, the Rana of Mewar. An estrangement occurred between Jahangir and Shah Jahan in 1622, partly owing to the influence of Jahangir's powerful queen, Nur Jahan, daughter of the vizier I'timad al-Daulah. Shah Jahan spent some time in the Deccan and did not see his father again. Jahangir died in 1627, undermined by his liking for drink and opium. His vizier, Asaf Khan, the brother of Nur Jahan but also the father of Shah Jahan's favourite wife, Mumtaz Mahall, engineered the succession of his son-in-law in 1037/1628.

Shah Jahan was on campaign in the Deccan in 1631 when Mumtaz Mahall died while giving birth to her fourteenth child. Stricken with grief, he set about the construction of her monument, the Taj Mahall at Agra, whose construction took some fifteen years. In 1648 Shah Jahan transferred his capital to his new city at Delhi, Shahjahanabad. Like those of Akbar, his later years were clouded by the pretensions of a son. The king would have preferred to be followed by his eldest son, Dara Shikoh, a poet interested in mysticism and the reconciliation of Hinduism and Islam. However, another son, the warlike Aurangzib, seized his father and held him in captivity in Agra

fort from 1658 until his death in 1076/1666. Aurangzib spent much time campaigning in the Deccan, to the detriment of the economy. He also became increasingly severe in his Islamic views, and hostile to Hindus. Aurangzib died in 1118/1707, the last of the Mughals to be described as great.

In 1152/1739 the Mughal power received a devastating blow when Nadir Shah sacked Delhi. Vast quantities of booty were taken, including the celebrated Peacock Throne of Shah Jahan. The central hold on the provinces weakened, and Oudh (Avadh), east of Delhi, and Hyderabad in the Deccan became in effect independent. Meanwhile the power of the Hindu Marathas and of the European trading centres was spreading. British domination grew from the mid-eighteenth century. Following the Mutiny, or war of Independence, the last Mughal, Bahadur Shah II, was deposed in 1858 and India was brought under the direct rule of the British Crown. Independence and the partition of India and Pakistan came in 1947.

Architecture

The earliest trace of Islamic architecture in the subcontinent is at Banbhore, east of Karachi, where foundations survive of a mosque of Arab plan datable to the first half of the eighth century. A few monuments of the period prior to 1192 remain in north-western regions; however, the earliest major site is that constructed immediately after the Ghurid conquest, at Mehrauli, the citadel of the defeated Prithvi Raj, on the southern outskirts of Delhi. Its principal building was a Masjid-i Jamic, which came to be called the Quvvat al-Islam (Might of Islam).

The conquerors found themselves in a land with a highly developed tradition of religious architecture, but one very different from their own. The central feature of a Hindu temple is a sculpted representation of a deity which is housed in a shrine whose name, *garbhagriha* (womb chamber), indicates a place which is sacred and enclosed. The shrine is often approached through antechambers whose small size can accommodate only a few worshippers at a time. Externally the *garbhagriha* is marked by a high tower of solidly built stone, whose summit may be crowned with the representations of a ring of lotus petals and a water jar, while its sides may be adorned with small shrines of further deities with their attendants and guards, with sculptured garlands of flowers signifying worship, and with miniaturised architectural features such as niches and pilasters. The temple stands upon a plinth, and a precinct round it may be enclosed by a cloister, the whole standing upon a platform. Cloisters, or their material, could be converted to Islamic use, but the central shrines and figures of deities would have to be cleared.

The Hindu and Jain masons were highly skilled in the working of stone, but their architectural methods reflected an older tradition in wood. The stone pillar was cut square in section and the corners were then chamfered down most of its length, producing an octagonal section and the impression of a tree trunk with sawn sides. The standard structure was trabeate, planks of stone being laid like lintels over such columns, sometimes with the support of stone brackets. The arches to which the Muslims had been accustomed, formed by radiating voussoirs of stone or bricks set at an angle, were not used, nor were the corresponding vaults and domes. Instead, the Hindu or

Jain dome was a shallow shape formed by laying stone planks horizontally across the corners of a cubic space, and moving inward, layer upon layer.

The Quvvat al-Islam (587/1192–592/1196) arose from the spoils of twenty-seven Hindu and Jain temples, and on the platform of a temple which had been extended for the purpose. Its courtyard was enclosed by riwaqs of re-used columns from which animate figures were removed (with accidental exceptions). Cross capitals were employed, and where necessary columns were superposed to give the requisite height, a technique found in some Jain temples. In the prayer hall the qiblah aisle was capped with five low Hindu domes.

Returning from a visit to Ghazni, Qutb al-Din evidently decided that a more Islamic impression was needed. By 594/1198 he caused the first purpose-built portion of the complex, a great screen wall of pointed arches, to be erected on the courtyard side of the prayer hall. The structure is unrelated to the hall beyond it and fulfils no utilitarian need: its function is to impose the vision of the pointed arch, which is clearly felt to be essentially Islamic. In a sense the whole screen may be said to act as a mihrab. The qiblah direction in North India is almost due west, and the arcade was designed to exploit this fact. By day the rich decoration on its east face could be appreciated from the courtyard, and at the evening prayer its strong silhouette was seen against the sunset. The silhouette continues to be important in later buildings. The profile of the arch used at the Quvvat al-Islam is interesting, for, although it otherwise resembles those of Persia, it has a slight ogee curve at the crown, a feature found in Buddhist ornament. But more distinctive signs of the meeting of different traditions lie in the actual structure of the arch and in its decoration. The span is not created by radiating voussoirs, but by blocks laid in horizontal courses which project as corbels ever closer towards each other, until long slabs meet at the crown. The decoration includes frothing scrolls and meanders, derived from Hindu sculpture, and sinuous lotus scrolls which run behind the qur'anic inscriptions.

In the early thirteenth century the courtyard and screen were extended by Qutb al-Din's successor, Iltutmish, and a similar mosque had been built at Ajmer in 596/1199–1200. In both of these, screens of arches are richly decorated but in an Islamic mode. The extension of the Quvvat al-Islam courtyard enclosed the base of the Qutb Minar, a huge minaret begun by Qutb al-Din, with three storeys added by Iltutmish. The minaret is related in form to the Gunbad-i Qabus tomb-tower in Iran, and the minarets of the Ghaznavids and Ghurids in Afghanistan. Like the latter, it was intended to serve both for the call to prayer and as a victory tower. Its name, derived from the honorific title of the founder Qutb al-Din (Axis of Religion), suggests that it was also seen as symbolising an axis between heaven and earth. A century later, in 710/1311, ʿAla al-Din Muhammad of the Khalji dynasty built at the foot of the Qutb Minar an entrance pavilion to the mosque, which has an air of elegance and gaiety. Known as the ʿAlay Darvazah, this is square in plan and has a dome capped with a Hindu finial in the form of a flanged ring (amalaka). Its graceful south entrance has a true arch of radiating voussoirs in a slightly pointed horseshoe shape, and its surfaces are richly carved with

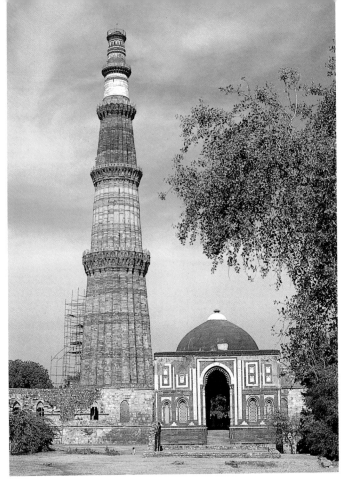

141 The Qutb Minar and ʿAlay Darvazah, Delhi, completed under Iltutmish (1211–36) and in 710/1311 respectively. The minaret is ornamented with both angular and rounded shafts. The windows of the ʿAlay Darvazah are screened with marble grilles (*jalis*). The intrados of the arch is rimmed with a motif variously described as 'spearhead' or 'lotus bud'.

142 BELOW The tomb of Humayun, Delhi, 1562–71. The wide platform is an important borrowing from Hindu architecture. The *ivan* in the centre of the south façade of the upper structure is almost closed, presumably against the sun. A system of corridors allows for the circumambulation of both the central cenotaph chamber and other family cenotaphs in the corner pavilions. Niches in the plinth were used for further burials.

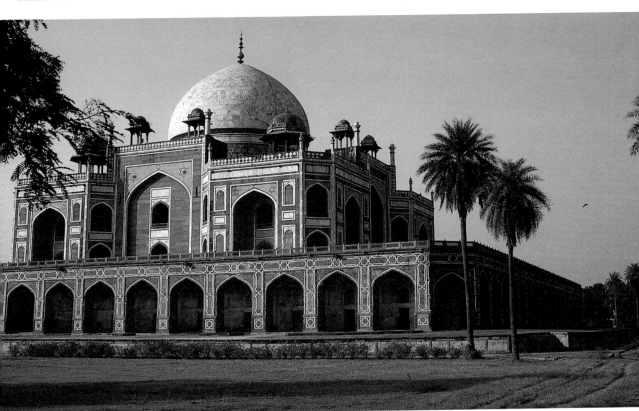

patterns which integrate Muslim and Hindu elements. The building material is red sandstone, set off by details in white marble.

The neighbouring tomb of Ghiyas al-Din Tughluq, built about 1325, creates a very different effect. Under a marble-faced dome the red sandstone walls of the square structure slant inwards, and marble framing is restricted to their upper level. The tomb is situated on a fortified island reached by a causeway, and looks as though it had been built to repel attack. Ghiyas al-Din also built at Multan an octagonal tomb which became known as the resting-place of a holy man, Rukn-i ᶜAlam. In the local brick and tilework, this resembles the tomb of Uljaytu at Sultaniyah.

With the decline in power of the Delhi Sultanate from the mid-fourteenth to mid-sixteenth centuries, diverse local schools grew up. Bengal made much use of brick, and also developed the *bangla* roof, a horizontal elliptical form imitating the bend of a cane pole. The Deccan also used brick and borrowed Persian styles, but it came in time to develop near-round domes nestling in lotus collars. Gujarat built in stone, incorporating motifs from Hindu temples and from wood carving. Jaunpur and Mandu built in stone with an inventive but stocky vigour. The character of Muslim architecture in India owes much to Hindu features adopted in the period. The *chhajja* is an eave of slanted slabs supported on brackets or struts, which deflected the monsoon rain or gave a measure of shade, and in addition provided a strong horizontal emphasis. The *chhatri* (a word also meaning umbrella) is a miniature domed pavilion on columns placed at roof level, serving as a place to take the air, or, when very small, as an ornament. There were also the balconied and roofed temple window (*jharokha*); and the covered veranda, which, wrapped round square or octagonal tombs, permitted circumambulation in comfort and seclusion.

Babur built a number of mosques and pavilions, but in the sphere of architecture he is best remembered for the construction of *chahar-bagh* gardens in Afghanistan and Hindustan. The form of Islamic gardens in general is encapsulated in lines from Babur's description of his garden at Istalif, near Kabul (trans. A. S. Beveridge): 'A one-mill stream, having trees on both banks, flows constantly through the middle of the garden; formerly its course was zig-zag and irregular; I had it made straight and orderly; so the place became very beautiful.' To Babur's mind the principle of the beauty of order was sadly lacking in Hindustan, but he tried to establish it in his gardens there. His Bagh-i Gul-Afshan (Rose-Strewing Garden) at Agra may have been the site for a seventeenth-century garden designed for Nur Jahan and now known as Ram Bagh.

Humayun constructed at Delhi a citadel, Din-Panah (Refuge of Religion), but this is thought to have been destroyed during the reign of Sher Shah Sur. Sher Shah was the builder of the pavilion there in which Humayun suffered his fall, the Sher Mandal, a stone octagon on two floors with a *chhatri* on the roof, which Humayun seems to have used as a library and observatory. The most celebrated building to be associated with the name of Humayun, however, is his magnificent tomb at Delhi. This was built during the 1560s, but whether Akbar or Humayun's widow, Hajji Begum, was chiefly responsible is debated. The main structure stands at the centre of a *chahar-bagh*, 14

real or false gateways marking the centre of the sides of the enclosing wall. The mausoleum is set upon a very wide, high platform, clearly derived from temple architecture. It is composed of four double-storeyed pavilions set in a square so that they create a central space between them; the format is that of a *Hasht Bihisht* (Eight-Part Paradise), a palace-pavilion of Persian origin. The central space is covered by a marble-faced dome on a drum. The corner pavilions are linked to each other by stately *ivans*, and on their flat roofs stand *chhatris* which were once tiled in turquoise. The articulations of the building are outlined in marble, and slim marble turrets with lotus caps carry the vertical lines above the roof level.

In the mid-1560s Akbar renovated the Red Fort at Agra, supplying it with massive and grandiose walls. In 979/1571 he founded his palace city of Fathpur Sikri, on a ridge of hill commanding the surrounding plain. A spacious mosque was built with a superb door on its south side, the Buland Darvazah (High Door), which is approached by a sweep of steps set against the hillside. The mosque came to contain the tomb of Shaykh Salim, which was clad in white marble in the reign of Jahangir. The palace itself has a system of courtyards and pavilions in sandstone. Areas are devoted to the business of state and to recreation, to the royal ladies and to storage. Evidence of the Hindu tradition of architecture is everywhere. The beam and post method is most evident in the Panch Mahall, an open structure in five tiers, in which the ladies could take the air. Elements of Hindu decoration, garlands, chains as of temple bells, and delicate formal patterns from Gujarat are much used in the women's quarters. There are also screens of fretted stone (*jalis*) of great intricacy. But the building which takes us closest to the mind of Akbar is known as the 'Divan-i Khass'. It is a small pavilion which contains a single central pillar surmounted by a circular throne, whence stone gangways lead to the corners of the room at first-floor level. Here Akbar would have sat, an axis between heaven and earth, the royal embodiment of the Divine Light. In another area of the palace, near Akbar's bedchamber, a royal and religious rite was practised each morning when the emperor showed himself at a window (the Jharokha-i Darshan) in token of the rising of the sun.

Akbar had begun work on a tomb for himself at Sikandra, near Agra, but it was completed by Jahangir in 1022/1613. The tomb is again at the centre of a garden. In its façade horizontal lines are yet more dominant than at Humayun's tomb, since the structure is in tiers of sandstone, with an upper marble terrace instead of a dome. A more vital effect is created by the south gateway to the garden, which is decorated with bold floral and geometric patterns in inlays of marble and stone, and crowned with four marble minarets. At the tomb which Nur Jahan built at Agra for her father, I'timad al-Daulah, who died in 1622, elements of the Sikandra tomb are brought together on a smaller scale but with exquisite effect. Set in the centre of a *chahar-bagh*, the mausoleum is entirely clad in marble with subtle inlays in yellow and grey stone. Four minarets rise from its corners, and on the roof is a small pavilion of marble screens under a squared dome. The tomb of Jahangir himself, which Nur Jahan completed at Lahore, again employs four minarets at the corners of a platform-like structure which once had a small pavilion over its centre. The exterior of the mausoleum is decorated with marble inlay

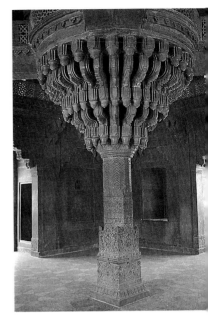

143 Throne pillar in the 'Divan-i Khass', Fathpur Sikri, about 1582. The chamfered column and serpentine brackets are in the tradition of Hindu architecture, but their combination into a free-standing feature which is both throne, balcony, and perhaps world axis, was inspired by Akbar.

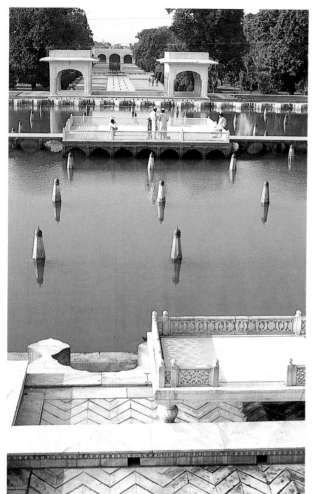

144 The Shalamar garden, Lahore, 1052/1642. Water flows under the baluster-legged throne and into the tank, whose edge is treated with a lotus ornament. The platform in the centre of the tank, sometimes called a *mahtabi* or place for viewing moonlight, might be used for musicians. The gangways from it lead to pavilions on graceful sandstone columns.

in stone, and its vaulted ambulatory has flowers in tile mosaic. In the central chamber, the marble cenotaph above the grave has a finer type of inlay, with semi-precious stones which inscribe the ninety-nine names of Allah and create Muslim floral arabesques and festoons of flowers in the Hindu manner.

The Taj Mahall, begun in 1632 and substantially complete by 1057/1647, is the climax of the development of Mughal tombs, indeed of Islamic tombs as a whole. The garden complex combines grandeur of scale with elegance of plan and fineness of detail, and the choice of qur'anic inscriptions to be inlaid in the gateway and in the mausoleum itself makes explicit its reference to Paradise. The rectangular garden is entered from the south. In contrast to the earlier royal tombs, the mausoleum is not placed at the garden's centre; instead, the crossing of the watercourses of the *chahar-bagh* is marked by a pool, which is clearly an image of the pool Kauthar from which flow the four rivers of Paradise. The mausoleum, flanked by attendant structures, stands on a terrace at the north end of the garden; it is thus seen as the culmination of a perspective, its marble surfaces changing hue as the sun crosses the sky and reflected in the watercourses. It is flanked, to the west, by a three-domed mosque in sandstone and, to the east, by an identical unit, once used as a guest-house. Surrounded by four marble minarets, the mausoleum derives

from that at Humayun's tomb, but with the four corner pavilions drawn towards the centre, and the dome higher as though floating. Shah Jahan himself was buried below it, his cenotaph, wreathed in floral inlay, being beside that of his queen but offset to the west.

The architect of the Taj Mahall is thought to have been Ustad Ahmad Lahori. Compositional effects were probably studied from models, and decorative ideas were borrowed from other media, the flowers used on dados in marble low relief coming from manuscript borders, and cartouche motifs from the work of European goldsmiths. Shah Jahan's passion for architecture of royal splendour is also displayed in work carried out for him at the palace forts at Agra and Lahore, where his additions are characterised by cusped arches, *bangla* roofs, lotus ornaments and the use of much marble with inlay. Another spectacular form of decoration is the mirror mosaic used at Lahore in the Shish Mahall (Glass Palace). Lahore is also the site of the greatest of the Mughal water gardens, which came to be known as Shalamar, a name shared with a garden in Kashmir and meaning either 'Abode of Bliss' or 'Black paddy for growing rice'. Constructed in 1051–2/1641–2, the garden has a rectangular plan, like that of the Taj Mahall, though with two changes of level. On the middle terrace a pool receives water from the central channel via

145 The Taj Mahall, Agra, 1057/1647. The garden is entered by a massive gateway inscribed with *surah* LXXXIX, *al-Fajr* (The Break of Day), which concludes with an invitation to a soul at peace to enter Paradise. The reflecting pool creates the impression that the mausoleum is floating, and the fact that the stairway to the upper platform is concealed denies its attachment to the ground: thus, by association with the title *al-Fajr*, it could be seen as a sun just risen above the horizon.

146 Jade-handled dagger (*khanjar*), Mughal, second half of the 17th century. The watered steel blade has a central ridge which terminates in a lily; above this another lily is set between quillons of split acanthus. The horse's eye is formed by an inlaid ruby. It is reported that the dagger was given by Haydar ʿAli of Mysore (the father of Tipu Sultan, d. 1782) to Sir Hector Munro. London, British Museum.

a chute (*chadur*, a tent or veil) and discharges it in a thin glassy sheet over niches in which lights were set at night. The pool has a throne at its upper edge, and in its centre a platform reached by gangways.

From 1639 to 1648 Shah Jahan built at Delhi his new palace city named Shahjahanabad. The central palace, known as the Red Fort and distinguished from older palaces by its symmetrical layout, became the centre of the Mughal empire, and an inscription in the private quarters declares it to be a paradise on earth. The last great work of the reign was the adjacent Jamiʿ Masjid of 1067/1656, a building of vibrant drama. The mosque is set on a high platform and reached by sweeps of steps on three sides. Its sanctuary, an expanded version of the mosque at the Taj Mahall, has three domes. These are clad in marble striped vertically with sandstone, while two minarets on the courtyard corners of the unit are in sandstone striped with marble.

The architectural style set by Shah Jahan was strong enough to produce an interesting posterity down the years in buildings from the Badshahi Mosque at Lahore, built by Aurangzib in 1084/1673–4, and the tomb at Delhi of Safdar Jang, who died in 1167/1753–4, to works of the eighteenth and nineteenth centuries for the Navvabs of Oudh at Lucknow (Lakhnau) and even of the early twentieth century for the Afghan Rohillas at Rampur. The style was also reflected in palaces for Hindu princes, from Amber in the seventeenth century to Mysore in 1897.

Jewels, hardstones and metalwork

The Indian tradition encouraged the Mughals in a lavish use of jewellery, and the land itself produced many of the gems. Jewels were often used in the exchange of gifts between ruler and subjects, to the former on an occasion such as a royal birthday, to the latter as a reward for service; thus as well as a financial value they might acquire the symbolic value of a bond. In 1526 a diamond was given to Humayun by the family of the Raja of Gwalior in thanks for their preservation at the capture of Agra. Humayun submitted it to Babur, who identified it as having belonged to ʿAla al-Din Khalji (reigned 1296–1315), estimated its worth at 'two and a half days' food for the whole world' and returned it to his son. It is possible that this stone was the source of the Kuh-i Nur, which is now in the British royal regalia. The larger gems, some so large as to be *objets de vertu* rather than of personal adornment, were engraved with designs or with names; thus the Carew spinel, which is of about the size and shape of a fresh date, bears the names of Jahangir, Shah Jahan and Aurangzib. Smaller gems were usually finished *en cabochon*, but faceted cuts were introduced by European craftsmen in the early seventeenth century. From the seventeenth century onwards, pictures of the emperors show them wearing ropes of pearls, pearl earrings and pearled aigrettes, and necklaces, armlets, rings and daggers studded with rubies, emeralds and diamonds.

The opportunity for the Mughals to emulate the taste of their Timurid forebears for jade came in the late sixteenth century, when Akbar was offered access to the jade of Khotan. Jahangir, the then prince Salim, soon showed an interest in the material. One of the harbingers of Mughal jade production

147 Jade cup of Shah Jahan, Agra or Delhi, 1067/ 1656–7. The cup is beautiful from every angle. The white nephrite jade is carved to translucency at the rim. The cup represents a fusion: the head of the ibex may be seen as representing the Mughals' Turkish and Persian heritage, while the lotus base is Indian. London, Victoria and Albert Museum.

may be a more than life-sized green terrapin, now in the British Museum, which was retrieved from a tank at Allahabad: presumably a garden ornament, it may date from the period of Salim's governorship and revolt. However that may be, some wine-cups made for him are securely dated by inscriptions. The earliest, of 1016/1607–8, is in the Brooklyn Museum, New York. It has the delicate shape of a Chinese porcelain bowl, but others are more solid and compact. Another piece for Jahangir is an ink-pot of 1028/ 1618–19 in the Metropolitan Museum of Art, New York; it is decorated in intaglio with panels containing flowers, in which a new naturalism begins to be discernible. From the second quarter of the seventeenth century, and probably under Chinese influence, the forms of the vessels themselves take on an organic character: a cup shaped like half a gourd, or a phial which mimics a lotus-bud. Gourd and lotus were joined by motifs from European sources, the acanthus leaf and the poppy – whose leaves in carving are often indistinguishable from acanthus. The portrayal of the poppy was probably derived from specimens drawn in European herbals, but Jahangir's liking for opium must have encouraged its adoption into the Mughal repertoire. The imagination of the craftsmen was not bounded by a literal naturalism, and thus the climax of Mughal jade carving is represented by a cup made for Shah Jahan in 1067/1656–7 (Victoria and Albert Museum, London) which unites an ibex-head to a half-gourd. Jade objects also include small cups for preparations of opium, archers' thumb-rings (provided with a flange at the side, these are seen hanging in twos or threes from grandees' belts), dagger hilts, bases for *huqqahs* (pipes equivalent to *qalyans*), amulets, jars with lids, spittoons and boxes for *pan* (a mild narcotic of areca-nut paste wrapped in a betel leaf). Similar, but more limited, use was made of rock crystal.

Mughal jades or rock crystals inlaid with gems survive from the mid-seventeenth century onwards, but the essentials of the inlay process were already recorded under Akbar, the socket for the gem being lined with lac and highly refined gold. Mughal settings, which have a plain torus, can usually be distinguished from the Ottoman, which have a petalled collar. Other

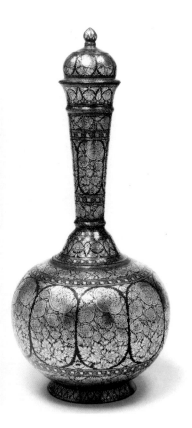

148 Alloy flask inlaid with silver (*bidri* ware), probably Bidar, mid-19th century. The motifs in *bidri* work reflect contemporary fashions, sometimes using large plaques of inlay and sometimes thin strips. This fine late example appears to have borrowed its densely packed poppy motifs from a textile. London, Victoria and Albert Museum.

branches of goldsmith's work were practised by the *zarnishan*, who would inlay gold into silver, steel, rock crystal, ivory or rhinoceros horn, and the *minakar*, who applied glass enamel. From the early seventeenth century European goldsmiths and jewellers began to appear at the Mughal court, and the influence of their designs spread to various media. Thus, gold coins with zodiac figures produced under Jahangir unite a traditional theme with the European enthusiasm for medals in relief, while Shah Jahan is thought to have employed one Austin of Bordeaux to make for him two jewelled peacocks for a throne completed in 1635, and to have imported from Italy fine panels of *pietra dura* for his *jharokha* at Delhi. Another European form to have found favour with Shah Jahan was the cameo. More generally, the use on his buildings of cartouches with discontinuous links and re-entrant angles or of lyre shapes marks a subtle assimilation of European motifs.

Armour and weapons were finely decorated. A moment of transition is marked by a steel breastplate and shield for Akbar, both in the Prince of Wales Museum, Bombay. The former, dated 1581, is rimmed with gold *kuftgari* work in dense floral scrolls resembling golden embroidery. The main field is emblazoned with cartouches in repoussé upon which fortifying religious inscriptions have thoughtfully been worked upside-down, so that they could be read by the wearer in the hour of need. In this piece the sentiment is Muslim. However, on the shield, dated 1593, a central sun-face suggests a reliance in the *Din-i Ilahi*. There is also a circle of zodiacal figures, which are slightly European in character. Numerous daggers survive from the late sixteenth century onwards. Different names distinguish different types; for instance, the *katar*, whose grip is a double transverse bar between two rods – as in a miniature ladder – is suited to giving the *coup de grâce* to a tiger while protecting the wrist. The blades of daggers are of watered steel, and the hilts may be of steel, jade, rock crystal, or even walrus ivory.

A metalwork technique which is peculiar to India, and a particular speciality of the Deccan, is *bidri* work, called after the town of Bidar. Silver, or occasionally gold or brass, is inlaid into an alloy which is then blackened by exposure to acid salts, throwing the decoration into strong contrast. Many *bidri* jars, trays and *huqqah*-bases are of the eighteenth and nineteenth centuries, but some are earlier.

Wood, mother-of-pearl and ivory

The shimmering effect of inlays of mother-of-pearl on dark wood was found particularly appropriate for canopies over the cenotaphs of holy men. On that at the tomb of Shaykh Salim Chishti, the mother-of-pearl is applied in small platelets, while on another example, installed in 1017/1608–9 at the tomb in Delhi of Shaykh Nizam al-Auliya (who died in 1325), it is in a tracery design. Mother-of-pearl and ivory were also used as inlays on various pieces of furniture, in particular chests and caskets. In the eighteenth and nineteenth centuries chairs of European character were given veneers of ivory. Ivory alone was carved from the seventeenth century onwards into powder-horns with grotesque combinations of animal forms.

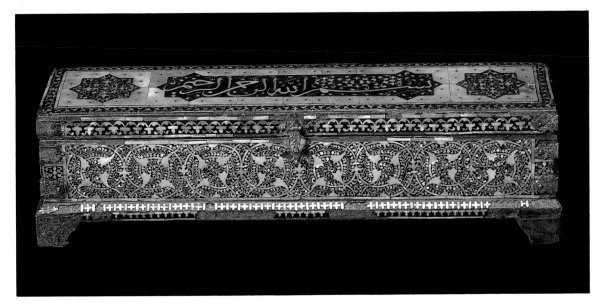

Arts of the book

The earliest paintings to survive from ancient India are the elegant Buddhist murals in the Ajanta caves, datable between the first century BC and the seventh century AD. Next come paintings in palm-leaf manuscripts from about AD 1000. By the thirteenth century, the graceful Buddhist style, which conveys an impression of volume, is overtaken by a linear and angular, though vivacious, style in Jain palm-leaf manuscripts. The colours used in these illustrations are principally yellow, red, blue, dark green and crimson.

The history of painting in the Sultanate period is not fully agreed, though literary references show that it goes back at least to the 1290s. The first visual evidence comes, not from Islamic pictures, but from items adopted from them in Jain manuscripts from about 1370. Where a Jain painter wanted to show the Saka kings, who were Scythian invaders from the north, he employed figures who are evidently Islamic. The kings are stocky, they have broad faces with a pink complexion and a fringe beard; they wear crowns, patterned robes which seem to be of a heavy material, and black boots. Their large and brilliant eyes, and the impression which they give of being vibrantly intent on the business in hand seem to be of the local tradition. It is not entirely clear whence these figures were derived; they have been compared to the Inju school of Shiraz, but a contribution from an earlier school cannot be excluded. Jain painting had previously been without landscape, but the Islamic school introduced undulating horizontal bands, which probably derive from the Persian rocky horizon but which are used for rolling clouds. From this point onwards Indian painters take the greatest interest in the portrayal of clouds, reflecting the importance of the annual monsoon.

West Persian styles were imported into the Deccan in the second quarter of the fifteenth century, and in the late fifteenth century two rulers in the more northerly Mandu, Ghiyas al-Din Khalji and his son Nasir al-Din, presided over the production of a group of manuscripts whose mixed character derives from several Persian sources. A delightful product of this workshop is the *Niʿmatnameh* (Book of Delectation; British Library), an illustrated recipe book of about 1500. Ghiyas al-Din had retired from political life with a

149 Wooden penbox with mother-of-pearl inlay. Mughal, in the style of Gujarat, mid-17th century. The lid is inscribed with the *bismillah*; the *thuluth* hand is similar to that of Amanat Khan who designed the inscriptions carved on the Taj Mahall. The scrolls on the side contain lotus leaves. Copenhagen, David Collection.

bodyguard of a thousand women and a support and entertainment staff of 1,600 more; he is depicted enthroned and wearing a large handlebar moustache, watching the preparation of dishes. The style is related to the simple Commercial Turkman, but a greater intensity is achieved by compositions more densely packed, and luxuriant Indian foliage. Some women wear Indian costume with transparent floating head-veils; other women, who must be the guards, wear turbans. Delhi and Jaunpur were probably also centres of painting, and certainly Bengal, where in 938/1531–2 a *Sharafnameh* was copied for the Sultan Nusrat Shah; the manuscript is now in the British Library. The *Sharafnameh* is the first part of Nizami's story of Iskandar (Alexander the Great), a hero much favoured by Muslim rulers in India, since they saw his invasion as an illustrious precedent to their own. Illustrations to the work are in a hybrid style of great vitality. The general lines of the compositions are Persian, but Indian features are evident. The narrow waists of the figures and a posture which presents the legs sideways and the shoulders frontally are found in Jain painting. The buoyant bosoms of the ladies are also an important borrowing, since this was a feature which Persian artists had always contrived to ignore in the clothed figure.

Nothing is known of any painting produced for Babur, but he had visited Herat, he writes knowledgeably of the painting of Bihzad, he owned Muhammad Juki's *Shahnameh*, and he was accompanied in his roving life by a fighting librarian. There is also, from the late sixteenth century, a distinct tradition for his likeness which may have had its roots in portraits from the life. Humayun, however, must have employed painters before his exile, since already in 1542 he could call upon a painter to record an interesting bird. It is also recorded that he temporarily lost a number of illustrated manuscripts while on campaign, but regained them when the camel on which they were loaded wandered back to camp. The decisive moment for the founding of the Mughal school, however, occurs in 1549 when Humayun, then ruling in Kabul, was joined by Mir Sayyid ʿAli and ʿAbd al-Samad, painters who had impressed him at the court of Shah Tahmasp. Both painters gave lessons to Humayun, and later to Akbar. A painting by ʿAbd al-Samad, belonging to the Gulistan Museum, Tehran, employs a conceit in which the young prince offers a similar painting to his father. The picture presents a most enticing vision of life in the Kabul court. Humayun sits on a carpeted platform in a *chinar* tree, and Akbar has reached him by a walkway from a double-storeyed pavilion. The only indication that this was not painted at Tabriz is the style of headgear worn by Humayun, a minimum of turban swathed round the upturned brim of a conical cap. An important work which has been attributed to either of the Safavid painters is a large, and rather damaged, painting in the British Museum known as *Princes of the house of Timur*. It is on cotton – an Indian usage – but in Persian style, and shows a gathering round a small pavilion in a mountainous landscape. Identifications of the figures shown are doubtful, and several were repainted in the seventeenth century.

The return to India and the change of rule which followed so soon after it led to a remarkable change of style. The decorative and decorous Safavid manner was transformed in two ways. It was transfused with a new energy, which is attributable to Indian painters drawn into the royal workshop. It also

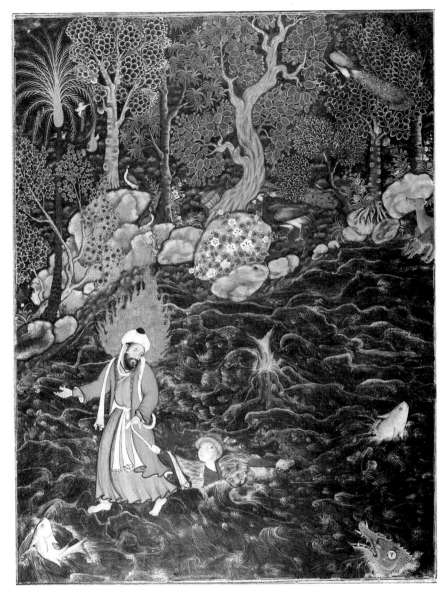

broke with the dominance of line and blocks of colour to show volume and recession in a much more emphatic way, with patches of shading and touches of feathery brushwork. This latter development seems to be the result of an influence from fifteenth-century European manuscript painting, something which would not be entirely surprising since the Portuguese had established a presence on the west coast from the early sixteenth century. It would seem that Indian painters, whose feeling for the three-dimensional was fostered by temple sculpture and whose painting tradition extended back to the sophisticated play of volume and space in the murals at Ajanta, seized upon European techniques for portraying these qualities and reinflated the two-dimensional style in which they had been trained.

The major project of Akbar's workshop in the 1560s and 1570s – perhaps the result of stories told to Akbar at rest on a hunting expedition – is the *Hamzahnameh*, a legendary account of the exploits of the Prophet's uncle

150

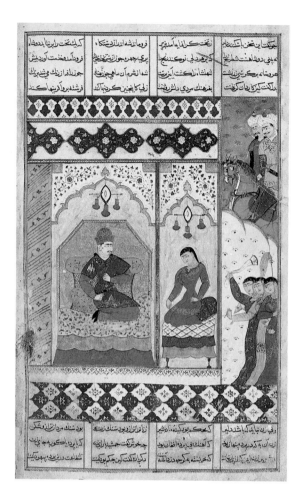

151 ABOVE LEFT 'Iskandar received by Nushabeh', from a *Sharafnameh* of Nizami, copied in Bengal (probably Gaur) in 983/1531–2 for Nusrat Shah. Indian influences are clear both in the drawing and in the use of fans. London, British Library.

152 ABOVE RIGHT 'Building at Agra in 1565' from an *Akbarnameh*, composition by Miskin and execution by Tulsi Khwurd, Lahore, about 1590. The painters carefully differentiate the various types of workmen and the technical detail of their work. London, Victoria and Albert Museum.

against the representatives of unbelief and evil. Akbar's copy was on a grand scale, some 1,400 illustrations on separate large sheets of cotton, stiffened with card. As the pictures were presented, the relevant text would have been read to Akbar, who appears to have been dyslexic – the performance would, in effect, have made a long-running adventure serial. The work was under the direction first of Mir Sayyid ʿAli and then of ʿAbd al-Samad. Some figures are drawn in the Persian tradition, but others are darker and more excitable, there is a new luxuriance of foliage, and overall a new bounding energy. The palette is strong but inclined to be muddy.

In the 1580s and early 1590s the workshop was directed to different types of subject-matter. Akbar was interested to know the beliefs of the people he ruled and had Persian translations with magnificent illustrations made of the Hindu epics, the *Mahabharata*, which he called the *Razmnameh* (Book of Wars), and the *Ramayana*, both now in the Maharaja Sawai Man Singh II Museum, Jaipur. He also set about an exploration of his own antecedents, starting with a history of the Timurids and continuing to illustrated copies of the *Baburnameh*, the Persian translation of the memoirs his grandfather had written in the Turkish of Central Asia, and of an *Akbarnameh* on his own achievements, composed by the courtier Abu'l Fazl. Some hundred painters, the majority of whom have Hindu names, worked in the *naqqash-khaneh*, and when the pressure was greatest a factory system was used with a senior artist

drawing the composition (*tarh*), another colouring (*'amal*), and sometimes a specialist completing the faces (*chihreh-nami*). Akbar would inspect their work and allot their rewards.

In addition to manuscript illustrations, numerous single pictures were produced. Some were purely for entertainment, but others, the portraits of courtiers, may have had a role in state documentation. Many pictures are strongly influenced by European styles, and in particular by Mannerism, which flourished in the sixteenth century. Examples of European painting would have entered the country in illustrated manuscripts and also in the form of separate prints. In this respect an important event was the Jesuit embassy of 1580, which brought Akbar a number of religious pictures. The key piece from the point of view of the Jesuits was a polyglot Bible whose engraved title pages, in Mannerist style, used classical motifs in the service of the Christian message in a complex, indeed recondite, scheme of symbolism. Pictures of this sort, and contributions from later embassies, were copied and subtly adapted and transmuted by the mixed tradition of Akbar's painters. They served to promote an interest in the individual face, to reinforce the interest in drapery, and to introduce the notion of recession, with distant views in which things grow small and pale; they also provided a new and exotic imagery. In the mid-1590s, during his residence at Lahore, Akbar's taste turned to the Persian classics, and the matured skills of his painters were lavished on manuscripts of luxurious finish. It became usual for paintings to be entrusted to single artists, and their more personal vision issued in works of a more romantic and sensuous atmosphere and meticulous execution.

Already during Akbar's reign, Prince Salim had been a patron of painting. At Lahore works brought by the Jesuits were copied for him, and at Allahabad he maintained a studio in which a Persian artist, Aqa Riza, played an important role. An interest in portraiture and symbolism from the one source and a sense of ordered beauty from the other suited the temperament of the prince, who looked to inherit the empire and to enjoy the public and private pleasures of secure rule. Pictures for him from the early seventeenth century have fewer figures than before, careful drawing and lyrical colour. One of the very earliest paintings of Jahangir's reign must be that which shows him enthroned and receiving a golden cup from the hands of his son Khusrau. Here history painting has caught up with contemporary events, for it would not have been painted after Khusrau's rebellion in April 1606. A political intention is clear: a faction at court had favoured the succession of Khusrau instead of Salim-Jahangir, but the picture marks a reconciliation between father and son. The cup which Khusrau offers is uncovered, and the message is that Jahangir can drink what Khusrau presents to him without the slightest qualms as to the consequences.

Jahangir kept fewer painters than had Akbar, and he directed his carefully selected studio away from scenes of action and towards scenes which express a state of being. Figures are often entirely still, though relations between them may be shown by the direction of their steady gaze. They are individuals who express the essence of their personality within time, and yet they seem timeless. In the painting technique which accompanies this shift in approach, outline tends to lose importance and objects are seen as shaded masses. This

153 PREVIOUS PAGE 'Khusrau and Shirin meet on the hunting field' from a *Khamseh* of Nizami, copied in Lahore in 1004/1595 by 'Abd al-Rahim ('Ambergris Pen'); the picture is by Nanha. The compositional type is ancient and had often been used to depict adversaries, but here the dawning of love is indicated by the shy gestures of the prince and princess, while their eventual union is suggested by the overlapping of the horses' heads. The melting distance, with white cities glimmering like pearls, is a Mughal adaptation of a European form. London, British Library.

contemplative style embraces Jahangir and his court, but it is particularly well suited to the portrayal of mystics and holy men.

Many single pictures were made for collection in albums, where they would be set on facing pages alternating with openings showing calligraphy. The margins of album pages are rich with gold work containing vignettes of hunting scenes, scatterings of small birds, European figures or studies of servants of the court, including the painters themselves. The pictures gathered within the albums were not only Mughal, but also from Persia and the Deccan, together with some European prints. Jahangir's keen interest in natural history, inherited from Babur and Humayun, led to fine studies of animals – local fauna, such as the nilgai and jungle fowl, and also rarities brought to court, such as the zebra and the turkey. The specialist in this field was Mansur (*fl.* 1590–1630), whose creatures have individuality without departing from their animal nature. A human could also be seen as a natural phenomenon, and thus Jahangir records that he ordered a drawing to be made of ʿInayat Khan, emaciated and dying of opium abuse; the drawing survives and also a worked-up painting, in the Museum of Fine Arts, Boston, and the Bodleian Library, Oxford, respectively. Studies of flowering plants were also made, with some influence from European herbals but with greater stylisation and imbued with a greater sensuousness. This floral style continued under Shah Jahan, when album borders were decorated with plants

154 ABOVE LEFT 'A Sufi discourses in a garden' from a *Divan* of Hafiz, probably Agra, about 1610. The tranquil but intense atmosphere, fine modelling and restrained colour scheme suggest that this is the work of Govardhan, one of the greatest painters to serve Jahangir and later Shah Jahan. London, British Library.

155 ABOVE RIGHT 'Royal baby', Mughal album drawing, third quarter of the 17th century. The child seems to have been posed on the arm of a nursemaid, since the weight falls vertically and the leg is sketchily drawn, but the nursemaid herself has been omitted. London, India Office Library.

156 ABOVE LEFT 'Jahangir receives a cup from Khusrau', album painting by Manohar, probably Agra, 1605 or 1606. The portraiture is of a high order, but Jahangir, as the most important figure, is drawn on a larger scale than the others, his status further emphasised by the frame created by the awning poles. London, British Museum.

157 ABOVE RIGHT 'Jahangir weighs Khurram [later Shah Jahan] against gold on his birthday in 1607', album painting intended for a history, probably Agra, 1628 or 1629. The Mughals adopted the Rajput custom of distributing a prince's weight in alms. Khurram sits as though enthroned; Iʿtimad al-Daulah and Asaf Khan stand on his right. London, British Museum.

such as rose, cyclamen, geum, narcissus and saffron, and the use of the naturalistic floral motif extended into the decorative arts.

Jahangir intended to have illustrated copies made of his memoirs, and, though no complete volume has survived, a number of pictures which may have been meant for inclusion are known. The emperor is usually shown enthroned or seated, and with a halo of light round his head; he is holding court, dispensing justice, visiting holy men, or on a hunting expedition. The faces of the courtiers who surround him are painted with exquisite care, and their clothing and accoutrements are appropriate to the individual. Figures are sometimes labelled, and the course of a courtier's career can be followed from painting to painting. The settings also are carefully particularised: the pomp of the audience halls (in which the appearance of the emperor on a balcony reminded James I's ambassador Sir Thomas Roe of a theatre, with Jahangir as the player-king), the gorgeous tents, the white dome of the shrine of the Chishti shaykhs at Ajmer, or the candle-lit garden in Kashmir. Night scenes are of particular interest, since in a new departure the Mughal painters now rendered them with darkness.

A class of picture which dates from the middle to late years of Jahangir's reign follows the Mannerist taste for allegory, a mode which would not have seemed entirely alien to a painter of Hindu background, accustomed to a complex juxtaposition of symbols in his own sculptural tradition. In a picture in the Freer Gallery of Art, Washington DC, Jahangir is seen as the 'lord of time', seated upon the round upper surface of an hourglass – a situation rather akin to that which Akbar would have had on the pillar-throne at Fathpur. He ignores two rulers, his Ottoman namesake Selim (Salim) and James I, while

he gives a book to a saintly person (possibly Sayyid Muhammad, to whom Jahangir gave in 1027/1618 a Qur'an copied by Yaqut al-Mustacsimi). In another picture, a portly Jahangir, standing on a lion which marks the position of India on a globe, embraces almost to extinction a smaller Shah cAbbas I who stands over Iran upon a white sheep, a reference to his connection with the White Sheep Turkman which is not intended to be complimentary. In other pictures Jahangir, again poised upon a globe, looses an arrow at the head of a political enemy, Malik Ambar, or of a figure representing poverty. In these pictures a framework of classical and Biblical symbolism is augmented by details which are Persian or Hindu.

In many ways painting under Shah Jahan continues the forms set by his father. Certain album pictures suggest that an illustrated life of the emperor was projected from the early days of the reign. Such a work, however, is not found until the *Padshahnameh* (or *Shahjahannameh*) in the Royal Library at Windsor, copied in 1067/1656–7, some of whose illustrations may pre-date the text and some post-date it. The pictures, which contain much interesting historical information, are replete with formal grandeur but sometimes lacking in animation. A better balance between a brilliant surface and a sense of the living individual is found in separate pictures of Shah Jahan, which show him in symbolic mode or engaged in the activities of kingship. The sons of Shah Jahan were also painted and were themselves patrons. Dara Shikoh is shown in conversation with mystics, while the less personable Shah Shujac, sitting with his wife on a terrace, is transfigured by love. When he came to power, Aurangzib had a lesser enthusiasm for painting and turned progressively against it from religious motives. However, pictures exist which show him at prayer, holding audience or hunting.

Paintings of considerable charm but of lesser power continued to be made in the eighteenth and nineteenth centuries for the Mughal court at Delhi, and in Oudh at Lucknow and Faizabad. Many scenes are set on white palace terraces with long perspectives extending behind them, and often by night. At this period painting in which elements of Mughal style blended into local Hindu traditions flourished in many of the Rajput courts. An Islamic school which ran in parallel with that of the Mughals, and occasionally borrowed from it, was that of the Deccan courts. Deccani painting owes much to Persian, and is sometimes very stylised, but its most characteristic trait is a highly charged atmosphere which is romantic, languorous and mysterious. In contrast, in the eighteenth and nineteenth centuries an old-fashioned and dry but decorative style was practised in Kashmir.

Textiles and carpets

In India the Muslims were able to benefit from and contribute to a rich tradition in the weaving and decoration of textiles. The classical world had already been glad to import the diaphanous cottons of Bengal, whose production was favoured by the damp local climate. Mughal rulers or their ladies are sometimes shown in outer garments of finely woven cotton or silk which have a semi-transparency not usually found in Muslim dress. Indeed, the seventeenth-century traveller Bernier alleges that the drawers of the ladies might be so delicate as to wear out in one night. Very fine fabrics were used

158 PREVIOUS PAGE 'Sultan Ibrahim cAdil Shah holding castanets', album painting from Bijapur, about 1615. Ibrahim II (1579–1627) was a patron of painting and a musician; his interest in the teaching of Hindu holy men is indicated by the rosary of *rudraksha* (a dried berry) which he wears. His turban and gown are of the Deccani form, and, as is often the case in this style, his skirts and draperies are touched by a slight breeze. London, British Museum.

for turbans, for the woman's veil or *dupattah* (two-breadth), or for a girdle adopted from Hindu costume and worn by either sex, the *patka*. The *patka* was tied to hang at the front; its ends have woven or embroidered ornament in silks and golden thread, often a row of naturalistic flowers.

The *jamah* was a sleeved and waisted garment ending at the knee, though in the earlier sixteenth century four points extended lower (*chakdar jamah*). For the most part the *jamahs* worn at court were in plain silks whose gorgeous colours witness to the Indians' unrivalled skill in dyeing. An addition to the gentleman's wardrobe was the *nadiri* (novelty), a sleeveless jacket with nipped-in waist introduced by Jahangir. An exceptional surviving *nadiri* in the Victoria and Albert Museum is in ivory silk with exquisite embroidery in chain-stitch – a speciality of Gujarat – showing rocks, trees and tigers.

A garment favoured by Akbar was the woollen shawl (*shal*). This enthusiasm probably dates from his residence in Lahore and Kashmir, since the shawl was made from the fine under-hair developed in the snows of winter by the Himalayan goat, which could be imported from neighbouring regions. Akbar's shawls evidently bore some decoration, since he ordered that they should be made in pairs and sewn together so that a reverse side was not visible. The shawl industry flourished long in Kashmir, and in the late eighteenth century shawls with intricate woven patterns became fashionable in Europe. Sadly, by the 1860s the development in Europe of the speedier jacquard loom ruined the market.

Rich or richly decorated textiles also had an important role in the furnishing of palaces, for items such as bolsters and bedspreads. Cotton was used for floorspreads, which were placed over carpets, and also for the ceremonial handkerchief (*rumal*) under which gifts were presented. The cottons might be embroidered, but alternative forms of decoration could include printing, stencilling and painting. Cottons in this technique, often showing fantastical flowering trees, were exported to Europe with the name of 'chintz'. Heavy cotton, silk or velvet were also used in the enormous and splendid agglomerations of tentage which formed movable palaces as the courts progressed about the land. Private areas were sheltered by screenwalls (*qanats*). The dominant colour for tentage was red and the principal decorative motif was a flowering plant filling an arch form.

The knotted carpet was not native to India, but would have been introduced in the Sultanate period. Production evidently expanded under the Mughals. Akbar's manuscript illustrations tend to show carpets with blue grounds, but they may be influenced by illumination, and the ground of surviving pieces is more often ruby red. Some have swirling arabesques, but others have semi-pictorial designs with hunts and elephant fights which seem to be related to lacquer manuscript covers of the 1590s. By the seventeenth century, and possibly earlier, some court carpets were made in a particular shape to fit a specific location. The use of the naturalistic floral style, with specimen plants ranged on red grounds, is probably datable from the reign of Shah Jahan onwards. A variation on this scheme which frames the plants in a golden lattice was probably developed in the time of Aurangzib, since lattice is a characteristic motif of architectural decoration in his reign, though it continued in use into the eighteenth century.

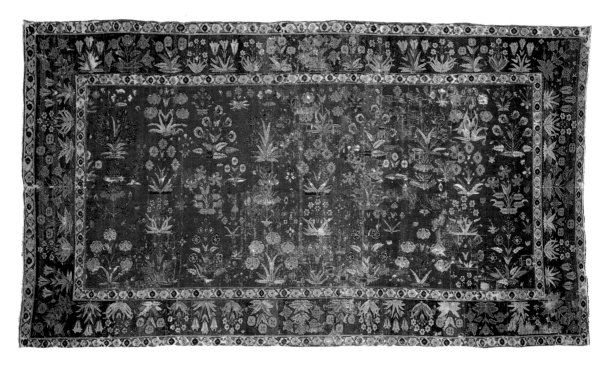

159 ABOVE Mughal carpet with flowering plants, mid-17th century. The flowers include rose, iris, poppy, narcissus, violet, marigold, various lilies and crown imperial. The carpet was probably designed for a particular location where it would be seen chiefly from the side. Three rows are repeated three times, but since some plants are large and some small there is a sense of order combined with naturalness. Kuwait, National Museum.

160 RIGHT Cotton prayer-mat, Mughal with Gujarati style silk embroidery, second half of the 17th century. The cloth is worked in chain-stitch, and delicate shading effects are created with two blues, two turquoises, green, yellow, raspberry and pink. The lily is surrounded by chinoiserie clouds. London, Victoria and Albert Museum.

CONCLUSION

The preceding chapters have traced Islamic art through the centuries by way of period styles, subdivided by individual media, and have tried to show how and why things were made in a certain way at a certain time. But there are, of course, many general questions which surround the subject, some of which have been touched on briefly, and others which may have made themselves felt only as assumptions. Three general questions will be raised briefly here, though each could give rise to a lengthy disquisition. The questions are: what is the specific nature of Islamic art; what is the scope of its influence beyond the world of Islam, in particular on Western art; and what is it doing now?

The first question is the most complex and debatable. In part, the character of Islamic art arises from the tensions created by its geographical and cultural background – a background which, with its aesthetic consequences, can be expressed in shorthand form as a number of dualities: desert and oasis, nomad and settled, discipline and sensuousness, light and shade, simplicity and complexity, straight lines and curved. To these simple propositions should be added the distinction between that which is specifically Muslim and that which merely falls within the Muslim cultural orbit, and, especially in the later periods, that which is a component part of Islamic art of long standing and that which has been adopted from abroad. Such pairs form the dynamics of Islamic art, lending it its peculiar excitement. But it must be emphasised at once that one pole of a pair does not necessarily operate to the exclusion of the other; on the contrary, it is precisely the mixing or the rapid transition from one to the other which induces feelings of exhilaration or wonder.

A second important characteristic is a deep sense of order. Among other effects, this calms and refines the aesthetic dualities, such as contrasts between plainness and decoration. But it can hardly be said to be part of a dual system itself, since its opposite, the random effect, though not entirely absent in Islamic art, is rare. The sense of order is rooted in the Islamic view that everything that exists is willed by Allah and has its place in the divine scheme of things. In the sphere of art, a very evident expression of this is the great confidence reposed in geometry, both in decoration and as the basis of architectural design. In a more general way, the sense of order is seen in the

high degree of organisation implicated in decorative surfaces, be it in repeating patterns or in systems of delimited zones, panels and cartouches. It may also be suggested that the tendency to stylisation of vegetal ornament, which gives rise to the arabesque, is less a flight from naturalism than a desire to improve the motif by means of greater control. Related to the feeling for order is the fact that the raw material of the Islamic arts often receives a high degree of processing. This is true both in terms of the handling of the medium, and of the vision which directed the artists or craftsmen. These worked within a strong tradition which relayed scrupulous skills and directed their aims. Their duty was to do their work well, rather than to introduce innovations or express a personal view, though individual merit often came to be valued once a high level of skill had been achieved.

The third area which seems of importance for the character of Islamic art is its particular treatment of symbolism, or how meanings are conveyed. In recent years this field has exercised considerable fascination for historians of Islamic art, in spite – or even because – of the absence in the Islamic tradition of any substantial body of theory which might confirm the opinions adduced. A problem, at least to the Western mind used to a rather explicit relation between signifier and signified, is that features of Islamic art which are apprehended as symbolic often seem to have meanings which are not closely defined. This may to an extent be because the meanings have been lost or changed in the course of time, but to an important degree it seems to be inherent. An amount of relatively specific symbolism is found in the decoration used in the early centuries. There is, for instance, the repertoire of images expressive of the power and pleasures of the ruler, but, so far as we can read the signs, this is rarely modified to suit a particular individual (exception made for the Umayyad period). Similarly, when the signs of the zodiac are portrayed, they presumably indicate cosmic harmony and invoke good fortune, but they are rarely adapted to the horoscope of an individual (some exceptions being found in fifteenth-century drawings). There is also the field of animal symbolism. Some of the most specific symbols are found here, when a creature is used in a visual metaphor, with a relatively distinct and limited correlation between the form shown and the meaning. The most obvious example is the lion, which, as in other cultures, is widely used to connote royalty. But even here we cannot be sure if a metaphor is always intended: when a lion is used as the mouth of a fountain, is this simply an imitation of classical models, or does it perhaps carry the meaning that the water is fit for a king to use? Similarly, in the case of birds, though raptors seem to indicate kingship, what is the meaning of the more numerous class of 'undifferentiated small' birds, which are so often added to a main theme? Do they indicate luck, or happiness, or on occasion even the soul? Or are they simply decorative?

More particular to Islamic art than the pictorial symbols of early decoration are abstract or semi-abstract forms which bear meanings in which the sole or the dominant theme is often religious. The character of geometric and vegetal ornament in Islamic art appears to be intimately connected with the Islamic view of the world, but can such ubiquitous features be described as symbolic? In the great mass of this ornament it is a rare example which positively

demands consciously to be read as a symbol: rather, the decoration is ever-present as an affirming background, so that it might be said to have a latent symbolism, which can in certain circumstances be brought to the fore. And what does it say? If convenience requires an answer in a single word, the vegetal ornament speaks of Paradise and the geometric of order, but it would probably be more true to say that each is capable of evoking a nexus of thoughts surrounding those concepts.

Symbolism in Islamic architecture seems to be of a similar nature, with forms whose potential can be activated in particular circumstances, and whose import is not the less powerful for not being precisely circumscribed. The dome placed over a cubic space is sometimes simply a convenient means of roofing and sometimes an awe-inspiring symbol of the heavens above the earth, which carries the further message of the all-powerful oneness of Allah. At what might be called an intermediate stage between these cases, the dome can symbolise the power of a ruler, whose power derives from Allah. The celestial dome may therefore be used over a majestic audience chamber, or, without incongruity, to cover a *hammam*. The use of an arch form, whether round or pointed, for doors, windows, niches, *ivans* and *mihrabs* means that any one can potentially be read as symbolising another, though it is, of course, the *mihrab* which carries the greatest symbolic weight amongst them. After the *mihrab*, the most characteristic architectural form is the minaret. Though the standard function of the minaret is to provide a location for the call to prayer, it is evident that its meaning extends far beyond this. On the one hand, the minaret is not absolutely required for the call to prayer; and on the other, minarets are sometimes found extra tall, or in pairs, or in multiple and reduced form. It is a matter of experience that a minaret acts as the external sign which informs the wanderer of the location of a religious building, much as a church spire does in Christian lands; it appears that symbolism gathers round this signpost function, so that the minaret can symbolise the victory of Islam over non-Muslim peoples, or, in an esoteric sense, can represent the axis of the universe. One of the most open questions in the area of architectural symbolism appears to be whether *muqarnas* ever has a meaning as such, or if it is simply used for aesthetic purposes. But the fact that it is normally placed above head height suggests that a particular field of meaning may attach to it. Is the effect which it creates of the dissolution of surfaces consciously used to show the insubstantial nature of this world in relation to the eternal world, or, in the zone of transition, is it intended to mark a discontinuity between the celestial and the earthly, like a cloud on the underside of the heavens?

It seems, then, that many features of Islamic art tend to point beyond the world of appearances to the eternal world, but that these symbols are often implied and general rather than systematic. The means often used to bring the latent symbol into full force is, of course, the addition of inscriptions whose texts are apposite passages, usually, but not invariably, chosen from the Qur'an; and it is, indeed, a truism to say that the importance of writing in Islamic art can hardly be exaggerated. In its most straightforward function writing can carry a text which guarantees a meaning in a structure or an object – so that a paradisal garden becomes a Paradise garden. But in the Islamic

context writing in itself can fulfil the loftiest symbolic function of giving a form of expression to the inexpressible, and so it comes to be used where other cultures might use pictures, music or dance.

The question of symbolism cannot be left without a further reference to the matter of figural representation. The character of Islamic symbolism is evidently deeply affected by Islam's rejection of any concept of incarnation in relation to Allah: figural religious symbolism, as it is found in Western and Hindu art, does not occur. Any representation, however, is symbolic in a broad interpretation, in the sense that any notation in which one thing stands for another is symbolic. It has sometimes been argued that, in order to make representation acceptable, figures were deliberately drawn in an unrealistic mode; which is to say that a distance was deliberately maintained between the symbol and the thing symbolised. This seems most unlikely to be true. Islamic drawing has its own character, which is strongly conditioned by the calligraphic line, and it employs various conventions to suggest space and movement, but those few texts which speak of quality in painting tend to value it for being lifelike. The fact that we today may not see it as realistic results from our exposure to vast quantities of pictorial material and in particular to photography. Islamic painting, like writing at its simplest level, aims to be precisely legible.

It is inevitable that an account of the formation and history of Islamic art should focus considerable attention on features which were acquired from other traditions, but this should not obscure the fact that Islamic art, in its turn, has exercised a fascination beyond the bounds of the Islamic world and enriched the arts of other cultures. A case in point is the development of blue-and-white decoration on ceramics, which goes from the Islamic world to China, through South-East Asia, back to the Middle East, and on to Europe. The history of blue-and-white is long and wide-ranging, and has been the subject of considerable research. For the most part, however, even if an enquiry is limited to the impact of Islamic art on Europe, the story is less coherent. This is not to say that there is not a quantity of material to consider – Europe lies adjacent to the central Islamic lands and there have often been contacts, some warlike and some peaceful – but many matters are undecided, and the consequences of many known facts have not yet been traced.

In the early centuries, many transportable items, such as pieces of rock crystal, glass and silks, arrived by trade or were brought back by pilgrims; they were evidently valued and admired, since many came to rest in cathedral treasuries. Their appeal must often have been partly on account of their real or supposed associations with the Holy Land, but it must also have depended upon their intrinsic beauty. The European donors would have been aware that these objects were often superior in technique to what was available locally; and, though they would not have expressed it consciously, they might already have experienced the attraction of the mixture of familiarity and strangeness arising from Islamic art's classical and eastern heritages. These treasures were often adapted to new purposes by remounting or recutting. The extent of their influence on European art is not fully known.

Naturally, a much greater diffusion of Islamic motifs and techniques occurred in Sicily and Spain, where close contact was followed by a change of

rule from Muslim to non-Muslim. From these sources styles of ivory carving were adopted, the tin-glaze technique became the basis for European maiolica, and Spain came to produce a knotted carpet which reflects Islamic design. Features of Islamic architecture are also traceable extending from Spain into southern France. Another period of contact, albeit hostile, between medieval Europe and the Islamic world was the time of the Crusader kingdoms. It is probable that this was the occasion of some Islamic influence upon Western architecture, especially in the matter of fortifications, but it is difficult to assess the degree of the influence. Features such as the pointed arch, ribbed vault, the machicoulis and bent entrance were current in the East earlier than in the West, but the latter may have received them from Byzantium, or in some cases have evolved them independently. Nevertheless, the experience of the Crusader kingdoms would have reinforced the use of such devices even if it was not the first cause of their adoption.

From the fourteenth century onwards there is more evidence of both trade and imitation. Italian paintings of that period attest to the importation of carpets; by the fifteenth century these were an established article of trade and efforts were made to copy them. Pictures also show Madonnas whose haloes are bordered with pseudo-kufic script probably derived from *tiraz* bands. Silks from the Islamic world continued to be highly prized and there was a fruitful but confusing interchange of designs between the Mamluks, the Ottomans, Spain and Italy. From about 1500 there occurs a type of inlaid metalware known as 'azzimina'; this is a Venetian form of an Arabic word for non-Arab, and the objects would either have been made in Venice or imported there. There was also imitation of Islamic glassmaking and Islamic bookbinding designs and other uses of stamped leatherwork. It is at this period that the Western interest in Islamic pattern begins to be analytical, an important milestone being Francesco Pellegrino's *La fleur de la Science de Pourtraicture, Patrons de broderie, Façon arabique et ytalique* published in Paris in 1530. Another subject of curiosity was the appearance of peoples of the Islamic world. Gentile Bellini had returned from Constantinople in 1481 with sketches of Turks, and records of this sort were used in Western religious painting as a point of departure for figures of the Magi, Jewish priests or bystanders at the Crucifixion. The mid-seventeenth century sees Rembrandt making studies of a number of recent Mughal drawings in his possession in a way which suggests not only an interest in exotic costume but also in the Mughals' way of seeing. In the sixteenth and seventeenth centuries the European view of the Islamic world was largely dominated by the Ottomans; it was marked first of all by dread and then, following the Ottoman failure to take Vienna in 1683, by relief. Turkish styles were much admired, though the conception held of them was touched with fantasy. However, by the seventeenth century Iran and India were becoming more accessible with a resulting increase in imports of pottery, carpets and silks from the former, and carpets and cottons – especially chintz – from the latter.

From the later eighteenth century, following eastward extensions of the Grand Tour and the new mood of the Romantic movement, a growing desire was felt to know more about the countries which produced the examples of Islamic art received by way of trade. This interest was served by topographi-

cal painters, who relayed accurate pictures of buildings in the Islamic world, thus stimulating an interest in Islamic architecture. Elements of the 'Moorish' architecture of Spain or of Mughal architecture were widely used in imaginative buildings of the nineteenth century. Meanwhile, Orientalist painters, whose treatment of their ostensible subjects revealed varying levels of discernment and veracity, were often extremely faithful in their portrayal of Islamic objects. Scholarly studies also multiplied. Following research in the field of numismatics in the eighteenth century, the first work to treat the material culture of an Islamic country extensively is the *Description de l'Egypte*, produced between 1809 and 1828, as a consequence of Napoleon's invasion of Egypt in 1798. From the mid-nineteenth century exhibitions began to bring Islamic art before a wider public, and museums and a few individuals formed collections which tended to give pride of place to pottery and metalwork. In the later nineteenth century William Morris, the most influential figure in the Arts and Crafts movement, drew considerable inspiration from the designs of Islamic carpets and silks, while William de Morgan experimented with techniques and decorative themes of Islamic pottery. In the twentieth century a scholarly framework has been developed for the discussion of Islamic art. New features have been the systematic use of archaeology and the beginning of the study of Islamic painting. From the early twentieth century a number of scholars from the Muslim world have contributed to the study of Islamic art, often, though not invariably, writing in European languages; from the mid-century onwards, Turkish scholars have been particularly productive, much of their work being in Turkish.

In the nineteenth and twentieth centuries the traditional Islamic arts have been affected by Western influence and the advance of industrialisation, and by political and economic change. The impact of Western styles has already been mentioned. This did not necessarily change the techniques of production, but industrialisation, at first associated with Western powers but now long naturalised, did. In the political and economic sphere the direct link between princely patron and artist or craftsman has largely disappeared. In some areas this is because the princes themselves are no more, but often now princes and their modern equivalents are more inclined to exercise an interest in Islamic art through the collection of and preservation of works of the past than through contemporary patronage. Without such support artists cannot maintain the high levels of skill required by the traditional media, and the lines of instruction which often ran in families have tended to break. The different arts have been affected in very differing degrees. Some techniques are no longer required; while others may now be imitated by an industrial process which cannot match their traditional quality. Some arts in which traditional techniques are still used are now supported to a considerable extent by a tourist trade.

The production of complex silks was always for a luxury market and was doomed by the tendency for the rich, from the nineteenth century onwards, to turn to Western dress. Conversely, hand-knotted carpets continue to be produced. Growing restrictions on nomadism have depressed this area of production, but carpets are still made as a cottage industry or in small factories. Sometimes, as in the Dobag project in Turkey, there is a policy to

161 'Advance and thou art free', calligraphy by Hassan Massoudy, France, 1990. The line is from the *Romance of ʿAntar*, the story of a 6th-century Bedouin poet, ʿAntarah b. Shaddad. The mother of the valiant ʿAntarah was a black slave, but at a critical juncture his Arab father gave him this encouragement. Hassan Massoudy was born in Iraq and now lives in Paris. Private Collection.

eschew the synthetic dyes which came into use in the nineteenth century in favour of natural ones, and to preserve old patterns. Where the arts of the object are concerned, though household items in metalwork continue to be made in many bazaars, many functional items have fallen to industrial production and metal as a material has in some cases been superseded by synthetic substances. On the other hand, ceramics have shown their usual capacity for survival. Pottery employing various traditional decorative techniques is made to a respectable level; and the glazed wall-tile, though its making may now be assisted by modern technology, is conceptually as it ever was.

Much building has been carried out in an international modern style; nevertheless, many important buildings are distinctively Islamic in character. This is especially true of religious buildings and those of related purpose, such as colleges and libraries, and of buildings which are of national importance and under state patronage, such as centres of government, airports and telecommunications structures; but it is also seen in private dwellings, grand hotels and factories. The relation of the traditional to the modern is various. Some buildings are in traditional materials, but most are in steel and concrete. In some cases Islamic features – arch forms or screens – are used merely decoratively on architecture of international type, almost as an afterthought; but many exciting buildings have achieved a synthesis of the old and the new, with pillared halls, arches, domes and forms derived from tentage fully integrated into new schemes. Two projects must be mentioned because of their importance to the whole Islamic world. Firstly, from the 1950s to the 1980s, under the Saʿudi kings ʿAbd al-ʿAziz, Faysal and Fadh, the Mosque of the Haram al-Sharaf surrounding the Kaʿbah and the Mosque of the Prophet at Medina have been considerably expanded to accommodate a vast increase in pilgrim traffic, in part attributable to air travel. Secondly, the programme of architectural awards instituted by the Aga Khan has encouraged both new building and restoration internationally.

162 Painted lorry, Lahore, 1986.

The adoption of printing as the normal method of book production naturally had a profound effect on calligraphy and painting. To consider the latter first: painting in traditional manuscript and album styles almost ceased to exist, but has revived to some extent for the tourist market; its technique sometimes reaches a sophisticated level, but the treatment of the subjects lacks conviction. Curiously, the advent of photography and the mass-produced picture – together with the availability of oil-based paints – assisted in the development of a popular art form in the third quarter of the twentieth century, the painted lorry of Afghanistan and Pakistan. In this colourful work the numerous compartments presented by the vehicle's structure are filled with script, floral work, landscapes, and images of men and women, trains, planes and rockets, in schemes conceptually very much akin to those of inlaid metalwork of the twelfth to fourteenth centuries.

Calligraphy has been affected in a different way from painting. This is the art least dependent upon patronage, since it can be performed with relatively cheap materials; and because of its association with religion and the fact that it is usually practised alone, it is also the most personal of the arts. Freed of the requirement to copy, the most innovative calligraphers have turned to the production of single pieces, which are now often intended to be framed for display on walls. The media used may be the traditional reed-pen and paper, but screen-printing and oil or acrylic paints have also been adopted. Prayers and invocations, and sometimes secular texts, are interlocked and shaped in a manner derived from designs of *tuğra* type or the calligraphic images or pages in *shikasteh* of the eighteenth and nineteenth centuries, but in a way which reveals an awareness of developments in twentieth-century Western art. Striking use is sometimes made of multiple repetitions and swirling forms – perhaps suggested by action photographs – which imply the universal repetition of a prayer formula, or of perspective, which suggests that calligraphy is the fabric of the world.

The two arts which remain most creative in the late twentieth century are thus architecture and calligraphy. Though these may be devoted to secular purposes, and have been so in the past, they are the arts most closely associated with the Muslim religion. The conclusion must therefore be that some parts of Islamic art have fallen away, leaving a Muslim core.

Select Bibliography

Reference

ᶜALI, ᶜABDULLAH YUSUF, *The Holy Qur'an: Text, Translation and Commentary*, repr. Brentwood, Maryland, 1989
ARBERRY, A. J., *The Koran Interpreted*, London, 1980
BOSWORTH, C. E., *The Islamic Dynasties*, Edinburgh, 1980
Cambridge History of Iran, vols 4, 5 and 6, Cambridge, 1975, 1968 and 1986
Cambridge History of Islam, vol. 1A, Cambridge, 1977
Encyclopaedia of Islam, 2nd edn, Leiden and London, 1960 continuing
FREEMAN-GRENVILLE, G. S. P., *The Muslim and Christian Calendars*, repr. London, 1977
HUGHES, T. P., *Dictionary of Islam*, repr. London, 1988
POPE, A. U., with ACKERMAN, P., *A Survey of Persian Art*, repr. Ashiya and New York, 1981

Periodicals

Islamic Art, New York
Muqarnas, Leiden and Cambridge, Mass.

General

Anatolian Civilisations: Seljuk/Ottoman, exh. cat., Topkapı Sarayı, Istanbul, 1983
Arabesques et jardins de paradis, exh. cat., Louvre, Paris, 1990
ARNOLD, Sir T. W., *Painting in Islam*, repr. New York, 1965
Arts of Islam, exh. cat., Hayward Gallery, London, 1976
ASLANAPA, O., *Turkish Art and Architecture*, London, 1971
ATIL, E., *Turkish Art*, Washington DC and New York, 1980
ATIL, E. *et al.*, *Islamic Metalwork in the Freer Gallery of Art*, Washington DC, 1985
BEHRENS-ABOUSEIF, D., *Islamic Architecture in Cairo*, Leiden, 1989
BINYON, L., WILKINSON, J. V. S. and GRAY, B., *Persian Miniature Painting*, repr. New York, 1971
DIMAND, M. S., *Oriental Rugs in the Metropolitan Museum of Art*, New York, 1973
ELGOOD, R. (ed.), *Islamic Arms and Armour*, London, 1979
ETTINGHAUSEN, R., *Islamic Art and Archaeology: Collected Papers*, Berlin, 1984
FEHÉRVÁRI, G., *Islamic Pottery*, London, 1973
FERRIER, R. (ed.), *The Arts of Persia*, New Haven and London, 1989
FOLSACH, K. VON, *Islamic Art: The David Collection*, Copenhagen, 1990

GRABAR, O. and ETTINGHAUSEN, R., *The Art and Architecture of Islam 650–1250*, Harmondsworth, 1987
GRUBE, E. J., *The World of Islam*, London, 1966
HOAG, J. D., *Islamic Architecture*, New York, 1977
HUBEL, R. J., *The Book of Carpets*, New York, 1970
JAMES, D., *Qur'ans and Bindings from the Chester Beatty Library*, London, 1980
JENKINS, M., *Islamic Art in the Kuwait National Museum*, London, 1983
MELIKIAN-CHIRVANI, A. S., *Islamic Metalwork from the Iranian World, 8–18th centuries*, London, 1982
MICHELL, G. (ed.), *Architecture of the Islamic World*, London, 1978
NASR, S. H., *Islamic Science*, London, 1976
PARKER, R. B., SABIN, R. and WILLIAMS, C., *Islamic Monuments in Cairo*, Cairo, 1981
PHILON, H., *Benaki Museum, Athens: Early Islamic Ceramics*, London, 1980
PINDER-WILSON, R., *Studies in Islamic Art*, London, 1985
PUGACHENKOVA, G. A., *A Museum in the Open: The Architectural Treasures of Uzbekistan*, Tashkent, 1981
RICE, D. T., *Islamic Art*, rev. edn, London, 1989
ROBINSON, B. W. (ed.), *Islamic Art in the Keir Collection*, London, 1988 (a supplement to four earlier catalogues by various authors)
ROGERS, (J.) M., *The Spread of Islam*, Oxford, 1976
ROGERS, J. M., *Islamic Art and Design, 1500–1700*, London, 1983
SOUCEK, P. P. (ed.), *Content and Context of Visual Arts in the Islamic World*, University of Pennsylvania and London, 1988
TAIT, H. (ed.), *5000 Years of Glass*, London, 1991
TITLEY, N. M., *Persian Miniature Painting*, London, 1983
Treasures of Islam, exh. cat., Musée d'art et d'histoire, Geneva, London, 1985
WULFF, H. E., *The Traditional Crafts of Persia*, Cambridge, Mass., 1966

Calligraphy

SAFADI, Y. H., *Islamic Calligraphy*, London, 1978
SCHIMMEL, A., *Calligraphy and Islamic Culture*, London, 1990
TOURNIER, M., *Hassan Massoudy calligraphe*, Paris, 1986
ZAKARIYA, M. U., *The Calligraphy of Islam*, repr. Georgetown, 1983

Chapter 1

CRESWELL, K. A. C., rev. ALAN, J. W., *A Short Account of Early Muslim Architecture*, Aldershot, 1989
GRABAR, O., *The Formation of Islamic Art*, New Haven and London, 1973

HAMILTON, R., *Walid and his Friends*, Oxford, 1988
KENNEDY, H., *The Prophet and the Age of the Caliphs*, Harlow and New York, 1986
RABY, J. (ed.), *Bayt al-Maqdis: ʿAbd al-Malik's Jerusalem*, Oxford, 1991

Chapter 2
BEHRENS-ABOUSEIF, D., *The Minarets of Cairo*, Cairo, 1985
BURCKHARDT, T., *Moorish Culture in Spain*, London, 1972
CASTEJON, R., *Medina Azahara*, Léon, 1985
GRABAR, O., *The Alhambra*, Cambridge, Mass., 1987
HILL, D., *Islamic Architecture in North Africa*, London, 1976
HUTT, A., *Islamic Architecture: North Africa*, London, 1977

Chapter 3
DANESHVARI, A., *Animal Symbolism in Warqa wa Gulshāh*, Oxford, 1986
GRABAR, O., *The Great Mosque of Isfahan*, London, 1990
HUTT, A., *Islamic Architecture: Iran I*, London, 1977
WATSON, O., *Persian Lustre Ware*, London, 1985

Chapter 4
ATIL, E., *Renaissance of Islam: Art of the Mamluks*, Washington DC, 1981
DEGEORGE, G., *Syrie*, Paris, 1983
ETTINGHAUSEN, R., *Arab Painting*, repr. Geneva, 1977
JAMES, D., *Qur'ans of the Mamluks*, London, 1988
MÜLLER, P. J., *Miniatures arabes*, Paris, 1979
PORTER, V., *Medieval Syrian Pottery*, Oxford, 1981
RABY, J. (ed.), *The Art of Syria and the Jazira 1100–1250*, Oxford, 1985

Chapter 5
GOLOMBEK, L. and WILBER, D., *The Timurid Architecture of Iran and Turan*, Princeton, N.J., 1988
GRABAR, O. and BLAIR, S., *Epic Images and Contemporary History: the Illustrations of the Great Mongol Shahnama*, Chicago and London, 1980
GRAY, B. (ed.), *The Arts of the Book in Central Asia*, Paris and London, 1979
LENTZ, T. and LOWRY, G. D., *Timur and the Princely Vision*, Washington DC, 1989
O'KANE, B., *Timurid Architecture in Khurasan*, Costa Mesa, Ca., 1987
WILBER, D., *The Architecture of Islamic Iran: The Il Khānid period*, repr. Westport, Conn., 1969

Chapter 6
BIER, C. (ed.), *Woven from the Soul, Spun from the Heart*, Washington DC, 1987
BLUNT, W., *Isfahan, Pearl of Persia*, repr. London, 1974
FALK, S. J., *Qajar Painting*, London, 1972
HUTT, A., *Islamic Architecture: Iran II*, London, 1978
MACKIE, L. W. and THOMPSON, J., *Turkmen*, Washington DC, 1980
WELCH, A., *Shah ʿAbbas and the Arts of Isfahan*, New York, 1973
WELCH, S. C., *A King's Book of Kings*, repr. New York, 1976

Chapter 7
ATIL, E., *The Age of Süleyman the Magnificent*, New York, 1987
COOK, M. A. (ed.), *A History of the Ottoman Empire to 1730*, Cambridge, 1976
DAVIS, F., *The Palace of Topkapi in Istanbul*, New York, 1970
GOODWIN, G., *A History of Ottoman Architecture*, London, 1971
PETSOPOULOS, Y. (ed.), *Tulips, Arabesques and Turbans*, London, 1982
ROGERS, J. M. and WARD, R. M., *Süleyman the Magnificent*, London, 1988

Chapter 8
BEGLEY, W. E. and DESAI, Z. A., *Taj Mahal*, Cambridge, Mass., 1989
BEVERIDGE, A. S., *The Bābur-nāma in English*, repr. London, 1969
BRAND, M. and LOWRY, G. D., *Akbar's India*, New York, 1986
Cambridge History of India, vols 4 and 5, repr. New Delhi, 1979 and 1987
GASCOIGNE, B., *The Great Moghuls*, repr. London, 1987
GRAY, B. (ed.), *The Arts of India*, Ithaca, N.Y., 1981
LOSTY, J. P., *The Art of the Book in India*, London, 1982
SKELTON, R. *et al.*, *The Indian Heritage*, London, 1982
SKELTON, R. *et al.* (eds), *Facets of Indian Art*, London, 1986
WELCH, S. C., *India*, New York, 1985
ZEBROWSKI, M., *Deccani Painting*, London, 1983

Conclusion
BLANC, J.-C., *Afghan Trucks*, London, 1976
SWEETMAN, J., *The Oriental Obsession: Islamic Inspiration in British and American Art and Architecture 1500–1920*, Cambridge, 1988

GLOSSARY

ʿabd Slave, a component in names, as in ʿAbdallah, slave of God; sometimes used with artists' signatures to convey humility.

ablaq (Persian) 'Piebald', ornament in black and white.

adhan Call to public prayer, whence the muezzin (*muʾadhdhin*), who gives the call.

alif First letter of the alphabet, a vertical stroke.

ʿamal In context of Mughal painting, execution; *ʿamala*, in art-historical contexts, 'he made', usually construed as 'work of'.

amir Army commander, lord.

ʿanazah Short spear on which the Prophet leaned when discoursing, seen as symbolic of his authority.

apadana (Old Iranian) Hypostyle hall.

arg (Persian) A small citadel.

atabeg (Turkish) Governor of a town or province entrusted with the upbringing of a young prince.

bangla (Urdu) Roof whose elliptical line imitates a pole bent down at the ends, the style derived from Bengal.

bannaʾi Brickwork including glazed brick-shaped elements.

barakah Blessing, a word sometimes found on pottery.

bay/bey/beg/bek (Turkish) Lord. *Beylik*, a principality.

bayt House, suite of rooms. *Bayt al-mal*, treasury.

bidri Metalwork style from Bidar, in which silver, gold or brass is inlaid in an alloy which is then blackened.

bismillah The opening words of 'In the name of Allah, the Merciful, the Compassionate'. Used as preface to formal statements, including inscriptions.

bohça (Turkish) Ornamental cloth used to cover a small object.

boghtaq (from Mongolian in various spellings) High red headdress of married women.

buteh (Persian) 'Bush', a drop-shaped element of pattern, for example, in 'Paisley' designs.

chadur (Persian) Tent, woman's enveloping veil, water-chute.

chahar-bagh (Persian) Garden with watercourses crossing at right angles.

chahar-taq (Persian) Structure in which four arches support a dome.

chhajja (Urdu) Eave.

chhatri (Urdu) Umbrella, miniature pavilion.

chihreh-nami (Persian) In context of Mughal painting, completion of faces.

chinar (Persian) Oriental plane tree.

chintamani (also *cintamani*, Sanskrit) The 'wishing jewel' of Buddhism, used of three roundels in triangular formation.

dar Abode, as in Dar al-Islam, Abode of Peace, the lands under Islam, or Dar al-Harb, Abode of War, lands not under Islam.

dervish (Persian, *darvish*) Mendicant mystic.

devşirme (Turkish) Levy of children for state service.

dinar (from Latin *denarius*) Gold coin.

dirham (Sasanian usage, from Greek) Silver coin.

divan In art-historical contexts, area of palace for certain formal uses, collection of poems.

dupattah (Urdu) 'Two breadth', woman's head-veil.

ebru (Turkish usage, Persian *abri*, 'clouded' or 'variegated') Marbling of paper.

fatihah Opening chapter of the Qurʾan.

ghazi Warrior for the faith. *Ghaza* raiding.

ghulam (Persian) Youth of slave status.

gul/gül (Persian/Turkish) 'Rose', possible meaning of repeating motifs on Turkman carpets. Alternatively, *göl* (Turkish), a lake.

guldasteh (Persian) 'Bouquet', aedicule at the top of a minaret.

gunbad (Persian) 'Dome', hence tomb-tower.

habb Large unglazed storage jar.

hadith 'Happening', tradition relating an action or saying of the Prophet which demonstrates a proper course or view.

hajj Pilgrimage to Mecca. *Hajji*, one who has made the pilgrimage.

hammam Bathhouse.

han (Turkish usage) Caravansaray.

haram 'Forbidden', in architectural contexts meaning sacred or private (whence 'harem'). *Haram al-Sharif*, the Noble Sanctuary.

hasht bihisht (Persian) 'Eight (-part) paradise', palace with four corner units of two storeys.

hatayi (Turkish usage) 'Of Cathay', chinoiserie.

hazirah Enclosure with unroofed tomb.

hijrah Departure of Muslims from Mecca to Medina in 622, from which the Muslim era is reckoned. Adjective *hijri*.

huqqah Hookah, hubble-bubble, water-pipe for tobacco.

imam Any adult male who stands before the ranks of believers to lead them in prayer; a man whose usual function this is; the leader of a Shiʿi community.

Islam Submitting oneself to the will of Allah.

ivan (Persian) Large vaulted chamber with an open end.

jali (Urdu) Screen of fretted stone or marble.

jameh (Persian) Garment, gown. *Chakdar jameh*, gown with four descending points, worn in sixteenth-century Hindustan.

jharokha (also *jharoka*, Urdu) Window. *Jharokha-i Darshan*, 'Window of the Appearance' where the Mughal emperor presented himself in the morning.

jihad Holy war.

juzʾ (pl. ajzaʾ) Section of the Qurʾan.

Kaʿbah The rectangular structure in the Haram al-Sharif at Mecca in which is set a black stone which was reverenced before the time of the Prophet.

kalimah 'Word', often used of the first clause of the *shahadah*, sometimes of both.

kashkul (Persian) Dervish's begging bowl in the form of a gourd.

khalifah Successor to the Prophet, caliph. The supreme leader of the Muslims.

khamseh (Persian usage) Quintet of books.

khan (Turkish) Prince, lord.

khanjar Dagger.

khanqah (also *khanaqah*, from Persian *khanagah*) Dervish convent.

khaqan (Turkish) Paramount ruler.

khass/khassah Private, for the use of the ruler and his close associates, as opposed to ʿamm/ʿammah, public.

khilʿah Robe of honour.

khutbah Oration at Friday prayer naming the ruler acknowledged by a community.

kilim (Turkish usage, from Persian *gelim* 'blanket') Floor covering in tapestry weave.

kimkha(b)/kemha (Persian/Turkish usage) 'Kincob', polychrome silk of compound structure, lampas.

kiswah Cover of black cloth sent annually by the caliph to the Kaʿbah.

kitab Book.

kufic Range of early scripts characterised by straight horizontal median line.

kuftgari (Persian) Superficial metal inlay.

külliye (Turkish usage) Architectural complex.

kurdi (Persian) Coat with a nipped-in waist.

kurnish (Turkish) Obeisance.

kursi Throne; preacher's seat in a mosque; box of pedestal form for the Qurʾan.

kuttab-sabil Structure combining Qurʾan school and unit for the distribution of water.

lajvardina (Persian *lajvardineh*, 'of lapis lazuli') Style of pottery decoration with cobalt blue glaze and enamelling.

lakabi (from *luʿab*, 'saliva', glaze) Style of pottery decoration with coloured glazes restrained by ridges.

laqab Honorific title.

madhhab School of law.

madinah City.

madrasah (Turkish usage, *medrese*) Religious college for higher studies.

mahall Palace.

maʾil 'Inclining', used of an early script.

mamluk Of slave status, sometimes still applied to the manumitted.

maqsurah Enclosure in the vicinity of the *mihrab* for the use of the caliph or other important person.

maristan (Persian) Hospital.

mashʿal Torch-stand.

mashq Elongation of the

235

horizontal lines in early kufic.

mashrabeh (Persian usage) Round-bodied jug.

mashrabiyah Window lattice formed of wooden reels and spindles.

masjid 'Place of prostration', mosque. Sometimes implies a small mosque with no *minbar*. A congregational mosque with *minbar* is known in Iran as *masjid-i jami*ᶜ, or as *masjid-i jumᶜeh* (Friday mosque).

matara (Turkish usage) Flask or water-pot.

mihrab Niche-shaped architectural feature, usually concave but sometimes flat, which indicates the *qiblah* direction.

millet (Turkish usage) Christian sectarian and national groups given a degree of autonomy within the Ottoman state.

minaret (*manarah*, 'lighthouse') Tower from which the call to prayer is given, a commemorative tower of similar shape.

minbar Stepped pulpit, used when the *khutbah*, is pronounced.

mina'i (Persian usage) Style of pottery decoration in which some colours are applied under the glaze and some over.

miᶜraj Mystical ascent of the Prophet into the heavens.

mudéjar (Spanish) Muslim under Spanish rule.

muhaqqaq A stately qur'anic script.

mulham Fabric which combines silk and cotton.

muqarnas A conglomeration of small niches or segments of niches, often used in the zone of transition from chamber to dome, also known as honeycomb or stalactite vaulting or decoration.

musalla Open-air place of prayer.

Muslim One who has submitted himself to the will of Allah.

nameh (Persian) A body of writing.

naqqash-khaneh/nakkaşhane (Persian/Turkish usage) Royal studio of painters.

naskhi Scribal hand.

nastaᶜliq (Persian usage) A script with diagonal sweeps often used for verse.

nisbah Appellation often referring to a person's place of origin (or that of his family), or to his occupation.

pishtaq (Persian) High arch which frames the front of an *ivan*.

qalyan (Persian) Hubble-bubble, water pipe for tobacco.

qasr Fort.

qiblah The direction of Mecca to which prayer is orientated.

qiyas Analogy, a procedure of Muslim jurisprudence.

qızılbash (Turkish) 'Red-head', tribal supporters of the Safavids wearing the red *taj-i Haydari*.

qubbah Dome.

Qur'an The Holy Book of Islam. The word has connotations of both reading and recitation.

quriltay (Mongolian) Tribal council.

rahlah Folding stand to support a Qur'an.

rayhani A qur'anic script whose vowels are written with a finer pen.

ribat Fortified religious frontier post, or in some contexts a fortified palace or caravansaray.

riwaq Used especially of the 'cloisters' round a mosque courtyard. Also tent-flap, portico, living quarters.

rumi (Turkish usage) Arabesque.

sahn Courtyard of a mosque.

sajjadah Prayer carpet.

salat Prayer, especially that made at five prescribed moments of the day.

sardab (Persian) Underground room for use in hot weather.

sarlauh Ornamental frontispiece or opening page.

sawm The obligatory fast in the month of *ramadan*.

sayyid Male descendant of the Prophet, lord.

saz (Turkish) In the context of decoration, the flower of the reed.

sedefkar (Turkish usage) Worker in mother-of-pearl.

senmurv Mythical creature with dog's head.

shah (Persian) King.

shahadah Profession of faith, creed: 'There is no God but God, Muhammad is the Messenger of God'.

shahi-sevani (Persian and Turkish) Devotion to the royal power in the Safavid period.

shamsah (Persian usage *shamseh*) 'Little sun', a disc or rosette ornament.

shiᶜat ᶜAli The party of ᶜAli, son-in-law of the Prophet, from which the Shiᶜi branch of Muslim believers is named.

shikasteh (Persian) 'Broken', a script in which segments of a word may be written on different levels.

simurgh Beneficent mythical bird.

siyah qalam (Turkish usage, *qalem*) A range of album pictures, in which demons and oriental subjects are prominent, some bearing an attribution to Muhammad Siyah Qalam. *Qalam-i siyahi*, drawing in black ink.

son cemaat yeri (Turkish) 'Place of late-comers', portico at entrance to an Ottoman mosque.

Sufi A mystic.

sultan Ruler, king.

sunnah The custom of the Prophet, from which the Sunni branch of Muslim believers are named.

surah Chapter of the Qur'an. In constructs, *surat*, as in *surat al-Nur*, Chapter of the Light.

susani (Persian) Needlework.

sutrah Small object such as a stone placed in front of a believer who is about to pray in the open air, to delimit a ritual space.

tabhane (Turkish usage) Hospice.

taj (Persian) Crown. *Taj-i Haydari*, cap with tall twelve-ribbed crown worn to demonstrate Shiᶜi beliefs in the early Safavid period.

talar (Persian) Open-sided columned hall or portico.

tarh In the context of Mughal painting, the composition.

tauqiᶜ A script resembling a small *thuluth*, used on royal diplomas.

thuluth (thulth) A script with a bounding rhythm.

tiraz (Persian) Ornamental band on a fabric, especially one with the name of the caliph. *Dar al-tiraz*, royal factory.

tombak (Turkish) Gilded copperware.

tuğra (Turkish) Monogram of the sultan.

türbe (Turkish usage) Tomb.

ᶜud Lute.

ᶜulama The learned class, clerics.

ulu cami (Turkish) Great Mosque.

ᶜunvan A heading.

waqf Perpetual religious bequest.

waqwaq (Persian usage *vaqvaq*) Mythical talking tree, and hence decorative scrolls with heads of people and animals.

yeniçeri (Turkish) 'Janissary', Ottoman infantryman.

zakat 'Purification', the obligation to give alms.

ziyadah Enclosure round a mosque.

ILLUSTRATION ACKNOWLEDGEMENTS

Abbreviations

ASC Al-Sabah Collection, Dar al-Athar al-Islamiyyah, Kuwait National Museum; courtesy of Sheikha Hussa al-Sabah. Photo Gulf International (UK) Ltd
BL Courtesy of the Trustees of the British Library
BM Courtesy of the Trustees of the British Museum
CBL Chester Beatty Library, Dublin. Photo Pieterse-Davison International Ltd
DC David Collection, Copenhagen. Photo Ole Wolbye
MMA Metropolitan Museum of Art, New York
TSL Topkapı Sarayı Library; courtesy of the Topkapı Sarayı Müzesi Müdürlüğü
V&A Courtesy of the Board of Trustees of the Victoria and Albert Museum

Photographs of sites not listed here are © the author

Frontispiece BL, Or. 6810, f. 214a
Figs
1, 2 BL, Add. 27261, ff. 362b and 363a
3 Photo Graham Harrison
7 National Museum, Damascus
10 Iraq Museum, Baghdad, A 1185; courtesy of the Directorate of Antiquities and Heritage, Republic of Iraq
12 BM, OA 1944.5-13.3
13 BM, OA +10621-2
14 CBL, MS 1422
15 BM, OA 1963.12-10.3
16 Keir Collection, Ham, Richmond (G. Féhérvari, *Islamic Metalwork*, London, 1976, no. 1)
17 BM, CM 1949-8-3-176
18 BM, OA 1966.4-18.1
19 L. A. Mayer Memorial Collection, Jerusalem, G-24
20 MMA, 1974.74 (Purchase Rogers Fund and Gifts of Richard S. Perkins, Mr and Mrs Charles Wrightsman, Mr and Mrs Louis E. Seley, Walter D. Binger, Margaret Mushekian, Mrs Mildred T. Keally, Hess Foundation, Mehdi Mahboubian and Mr and Mrs Bruce J. Westcott, 1974)
21 BM, OA 1954.10-13.1
22 ASC, LNS, 9 C
23 V&A, 1314-1888, T13-1960. Photo Daniel McGrath
24 Musée Historique Lorrain, Nancy, 95-1584. Photo Gilbert Mangin
26 Photo Dr Geoffrey King
27 Robert Harding Picture Library Ltd
30 Photo Graham Harrison
32 Photo Vivienne Sharp
33 National Archaeological Museum, Madrid
34 Museum für Islamische Kunst, Staatliche Museen Preussischer Kulturbesitz, Berlin, I. 6375. Photo K. H. Paulmann
35 ASC, LNS, 52 W^{ab}
36 V&A, 7904-1862

37 BM, OA 1959.4-14.1
38 Courtesy of Il Ciantro della Cappella Palatina, Palermo
39 Biblioteca Apostolica Vaticana, Cod. Vat. Ar.368, f.9a
40 Keir Collection, Ham, Richmond (*Islamic Art in the Keir Collection*, 1988, c8)
41 Benaki Museum, Athens, no. 19376
42 Musée du Louvre, Paris, MR 1569. Photo © Réunion des Musées Nationaux
43 V&A, 275-1894
45 Courtesy of the World of Islam Festival Trust
46 From D. Hill and O. Grabar, *Islamic Architecture and its Decoration AD 800–1500*, London (Faber and Faber), repr. 1967, fig. 145 (photo of 1880). Courtesy of Derek Hill
49 MMA, 67.119 (Gift of Mr and Mrs Lester Wolfe, 1967)
50 CBL, K.16, f.9b
51 Bodleian Library, Oxford, MS Marsh 144, p. 167
52 TSL, H.841, f.27a
53 BM, OA 1956.5-18.1
54 ASC, LNS 185 C
55 BM, OA, 1958.12-18.1
56 Ashmolean Museum, Oxford, 1956.33
57 BM, OA 1945.10-17.261
58 BM, OA 1848.8-5.2
59 BM, OA 1938.11-12.1
60 BM, OA 1950.7-25.1
61 Museum of Turkish and Islamic Art, Istanbul, 685; courtesy of the Türk ve Islâm Müzesi Müdürlüğü
62 Musée Historique des Tissus, Lyon, no.23.475. Photo Alain Basset
65, 67 Photos Dr Bernard O'Kane
68 MMA, 91.1.2064 (Bequest of Edward C. Moore, 1891)
69 BM, OA 1855.7-9.1
70 BM, OA 66.12-69.61
71 Musée du Louvre, Paris, LP 16. Photo © Réunion des Musées Nationaux
72 Kunsthistorisches Museum, Vienna, WS C 113
73 Courtesy of the Islamic Department, Sotheby's
74 BM, OA 1906.7-19.1
75 BM, OA G.1983.497
76 Österreichische Nationalbibliothek, Vienna, Cod. AF 10, f.1. Photo Lichtbildwerkstätte Alpenland
77 National Library, Cairo, 7. Photo Alexandria Press
78 Bibliothèque Nationale, Paris, MS Arabe 5847, f.89
79 Bodleian Library, Oxford, MS Pococke 400, f.70a
80 Museum für Islamische Kunst, Staatliche Museen Preussischer Kulturbesitz, Berlin, I. 3191a. Photo Liepe
81 MMA, 1970.105 (Fletcher Fund 1970)
82 Photo Professor Ernst Grube
87 Ashmolean Museum, Oxford, 1956.59
88 V&A, C.232-1985
89 DC, 38/1982
90 Courtesy of the Islamic Department, Sotheby's
91 BM, OA 1970.6-4.1
92 TSL, E.H. 1637
93 BL, Or.6810, f.3b
94 Edinburgh University Library, Or. MS 20, f.134b

95 Biblioteca Berenson, Harvard University Centre for Italian Renaissance Studies, Florence
96 BL, Add.18113, f.45b
97 TSL, H.2160, f.10a
98 Freer Gallery of Art, Smithsonian Institution, Washington DC, 32.34
99 Royal Asiatic Society, London, MS 239, f.180a
100 BL, Add. 25900, f.161a
101 Photo Roger Wood
102 Photo Dr Patricia Baker
104 BM, OA 1948.7-13.1
105 DC, 1/1986
106 Photo Paul Fox
107 BM, OA 1948.12-11.023
108 BL, Or.2265, f.57b
109 BM, OA 1948.12-11.017
110 V&A, IPN.1992
111 BM, OA 1948.12-11.08
112 V&A, 720-1876
113 BL, Or.4938, f.6
114 Royal Museum of Scotland, no. 31; courtesy of the Trustees of the National Museums of Scotland
115 Institut Royal du Patrimoine Artistique, Brussels, Tx 1504; © A.C.L. Bruxelles
116 V&A, 650-1894. Photo Daniel McGrath
117 Glasgow Museums and Art Galleries, Burrell Collection 9/2
118 Textile Museum, Washington DC, R 37.5.2
119 V&A, 272-1893
120 BM, OA G.1983.4
125 BM, OA G.1983.46, G.1983.49
126 DC, 2/1962
127 Topkapı Sarayı Museum, 2/484; courtesy of the Topkapı Sarayı Müzesi Müdürlüğü
128, 129 Courtesy of the Islamic Department, Sotheby's
130 Courtesy of the Oriental Manuscripts and Miniatures Department, Sotheby's
131 Österreichische Nationalbibliothek, Vienna, Cod. mixt.313, f.12b
132 BL, Or.14010, f.95b
133 CBL, MS 413, f.115b
134 TSL, H.2164, f.18
135 BL, Or.7094, f.54b
136 V&A, 771-1884
137 Textile Museum, Washington DC, 1.68
138 Musée des Arts Décoratifs, Paris, tapis inv. 7861. Photo M. A. D. Sully-Jaulmes
139 Royal Armoury, Stockholm, LRK 3940 and LRK 3938; © Livrustkammaren Skoklosters Slott Hallwylska Museet
143 Photo John Youngman
146 BM, OA 1959.10-16.1 (Henderson Bequest)
147 V&A, IS 12-1962
148 V&A, IS 27-1980
149 DC, 35/1976
150 BM, OA 1925.9-29.01
151 BL, Or.13836, f.37b
152 V&A, IS 2-1896 (46/117)
153 BL, Or.12208, f.63b
154 BL, Or.7573, f.88a
155 BL (India Office Library), MS Add. Or.1087
156 BM, OA 1920.9-17.02
157 BM, OA 1948.10-9.69
158 BM, OA 1937.4-10.02
159 ASC, LNS 15 R
160 V&A, IS 168-1950
161 Private collection

237

238